LIFE'S JOURNEY:

Lessons Learned Along the Way

By

Hilary A.P. Williamson

Table of Contents

Dedication .. i

Acknowledgement ... ii

About the Author ... iii

Introduction ...1

Chapter One: Where My Journey Begun6

Chapter Two: Unwelcomed Change14

Chapter Three: Pick Your Friends Wisely20

Chapter Four: My Heart's Desire...................................33

Chapter Five: The Beginning of Mayhem45

Chapter Six: Turbulence and Strife59

Chapter Seven: Standing at Death Doors........................72

Chapter Eight: Midnight Fire94

Chapter Nine: Wrong Reasons......................................106

Chapter Ten: Heartbreak and Sorrow123

Chapter Eleven: Operation Rescue Max150

Chapter Twelve: Unexpected News................................162

Chapter Thirteen: Living With Regret178

Chapter Fourteen: Saying Goodbye187

Chapter Fifteen: Family Feuds.......................................197

Chapter Sixteen: I Should Have Said No212

Chapter Seventeen: Not What I Expected.......................222

Chapter Eighteen: Unforeseen Circumstances.............233

Chapter Nineteen: When I least Expected259

Chapter Twenty: Saying Goodbye to Fluff.....................275

Chapter Twenty-One: Wilderness Journey288

Chapter Twenty-Two: Feelings of Despair...............................302

Chapter Twenty-Three: Bittersweet...317

Chapter Twenty-Four: For My Own Good342

Chapter Twenty-Five: Do Good to Others.................................359

Chapter Twenty-Six: Approaching the End of the Tunnel379

Chapter Twenty-Seven: Open Doors ...397

Chapter Twenty-Eight: I Did My Best.......................................414

Chapter Twenty-Nine: Reflections ...419

Dedication

This book is dedicated to my mother, Dorothy Matthews Cornelius, who always believed in me no matter what I did. She believed I could accomplish anything in life that I put my mind to and encouraged me to work towards making my dreams come true. She was my teacher, my rock, my friend and my comforter in times of heartbreak and sadness. Mom passed away on August 14th, 1998, but she will never be forgotten and shall forever remain alive in my heart.

I also dedicate this book to Max and Fluff, who, too, have both passed on and left me. They were a major part of my life and were also an inspiration for this book. My four-legged boys brought so much joy and happiness into my life each and every day for over a decade. Their unconditional love enabled me to see rays of sunshine on my dark and cloudy days.

Acknowledgement

There are a few people I want to express my gratitude to for their contribution to this book. For being instrumental, supportive and providing constructive criticism. There is one person in particular that I would especially like to acknowledge because she taught me the concepts of writing. I have no idea where she is right now, but she was one of my professors at Cambridge College in Massachusetts, Professor Anne Scott.

Thank you to my best friend, Beverly Jarrett, for her inspiration, endless support, input, advice and encouragement, but most of all, I thank her for believing in me. Thank you to my brother, Andrew Cornelius, for allowing me to share a season in his own journey through life. Thank you for your encouragement and belief that this book would be successful.

Thank you to Elaine Fulton, who really pushed and encouraged me to keep on writing no matter what obstacles came my way. When I wanted to quit, she would not allow me to give up. Elaine had faith in me, even when I didn't have it in myself. She was convinced my book would be a top seller, as she put it. She spoke life into my project, which in turn energized and enabled me to keep on going. So, Elaine, I thank you from the bottom of my heart for believing in me when I stopped believing in myself.

Last but not least, thank you Jill Kavanaugh-Green for being my first critique, and for your honesty after I wrote the first page and asked for your thoughts. You told me to start again and make it captivating. Because of you, this book is what it is today.

About the Author

Born and raised in Nottingham, England, Hilary came to the United States to live permanently with her mother, stepfather, and siblings when she was nineteen years old. Being sociable, humorous, communicative, quick-witted and very expressive are a few of her traits that draw people towards her. Feeling like a magnet for people who sought her out for help and advice, led her to pursue a master's degree in counseling psychology, in order to better understand the human mind and behavior.

Although Hilary did not end up pursuing a career in counseling after receiving her master's degree, she did help hundreds of people through an array of self-sufficiency programs, during her combined ten-year tenure as Planner, and Executive Director/CEO of a non-profit organization in Boston, Massachusetts. Feeling the need for a major change after the loss of her mother, Hilary packed up and moved from Massachusetts to Miami, Florida, where life as she once knew it, came to a crashing holt.

With three failed marriages to men, she should never have married in the first place, Hilary thinks of herself as an expert in who not to marry. Although she never gave birth to children of her own, she has been a mother to many. Hilary is an animal rights advocate and humanitarian, who longs to be in a platform where she can better help alleviate the suffering of both people and animals who are unable to defend or help themselves.

Hilary as had her fair share of drama, heartbreak, loss and sorrow, which led her to begin writing, after years of listening to friends and associates trying to compel her to do so. Because Hilary is a very private person who had no intention of airing her personal business to the public - it wasn't until she had reached a place of total brokenness, that she began writing her long-awaited memoir. Hilary wants to

share her life's journey with the hopes that her readers will not only be entertained but will apply her lessons learned to their own lives and use wisdom when making decisions.

Introduction

Whilst traveling down memory lane, I reflected on all the important lessons I have learned along my life's journey so far. I then asked myself, "Out of all my lessons learned, which one has been most valuable?" I came to a conclusion that "Keeping Hope Alive" by far has been the most valuable. Why? You might ask, - because - - hope or the lack thereof intensely impacts our present state of mind. I think of it as a strong invisible force that shapes and structures our thoughts in expectation of a brighter future. Without it, there is nothing to look forward to, and in some instances, life just does not seem worth living.

It changes the way we see things and affects the way we act. When I have hope, my thoughts are always positive. They are filled with joy and excitement as I look forward to all the great things I expect to accomplish with my life. Then there were times when unforeseen events or the bad decisions I made caused a ripple effect of consequences which led to a feeling of great despair. When that happened, my future began looking hopeless and dim and sometimes very dark. I could not seem to foresee a way out of the predicaments I found myself in. That was when my hope began to grow faint and eventually disappeared.

Once my sense of happiness and purpose ceased, I used to tell myself, "There is no point in trying to accomplish my dreams anymore because nothing good will happen to me. When my hope was totally depleted, I would ask myself, "What is the point of living?" It was during those dark times that I would ask God to take me while I slept, so my misery could finally end. It is, for this reason

1

I say it is imperative that we keep our hope alive as we travel through this unpredictable journey called life.

"For faith is the substance of things hoped for and the evidence of things not seen." (Hebrews 11:1). That means that when we hope for something, we need to put our faith into action. Faith is believing without doubt that even though we might not see the thing or things we are hoping for, it will manifest into reality. It might not happen when we want it to, but it will happen so long as we do not lose hope and start doubting.

Everyone's journey is different, our trials and tribulations are not the same, but we all experience some sort of adversity, turbulence and heartbreak on our adventurous journey through life. Life can be as sweet as honey at times; then there are bitter times. The thing is, we can prevent some of the bitterness if we use wisdom and think of the consequences before we act. Sometimes the dilemmas in life that we find ourselves in are of our own doing; other times, the unfortunate circumstances we find ourselves in, are ones we were unable to prevent.

I believe that is when fate comes into play. Those are the times when a situation is going to happen regardless of what we did or didn't do. The times when there was absolutely nothing in our power that we could have done to change the outcome. Like losing a loved one, for instance – there is nothing we can do to add one extra day to a person's life, no matter how hard we try once that person's journey here on earth has ended.

Some couples try to prevent themselves from having a child and take all the necessary precautions, and a baby still comes. I believe

in destiny and that we were all predestined to be born and to leave this earth at a certain time. Some people are destined for greatness whether they work towards it or not. Some people get rich overnight without working for the riches they obtain, while others work and strive their entire lives to obtain it and never do.

I have learned in the school of life that some things are going to happen, and no matter how we would love to change them, there isn't a damn thing we can do about it. In fact, I have learned that some things that happen are good for us, even though at the time of the occurrence, we wish it didn't. Sometimes those disappointments turn out to be beneficial or for our own good. On the other hand, there are things that happen in life that we can prevent or change but don't because we lack wisdom.

Mom used to tell me over and over that "Prevention is better than the cure." That means it is wiser to prevent something bad from happening than having to fix the problem after - like a sexually transmitted disease, for instance. Many people suffer from incurable diseases because of recklessness, poor lifestyle choices, or one unlucky sexual contact. Those who have not lost their lives have destroyed their lives and are now suffering because of their bad choices. Many could have prevented it from happening in the first place, but instead, they are now trying to cure it. So, as mom said, prevention is always better than cure.

Certain decisions we make in life can either make us or break us. Some people had only one chance to make a bad decision because it cost them their lives, freedom or health, just to name a few. Then there are some people whose decisions have changed their lives for the better. They are now living a happy and contented life because of

the good choices they made along their journey. Life is like a highway we travel down, but sometimes we get off at the wrong exit. When we do, we should learn from our mistakes, get back on that highway and keep it moving.

I have taken many wrong exits, but I, on the other hand, tend to sometimes stay there too long, which in turn prolongs me reaching my destiny. I believe that highway we travel leads to our destiny. That inevitable or necessary fate which a person is destined to, or one's lot in life. I believe before we were born, God already predetermined our course of events which is something beyond human power or control.

Some people delay or lose the chance of reaching their destinies because of one wrong decision, which led them in the wrong direction, which turned out to be fatal, like getting into that wrong relationship, for instance - that wrong relationship which has cost many men and women their lives. That one wrong move caused them to never reach their life's potential because their journey was cut short before its time.

As you read on, you will see that my wrong moves came with much unhappiness. If I had made better decisions, I wouldn't have experienced some of the tribulations that I did. And I certainly would not have ended up in a particular relationship that nearly cost me my life. Don't get me wrong; I have had many good days filled with love, joy and laughter. But it seems as though much more days were consumed in tears and sadness, especially after losing the people I loved the most.

When I hear people say, "If I could do it all over again...." I think

to myself, "How I wish I could turn back the hands of time and do it all over again, so I could make different choices." Then I snap out of it and accept the fact that I cannot go back because "time waits for no man." We can only learn from our mistakes and try to make better choices with the time we have left. Time is certainly moving by quickly, so make the most of it. As I share segments of my journey with you, I hope that you will learn something valuable that you can take with you on your own life's journey.

Chapter One:
Where My Journey Begun

Have you ever wondered how different your life would be if you were born with different parents or in another country? Have you wondered how different your life may have turned out? I have wondered sometimes, but I always end up with the same conclusion. If I were given a choice, I would not change my place and country of birth or the parents that were chosen for me. I count myself blessed to have had three wonderful people whom God chose to raise and care for me.

Valda and Lester Case were my mother's elder sister and husband, who migrated to England from Jamaica back in the late 1950s. When mom turned eighteen years old, aunt Valda and Uncle Lester sent for mom so she could join them in England. After spending a couple of years in Nottingham, mom decided she wanted to attend nursing school, so she moved to Reading. Whilst there, she met and fell in love with Terry Williamson, who later became my father.

It turned out that mom was not cut out for nursing after all. She was unable to cope with the sight of blood and incapable of containing her emotions when she saw a wounded patient. Mom quit nursing after she completed all her courses and ended up pregnant with me instead. She did not go into details about what caused the breakup, but she ended up moving back to Nottingham without my father. Shortly after, she gave birth to me at Sherwood Hospital with my aunt Valda and Uncle Lester by her side.

My aunt and uncle didn't have any children of their own, so I was the next best thing. Their childlessness was beneficial for me because not only did I have three very loving parents, but I was also afforded a very privileged childhood. I'm not sure at what point I started calling them aunty and daddy, but Uncle Lester was daddy to me until he left this earth. They most certainly spoiled me by giving me everything my little heart desired, and I most certainly loved it.

I believe I was fortunate to have been born and raised in Nottingham, England, entwined in both the British and Jamaican cultures. The valuable lessons I was taught at an early age by the wonderful people who loved and invested so much into my life made my childhood a very happy one.

Considering the way society is today, with so many broken homes, single-parent households and children in foster care, it was a privilege to have had such a great family support system. Having a close-knit family with all the love and support I needed, which in turn played a pivotal role in the shaping of my character, personality and coping skills needed for the journey I had ahead of me.

Up until age six, I spent my weekends with aunty and daddy at their home on Teversal Avenue in Lenton. During the week, I lived with mom in her apartment, which was located on top of her hairdressing salon in Radford. As much as I enjoyed being with mom, I always looked forward to Friday evenings when I knew daddy was coming to get me. We had a weekend routine - on Saturday, aunty and I went shopping downtown at Victoria Center markets, and then she would go to Jessop's or Debenhams to buy clothes or her designer perfumes.

The only thing I hated was when she took me to Clark's Shoes to buy my school shoes. Back then, I never realized I was getting shoes of good quality; I was only interested in getting what was in style at that time because my friends were wearing it. After aunty and I returned home from town, she would start cooking Saturday dinner, which was usually something I didn't want, so aunty would send daddy to buy my favorite meal instead, which was fish and chips.

Visitors were always stopping by, and usually, when that happened, I had to go into the living room and watch television. Back then, a child was not allowed to be listening to the conversation of adults. Sunday mornings, aunty and I went to church, and daddy stayed home and read the News of the World newspaper. When we returned home, preparation for dinner would begin, and once dinner was finished, we went on our Sunday afternoon excursions.

Daddy enjoyed going to Trent Bridge to watch cricket matches, so when we did that, aunty would knit while I went off somewhere to play. Other weekends were spent enjoying other types of excursions or visiting friends and family. Most Sundays, though, we drove to Birmingham to visit our family. Whatever we did on the weekends was very enjoyable, and so I always looked forward to the following weekend.

One evening, after arriving home from school, mom told me she had something very important to tell me. Excited to find out what it was, I waited with great anticipation for the important news. As my wild imagination wondered what it could be, nothing I imagined came close to what she ended up telling me. "I will be leaving to go to America, and I am going to leave you with Valda and Lester until I am settled, then I will come back for you."

It was a dream come true - my heart's desire had been fulfilled, and I was the happiest six years old alive that day. I don't think I slept that night out of excitement. Life as I had known it was about to change, and I couldn't wait until the day came that I was going to permanently move in with aunty and daddy.

I remember the tears rolling down mom's cheeks as she held me tightly and kissed me goodbye the day she left for Heathrow Airport. I was so happy but had no idea at the time why she was weeping. I realize now that those tears came from the sadness of leaving her only child behind while she left on her adventure to find better opportunities. Opportunities in the country which was known at the time as the land of milk and honey.

I found out years later that mom's other sister Daphne, who was already living in America at the time, convinced her to leave England and join her there. She had told mom that America was the place to be because the possibilities of a better life were endless. Those were the days I used to hear grown-ups saying America was the land of milk and honey. So, while mom set off on her adventure, I was looking forward to enjoying mine. Aunty registered me at St. Mary's Catholic school on Derby Road, which happened to be the place where the foundation of my faith in God began.

Those were the good old days, days that were so totally different from what they are now. Life was great back then because, as kids, we were so carefree and innocent. When we were as young as six years old, we walked home from school by ourselves. Times were much safer for kids because we didn't have to worry about being kidnapped or molested. Those thoughts never entered our minds as we had never heard of anything like that happening back then. There

were no cell phones, and when we were out playing all day away from our homes, our parents didn't have to worry because they knew we were okay.

We had no childproof lids on medicine bottles, no car seats for children, and when we rode our bikes, we didn't wear helmets. We had no video games at all and definitely did not have the privilege to surf 100 channels on the television because we only had 3 or 4 channels to choose from. There were no personal computers or internet - all we had were our friends, and so we went outside to find them. We had freedom, failure, success and responsibility, and we learned how to deal with it all.

Daddy's nieces, Maxine and Sandra Case, were my partners in crime, as we made it our duty to get into mischief. Especially on our walks back home after attending classes at the British Red Cross Society, of which we were junior members. We had many friends from all walks of life, English, Irish, Polish, Indian, Italian, Spanish, and West Indian, and we all lived loving with each other. We didn't know what racism was because we were not taught, and we didn't see color; we only saw our friends. We were equal; none was considered higher or lower than the other.

We were raised to have respect for our elders; it did not matter what nationality they were. If they were adults, we had to respect them. As children, it was frowned upon if we passed an elder on the street and didn't acknowledge them by saying "Good Morning, Good Evening, Mr. or Mrs.," whatever their names were. I was taught to help the elderly, and in fact, it was my duty to check on those who were widowers that lived on our street. If they needed anything at the shop, it was my job to buy it for them and return with all their change

and not take even a penny.

When I turned eleven, daddy took me to Paris, France, on a weekend trip because I was learning French at school. Mind you, when I got there, I did not understand a word they were saying, and the only food I was able to pronounce was chocolate. Although both daddy and I were skeptical about eating the food, we did have a lovely time, which left me with a memory that will always warm my heart.

Well, as they say, all good things must come to an end, and they did. Less than a year later, life, as I had known it, came to an abrupt end. Right after my twelfth birthday, mom insisted it was time for me to join her in America. Mom had returned when I was eight years old and wanted to take me back with her then, but somehow, aunty convinced her to let me stay until I was older. But this time around, there was nothing aunty could say to convince mom to let me stay longer.

Aunty and daddy's love for me was deeply felt as they took such good care of me and arranged my birthday parties every year. They provided me with many wonderful childhood memories filled with love, laughter and so much happiness. I couldn't have asked for a happier start in life because the beginning of my life's journey was filled with much joy. Having joyous memories to reminisce on helped me through the sad times that were waiting ahead for me.

When that dreadful day appeared, and the time came to leave for Heathrow Airport, aunty, daddy, and myself I was terribly heartbroken. Aunty, her best friend, aunty Davis and her grandson, Shaun, were accompanying me to the airport, but daddy was not, and I could not understand why. I repeatedly asked, before we left the

house, why he was not coming with us. Daddy told me he was unable to come with us because he had to work, but I found out later that wasn't true.

Aunty finally told me that daddy had a broken heart and did not want me to see him cry. I turned around to run back upstairs to beg him to come with us, but she stopped me. She told me I would only make it worse, so I should leave him alone. Hearing those words only broke my heart even more, and so I begged aunty not to let me go. Instead, she sang a song to me as we were about to walk through the front door. She sang, "Before the next teardrop falls." Somehow, I guess aunty thought she was helping me, but she only made it worse.

She told me that I might like it once I landed in America, but if I did not, I should just call, and she would be there before my next teardrop falls. At that point, I cried so much that I could swim in my tears. I cried all the way to the airport, sitting next to aunty in sorrow. I tried to comprehend how I was going to manage in a strange land without the people I loved so much. I continued to ask aunty not to let me go, while at the same time, I tried to make the most of our time together. I knew that once we entered Heathrow, life as I had known it, was going to change dramatically.

Those three hours on that coach went by so quickly, and before I knew it, we were at Heathrow airport. I clung tightly to aunty when they called my name to board the flight and begged her not to send me. Aunty tried to hold back her tears but failed. As we stood there hugging each other, we were still weeping when my name was being called for the second time on the intercom to board my flight. Aunty Davis had to step in and say, "Pat, you have to go now."
Aunty told me not to worry because I would see her again soon.

One by one, I kissed them goodbye, but Shaun held on to me, refusing to let go. Aunty Davis stepped in again to pull us apart and insisted I go before I missed the plane. Once I walked away from them and headed to the boarding area, I turned around to see if they were still standing there. I was unable to stop the overwhelming emotion that came over me and was unable to prevent my legs from running back to them, so I could hug and kiss them one last time.

I cried all the way through the flight to John F. Kennedy Airport, and nothing the flight attendants said or did could make me feel any better. The woman sitting next to me tried to cheer me up, but that wasn't working either. When she asked me what was wrong, I told her I wanted to go back home. Once the plane landed, my stomach fluttered with anxiety, as England was now thousands of miles behind me. I had landed in a new and strange country, having no idea what to expect.

Chapter Two:

Unwelcomed Change

Change isn't always easy, especially when you like things just the way they are. Having to start over again can be very stressful, especially when moving from one city to another, but even more so when moving to another country. Sometimes parents don't realize how much it affects their children who have to leave their friends and other family members and move to the unknown to begin anew.

I was looking forward to seeing mom and my baby sister for the first time, but I wanted only to visit them and go back home to England. I had no idea about the surprise waiting for me when I finished with baggage claims and headed to the area where mom was waiting for me. She was seven months pregnant, which totally shocked me. By this time, mom had already been married for three years and had already had my baby sister, who was a year old when I met her.

"Wow, what a difference!" were the first thoughts that entered my mind after stepping out onto the streets of New York for the first time. The streets were so wide, the cars so big, and the taxis weren't like any taxi I had ever seen before. The tall buildings, crowded streets and highways left me in awe. It felt like I was in a whole new world because it was nothing like the small city of Nottingham that I was used to. Talk about culture shock; well, I certainly got one.

It was awkward meeting my stepfather for the first time because I was not willing to accept anyone else as a father figure other than

daddy. I always wanted a sister, so when I met my baby sister Debbie for the first time, it was a very joyous moment. I was used to living in a house with a backyard, so having to adjust to living in a small three-bedroom apartment with no backyard to play in, was going to take some time to get used to. Well, I didn't get used to it; in fact, I hated it; I hated the Bronx, I hated the school I attended and the kids who bullied me because I had braids in my hair and a British accent.

I was unhappy and miserable and wanted to go back home to England. Because of this, every evening after school, when mom was preoccupied with my baby sister, I made collect calls to aunty and daddy and begged them to come get me. Aunty finally called mom and asked her to send me back to them, but mom refused. She made it quite clear to both aunty and me that I belonged in New York with her, and she was not going to send me back.

After that phone conversation with aunty, mom told me to stop calling her every day because I was running up the phone bill with all those collect calls. Mom also reminded me that she allowed me to stay with aunty and daddy longer than she had planned, so basically, that meant I was to be grateful for the extra time I did get to live with them. That did not make me feel any better, and in fact, I began calling aunty even more from pay phones instead.

By the end of my first month in New York, I noticed a little rash on my right arm that wouldn't stop itching. Mom used various home remedies, but nothing worked, so it continued to itch and began spreading very quickly. Mom ended up taking me to a doctor who referred us to a dermatologist. Not knowing what the rash was or its cause, the dermatologist prescribed ointments that were of no help.

So, on top of depression and being away from everyone I loved in Nottingham, I was extra miserable because my skin continued to itch day and night. One thing that did give me joy amid my miserableness was the night mom unexpectedly went into labor. It was an exciting time for me having to rush to the hospital with mom in anticipation of what gender my sibling was going to be. He turned out to be a beautiful little boy whom mom named Andrew, after a disciple of Jesus.

I couldn't wait until my brother and sister grew up so we could have conversations, go places together and teach them all that I knew. But in the meantime, I was still lonely, friendless and longing to go back to England. I had no friends at school except for the fake ones who talked about me behind my back. When they weren't doing that, they were always trying to set me up to fight with someone because they wanted to know if I could fight.

I wasn't involved in any after-school sports or other activities like I was in England, except for weekly church attendance and mom's prayer meetings. Mom did take me to the Empire State Building and sightseeing, and we took many train rides to downtown New York to shop, but it just wasn't the same as when aunty, daddy and myself went places. I did not have anyone I could trust to share my innermost feelings with. I didn't want mom to know how I really felt because I didn't want to hurt her feelings. So, I internalized my emotions and tried to adapt to my new way of life.

After six months of living in the Bronx, I was terribly homesick and missed aunty and daddy so much. At times it felt extremely unbearable, so I couldn't help myself; I had to continue making collect calls just so I could hear their voices. Aunty didn't tell mom

that I continued to call her collect; instead, she just paid the bills, which must have been extremely high. Knowing now that international calls are expensive, I can't even imagine how much I ran the cost of her phone bill up every month.

Aunty was secretly planning unbeknownst to me, and what a great surprise it turned out to be when I returned home from school on that glorious day. Aunty and aunty Davis were sitting in the living room. I thought I was dreaming at first. It took a few moments for it to register that they were really in front of me and that it wasn't my imagination. The tears rolled down my cheeks as I hugged and kissed them, not wanting to let them go.

Aunty told me that it was cheaper for her to come and visit me than it was paying for all the collect calls I was making. I was elated, and the joy I felt was consuming, even more so when aunty told me she had come to take me back home. She brought aunty Davis as her backup to help persuade mom to send me back with them, but mom would not allow me to leave. Aunty and aunty Davis stayed two weeks with us, during which time I basically went everywhere they did.

During our time away from mom, aunty and I had the heart to heart conversations in which she tried to convince me that it would all work out. She kept telling me not to give up hope and that I should continue to believe that I would be back in England with them soon. When the time came for aunty and aunty Davis to leave, my heart was severely broken. Once again, my happiness was replaced with sadness, and I was devastated.

After aunty and aunty Davis left, I became very depressed, and

my rash began spreading rapidly. So much so that within a few days, it had covered my legs and stomach. Mom, being worried, took me to another dermatologist who concluded it was eczema. A series of tests were done, but he was unable to identify the cause. Although he prescribed a medication he claimed would help the problem, it didn't.

Mom continued trying natural home remedies to no avail, so she called aunty to see if she knew of anything that could help. Aunty suggested mom send me back to England so she could take me to an herbalist doctor, as she was confident that a cure would be found. Mom, of course, did not agree to that idea, instead she continued searching for a doctor in New York that could help. A year later, there was still no cure, at which point the rash had spread everywhere on my body except for the soles of my feet.

After being in the country a year and a half, mom told me we were moving to Boston, Massachusetts. It was arranged for them to move with two other families they knew from church, and so we all moved together on the same day. I had never heard of Massachusetts before then, so I had no idea how far it was and what it would look like once we got there. Although it wasn't Nottingham, it was someplace new, and it gave me something to look forward to.

I was pleasantly surprised when we entered our new home, which was spacious and even better when I realized I had my own room and did not have to share it with my baby sister. I liked Boston much better than the Bronx because it was cleaner, it wasn't as fast, and the scenery was much more pleasant than the Bronx was at that time. Even though my surroundings were better, I was still pinning to return to Nottingham.

Mom enrolled me at Dorchester High school, which didn't seem to be much different from the school I attended in New York. I was still made fun of because of my British accent, the clothes I wore and my hairstyle, but I didn't let it bother me too much. I made a few friends, but there was one, in particular, Donna, whom I was closer to. We came from similar backgrounds, so I bonded more with her than I did with the other girls. A bond that led to an incident that could have cost us our lives.

Chapter Three:

Pick Your Friends Wisely

It seems that no matter what age a person is, whether young or old, some make the wrong choice when picking a friend. There are many instances where people have chosen the wrong person as a friend and that bad choice ends up costing them their lives. If your friend tries to influence you to do what you know to be wrong, that is not a good friend. I have picked bad friends in the past, but this particular friend could have cost me my life at a young age. Had God not been watching over me this specific night, mom would have received that call all parents dread.

As Donna and I got to know each other better, she revealed how much she hated her life at home and wanted to run away. When Donna asked if I would run away with her, I initially said I couldn't. Once I started thinking about what she asked, I couldn't shake the thought out of my mind. I didn't like being at home either, especially having to live with my strict stepfather. In the end, my unhappiness at home, combined with the absence of aunty and daddy, was all it took for me to agree to run away with her.

A couple of days later, I told Donna to let me know when she was leaving because I was going to run away with her. I decided if mom was not going to let me go back to England, where I was happy, then I would have to take matters into my own hands and leave. Donna set a date for our departure and arranged for us to stay with her cousin. The plan was that we would both get a job and stay with her cousin until we were able to get our own place. I had it all planned out. Once I saved enough money from the job I was going to get, I would buy my plane ticket back to England.

I had just turned fourteen, and Donna was fifteen, so looking back now, I have no idea why we thought we were grown. As grown as we thought we were, it never occurred to us that we were not old enough to get a job, never mind renting our own apartment. Mom and my stepfather both worked a three o'clock to eleven o'clock shift, so by the time I came home from school in the afternoons, mom was getting ready to leave for work. It was my job to feed my brother and sister in the evenings, after which I would bathe them and put them to bed.

Because I was home alone in the evenings, it made our plan to run away much easier, knowing there was no one at home to stop me. On the evening we chose to run away, I did my usual routine and then packed my suitcase. When I was leaving, I didn't put my brother and sister to bed, I put the television on for them in the living room and told them not to open the door for anyone. I then kissed them goodbye and left the house. Mind you, my brother and sister were only three and two years old at the time. It obviously did not occur to me that they were too young to be left on their own, even if it was only for an hour.

I met Donna on Bowdoin Street, around ten o' clock that night as planned, at a location just three blocks from the house. I did not have to walk too far with my suitcase, which was packed with every piece of clothing I owned. Donna was already there waiting for me at the designated spot, which was when she informed me the plan had temporarily changed. Her cousin was supposed to meet us on Washington Street, but instead, she told me we had to wait at someone's apartment until her cousin came to get us.

It was a short walk to the apartment, which was basically across the street from where we met. When we arrived at the address, it turned out to be on the third floor of a three-family house. We struggled with our suitcases as we climbed all the steps pulling our cases behind us. It seemed like it was taking forever to reach the third

floor, and then finally, we were in front of the door. I found it strange that there was a square hole cut out with a shutter over it in the middle of the front door, because I had never seen a door like that before.

When Donna knocked on the door, the shutter opened. I saw part of a man's face, but I was unable to see all his features. He wouldn't open the front door at first; instead, he asked who we were, and what we wanted. After Donna explained that her cousin told us to meet him there, and told him her cousin's name, the door opened. The man was a bit startled when he saw our suitcases, so he asked what was in the suitcases. Donna explained that we were in the middle of moving, so he told us to put the suitcases in the front room and suggested we have a seat.

A very bad feeling came over me, which worsened once I saw different men walking back and forth. Some were smoking, and some were walking in and out of another room, but I had no idea what they were doing in there. Although I had no idea what was going on, I did know that apartment wasn't somewhere I wanted to be, so I kept telling Donna we needed to leave.

I became quite nervous as I kept asking her why her cousin had not shown up yet, but she kept telling me not to worry because he would be here soon. Every few minutes, someone was knocking at the front door - that was when I realized what the shutter was for. I saw small packages and money being exchanged through the shutter instead of the front door being opened. It was at that point I knew they were selling something, although I had no idea what substance was being sold.

Becoming more uncomfortable and agitated, I decided to leave with or without Donna, having no idea where I was going. I was not going to chance going back home, because it was already after eleven and mom would have already reached home. I kept saying, "Mom must have found out I ran away by now." Donna insisted I stay with

her, as she tried to calm me down by attempting to reassure me that her cousin would show up shortly.

The door knocked again, but this time the door attendant, for lack of a better word, opened the door. That was the second time I saw the door open since we arrived. At first I thought it must have been a friend or a special customer, because the door wasn't opened for anyone else who came to buy. It was a white man who was clean-cut, but there was something strange about the way he was acting. I observed as he keenly observed his surroundings and every movement made. With a serious look on his face, he stood in the hallway waiting for whatever he came to buy.

It was obvious to me, as naive as I was at the time, that he was staking the place out. He bought a package, and when he was leaving, he kept looking around again as though he was taking a mental picture before he went through the front door. Fear overwhelmed me, and I became afraid. As young as I was, I knew something was not right about him. I thought he was either the police, or he was going to rob the place, and I didn't want to be there when it happened.

By this time, I was aware the door attendant was named John, and so I asked him if he knew the customer well who had just left. Off course, he wanted to know why I asked, so I told him I had a bad feeling about him. I explained that I observed how he was checking the place out, which seemed very suspicious to me. I even told him how I had a strong feeling something bad was about to happen, but John told me I had nothing to worry about because the man was a trusted customer.

I did not care how much he trusted his customer because I knew in my spirit that something was about to happen. I then asked Donna if she didn't think the guy looked suspicious, but she didn't see anything wrong with him. At that point, I proceeded to get my suitcase and said, "Something bad is about to happen because I can

feel it, so I am getting out of here before it does." I wanted to go back home, but by that time, mom had already reached home from work. She would have already found out I ran away, and I was afraid of the consequences I was sure I would receive for running away.

I didn't know where I was going to go, but I felt a sense of emergency and knew I had to leave that apartment immediately. The moment I picked up my suitcase, I heard a very loud banging at the front door. It sounded like someone was banging on the door with something, or they were trying to kick the door down. Within a few seconds, the place was in total chaos. I didn't realize how many men were in the apartment until the banging started. It was then that I saw a total of 6 men running out of rooms and heading towards the back of the apartment.

In the midst of my panic, I heard glass breaking, but I didn't know which way to run. As soon as I saw the front door partially opened from the force behind it, I started running in the direction everyone else was running in. It was the kitchen everyone ran too. I appeared just in time to see one of the men jump through the kitchen window. In my attempt to escape, I also proceeded to jump out the window. Just when I positioned myself to sit on the windowsill so I could jump out, I heard someone say, "Don't move, or I'll shoot."

When I turned around to see who it was, I saw four police officers pointing their guns at me, as well as Donna and one of the men whom I had no idea was behind me. They told the three of us to sit down on the kitchen floor while they searched the place, but one of the officers kept his gun pointed at the man's head. The three of us were sitting on the floor in front of the kitchen sink, and I was in the middle. The man sitting next to me was named Don, as I found out when the police asked his name.

When Don moved, the officer rested the gun on his forehead, and told him if he moved again, he would blow his head off. I was so

frightened and unable to think straight, with all the thoughts that were running through my mind. I turned my head towards Don and pleaded with him not to move because I couldn't bear the thought of someone's head getting shot off in front of me. I had never seen a real gun before that moment, so seeing four of them at the same time, and one pointed at someone's head, was too much for me to handle.

At that moment, I was thinking, "Mom can't find out about this, because she will kill me for sure." When one of the officers asked Donna and I how old we were, we told them we were both eighteen. Donna recognized one of the officers who was an acquaintance of her father, so she started talking to him, although it seemed more like flirting to me. He had no idea how old she really was when he asked why we were there. When she informed him that we were supposed to meet her cousin, he didn't believe it at first. He thought we lived there because of our suitcases and house keys that we had with us.

The officer then informed us that if our keys fit the front door, we would be arrested along with Don. We had no fear of that happening because we knew the keys were not going to fit. Being confident that our keys were not going to fit, we sat there with smug looks on our faces, as we watched him try our keys. When he realized our keys were not for that apartment, he knew we were telling the truth and told us we were free to leave. When they put the handcuffs on Don and removed him along with all the evidence they found, they left us behind in the apartment.

It was about one o'clock in the morning when the police left, and Donna's cousin never did show up. Neither one of us had any idea where we were going to go at that point, so we sat there contemplating what to do next. The house phone started ringing, although we were afraid to answer it at first, but it kept on ringing, so I answered. It was John on the other end of the line; he apparently jumped out the window along with the other men. He was calling to find out if the

police had left and asked if anyone got arrested. He also wanted to know why the police left us there, so at first, he thought it was a trap.

When he realized I was telling the truth, he came back to the house with his leg in a cast. His leg wasn't broken when we first saw him, so I asked why he had a cast on his leg. That was when he informed us that he broke it when he jumped out the window. I was bewildered at how he managed to escape with a broken leg and not get caught. Not only that, but it was about two o'clock in the morning when he returned, so in less than two hours, he made it to the emergency room, was treated and returned to the house.

He then asked us where we were going to stay, but we had no idea. John then suggested we stay with a friend of his who lived in Codman Square. It was less than a ten-minute drive from where we were, so we there in no time. He introduced us to his friend Leroy, who lived in the apartment by himself, and told us we could stay until we decided what we were going to do. Donna and I shared a room, but we could not sleep as we were busy reviewing everything that had happened that night. We were also busy trying to figure out what our next move was going to be and how we were going to get out of the dilemma we put ourselves in.

I was uncomfortable being in a strange place with a strange man and wanted to go back home but was too afraid to do so. Leroy made breakfast for us that morning, and while we were eating, we debated whether we should go to school or not. We were afraid to go in case our parents were there, so we decided not to. The following day was Saturday, and after breakfast, Donna decided she was going to the Square to buy something, but I stayed in the apartment with Leroy.

Leroy and I were sitting at the dining room table talking, during which time he was trying to convince me that I should go back home to my parents. Whilst telling him how afraid I was to go home because of the trouble I was going to be in, he became nervous. He changed

the subject to make me aware that Donna had been gone for nearly two hours. He then asked me if I could really trust her, to which I replied with confidence that I could. I reassured him that she was coming back and that I could trust her, or so I thought.

Within a few minutes of him asking me that question, I thought I heard my baby sister's voice but brushed it off as my imagination. That was until I saw my mother, my baby sister, a female police officer and Donna walk through the living door. I thought my heart was going to stop from the shock I went into. I was absolutely speechless, "This can't be really happening," I told myself. But that was until mom, with a look of great disappointment and anger on her face, said, "Pat, what are you doing here?"

My state of shock then turned to fear - I couldn't speak; I gave Donna the evil eye without saying a word. What a traitor she turned out to be, I thought. Donna, as if she knew what I was thinking, said, "I had to tell your mom where we were because she saw me in the store and grabbed hold of my arm, I couldn't run." The police officer began questioning Leroy, and because he had a knife in his hand, she proceeded to search him. He had just finished using the knife to peel the orange he had eaten, so I spoke up for him, but mom told me to shut up.

The officer then said that Leroy was probably a pimp and wanted to use us for prostitution. I had to speak up for him again because I knew that was not true, especially after he tried to convince me to go back home. Neither mom nor the officer had any idea what had happened to cause us to end up at Leroy's apartment in the first place. They were just making assumptions, so I felt the need to set them straight. I proceeded to speak up for him, but mom once again told me to shut up, but I couldn't.

I knew he didn't mean us any harm, and I felt so bad for him because of the position we put him in. Because he was being

27

questioned and falsely accused because of us, I had to defend him. He was so kind to us, and at no time did he cause us to feel afraid or threatened by him. He only wanted us to go back home, so I wasn't going to let the officer talk about him that way. The officer proceeded to arrest him because we were under-aged, but I couldn't let that happen.

Donna never said a word, so I did all the talking as I managed to convince the officer that Leroy had no idea how old we were because we lied to him. She finally believed me and decided to leave him alone. The officer then told Donna and me to get our suitcases while she and mom waited for us in the hallway. Before I left, I told Leroy how sorry I was for what had happened, but he was too upset to answer.

The police officer drove Donna back to her home, and I was secretly panicking in the car while mom drove me back home. Mom never said a word to me in the car, so I anticipated the whooping I was going to get once we reached. When I took my suitcase back to my bedroom, mom called me downstairs. I thought, "This is it, I'm going to get it now," but to my great surprise, I got a good telling-off instead. She did however ask me if I had any common sense because I left my siblings by themselves. She made me realize the danger I left them in and the various outcomes that could have happened.

Mom never mentioned that incident again, and my stepfather never said a word to me about it either, so I ended up getting off quite easily. I learned a few valuable lessons from that experience I found myself in. It made me wiser for sure, and less naïve in certain decision-making, especially when it came to peer pressure or following friends. I had lived such a sheltered life because mom tried to keep me sheltered from the evil and wickedness going on outside the safety of our home.

That experience opened my eyes to what was going on in the outside world. I never did tell mom that I ended up at a drug house that got busted. That horrific experience was the punishment I received for my actions. I could have ended up being raped or losing my life that night, but I was spared, yet many other teens have not been spared from their bad decisions.

After that experience, it never crossed my mind to run away from home again, no matter how unhappy I was. My friendship with Donna began to fade away after that incident because I no longer trusted her. I made other friends who I hung out with at school, but I wasn't allowed to meet up with them after school. I still longed to go back to England, and it seemed that the more I pinned, the more my eczema spread.

My eczema had spread so much that the doctors at Boston City Hospital as well were unable to figure out why none of the medications prescribed to me were not working. Instead of it getting better, it got worse. Apparently, they found it necessary to have a specialist flown in from another state. I became like a lab rat for them to experiment on. The doctors had not seen eczema to the extreme in which I had it, which left them perplexed as to what to do next.

The day they did the allergy test, which consisted of them removing a piece of flesh from my arm, caused me to scream from the pain. I looked over at mom to save me, and I will never forget the tears running down her cheeks. After the test results came back which showed that I wasn't allergic to the things they thought might be causing the eczema, the specialist suggested that the only other alternative would be radiation treatment.

By that time, the eczema had covered my face and entire body. The rashes, at that point, looked like gigantic scabs that would weep and peel off when I removed my clothes and stockings. Although I brought a letter to school from the doctor who informed the teachers

that what I had wasn't contagious, the teachers still quarantined me in school. I had to sit in a class by myself and wasn't allowed to do activities with the other children.

Some kids made fun of me in the school yard in the mornings. I remember one boy telling me that I could play the part of a monster in a horror movie without having to put on any makeup. Other kids laughed at me as I walked to my lonely classroom, and the teachers wore gloves to give me my assignments. I would sit in class day after day and daydream about being back in Nottingham, where I was happy, because those memories helped me get through those sad times.

Mom saw my sadness every day when I came home from school, and I begged her to let me try the radiation treatment, but she was adamant about not allowing the doctors to put me in the radiation booth. Now when I look back, I see how naive I was, not having any idea of the negative effects that radiation would have had on my body. But, off course, mom knew, so she told the doctors that radiation treatment was not an option.

The dermatologists informed mom that they had tried every available medicine and had run out of solutions for a cure other than radiology. One of the doctor's I was seeing suggested mom make an appointment for me to meet with a psychologist. He came to the conclusion that the eczema must have something to do with my nerves, because I wasn't allergic to anything they tested for. He informed mom that he hadn't a clue what was causing it and had already tried every medicine available. There wasn't anything else they could think of other than radiation because the eczema was so severe.

But thank God mom agreed to have me speak with a psychologist, who came to visit with me at the house. She wanted to meet with me in privacy and asked if she could speak with me in my bedroom. She

only asked me a few questions, although I don't remember what the questions were. But I do remember telling her how much I missed aunty and daddy and I wanted to go back to England. That meeting didn't last long at all, in fact, I don't think it lasted longer than ten minutes. I questioned the reason for the visit but had no idea how that visit was about to change my life.

Apparently, she told mom that the eczema was caused by emotional stress because I wanted to go back to England. I didn't know that right away, as mom didn't tell me what the doctor told her. About two weeks later, though, one afternoon, after getting home from school, mom told me to go upstairs and change my clothes because we were going to Quincy. When I went upstairs to change my clothes and tried to take my stockings off, they were stuck to my flesh.

The scabs had been weeping, so when they dried, my stockings were stuck to them. When I tried to take my stockings off, my skin was peeling off with it. I started screaming, and mom came running upstairs to see what was wrong. When she saw my legs, she told me to fill the bath with water and sit in it with the stockings on, so I would be able to take them off easier. As I sat in the bath and cried, I wondered how much longer I would have to suffer that way.

When I got dressed and asked mom why we were going to Quincy, she didn't answer my question, she only told me that I would see why when we got there. She took me to a department store and told me to pick out some clothes that I liked. I wondered what the occasion was for me to be getting new clothes when I already had clothes, but I decided to wait until she told me. When I figured I had waited long enough, I finally asked. It was like music to my ears when I heard mom say, "You are going back to England."

It was as though time stood still the moment those words came out of mom's mouth. I couldn't believe it - I was finally going back

home. I felt I was the happiest person alive that April evening. I saw the sadness on mom's face which made me sad, but although I loved my mom very much, I just was not happy where I was. I didn't want to break mom's heart, but at the same time mine was broken. The days leading up to my departure were happy for me, but I saw the sadness on mom's face every day.

On my last day at school, I was let out of quarantine to say goodbye to the few friends that I had. They gave me their addresses and made me promise I would write to them once I got to England. I didn't say anything to Donna, because by then the most we said to each other was hi and bye. That day when I walked off the school grounds knowing it was going to be the last time, it felt like a weight lifted off my shoulders.

I was overwhelmed with joy the day before my flight, although I tried to hide it from mom because of the sadness I knew she was feeling. She did not want to be separated from her firstborn child again, and had the eczema not gotten so severe, I know she would not have let me leave. I was going to miss her and my siblings, but I missed my life in England more. So, it turned out that my time spent in America was only two and a half years before I returned to aunty and daddy.

Chapter Four:

My Heart's Desire

"Hope deferred makes the heart sick, but a desire fulfilled is a tree of life." (Proverbs 13:12). I had lost all hope that I would ever return to England, which in turn caused my ailment. But once I received the desire of my heart and joy filled my soul, my healing practically came over night.

I was two months away from my fifteenth birthday when I boarded the plane at Logan Airport and headed back to England. Excitement was killing me, and I couldn't wait for that plane to land in London. I was the first to jump out of my seat once the plane touched down. In such a rush to get off the plane, I was told to take my time by one of flight attendants. It was obvious to the person standing next to me at the conveyer belt that I was impatient while waiting on my luggage. The gentleman next to me told me to be patient because it takes time for workers to remove the luggage from the plane.

It seemed like my suitcases were taking forever to arrive, but once they did, I quickly grabbed them and asked for directions to the exit. I started feeling butterflies in my stomach the closer I got to the waiting area where aunty would be waiting for me. I didn't have to look very hard, because there they were, standing straight ahead of me. I dropped my bags and ran to aunty, hugging her so tightly as I wept. I then leaped into aunty Davis's arms, whom I was just as happy to see. I expected to see daddy and Shaun but was told they were waiting for me at home. My dream had finally come true - I was back in the land that I loved with the people I so longed to be with.

When aunty and Aunty Davis saw how bad my skin looked, they were both upset and shocked. Aunty, the woman with whom appearances were extremely important, quickly covered me up with her coat to hide my rash from onlookers. They both talked about how bad my skin looked just about the entire coach ride back to Nottingham. When we reached Nottingham, we went to aunty Davis's house first, because they wanted to surprise Shaun. They didn't want the neighbors to see me when we got out of the taxi, so they made me walk quickly to the front door.

Once inside, the first thing I asked for was fish and chips. Unfortunately for me, the fish and chips shop wasn't open at that time. Shaun got home from school about forty-five minutes after us. Once we heard him at the front door, aunty Davis told me to run into the sitting room so he wouldn't see me. That is a moment I think I will always remember – his response would have been a great kodak moment. I heard aunty Davis tell him to go into the sitting room because she had a surprise waiting in there for him.

He rushed through the door, eager to find out what the surprise was, but seeing me was the last thing he expected. He abruptly stopped when he saw me standing there with the biggest smile on my face and made a U-turn while screaming and crying at the same time. It took a while for aunty Davis to calm him down, as none of us anticipated the state of shock in seeing me would have caused him. When he did calm down, he was speechless, and so was I. I felt a sense of contentment and peace because I no longer had anything to worry about.

I was eager to leave after spending a couple of hours with Shaun because there was one other person, I was eager to see. Aunty and aunty Davis had come to visit me in America, but I had not seen Daddy in two and a half years. I'm tearing up right now with the emotions I felt back then as I take this trip back down memory lane. I feel as though I am reliving it all over again, the overwhelming sense

34

of happiness and relief I felt, knowing my heart's desire had been fulfilled.

As soon as we pulled up at 63 Teversal Avenue, I could hardly wait until the taxi fully stopped before I jumped out. My heart was pounding so much, that I thought it was going to jump out of my chest. I couldn't control my emotions when I burst into tears as I stretched my hand to ring the doorbell. Before my hand touched the bell, daddy was already opening the front door. I jumped into his arms and did not want to let go. I held him tightly and told him how much I missed and loved him.

I was in awe as I took it all in - I was finally back home where I so longed to be, after losing hope that it was ever going to happen. Daddy went to buy me fish and chips, which happened to be something else I loved and missed. We sat and talked for hours as I filled them in on my experiences while in America, except for running away, of course. They never brought it up, so I guess I will never know if mom ever told them about it. That night as I was laying in my bed taking it all in, I was afraid to fall asleep, in case I woke up and found that it was all just a wonderful dream.

When I woke up the following morning and realized it wasn't a dream, excitement hit me all over again. Aunty wasted no time trying to find a remedy for my eczema. Immediately after I had eaten breakfast, she told me to get my coat and shoes on because she was taking me to the herbalist doctor on Alfreton Road. Once he examined my rash, he gave her a bottle of giant pills and told me to take one three times a day.

After leaving the doctor, I wanted to go downtown, but aunty didn't want anyone to see me looking the way I did. She reassured me that once my skin started healing, she would take me wherever I wanted to go. Upon returning to the house, aunty insisted I start taking the pills even though I told her they were too big. I tried taking

one, but it was too difficult to swallow, so I threw it in the garbage without her knowing. Every day, aunty asked if I was taking the pills, to which I lied each time and told her I was.

Within only three weeks of returning to England, my entire body was completely cleared up, with no evidence of ever having eczema. I happened to walk into the kitchen one morning right when aunty was bragging to her friend who was visiting about how good the herbalist doctor was. But I, being outspoken from an early age, was incapable of keeping my mouth shut. I had to tell her the truth that the herbalist doctor had nothing to do with my healing, because I did not take even one pill. She didn't believe me, so she sent me up to my room to get the bottle of pills, so she could see for herself.

She was speechless when I returned with the full bottle, minus the one I threw in the garbage. I didn't think of it then, how embarrassed she must have felt. Especially after bragging to her friend that the herbalist doctor was the one that helped me. Although, I'm sure she found some satisfaction when she relayed the news to mom that I was cured within only three weeks after suffering from it for two years and five months. So, the psychologist was proven to be correct after all, when she said the eczema was caused by emotional stress.

Once I no longer had to be hidden from the public eye, daddy registered me at Trinity Comprehensive Catholic School. It was at Trinity that I met Marie Hanlon who became a very good friend. I quickly gained friends, but Marie was the main one I hung out with during and after school. Marie's parents were Irish, and they were really cool. I spent a lot of time at her house, which was literally next door to school. Being around Marie was my first experience of what life as a teenager was really supposed to be like.

When I turned sixteen, we had sleep overs, but aunty met her mother before she gave her approval. Aunty really liked Marie, so when she did give her approval, we both had a ball. Her parents were

more lenient than aunty, so we were allowed to go to parties unbeknownst to aunty. Marie was mature and independent when she started working at sixteen. It didn't cross my mind to even think about getting a job. I guess it was because I was so spoiled and got everything I asked for, so I didn't see the need. When she wasn't working, we enjoyed so many activities, and I loved every moment we were together.

After finishing school at age sixteen, I went to Beeston College. On my first day, during our lunch break, to my great surprise, I saw an old enemy I had totally forgotten about. It was Beverly Wallace, who caused me to freeze on the spot the moment our eyes met. I thought, "Oh no, this cannot be happening to me." I had known Bev since I was around eight or nine years old through aunty, who was friends with her mom and dad. Bev was basically a bully back then and picked on me every chance she got. If I looked at her when we passed on the street, she would threaten to beat me up, so I was afraid of her, and would run the other way whenever I saw her.

So, this is why I froze when I saw her sitting in the lunchroom with a mutual friend named Kay. Kay told me to come and join them, but I refused and proceeded to make a U-turn, when Bev spoke up and told me to come and sit with them. I was skeptical at first, but I did join them. Bev was actually very pleasant, which totally shocked me. That afternoon two life-changing events happened in my life. The first was that I gave into peer pressure and started smoking cigarettes when Kay convinced me to take a drag of her cigarette.

The second was that afternoon turned out to be the beginning of a beautiful and life-long friendship between Bev and me. To this day, Bev is and will always be the best friend I will ever have. From the start of our friendship, we hardly went anywhere or did anything without each other. Bev taught me so many things that she learned from her elder sister Barbara, and I basically became an addition to her family. I went everywhere with her family on out-of-town trips,

and whenever aunty and I went to London to visit family, Bev came along too.

We were basically inseparable, so much so, that we even accompanied each other on our dates. Our friends considered us as being each other's shadows, because when they saw one of us, they knew the other was nearby or coming around the corner. We helped each other do our chores at home and as we got older, we sometimes sneaked out to go to parties when we were not allowed to go.

When I was seventeen and Bev was eighteen, we were chosen to sing at a stage show being held at Zhivargo's night club on Boxing Day. We were one of the opening acts for some known reggae artists, but aunty didn't know I was performing. I told her I was spending the night at Marie's house so we could watch movies. Meanwhile, Marie was going to meet Bev and I at the show.

There were so many people there that night, people I hadn't seen in ages. Someone there thought it necessary to call aunty and tell her I was performing, although, to this day, I never did find out who it was. The following day when I returned home, aunty asked how I enjoyed the sleep over. I wondered why she asked what movies Marie and I watched, but being the quick thinker that I am, I made up something fast. All along, aunty knew I was lying and did not hesitate to let it be known.

When I finished telling my lies, aunty then asked, "So how was the show you and Bev were singing at last night?" I was busted, but aunty only smiled, and asked how I pulled that off without her knowing. I ended up telling her everything; how I practiced with the band for six weeks prior to the show, and how I ended up in the show in the first place. Bev and I went to Danny's record shop to buy a record I wanted, but Danny wasn't there, and I didn't know the name of the song, so I had to sing it for the person behind the counter.

The man then told us to hold on while he went to the back of the shop and brought out an older man who asked us to sing the song again. When we did, he told us he was a promoter and was putting on a show for Boxing day and wanted us to perform in the show. Aunty was baffled as to how I managed to go to band practice twice a week for six weeks, and her having no idea about it. Now that I think about it, she probably kept a closer watch on my after-school activities, after that confession.

Bev and I were also players on a netball team that Ronnie Brown coached, which was a lot of fun, and it was even more exciting the day we won the championship. As I look back now, I still can't imagine how it could have been possible to have had better times than I did during those teenage years, which happen to still be the best years of my life so far. Life was wonderful as I spent it being carefree and happy with not a care in the world. I still got everything I wanted, and I was wanting of nothing. As I became older, I was curious to know what my biological father was really like.

I remember I met him for a few hours on the evening of Halloween when I was ten years old. I never forgot that, because I was out playing with my friend's and I wanted to get home before it got dark because I hated Halloween and still do. When I entered the house, my father was in the kitchen. I had no idea who he was, but once I looked at him, somehow, I knew we were related.

Aunty introduced him by saying, "Pat, this is your father, Terry." I was surprised, but I wasn't very excited to meet him. As far as I was concerned, I already had my daddy, and no one else could take his place. Terry was a long-distance truck driver at the time, who happened to be passing through Nottingham that evening and stopped by to see me, but I never saw or heard from him again until nine years later.

When I turned nineteen years old, I was curious and wanted to get to know my father, so I informed aunty that I wanted to meet with him. Aunty had no idea how to find him, but suggested I try to find him through his brother Danis, who was living in Reading. She went on to let me know that the address in Reading, was listed on my birth certificate. Aunty suggested I send a letter to my uncle Danis, whom I had never met before, so I could ask him if he knew of my father's where-a-bouts.

Apparently, I put the wrong house number on the envelope, but the mail man knew my uncle and delivered it to him. He called the day he received my letter as he was quite happy to hear from me. He did not know where my father was, nor did he have a working phone number for him, but he did say my father called him every couple of months. I wanted Bev to come with me when I went to visit him and his family, but aunty insisted I go meet my uncle and cousins by myself, so I went on that journey on my own.

About two weeks after returning to Nottingham, I got a surprise call from my uncle telling me that my father had called him. He told me to expect a call from my father, who was living in Sheffield at the time. He also gave me my father's number, but I waited for him to call me. Shortly after, I received a call from my father, Terry, who asked me to come visit him in Sheffield that upcoming weekend. He informed me that I had a sister named Donna who was also going to be visiting him, and he wanted us to meet.

I had no intention of going without Bev, so once he said I could bring her with me, I looked forward to our adventure. He didn't meet us at the coach stop, instead, we found our own way to his home. We arrived a few hours before Donna, so he took us pup-hopping to meet his friends until it was time to meet Donna. It felt quite strange at first meeting both my father and half-sister, but Bev's presence made it much easier for me. As soon as we returned to his apartment so

Donna could put her luggage down, Terry told us to get ready because he was going to take us out on the town.

It didn't take long for us to realize he loved hanging out at the pub and drank way too much. He told us he was planning to stay at a friend's house that night so we could have the place to ourselves. We were happy to hear that and so we made plans to go to a club. While he was playing dominos with his friends, we were asking random people to tell us where the best club was to go that night. For some reason, I have always remembered the name of the club that was referred to us, the Donkey Man Club.

Anyway, Donna, Bev and I, decided that was how we were going to enjoy the rest of the night, by going to that club. But that changed when Terry overheard us making plans for our night out on the town, because he told us we couldn't go. I was very upset when I told him it was too late for him to tell us what we could or couldn't do, because he had not partaken in our upbringing. My words changed nothing, instead, he decided not to spend the night with his friend, so he could stay and make sure we didn't leave the apartment.

The following morning after we ate the breakfast he made for us, I began enquiring why he only came to visit me the one time that he did when I was ten years old. He told me how he and my mother met, and that aunty was the cause of their break-up. He also told me how much he loved my mother, and that when I was born, he wanted to raise me, but they wouldn't let him have me. He then let me know that the reason he wasn't in touch with me, was because aunty was the one that kept him at bay, to which I responded, "Well, I can see why."

He then told Donna and me that we had many more brothers and sisters, but he had no idea where they were. I was glad that I met him and was able to put an end to my curiosity. I was finally able to see for myself what kind of man my biological father was, realizing that

41

aunty was right all along. We ended up spending the last evening pub hopping again, although it was better than sitting around in the apartment. Donna, Bev and myself, decided we would make the most of it and enjoy our last night in Sheffield.

Bev and I left early the following afternoon, although Donna wanted us to stay an extra day. I wanted to get back home to aunty and daddy, so I declined. Instead, I invited her to come to visit me in Nottingham as soon as she could. We said our goodbyes at the coach station, and Bev and I headed back to Nottingham. That was the very last time I ever saw or spoke to Terry. I never kept in touch with him after that. I found out what I wanted to know, and so my curiosity was put to rest.

When I got back home, aunty asked me if I was satisfied that I had met Terry and found out for myself the type of man that he was. I let her know that I had no intention of going to see him again, because, as far as I was concerned, daddy was my real father, and no one else could compare to him. When daddy came home that evening and asked me how my trip went, I told him Terry was nothing like him and not even fit to tie his shoe lace. I went on to let him know how much I appreciated and loved him and that he was the only man I would ever call my daddy.

I called mom to let her know I went to see Terry, and apart from asking me how he was doing, the only thing she wanted to know was if I was working. When I told her I was temping, she told me if I didn't find a permanent job soon, then I needed to come back to America, where there would be more opportunities for me. Shortly after, Bev had gotten a job at the gas company. Once she learned, mom said I would have to go back to America if I didn't have a job, she quickly got me an interview.

The weekend before the interview, Bev, her sister Paulette and I, went to Birmingham for the weekend to visit one of their older sisters.

We were having so much fun that we didn't return to Nottingham until late Sunday night. The interview was early the following morning, which I went too, without filling in the job application I was supposed to bring with me. Needless to say, I didn't get the job, and when mom found out, she insisted I had to come back to America.

When Bev heard the devastating news, she suggested we run away to London. She tried to convince me I would have nothing to worry about, because we would get a job in London. Even if I didn't find a job, she assured me she would take care of me until I did. Her words broke my heart - I wanted to run away with her, but I was ambivalent. Bev begged me not to leave her and go as she reminded me that I was nineteen and old enough to make my own decisions. I thought long and hard about it, but in the end, I couldn't disobey my parents, no matter how heartbroken and miserable I would be having to leave again.

The arrangements were made for me to leave a few months later, during which time I tried hard to find a job, to no avail. As the months turned into weeks, and time drew closer for me to leave, Bev and I became totally depressed, not to mention how aunty and daddy felt. I was an emotional wreck - I couldn't imagine my life without Bev in it, and so I was in mental agony. The thought of having to leave my happy life and the people I loved so much again, left me in total despair.

When that dreadful day came for me to leave again, the atmosphere was bleak and somber. Utter sadness filled the house, which could be seen on all our faces. Daddy once again couldn't bear to see me leave, so once again, he decided not to accompany me to the airport. I thought my heart was going to stop beating when I hugged him tightly. Auntie had to pull us off each other because neither one of us wanted to let the other go.

Auntie, Bev and auntie Davis, came with me to Heathrow Airport, and my sister Donna met us there, because she lived in London. Bev was strong until I checked in and they called my name to board. The same thing happened at the airport as it did when I first left England to go to America, I was the last one to board the plane. My name was called a couple of times, but once again, I did not want to go. After a few minutes, my name was called again, and that was when aunty, with tears in her eyes, said, "Pat, you have to go now."

Bev and I burst into tears, hugging each other and refusing to let go. The more they called my name, the more we held on to each other and wept. Aunty had to pull us apart, insisting I leave so I wouldn't miss my flight. Once I finally took a few steps towards the boarding area, I turned around to say goodbye one last time, but ended up running back to Bev. I held on to her until aunty once again pulled us apart and told me to go and not look back.

I cried so much that I could barely see where I was going. Once I boarded the plane for my flight to Logan airport, I found myself itching again. Before the plane landed in Boston, I saw that I had a rash on my arm – and sure enough, the eczema was back. This time around though, I was able to control the eczema outbreak because I knew stress was causing it. In order to cope, I told myself that I would get a job, save my money and return to Nottingham, as soon as possible, but unfortunately, my plans didn't turn out as expected.

Chapter Five:

The Beginning of Mayhem

Don't make a rash decision before thinking it through properly. Sometimes we may want out of something so badly, and act upon our first thought, which seems like a viable solution. I'm sure you have heard the saying, "The grass isn't always greener on the other side." Well, that's what I eventually found out after naively making a rash decision.

Mom was waiting for me at the airport, so I tried to put a smile on my face when I saw her. The fake smile was an attempt to hide the brokenness I was feeling inside. My eyes were swollen from crying through the entire trip, so I guess she knew how I really felt about coming back. My brother and sister, on the other hand, were very excited to see their big sister. They didn't remember me, because they were very young when I left, although I did speak with them over the phone.

Transitioning from having teenage friends to only having my brother and sister as companions, was very hard on me. I was so frustrated with them at first, because they told mom everything I did. I tried bribing them at first, but that didn't work. Instead, I waited until I saw them doing something they shouldn't have done. Once I had something to blackmail them with, I was finally able to stop them from snitching on me. They didn't want me to tell on them, so blackmail eventually worked.

Two weeks after my return, mom insisted I register for college, but I frowned at the idea. I already went to college, I explained, unable to grasp the need to go again. But mom made it clear it was a demand and not a request. My only plan was to get a job so I could

save and return to England as soon as possible. We had quite a few conversations on the subject which finally ended with a compromise. We both got what we wanted – I would get a job and register to take night classes at college.

With mom's help, I got my first job at John Hancock Insurance as a data entry clerk. Having a job gave me a sense of pride – I remember how good it felt when I received my first paycheck. Instead of saving my money as I originally intended, I went on a shopping spree. I then decided to save when I got the next paycheck, but that didn't happen either. I was miserable at home with no friends outside of my co-workers, so the only thing I had to look forward too was pay day.

Other than in-home church services on Sundays and bible study on Wednesdays, led by my mom and my stepfather, I had no other activities to attend. During the week, mom ran a daycare in which I met one of the parents named Rachal. She must have felt sorry for me because she asked mom if I could come to her house and hang out with her. When mom agreed, I'm assuming it was because Rachel was about ten years older than I was, so mom thought she was mature and responsible.

In front of mom, Rachel acted like a lady, but behind her back, she was a totally different person. She was the type of woman whose mouth was like that of a drunken sailor. She was married but was seeing different men, and partied every weekend, among many other things. The company she kept wasn't the kind of company I was used to being around, so I wasn't comfortable being around her, but I didn't tell mom.

In fact, the day I first went to Rachel's home was the beginning of the end of life as I had once known it. My life quickly geared off track and took a wrong turn. That wrong turn then caused ripple effects, which caused one thing to lead to another. Meeting one

wrong person after another, people who I had no business associating myself with, especially one in particular who nearly took my life.

One day after sitting around feeling lonely and missing Bev, mom told me to go visit Rachel for a while. I really didn't want to go, but just to get out of the house, I ended up going, and that's when Rachel introduced me to her neighbor Anna. Anna and I were the same age, so I felt a bit more comfortable with her than I did with Rachel. From that point on, when I wanted to get out of the house, I would tell mom I was going to hang out with Rachel, but I was really with Anna.

I had registered at college and took accounting classes, but I didn't really like it, so I dropped out without telling mom. I didn't tell mom because that way, when she thought I left work to go to my night classes, I could hang out with Anna instead. Anna's boyfriend at the time, had a friend named Reggie who liked me, but I didn't like him at all. Anna wanted us to double date, even though she knew I had no interest in being with Reggie, so she decided to trick me into going out with him instead.

One evening when Anna and I were hanging out, she called Reggie unbeknownst to me, and told him where we were going to be. I was highly upset when he showed up because I made it very clear I didn't want to see him. I couldn't stand being around him, but that didn't stop him from pursuing me. Every time I went to meet Anna, he was there, but after much persuasion, I eventually gave in and went on a couple of double dates, against my better judgment.

I only saw him during the hours I was supposed to be at night classes. Although I was twenty years old at the time, I wasn't allowed to go out during the weekday, unless it was to my classes. I wasn't allowed to go out on weekends either, unless it was to Rachel's house, and even then, I had to be home by ten o'clock. The restrictions I had to adhere to were too much for me, especially after being allowed to go out and enjoy myself when I was in England.

One Saturday evening, Rachel called and asked mom if I could go out with her, but mom had no idea it was a party Rachel wanted me to go to. My curfew was still 10 o'clock, and mom made sure to remind me of that, before I left the house. Rachel came to pick me up, but I had no idea the party was at her house. The street was crowded with people, the music was loud, and I was having a good time until I saw Reggie show up.

After a few drinks, I ignored the fact he was there and ended up enjoying myself so much, that I forgot to watch the time. It was nearly three hours past my curfew, when I finally returned home. I carefully snuck into the house and tip-toed up the stairs. I went to bed with confidence, thinking I was quiet. I was sure no one heard when I opened the front door and crept upstairs to my room. I laid in bed reminiscing about my evening out, not anticipating the events that awaited me the following morning.

I was up bright and early Sunday morning, looking forward to the day ahead. I was supposed to attend the church service in the living room, but I had other plans. Arrangements were made the night before for Rachel to pick me up on her way to the flea market. When I was dressed and ready to leave, the church service was just starting. Mom was upstairs getting ready when the doorbell rang, so I rushed to open it because I knew it was Rachel.

The front door was located next to the living room, so my stepfather was looking when I opened it and heard Rachel ask me if I was ready. That was when my stepfather came rushing to the door and said, "Pat, where do you think you are going?" I replied by telling him I was going to the flea market with Rachel because it was only open on Sunday's and I had never been to a flea market before, so I wanted to go. He responded by saying, "You aren't going to any flea market today. If you live in this house, you are going to abide by my rules.

I was upset when I reminded him that I was twenty years old and should be able to go to the flea market if I wanted too. He replied by saying, "You are not leaving here when church service is going on to go out anywhere, so come in the service and sit down." At that point, I didn't know what to do. Rachel observed my confusion as she whispered in my ear, telling me to let him know I was a grown woman, and leave anyway. I didn't want to do that, so I tried to reason with him by reassuring him I would attend the following Sunday.

That didn't work either because he then said, "You came in after twelve last night and think you're leaving again this morning while the church service is going on. You aren't leaving this house today, so shut the front door." I remember the embarrassment I felt as I observed the church members whispering. I knew I was going to be the main topic at dinner when they got home, so I was even more upset that he chose to embarrass me in front of everyone. I don't quite remember what I said next, but I was still insistent on going.

Rachel kept trying to persuade me to leave, and so I decided to follow her foolish advice. When my stepfather realized I was planning on leaving against his wishes, he gave me an ultimatum. I was basically told that I could either "Obey and Stay" or "Disobey and Go," which was a term I heard a lot growing up. When I chose to go, my stepfather said, since you think you are a woman, you can pack your suitcase and leave." I thought to myself, you don't have to tell me twice, but I had no idea where I would go. I looked at Rachel as if to say, I guess I'm not going with you after all, when she said, "Go get your stuff because you can come live at my new house."

I was bewildered at first and overcome with emotion. I turned and ran upstairs to my room as I quickly packed, while trying to hold back the tears. I ended up making a few trips up and down the stairs with my luggage. On the way down the stairs with my last piece of luggage, mom stopped me in the hallway. "Where do you think you're going?" she said. "Didn't you hear what he said? He said I

should pack my suitcase and leave, so that is what I'm doing." To which mom responded, "Take your things back upstairs, because you aren't moving out of this house today."

I was looking for an excuse to leave, so as far as I was concerned, my stepfather had given it to me. I wasn't going to let mom stop me, because I couldn't put up with their strict rules any longer. This was my opportunity to leave, although at the time, I wasn't thinking about the consequences of my rash decision. Mom tried to take the suitcase from me, but I held on to it and said, "He wants me out of his house, so I'm leaving his house."

As I recollect and remember the look on mom's face, I saw the fear in her eyes. When we are young and do foolish things, we have no idea the pain we cause our parents. Sometimes it's not until we become adults that we realize the heartbreak we caused. Mom being the overprotective parent, especially when it came to me, undoubtedly knew I was still very naïve and not mature enough to move out on my own at that time. I told mom goodbye, but she didn't answer, instead she stood there in shock. When I walked through the front door, I didn't look back.

Needless to say, once I left with Rachel, we didn't end up going to the flea market after all. Instead, we went to the house she and her husband had recently bought and were still moving into. The house looked like a disaster area; boxes, clothes and furniture were all over the place. Because she had so many kids, there was no room for me to sleep in, so I had to sleep on the couch. My first thought was, "I can't believe I left my bed to end up sleeping on her couch.

I hated it there, having to deal with all the drama that went on in that house was very frustrating. I was so broken inside and regretted moving out, but I tried not to show it. I went to work as usual and kept my head up high. I dreaded when evening came and work ended, knowing I had to return to that zoo. Thank God though, that it didn't

last more than three days. That's because on the third day, after returning from work, Rachel told me I would have to find somewhere else to stay because the house wasn't big enough for all of us.

I thought, "This woman convinced me to leave my mother's house, and now she's telling me the place isn't big enough. Didn't she know this before she convinced me to move out?" I was so uncomfortable there anyway, but I refused to go back home. I decided I was going to make it on my own - the only problem was, I had no idea where I was going to go. I didn't have any other friend except for Anna, and she lived with her mother, so I couldn't go there.

Rachel suggested I call my cousin Urceline, who was staying with mom before I came back from England. She left upon her acceptance to Northeastern University, and was living in a studio near the university. She stopped by to visit mom now and again, but I didn't know her that well, although she was one of my first cousins. I did know that we had absolutely nothing in common at the time, but she was family, so I called her. At the time, she was sharing a studio with her roommate, but she told me I could come.

I had no idea what a studio was until I saw that it was basically one big room with a small kitchenette and bathroom. Urceline had a single bed that we had to share, but as I think back now, I wonder how we managed to pull that off. I was much more content there, than at Rachel's, but it was a tight fit for three people. Reggie and I were still seeing each other now and again, and when I told him I was no longer living at home, he saw it as an opportunity for us to be together.

One evening he came to take me out for dinner and came inside to get me. After seeing how small the place was, he insisted that he had to move me out of there. Although I was getting use to him and felt a bit more comfortable around him, living with him was not an option for me. Being the very persistent man that he was, I eventually

gave in and decided to take him up on his offer. If only I had known at the time, that it was going to be to my own detriment.

Unbeknownst to me, Reggie's cousin was in the process of purchasing a house in Malden, so Reggie had made arrangements for us to live there after the closing. Once the paperwork was finalized, Reggie rented the bedroom on the first floor for us to stay in, before he came to the studio to get me. I'm pretty sure Urceline was probably relieved I was leaving, especially since the place was small for two people, never mind three.

It turned out that I lived with Urceline for one month, sharing a twin bed. I know if the shoe were on the other foot, I would have been happy to get my bed back to myself in order to finally get a comfortable night's sleep. After my cousin and I said our goodbyes, I set off to the unknown. Our first stop was to a furniture store, where once inside, Reggie told me to look around and pick out a bedroom set that I liked. I was pleasantly surprised and looked forward to it, because prior to that day, I had never shopped for furniture. Once I picked what I liked, he paid and arranged to have it delivered that same day.

I was quite nervous about going to live a man, and what made it even worse was, I didn't like his cousin. He was very unfriendly and intimidating, so I was not looking forward to having to stay under the same roof with that man. When we pulled up in front of the house, I was pleasantly surprised at what I saw. The house was in a good neighborhood, and I could see from the outside that it was well maintained. Inside the house was clean and updated and I really liked it.

His cousin came down from the second floor to greet us and showed me around. Shortly after, the cousin left, so I was quite happy about that. Before I was able to finish unpacking, the furniture arrived. By the time everything was set up, it was just time to take a

bath and get ready for bed. Reggie left once I came out of the shower, so I had the place to myself. As I laid in bed thinking, I thought about the situation I found myself in. How within the space of five weeks, I had left home, moved to Rachel's, then with Urceline and ended up with Reggie.

I felt like a fish out of water – I felt out of place, lonely, sad and fearful of the unknown. I left my mother's nest and no longer had its security or comforts. I was now on my own and had to fend for myself. I was afraid of what was ahead, knowing I did not want to be living with a man whom I hardly liked. I knew I did not want to go back home, so at the time, I felt I had no other choice. Thoughts of what I had and what I now didn't have, flooded my mind all night, until I finally fell asleep.

Reggie drove me to work the following morning and picked me up after, but as soon as we returned to the house, he told me he had to leave and would see me later. That happened every single day thereafter, so I was basically in the house by myself until around midnight or later, when he and his cousin returned. Once I figured out the bus and train route, I took public transport back and forth to work. That meant I didn't see Reggie most evenings, because I was already sleeping when he got home.

Life wasn't too bad for the first month or so, but then all hell broke loose when we had our first fight. I don't remember how it started, but I do remember him throwing me down on the bed and punching me in the face. I had a cigarette in my hand at the time, and when I somehow managed to overpower him, I got on top of him and put the cigarette out on his cheek. I started punching him back in his face, and when he managed to overpower me again, he really let me have it. I ended up with a black eye and some bruises, before his cousin came in and stopped the fight.

There's a saying, "Monkey see, monkey do," well, that's what happened when I burned Reggie with the cigarette, because when we had our next fight, he decided to do what I did to him. Only this time, he purposely lit a cigarette just so he could put it out on my face as revenge. Thank God my skin healed quickly, because before I knew it, all traces of cigarette burn marks on my face had disappeared.

We had many fights, but with each one, he became increasingly violent. It got to the point that I was too afraid to hit him back as the fights continued. Instead, I just tried to position myself to block some of the blows I would get to my face. Foolishly, I took his abuse over and over because I didn't want to go back home. I felt so ashamed and didn't want my mom to know what was happening in my life, as I wanted her to think I was doing well.

Reggie turned out to be a player on top of everything else, and so was his cousin. It was a surprise to me when I was told his cousin was married and was sending for his wife from Jamaica. I got home from work one evening and saw her there. I thought she was another one of his cousin's women, but she was introduced as his wife. I found out later that the only reason he sent for her was because I was living there. He didn't want to send for her and have her in the house by herself, so he thought I would be a good companion for her.

My new companion was very quiet and uninteresting, and whose company I certainly did not enjoy. She was someone to talk to in the evenings when I got home from work, but that was about it. Since her husband and my boyfriend were out all day every day, we were all each other had, especially on weekends when I didn't go to work. Except for spontaneous fights Reggie and I had, life wasn't too bad until the atmosphere in the home changed.

Reggie and I lived at his cousin's home for approximately five months, before our living arrangements came to an abrupt end. As usual, he and his cousin didn't get home until around midnight or

shortly thereafter. On this particular night of discussion, the cousin came home, but Reggie wasn't with him. I heard when his car pulled up in the driveway, and a few minutes later, I heard my room door open. I knew it wasn't Reggie but his cousin who had entered the room, so I pretended to be sleeping.

He walked up to the side of the bed I was laying on, then bent over me, whispering my name. I didn't answer because I wanted him to think I was sleeping, so he would go away. That didn't work because he then began to shake my shoulder, trying to wake me up. I turned my head and rubbed my eyes, trying to lead him to believe he had just woken me up. I was startled by the fact he was in the room in the first place, but even more so when he said Reggie was fine, after I asked.

"So, if Reggie is okay, then why are you in my room, and why did you wake me up?" This man had the nerve to say, "I want to get in bed with you." I thought of him as a very intimidating person, but at that moment, I was too angry to be intimidated. After telling him he needed to leave and go upstairs to his wife, he continued trying to talk me into having sex with him. He asked me not to tell Reggie he came in the room, so I agreed if he would leave.

He didn't want Reggie or his wife to know what he tried to do, so I took advantage of that. I told him if he left right then, I wouldn't tell anyone what he did. I was infuriated with Reggie and blamed him for what happened. If he had come home with his cousin, that couldn't have happened. I was too paranoid to sleep, so I decided to stay up and wait for Reggie to come. It turned out I waited in vain because Reggie never did show up, so I ended up being more upset than I already was.

I went to work that morning with the dilemma on my mind. The dilemma of trying to decide whether I should tell Reggie or not. I couldn't shake the thought that if I told him, someone might end up getting shot. At the very least, it would cause a falling out between

them both, and I wanted to avoid any contention. Out of guilt, Reggie decided to pick me up from work that evening. When I got in the car, he informed me he had to pick up his cousin from the airport.

I thought to myself, "His cousin was in the room this morning trying to get in the bed with me, so where has he flown too and returning that quickly?" I didn't want to be in the same car with him, so I told Reggie to take me home first. He insisted he would be late to pick him up if he took me home first, so I ended up at the airport. Reggie had planned to leave me in the car while he went inside the airport to meet his cousin, but that plan changed when I blurted out what his cousin did, though I said it happened in a dream.

Reggie immediately became enraged, as he didn't believe me when I said it was a dream. I became fearful when he started saying what was going to happen when he saw his cousin. I began begging him not to say anything, but he wasn't listening. I then suggested we just look for someplace else to live and then move out, but he wasn't hearing that either. He was out for revenge, and nothing was going to stop him. All I kept thinking about was how uncomfortable the ride back to the house was going to be, with the three of us in the car together.

Once we reached the airport and the car was parked, Reggie told me to come with him. I had no intention of being there during the confrontation, so I refused. He wanted me to be present in front of his cousin when he confronted him, but nothing he said could change my mind. I was adamant about not going into the airport, and nothing Reggie said or did was going to get me to go, so I ended up staying in the car. I sat in fear with regret that I told Reggie what happened, because I was convinced they were going to start fighting in the airport.

Upon his return, Reggie told me he ran up to his cousin and asked why he came into my room and asked me to have sex with him. His

cousin denied it off course, but Reggie knew I was telling the truth. After they argued and Reggie told him a few choice words, he left his cousin standing in the middle of the airport and told him to find his own way home. I was relieved he wasn't riding back with us, but I knew it wasn't going to be good when we returned home. I dreaded the awkwardness of the situation.

I was grateful we reached the house before his cousin did. But once we got inside, Reggie called his cousin's wife downstairs and told her what her husband did. Instead of being upset with her husband, she was upset with me for not telling her when it happened. The cousin didn't come home that night, which also turned out to be our last night there. While I was at work the following day, unbeknownst to me, Reggie was out looking for somewhere else for us to live.

Once my workday ended, I was reluctant to go back to that house alone. It turned out that I didn't have too. Whilst walking towards the train station, I heard someone shouting my name. It was Reggie standing in front of a moving van beckoning me to come. He had a friend with him who was there to help us move. Even though we were about to move, I was still anxious about returning to the house because I knew there was going to be a confrontation, and I was right.

The cousin and his wife joined forces while standing at the front door waiting for us. They followed us back and forth as we were moving the stuff out, talking a lot of crap. Reggie and his cousin started arguing, but Reggie's friend that was helping us, stepped in and calmed the air. The wife then started disrespecting me, so I responded by informing her of how pathetic she was. I then revealed that I knew she had caught an STD from her husband.

She stood with a puzzled look on her face, so I jogged her memory. I reminded her of the day when she received a letter from her doctor and gave it to me to read to her. The letter stated she tested

positive for an STD and needed to make an appointment to see the doctor. The shock on her face was memorable as she stood like a statue with nothing else to say. I guess I wasn't moving fast enough when Reggie ushered me to hurry up and get in the van. It was finally over as I breathed a sigh of relief. Before I got into the van, I turned around to observed both husband and wife standing on the porch watching us, as we drove off to our next destination.

Chapter Six:

Turbulence and Strife

Some people see danger ahead of them, and yet they continue to walk right into it. When I was growing up, I heard people say, "If you play with fire, you will get burned." In my case, I knew Reggie was a danger zone - the signs were bright and clear for me to see, but I ignored the warning signs and entered anyway. Be very careful when getting into a relationship, pay attention to the things your partner says and does, and most importantly, don't ignore the signs. Once you see the red flag, get out of it as quickly as possible.

Our destination turned out to be an apartment that was leased to one of Reggie's friends named Jerry, whom I met for the first time when we arrived. Jerry seemed pleasant when we were introduced, and I had a good feeling about him when we met. The apartment was spacious, and so was the room that we were going to be staying in. After we brought the bedroom set in and the rest of our stuff inside, it wasn't long after that Reggie and Jerry left. Everything happened so fast, so I was glad for the time alone, which enabled me to gather my thoughts and get used to my new surroundings.

Jerry and Reggie shared most of the same friends, so the apartment turned out to be a hangout for all of them. Most of them I had already met through Rachel, so the five regulars who came over just about every evening, came to drink, smoke and talk about things men talk about. They got a kick out of my British accent, so they would insist I come out of the room whenever they came over, just so they could antagonize me. I liked all of them because they were fun to be around, and they were good to me. They were also very protective of me, but sometimes too protective.

A few months had passed by without any conflict between Reggie and I, until the one evening we had a fight right before the regulars showed up. Jerry was trying to stop it but couldn't, so when he opened the front door for their friends, they came in and stopped it. They wanted to know what we were fighting about, and when I told them, they warned Reggie not to put his hands on me again. Reggie was looking uncomfortable and embarrassed, and so once I realized he was intimidated by them, I decided to use that to my advantage.

A couple of months passed without us having another altercation, until shortly after my twenty-first birthday. I was on my way home from work one evening, about to go turn into the house, when I saw a family friend. He was someone I had known since age fourteen. Mom met his parents at church when we first moved to Boston from New York. His sister Joan and I used to have sleepovers, so it was a pleasant surprise to see him.

We greeted each other with a hug and a kiss on the cheek and began catching up, informing each other as to what was going on with our lives. We talked for about fifteen minutes before we parted ways, and then I went inside the house. I didn't see Reggie's fist coming around the corner, I only felt it when it hit my face. Before I could fathom what was happening, I was being dragged into the bedroom, pushed onto the bed, and getting punched in the face.

Afterward, he grabbed me off the bed and pushed me against the closet door. He left the room for a few seconds, then came back as I was about to run to the bedroom door. He then accused me of being with Joan's brother because he saw us hug and kiss each other on the cheek. I tried to explain who he was, but he wouldn't listen. Instead, he pushed me back into the closet door, pulled out his five-and-a-half-inch knife and started poking my stomach with it.

I was frozen with fear, with all sorts of dreadful thoughts that entered my mind. All I could do was stare at him, while trying to

contemplate if he was going to try and kill me. As I did that, I noticed his countenance begin to change. I saw the veins in his forehead begin to rise and pure evil lurking through his eyes. His appearance caused my level of fear to increase, since I felt as though I was looking at Satan himself.

At that point, my only thought was, "I'm going to die." I remember thinking, "I'm only twenty-one, and I'm not going to be able to say goodbye to my siblings, as well as aunty, daddy, mom and Bev." I have heard people say that before a person dies, their life flashes in front of them. I thought about that during this ordeal, but my thoughts were too frantic for that to happen. All I was concerned about, was that I wasn't going to see the people I loved again, and I remembered saying to myself, "I haven't even truly lived yet."

I was extremely afraid and unable to think straight, not knowing what to do. Suddenly, I heard a voice whisper and said, "Look straight into his eyes and repeat the name of Jesus." I didn't stop to think how in the world that was going to help, I just did it, because I had nothing to lose. So, I stood there, stared him in his eyes and kept repeating the name of Jesus. Once I started doing that, Reggie began looking even more demonic, right before he said something I will never forget. "If you know what the devil is telling me to do, to just push this knife in your stomach six times and pull it out."

I felt a sense of greater doom clouding the room, as he started poking me faster with the knife. "Oh my God," I said in my mind, as I was crippled with fear. I started saying in my thoughts, "He is stronger than I am, and he has this long knife, so there is no way I'm going to get out of this alive." But, in the middle of my panic attack, I heard that quiet voice again in my head telling me, "Don't fear, just continue repeating the name of Jesus."

In the midst of it all, I began to feel a strange sense of calm, and so I tried to keep focus and began repeating over and over, "JESUS,

JESUS, JESUS…," while staring Reggie in his eyes. As Reggie continued poking my stomach, I felt the sharpness of the tip of the knife, but I knew it hadn't pierced my flesh, which I thought was strange. Instead of continuing to call on the name of Jesus, I started imagining what would happen if the knife went through my flesh. Just the thought of what it would feel like was horrific, and so I lost my calm and once again began to panic.

I went back to thinking, "I'm not going to see mom and aunty again, I'm not going to see daddy or Bev," which made me realize for the first time, how abrupt and final death was. I blocked out my dilemma for a few moments and started thinking about the good old days and the wonderful times I had with Bev. After returning to the situation at hand, I kept telling myself that I was going to die at any moment.

In the midst of scaring myself, that voice in my head reminded me to stay focused on what I was supposed to be doing. So, as Reggie continued to poke me harder, I reverted back to calling on the name of Jesus. For about a minute, I just stared Reggie in his evil-looking eyes and kept repeating, "JESUS, JESUS, JESUS…" Then, all of a sudden, Reggie had a confused look on his face.

He stopped poking me and started backing away from me, while staring at me the entire time. He backed up all the way out of the bedroom, and then closed the door behind him. I was stationed in the same spot for a while in shock, trying to pull myself together. Eventually, I built up the courage to walk to the door, so I could peep out and see where he was. I didn't hear any sound, so I started deliberating what to do, should I or shouldn't I? I wanted to open the door and make my escape, but I was afraid to, in case he was behind the door.

I listened keenly for any sound, but I couldn't hear a thing. I wanted to run so badly, but my legs felt like jelly, and I couldn't move.

Suddenly, I heard a loud noise that sounded like the front door slamming, but I wasn't sure if it was a trick. I decided to peep out to see if he was really gone, and although I didn't see him, I still wasn't sure. I no longer felt his presence, so I walked slowly down the hallway to peek. It so happened that I made it to the front door just in time to see him speed off in my car.

I can't even find the words to explain the relief I felt at that moment when I saw him leave. I was in awe, knowing that I made it out of that scenario alive and without even a scare. I tried to imagine the extreme sorrow my family would have experienced if he had actually killed me. But Jesus showed up to my rescue that day, which was the first time I witnessed firsthand, that there is truly power in the name of Jesus.

When I sometimes travel back to that frightful day, I usually only think about how evil Reggie looked, and how stupid I was to have accepted his apology when he came back that night. I was also a fool to have continue living with him after that experience which was evident that it was time to leave. I should have left and gone back home to the safety of my mother, but my stupid pride prevented me from doing so. Instead, I stayed in an abusive relationship, believing a man who told me he wouldn't hurt me again.

It didn't take very long for another fight to break out between us, but the incident that followed is one that will forever be etched in my mind. I have no idea what we were fighting over this time, but just as we had finished fighting, his friends came over to hang out before they went to the club. We were in the bedroom when one of his friends knocked on the door and told us to come out and join them in the kitchen. Reggie left the room and joined them as soon as the door knocked, but I had no intention of going out there, because I was still very upset.

They eventually persuaded me to come out of the room by telling me they would break the door down and come get me if I didn't. I finally came out, but for some reason, I didn't sit around the dining room table with them as I usually did. Instead, I leaned over the stove and watched them drinking and talking. As they sat there drinking, talking, laughing and having a jolly old time, Gary decided he was going to show everyone his new 45 caliber automatic gun.

The second I saw the gun, I started panicking because I hate guns. As far as I'm concerned, they only represent one thing, and that's death. I began shouting at Gary, telling him to put it away. The rest of the guys also told him to put it away, stating that a bullet might still be in the head, as they put it. At the time, I had no idea what that meant, all I knew was that it was dangerous, and I was furious. Gary insisted the gun was safe, so in anger, I replied, "Safe? How can a gun be safe, when it's made to kill people?"

I then quoted the proverb, "If you live by the gun, you die by the gun," but he still insisted the gun was safe and told everyone to chill out. I was enraged, and so was everyone else, when Gary proceeded to wipe the gun down with a cloth. Suddenly, I heard the loudest bang I had ever heard in my life. I guess I must have automatically closed my eyes, because when I tried to open them - all I could see was orange, and all I could hear was a loud ringing noise in my ears.

To this day, I have no idea if it was shock that caused my temporary memory loss, because, in the proceeding minutes, I had no idea who I was, what I was or where I was. I felt like I was in an orange maze trying to find my way out, and as my confusion continued, my thoughts went haywire. I was trying to figure out if I was a person or an animal, it sounds crazy, but that's what happened. When I remembered I was a woman, I had no idea who I was, where I came from or what my name was.

I had no idea where I was, and I remembered trying to open my mouth, but there was no movement. I couldn't speak, so I started wondering if I was dead, and if not, what had happened to me. I remember being fearful because at that point, I thought maybe I was dead and traveling through that tunnel I heard people talk about. I couldn't see anything but orange; my sight had temporarily disappeared, which led me to believe I was blind. It was a scary place to be - not being able to speak or see. My silent distress was internalized, which left me feeling paralyzed and in a place of no escape.

Finally, after I don't know how long, the loud ringing started to subside. I began faintly hearing sounds, but they were muffled and sounded as though they were coming from a distance. I listened keenly, trying to identify the sounds I was hearing. It wasn't until my senses gradually started to fully return, that I realized the sounds were people's voices. I had no idea who the people were, but as my hearing became clearer, I realized the people were shouting and their voices sounded very distraught, but I had no idea what was going on.

I was silently frantic because although I was finally able to hear, I couldn't speak and was still only able to see orange. By that point, I was convinced that I was permanently blind. After additional minutes went by, the orange fog started to clear, leaving me with blurred vision. It felt like a very slow process before I was finally able to see clearly. When that happened, my memory fully returned also, but with all the confusion going on, I still had no idea what had happened.

All I could hear and see were the men cursing and frantically running around looking for something, but I had no idea what it was. That was until I heard Jerry telling Gary that the other tenants must have heard the gun go off, and that he had better find the bullet before the tenants called the landlord or the police. It was then that I realized

the loud bang I heard was the bullet from Gary's gun, which we had told him to put away.

I was bewildered as to why they couldn't find the bullet when the kitchen wasn't that big. I was still in the same spot, frozen into place, leaning over the stove. I couldn't move, so I watched in silence as they ran around like chickens without their heads. When they had searched everywhere and still couldn't find the bullet, they all looked confused, but I was still unable to speak, so I just watched in shock and listened.

That was until one of them walked over to me and said, "British, step out of the way a minute and let me see something." I couldn't move or speak; I guess I was still in shock, so he eased my head out of the way so he could see behind it. I then heard him say, "Wait a minute, wait a minute," and then he called everyone over to see. "Come look at this," he shouted. Everyone rushed over to the stove to see what he was showing them.

Although I was aware of my surroundings, I was in oblivion as to why they were causing such a raucous. Everyone was cursing and shouting at the same time. One of them told me to turn around and look at the knobs on the stove behind my head. I didn't look right away, as I was still a bit shaken up. After they demanded I turn around and look, I was in awe at what I saw. I stood there in disbelief for a few moments, and although my speech had returned, I was speechless. The bullet landed and tore the stove top open directly behind where my head was.

My eyes were fixated on the stove as I thought, "If that bullet had hit me, my head would have been torn open like the stove was." I looked at Gary and said, "You nearly blew my head off with the gun that you insisted was safe." He was unable to speak from the shock he was experiencing himself and was obviously sorry for what he did.

What baffled everyone though, was how the bullet landed behind my head, when Gary was sitting directly in front of where I was standing.

Although they were questioning it at the time, I knew it was none other than God that spared my life yet again that night. Unfortunately, I didn't take the time to give God thanks for sparing me from a trip to the morgue. After we all settled down, the men insisted I get dressed and go with them to the club to celebrate. I went to Station Café with them that night to celebrate the fact that I didn't get my head blown off.

About two months later, Reggie and I were at it again. This time, he thought he could just use me as a punching bag, because I was too afraid to fight back after the knife incident. One Saturday night, I had planned to go to the club with Anna, and it so happened that he was going to the same club and told me I couldn't go. I had already gotten dressed and was ready to leave when he told me I had to stay home. I was determined to go and decided once and for all, I was going to stand up for myself. I told him he wasn't my father and couldn't tell me where I could and couldn't go.

That was a major mistake, because the next thing I knew, I got punched in my mouth. When I saw that my mouth was bleeding, I tried running for the door, but he pulled me back and threw me on the bed. He tried to jump on top of me, so he could hold me down and punch me some more, but I managed to get him off me. When I did, I jumped up and ran to get something to hit him with. I wasn't going to take his abuse any longer, so I made up in my mind to fight back.

I grabbed the first thing I laid eyes on, which happened to be my wedged-heeled sandals. The bottom of the shoe was so hard it felt like it was made from stone. When I bent down to pick it up, he tried to grab me and hit me again, but I moved, and he missed. With the shoe in my hand, coupled with all my might and anger, I swung that

shoe towards his head. That blow he got startled him before he turned and ran towards the front door holding his head.

I ran after him with the shoe in hand, so I could give him another dose for all the times he hit me. But when I ran out the front door after him, he was already driving off in my car. I felt quite proud of myself that night, although my lip was busted. That didn't stop me though because I bathed my lip and went out as originally planned. Shortly after returning home, Anna's husband called to tell me that Reggie was at the hospital getting stitches because I had split his head open. I responded by telling him I didn't care, and it was a pity his entire head didn't need stitches.

It turned out that Reggie never did hit me again until after we were married, yes, married! Bloody fool that I was. Before we got married though, I found out that I was barren. My so-called friends, who were having children, kept asking why I had not gotten pregnant yet. Having a child with Reggie never crossed my mind, but their questioning did cause me to wonder. When I couldn't deal with the questions anymore, and especially after Anna called me a mule, I decided to make a doctor's appointment. I had to find out why I was having unprotected sex and had not gotten pregnant.

The doctor wanted to know why I thought I couldn't have kids, but I couldn't tell him because my friends kept asking, so I told him I had been trying for a couple of years, which was a lie. I went back a couple of weeks after for the test, which showed I couldn't get pregnant after all. I kept that secret to myself because I felt ashamed, and less of a woman, even though the doctor told me my problem could be fixed through surgery.

I decided in the meantime that I would tell my friends I wasn't ready to have kids, when they asked. I definitely didn't want children with Reggie anyway, but I did want them. I figured I could do the surgery, and then later in life when I met the right person, I would be

able to have children - but as usual, my plans never went accordingly. I thought I could just make an appointment to have the surgery, but I was greatly disappointed when I found out I had to go through a series of tests first. Tests that would deem me eligible or not for surgery.

The doctor explained that I wasn't the only one that needed to be tested. Both me and my partner would have to go through a series of tests. One of which was a progesterone test to see if I was ovulating. My partner would have to be tested to see if he produced enough sperm. After thoroughly thinking about it, I decided to tell Reggie what I was told, since I was going to need his help. He agreed to do the tests, and so I got everything scheduled.

Our tests were scheduled for different days, but he didn't want to go alone, so I accompanied him. When I went to do mine, the nurse surprised me with the new information. She explained before the testing that I would only have a window of twelve months to get pregnant after surgery, before my chances of pregnancy were gone. She also explained that the fertility test was measured on a scale of one through ten. If I scored below six, I wouldn't be eligible to do the surgery, because my chances of getting pregnant within the year would be very slim.

That information put a damper on my plans, but I went ahead and did it anyway. When I went back the following week for the results, anxiety was killing me. I tried to wait patiently in the room for the nurse to enter. I wasn't only going to get the results for my tests, but I was getting Reggie's results too. The nurse finally appeared after what seemed like forever with a big smile on her face, so I thought, "That must be a good sign."

Before she was able to sit down, my patience had already run out. "I can't wait any longer, did I score higher than 6?" I will never forget her response, "If you could get pregnant, you would breed like a roach, because you scored 9.3 on the test." I was elated, so much so,

that I responded by saying, "Wow, I never expected it to be that high." When I asked her for Reggie's results, she burst out laughing and took a while to stop. That didn't seem like a good sign to me, so I asked her what was so funny.

When she finally composed herself, she said, "A man produces millions of sperm during ejaculation, but your partner only produced one sperm." She started laughing again, although I wasn't finding it funny at all at the time. She then continued to say, "And the one sperm that he produced was very slow and sluggish," and so she started laughing again. She then suggested Reggie make an appointment to be tested to find out why his sperm count was so low.

The more I thought about it after I left the doctor's office, the more it became funny to me, but it was certainly a shock when the nurse first informed me. My only concern was it was going to delay my operation, and I couldn't bring someone else to test in his place, because the doctor already had his information. Reggie did end up making an appointment to find out why he only had one sperm, and they found the problem. It had something to do with his veins, after which he had a minor surgery to correct it.

I, on the other hand, decided to wait until I was with someone else to continue the process – because I didn't want to have children for Reggie in the first place. I no longer cared what some so-called friends said, like Anna, for instance, who told me I couldn't have any children because I was a mule. I never forgot how those words cut like a knife and hurt me so deeply, but I continued with my secret and carried on with my life. That brokenness I was feeling though, caused me to miss the comfort of my mom, so I decided to go and visit for the first time since I left home.

It had been over a year since I left home, during which time, it never occurred to me how much mom must have worried about me. When I arrived at the house, she was smiling – I was expecting a good

scolding, but instead, she welcomed me with open arms. She wanted to know what I had been doing and where I was living, but apparently, she already knew. I told her I had a boyfriend and that we were living together, but she wasn't happy about that at all.

Whoever told mom my business, obviously didn't tell her about the fights Reggie and I had, because she would have certainly stepped in and ended that relationship. After she met Reggie, she kept insisting that if I was going to live with a man, then we should be married. I thought, "Definitely not," but I was too embarrassed to tell her what our relationship was really like. Reggie had suggested marriage, but I had no intention of marrying him, so I had already told him no.

Mom brought up marriage every time I went to visit. Because she was a devoted child of God, who lived a life that was pleasing to the Lord, she wanted her children to live a life according to God's word, but we had other plans. Mom was also concerned about what her friends thought, even though she had no idea what her friend's kids were doing behind closed doors. I was usually an obedient child and adult, never wanting to disappoint mom again, so eventually, I let her talk me into it.

Chapter Seven:

Standing at Death Doors

Never let anyone talk you into doing something you know you should not do. Even if it is your parents or someone else you trust. Sometimes they are right, but there are other times when you have that gut feeling deep down inside. When I have that gut feeling, I have learned from experience not to ignore it, because when I do, I always end up regretting it.

When I think about it, I can't believe I really let mom talk me into marrying Reggie, especially when I knew he was basically a demon from hell. The wedding date was planned to take place three months after my twenty-second birthday. There wasn't much time to prepare, so I called Bev, her sister Paulette and my friend Marie in England to let them know I was getting married. I wanted them to take part in the wedding, and only gave them one month's notice to prepare.

Bev was to be my maid-of-honor - an agreement we had already made as a teenager. Back then, we planned to have double weddings, and if that didn't turn out as planned, we would be each other's maid-of honor. When Bev, Paulette and Marie arrived and met Reggie, although he was on his best behavior, they were not happy about my plans to marry him. Aunty and daddy came too, and when they met Reggie, they weren't keen on him either.

In fact, Auntie wasn't acting very pleasant at all when she met him. The moment she laid eyes on him, she had a very disappointed look on her face, and she didn't hide the way she felt about it. Bev wanted me to call off the wedding, leave Reggie and go back to

England with her, but I didn't. Once again, I didn't want to disappoint mom, so against my better judgement, I went ahead with the plans.

On the morning of the wedding, Bev, Paulette, Marie and I, left out early from Brockton, where Reggie and I, were living at the time. We left early and headed to my mother's house, so we could do our last-minute preparations and get dressed there. Family members whom I hadn't seen in a while had traveled for the wedding, and were staying with mom, so I was eager to see them. Upon entering the house, we found aunty sitting in the living room crying. The moment she looked up and saw me, I didn't have to ask what was wrong, because she made it a point to tell me.

She was crying because of the dream she had the night before, which was regarding my marriage to Reggie. Aunty insisted the marriage would end up very bad, and I would be in danger, so she wanted the wedding to be called off. Shortly after aunty stopped crying, mom opened the fridge and took out the fresh meat she had bought and seasoned the day before. The meat was to be cooked for the wedding reception, but when she opened the containers, all the meat was spoiled.

Everyone present, insisted that the wedding had to be canceled, believing that the spoiled meat was yet another sign that the marriage was doomed. Mom was the only one that wanted to proceed as planned. When I went upstairs to take a bath before I got dressed, I started crying and called Bev into the bathroom. I told her I didn't want to marry Reggie, and broke down as I finally informed her about the abuse.

Like mom, I too, was concerned about what people would say, especially because some of the guests were already at the church. My mind was wavering back and forth, unable to make a final decision. Bev told me if I didn't want to marry him, I shouldn't care if everything was already prepared, or that some of the guests were

already at the church. She suggested we send someone to the church and announce that the wedding had been called off. I agreed, and so I sent her downstairs to tell mom that I wasn't going to go through with it.

After Bev relayed the message, mom came running up the stairs into the bathroom and told me I couldn't call it off, because the guests were already in the church waiting. Mom also insisted that I needed to hurry up and get dressed, because I was already over an hour late. Now that I am thinking about it, I really was a big idiot back then - as much as I loved and respected my mom, I should have drawn the line. I should have let her know that it was my life and happiness at stake, not hers. I was the one that would have to live with this man, not her.

It was me who was going to live in misery and heartbreak, and I knew that. But just because I didn't want to disappoint my mother, I went through with it. So, the wedding went on with my maid-of-honor, four bridesmaids, four groomsmen and three flower girls, who nearly didn't end up being in the wedding. That was because the dressmaker didn't finish making their dresses until an hour before the wedding. About a hundred guests attended, most of whom mom invited. The actual wedding ceremony turned out to be quite nice, though, it was just a pity it wasn't with the man of my dreams.

The reception ended up being buffet style, and mom somehow was able to buy more meat, have it seasoned, cooked and ready for the reception - although I have no idea how she managed to pull it off. The DJ was one of Reggie's friends, and in the middle of playing the type of music I requested, which were reggae lover's rock, and R&B, mom told him to stop playing the music I wanted, and to play gospel songs instead.

The wedding party, along with our friends, all turned and looked at each other when the music changed, as if to say, "What is going on." I quickly went over to ask the DJ what in the world he was doing,

when he informed me that my mom told him to play gospel music. When I went and asked mom why she did that, she replied by letting me know that the music he was playing was not appropriate for her or her friends from church who were in attendance.

The wedding party decided we would go to a club instead, so we could enjoy ourselves. We decided to leave mom and her friends at the reception to enjoy their church music. At the club, there was no affection between Reggie and me that evening. No romance, kisses or anything of that nature. He spent the night in one corner of the club with his friends, and I spent the night in the other corner with Bev, Paulette and Marie. I enjoyed every moment with them and made the most of it, because I knew they wouldn't be with me for much longer.

Before Bev, Paulette and Marie, went back to England, we planned a night out on the town. We wanted to enjoy one last night out together, before we had to part ways again. We got dressed and were deciding where we would go first, because we were going to paint the town red, as the saying goes. Reggie happened to come home before we left and asked where we were going. We told him we were going to go to a club, but to our surprise, he told us we were not going anywhere.

I spoke up and told him he wasn't going to stop us from going out. Bev and Paulette then jumped in and asked him why he wanted to prevent us from going out. They tried to persuade him to let us go, since it was our last chance before they returned to England. He still insisted none of us were leaving the apartment that night, but we continued with our preparations any-way. When we were ready and about to leave, he said, "I already told you that none of you are going out tonight," to which I responded, "Oh yeah, well, you can't stop us."

He didn't respond, instead, he walked to his closet and took out a gun, that I had no idea he owned. He then took out four bullets from

his closet and laid them next to the gun on the table in front of us. Bev asked him what the bullets were for, and he responded by saying, "There is one bullet for each of you, if you go through that front door tonight." Needless to say, we didn't get to go out that night. We contemplating to jump him and beat him up, but maybe it's a good thing we changed our minds.

At that point, Bev was adamant about me leaving with them and returning to England. She was afraid that my life would be in danger if I stayed, so she didn't want to leave me behind, but I just couldn't leave. The day they were leaving totally broke my heart, because I loved them so much and was going to miss them terribly. I knew I was going to miss Bev especially, but I didn't want to leave mom again, as I knew it would break her heart if I wasn't around.

When it was time to say our goodbyes at the airport, I wept profusely, and continued to cry for days after they left. Eventually I got back into my usual routines, but there was a void inside me without them by my side. A few days after Bev, Paulette and Marie left, Reggie also left, and I didn't see or hear from him for over a week. It didn't take very long to find out that he spent the week with some woman he met who had moved to Boston from New York.

I hardly ever saw him after we got married, because he was either with his woman or his friends, so while he was enjoying his life, I was focused on mine. Approximately three weeks after the marriage, when he did show up one evening, he had the nerve to ask me if I was going to file for him to get his green card. I had no intention of helping him, and so I made it very clear that if he ever did get his green card, it certainly wouldn't be because of me.

I guess he was trying to be nice after that, because he began offering to take me out whenever I did happen to see him, but nothing he did was going to change my mind. We went out sometimes on weekends, but apart from that, we went our separate ways. The only

time he stayed home for half the day was on Sundays. Once he ate dinner and watched a movie, he left. That was the usual routine, one that was no bother to me by that point in our relationship.

During the weekdays, I had no idea where he was or what he was doing, and quite frankly, I didn't care. Every evening after work, I headed to moms for my dinner, which was always ready for me. I would then go home to Brockton after spending time with mom and my siblings. I spent most nights at home in Brockton by myself and enjoyed my alone time, which provided the time I needed to think about my life and the changes it needed.

I was basically living by myself, in a relationship with no resemblance to a real marriage. About two months before my twenty-fourth birthday, I decided it was time to put an end to the madness, and so I told Reggie he was free to do as he wished, because there were plenty more fish in the sea. He responded by telling me that I was too old and that nobody would want me. "Oh yeah, we will see if nobody else want's me," I replied. Once again, I didn't see his fist coming, I only felt it.

That was our first fight as a married couple - he apparently forgot about me splitting his head open with my shoe, and I had forgotten he had a gun. So, I punched him back, and by the time we were finished, I had a black eye, but then again, so did he. It so happened that the following day, mom wanted to see me. I had to make up an excuse as to why I was unable to go, because I didn't want her to see my eye. "This relationship has to come to an end," I told myself. My only problem was, I had no idea how to do it without an incident.

I knew it would be impossible to walk away easily, or unharmed, so I pondered on how to make my way of escape. It turned out that about a month after our fight, I had a vision that I met a Hispanic-looking guy in an apartment building where some of Reggie's friends lived. Although the dream was very vivid, I didn't think much of it

at the time. That was until a couple of weeks later, when Reggie went to see one of his friends in that same apartment building. While sitting in the car waiting for him, I happened to notice a very good-looking man who looked Hispanic, walk out of the building.

I thought, "Wow, he's so fine." I couldn't take my eyes off him as I watched his every move. Shortly after, Reggie returned to the car and sat waiting on a friend to come. While waiting, he asked me if I saw the man who had just exited the building. I was afraid to say yes at first, so I pretended I had no idea what man he was talking about. After he described the person, I told him I had no idea he was talking about the Hispanic guy. That was when he informed me he was not Hispanic, but was Jamaican Chinese.

"How interesting," I secretly thought, as I proceeded to find out as much as I could about him. Reggie, having no idea what I was up to, freely gave me all the information I wanted. I found out he was the cousin of a mutual friend. He told me where and whom he was staying with, as I secretly stored all the information in my memory bank. It didn't dawn on me at the time, that he was the man I had seen in my vision a few weeks prior.

I went home with joy in my heart as I couldn't stop thinking about this mystery man, whom I wanted to know everything about. Later that evening, it dawned on me that he was the one in the vision, which was finally manifesting. I had to find out more about him, so I called Anna to find out if she knew anything. She knew off him, but hadn't met him, so I asked her to investigate. I wanted to know if he was single, and if so, I wanted her to find a way for us to meet – and so she did.

Anna knew his cousin Basil better than I did, so she called him to find out the mystery man's name. Derrick was his name, and luckily for me, he was in fact single. Anna told Basil I wanted to meet Derrick, and although Reggie and Basil were friends, he didn't think

Reggie deserved me. Therefore, Basil had no problem arranging for Derrick and me to meet. Anna was the middle-man, so to speak, and so she and Basil set the day and time.

It was a beautiful summer's evening in July, when I went to pick him up outside the apartment building where he was staying with Basil. I borrowed Reggie's car to go meet him and told Reggie I needed to run an errand for mom. I made up a story that I needed to pick up my cousin Winsome who was flying in from New Jersey to Logan airport. I left out from Brockton, and headed to Mattapan, overwhelmed with various emotions. It had been a long time since I had something good to look forward too, so I was filled with excitement.

I couldn't wait to see Derrick, although I was experiencing anxiety attacks at the same time. All sorts of thoughts were running through my mind. "We will have such beautiful children, if we end up together." I was busy thinking about what my children would look like, and not focusing on the fact that I was playing with fire. If only I could have foreseen what was about to happen a few hours ahead. Never once did it occur to me that I was entering a danger zone.

Even though I knew it wasn't a good idea to meet Derrick in front of the same building Reggie's friends lived in, I did it anyway. My brain was obviously malfunctioning back then - I knew it was a big risk, and a very, very, very bad move, but I was convinced I wouldn't get caught. I figured I was safe because I left Reggie in Brockton, and he had no other transportation, because I had the car. The bus had already stopped running for the evening, so he was stuck at home until whenever I returned – at least, that's what I thought anyway.

Upon reaching my destination, I saw Derrick waiting for me as planned. I quickly pulled up to where he was standing and rushed to open the passenger door. I was in haste to get away from there before someone saw us. Shyness then took over me when he closed the door

and turned to greet me. After everything I had rehearsed to say, I ended up forgetting my speech. All I could do was smile, not knowing what else to do. I felt quite foolish at that point, not knowing what to say. With his friendly demeanor coupled with his outgoing personality, Derrick made his introduction, which in turn made it very easy for me to make mine.

After explaining how I knew of him, he responded by telling me he was happy to meet me. It didn't take long for us to feel as though we had known each other for years, which left me feeling very comfortable around him. I decided somewhere picturesque was a good place to go, so I chose Houghton's Pond. Houghton's Pond is located in the Blue Hills Reservation, which sits on 7,000 acres of land in Milton, Massachusetts. I figured we could sit by the pond or take a walk on one of the trails, just spending quality time getting to know one another. Well, that was the plan anyway, but my first date definitely didn't turn out the way I envisioned it.

Just after passing the stop sign, approximately two miles away from Houghton's Pond, I heard a police siren. When I looked in the rearview mirror, to my dismay, I realized it was me that was being pulled over. Once I stopped the car, the officer came up to my window asking for my license and registration. Before I gave him anything, I asked what I was being pulled over for. To my great surprise, he told me I didn't stop long enough at the stop sign.

I was beyond embarrassed to have gotten pulled over on my first date with Derrick, but it got much worse. The officer then told me my license had expired. As if that wasn't bad enough, I nearly fainted after his next statement. "I'm sorry to inform you that I am going to have to tow the car." I thought I was going to drop dead. When I remembered Reggie, I began panicking as I wondered what I was going to tell him. I tried everything I could think of to convince the officer not to call the tow truck, but fate had other plans for me that evening.

I thought my heart was going to stop when the tow truck pulled up, and it was time to get out of the car. The spot where we had been pulled over was quite a distance from the main road, so the officer offered to give us a ride back to Blue Hill Avenue, but I refused. He didn't seem to understand that I didn't want a ride from him, so he offered again. "After you called the tow truck and let him take my car, you want to give us a ride? I would rather walk," I responded, as I walked away from him. Derrick chose to explain to the officer that it was a nice evening, so we didn't mind walking. Shortly after, the officer left without us, so did Reggie's car, on the back of a tow truck.

I don't know how many times I apologized to Derrick for what happened, but he didn't seem to mind. He actually looked forward to the walk, while he held my hand and told me everything was going to be okay. He reminded me of what a beautiful summer's evening it was, and suggested we enjoy it while using the time to get to know each other. I thought that was easier said than done, knowing he wasn't the one who had the explaining to do.

All I kept thinking was how I was going to explain to Reggie that his car got towed from the Blue Hills. I was supposed to be on the way to the airport, which was in the opposite direction. Even though Derrick tried his best to take my mind off my dilemma, I was preoccupied with trying to concoct a good story. As quick-witted as I was, I couldn't come up with anything that made sense, so I started to panic. Somehow, Derrick managed to calm me down for a while by changing my train of thought too something more pleasant.

We ended up walking for about two hours, and really did end up having a good time. We were laughing, telling jokes and sharing stories which actually caused me to forget what was laying ahead of me. By the time we reached our destination, we already knew so much about each other, and he knew about my abusive marriage. The destination turned out to be the phone booth across the street from the apartment building I picked Derrick up from. I stopped there to call

Reggie to tell him the police stopped me and towed the car on the way to the airport.

When I told Derrick that Reggie wasn't answering the phone, Derrick replied by saying, "Isn't that your husband coming across the street?" I didn't turn around to look, as I was confident that Reggie was in Brockton. As far as I was concerned, Derrick's eyes were deceiving him, because what he thought he saw was totally impossible. After I called Reggie the second time and got no answer, Derrick demanded I turn around and look. When I turned around, my eyeball's nearly fell out after what I saw. There was Reggie running across the main road towards us, looking like a crazy person.

I was stunned, shocked, panicked and petrified. I wanted to believe it was my imagination, but unfortunately for me, my eyes were not deceiving me. I felt paralyzed to the point that I couldn't think straight, then I thought I was having a heart attack because my heart began beating so fast. As Reggie ran across the street looking deranged, I said to Derrick, "He's going to kill me for sure this time." It all happened so fast – one minute, he was running towards me, and the next, he was in front of my face.

He grabbed me so violently that the two gold chains snapped off from around my neck. I watched in shame as Derrick bent down to pick them up, during which time I was trying to free myself from Reggie's hold. When Reggie grabbed me for the second time by the neck of my t-shirt, he punched me so hard that I thought I saw stars. He then asked where his car was, so when I told him the story I made up, he wanted to know what I was doing on Blue Hill Avenue, if the car was towed on the way to the airport.

I couldn't answer, so Derrick then jumped in and told him not to hit me again. Reggie then turned and looked at Derrick, but never said a word. He refrained from hitting me again in front of Derrick, instead, he literally dragged me across the main road into the

apartment building and into his friend's apartment. Once inside, he asked me again why his car was towed, so I told him the same story. He then told me to call mom so he could verify if she really sent me to the airport to pick up Winsome.

I called some random number instead – I was too afraid mom wouldn't have caught on and backed up my story. When the random person I called didn't answer, I told Reggie that mom wasn't answering. In a rage of anger, he took the phone from my hand and slapped me right on the side of my head with it. Not one of his friends said a word, they just sat there staring at me. When Reggie left me standing there to go to the bathroom, I made a run for it straight through the front door.

I headed for the parking lot at the back of the building, with the intention of hiding. I figured by the time Reggie came out of the bathroom, he would think I ran through the front exit and got away. It was my plan to hide behind any random car, until I thought it was safe to leave. Once again, my plan didn't go as I envisioned. Apparently, after thinking I was free and clear of danger, I wasn't. I had no idea Reggie had exited the apartment just in time to see me through the back windows.

Stooped low behind someone's car, thinking I was safe, I made a sigh of relief. Well, that was until I felt Reggie's hand grab me and pulled me up by the neck of my shirt. He then dragged me to the front of the building, during which time I was screaming for someone to help, but no one came to my rescue. I called out to everyone passing by, begging them to contact the police because he was going to kill me, but no one did.

I was convinced that I had reached the end of my road this time around. I was certain Reggie was going to try and put an end to my life once we reached Brockton. Attempting to prevent my demise, I made a run for it each time Reggie tried to flag down a cab that passed

by. I was unaware he had his gun with him until he pointed it at me and told me to stop all the noise I was making. A few cabs slowed down but drove off when I asked them to call the police for me.

I became frantic when one cab driver stopped and picked us up because I was hoping none of them would stop. I thought a police car would pass by and rescue me before a cab driver stopped to pick us up – but off course, that didn't happen. As soon as I got in the cab, I begged the driver to go straight to the police station, but he didn't. I guess he was too afraid for his own life and chose not to get involved.

Reggie started repeating over and over, "Just wait till we get home." After hearing that, I decided I would have a better chance by jumping out of the cab while in motion. That plan didn't work either, because each time I tried, Reggie managed to pull me back. It seemed as though we reached the apartment way too quickly, then again, the cab driver was speeding the entire time. Reggie had problems getting me out that cab, as I tried holding onto the seat belt and whatever else I could hold on to.

Reggie then decided to drag me out of the cab at gunpoint, when he saw I had no intention of getting out. It was a struggle for him to get me out, even with the gun pointed at me. The cab driver said and did absolutely nothing. I don't know why I bothered to tell him the apartment number and begged him to go straight to the police station and let them know Reggie was going to try and kill me. The moment I was pulled away from the cab door, he sped away so fast, I thought he was going to crash into something.

At the time, I thought the cab driver was my last hope, but God was my only hope. I chose to believe the cab driver was on his way to the police station, but that was wishful thinking. We lived on the fourth floor, with fifty-three steps to climb. I know this because I used to count them when using them as an exercise tool. I was hoping

someone would walk by or be leaving their apartment, so I could ask them to call the police, but that did not happen either.

I was trying to walk as slowly as I possibly could, but when Reggie realized what I was doing, he decided to come to my aide. He held on to me and practically pulled me up them steps. All hell broke loose when we reached the top of those four flights of stairs. While taking the keys out of his pocket to open the front door, he held on to me, knowing I was going to make another run for it.

When the front door closed behind us, Reggie was silent. It felt like a deadly silence. He walked towards the living room and pulled me behind him – then he told me where to stand. I happened to be standing in front of the living room window when he took his gun out again, this time pointing it at my head. The interrogation then began, "What were you doing on Blue Hill Avenue, and why were you at the phone booth with Basil's cousin?" He kept asking the same questions, expecting to get a different answer, but I stuck to my story.

"Basil's cousin was already at the phone booth when I got there," was my reply. Unbeknownst to me at the time, Reggie was watching when Derrick and I showed up at the phone booth together, side by side. It was just my luck for Reggie to have been looking out his friend's apartment window at that appointed time. I couldn't come up with an answer for the car being towed near Houghton's Pond, when Logan Airport was in the opposite direction.

After I accepted the fact that he wasn't going to believe anything I told him, I seriously contemplated jumping through the living room window. I figured breaking my legs or back would be much better than getting a gunshot wound to my head. The more I looked out the window and saw how far a drop it would have been to the concrete beneath, I decided to try another attempt at running for my life instead.

My chance came along when Reggie decided to go into the kitchen to get something to drink. When he opened the refrigerator door, I made a run for it down the hallway towards the front door, but I only made it halfway. That's because while still in motion, I felt a metal object hit me on the right side of my head 5 times. I immediately felt weak and dizzy while turning around to see what was used to strike me. I wasn't expecting it to be the barrel of his 38mm revolver.

I looked him in his eyes and saw fear on his face. Fear that came when he looked at my t-shirt then bolted through the front door. When he left, I was incapable of standing any longer. All my strength had left me when I fell to the ground. Once I hit the floor, I had an overwhelming desire to go to sleep. I told myself I would be alright once I took a nap, because I was struggling to keep my eyes open. I felt myself dozing off, then out of nowhere, a program I had previously seen, came back to my remembrance.

I remembered hearing, "The last thing a person should do is go to sleep after receiving a head injury." Immediately, I tried to get up but couldn't. My head felt as though a ton of bricks were weighing it down. It took a few attempts to raise my head up off the floor before I was finally able too. Once I was able to stand, although I was quite dizzy, I made it out the front door. In a panic, I was banging on the neighbor's door, telling her to hurry up and answer, worried that Reggie was going to pop up out of nowhere.

Time was moving in slow motion while waiting for my neighbor to open her door. As soon as she saw me, she stepped back with a look of horror on her face. I noticed her eyes were fixated on my t-shirt with the same expression on her face as Reggie did before he ran out the front door. It led me to look down at my shirt so I could see what it was they saw. I was taken aback when I saw that the front of my white t-shirt was totally covered in my blood. I told her what my

husband had done and asked her to call the police for me, because Reggie had pulled the phone cord out of the wall.

My neighbor then informed me that she couldn't make any calls because her phone had been disconnected. Instead, she suggested I go across the street and use the pay phone in front of the bus station. I was so afraid to go outside, thinking Reggie was some place hiding and would attack me, but I had no other choice but to take that risk. I fearfully walked across Main Street, observing everyone and everything around me. I thought for sure Reggie was going to jump out from hiding and finish me off. I felt a bit safer when I made it to the bus station, especially after seeing a few people hanging around.

I called Anna first to tell her what happened, but her advice was not to give the police Reggie's real description. She felt that if he were to get arrested, he would come after me with a vengeance once released. After calling the police and informing them of what happened, they suggested I not go back to the apartment. Instead, they wanted me to wait for them at the bus station until they arrived.

Two officers show up within five minutes of me hanging up the phone. They too were startled after seeing my bloody t-shirt. The officers proceeded to call an ambulance, but I stopped them, insisting I was okay. I was feeling much better by then, and oddly enough, I wasn't experiencing any headaches or pain. When I was asked to give a full description of Reggie, I remembered what Anna said, so I didn't convey the full truth about his appearance. The officers then called in an APB with the description I gave, before asking me to lead the way to the apartment.

Upon arriving, they didn't allow me to enter the apartment with them. They wanted to thoroughly search the place first, to make sure Reggie hadn't returned while I was gone. The apartment was deemed safe to enter, which was a major sigh of relief for me. Before they

left, one of the officers told me to secure myself in the bedroom until morning, just in case Reggie returned during the night.

The only way to feel somewhat safe, was to push the heavy dressing table behind the bedroom door. It was after midnight when the officers left, so it was my plan to stay up until it was time to take the 5 a.m. bus out of Brockton. Those few hours were absolute torture. Every sound I heard, I thought was Reggie coming to get me. I became even more terrified when it was time to take a shower and get ready to leave. I kept thinking he had come back quietly and was in the apartment hiding.

My heart was pounding when it was time to remove the dressing table that was in front of the door. I kept imagining him jumping from behind the door, so I stood in silence for a few minutes. I keenly listened for any sounds or movement, and when I heard nothing, I figured it was safe to proceed. The bathroom was directly facing the bedroom, so I made a quick run for it, so I could take a shower. While in the shower, I was totally paranoid. But thank God I managed to get dressed, pack a few of my clothes and make it to the bus stop unscathed.

Apparently, I had no cause for alarm, because I found out later that when the police left me, they went looking for him. Although I gave them an entirely different description from what he really looked like - they saw him walking down Main Street and arrested him. I took the bus and went straight to Anna's apartment, believing I would be safe there, but she insisted I leave. She was adamant her apartment would be the first place Reggie would come looking for me. It turned out she was right, so it was a good thing I left.

My mother's house was the last place I wanted to go. I was too ashamed for her to find out what had happened to me. Instead, I went with Anna's suggestion, which was to go to Basil's apartment, where Derrick was staying. I knew that even if Reggie found out where I

was, he wouldn't be able to hurt me. I was totally embarrassed having to show up at Basil's apartment, but I knew I would be safe. When Basil opened the front door and saw me, he stood there in shock for a moment, but he welcomed me with open arms.

After Derrick was informed that he had a visitor, I saw a big smile on his face once he realized it was me. The three of us, along with Basil's girlfriend, immediately got to talking about what happened. During the conversation, Basil told me they heard and saw when I was being pulled from the parking lot. "I had to stop Derrick from getting involved, because I told him he could not get involved in a wife and husband argument," Basil then said. It was only then I realized why none of Reggie's friends lifted a finger to help me.

Upon sharing everything that happened, after Reggie dragged me away from their building, Basil then voiced his regret for not intervening. He revealed that he didn't think Reggie would have done all that he did. I was invited to stay as long as I needed too, while being reassured that I would be safe where I was. Basil must have read my mind when he offered me something to eat, because I sure was hungry.

A few hours after getting there, Anna called Basil to find out if I showed up. She wanted to update me on what happened after I left her apartment. After she told me Reggie was arrested and released that morning, she informed me that he came to her apartment looking for me shortly after I left. I was horrified to hear Reggie held her at gunpoint, insisting she reveal my where-a-bouts. When she told him she did not have any idea where I went, he held her at gunpoint and made her drive to my mother's house.

Well that day, mom finally found out what the relationship was really like between Reggie and me. I can't even imagine what went through mom's mind when Anna showed up being held at gunpoint by Reggie. He tried to demand that someone tell him where

I was hiding. It so happened that my stepfather was just about to leave for work, when he went outside and told Reggie to get off his front porch. Anna begged me to allow her to tell mom where I was, so mom could stop worrying, but I insisted she not tell her.

Meanwhile, Derrick was searching through my braids to see the damage caused to my head. When he saw that my head needed stitches, he pulled out each braid and bathed the wounded area. He touched my heart that day with his gentleness and compassion, something I had never experienced with Reggie. I felt safe along with all the attention I was getting, so I was not in a rush to leave. Knowing Reggie couldn't get me, even if he did find out where I was, allowed me to breath much easier.

The news of what Reggie did to me, spread like wildfire. It didn't take long for him to find out where I was staying either. The following afternoon while walking into the kitchen, I noticed Basil opening up the living room window. I thought nothing of it until Basil suggested I come to look and see who was outside. I couldn't believe my eyes, when I saw Reggie standing below the window in the parking lot at the back of the building. Basil observed the fear written on my face, when he told me I had nothing to worry about.

I stepped away from the window when Basil asked Reggie what he wanted. Reggie asked him to ask me to come downstairs, so he could speak to me. Basil responded by telling Reggie that I was not going to leave the apartment, so anything he had to say to me, he would have to do from where he was standing. Basil then motioned me to come forward, right before he told me to listen to what Reggie had to say.

Reggie asked if I was okay, and then tried to convince me that he was sorry for what he did. Thinking I was going to fall for his trick, he asked if I would come downstairs so we could talk. I repeated what Basil had told him, as well as telling him that he would

never get the chance to hurt me again. When he asked again if I would come downstairs, I told him I was done and would be filling for a divorce. He was still trying to tell me how sorry he was, when I abruptly closed the window and walked off.

The following day, mom went to Anna's mother's house and asked her to find out from Anna where I was. I guess Anna could no longer handle the pressure she was under, because she succumbed and gave mom Basil's phone number. She not only gave mom the phone number, but to my surprise, she gave her Basil's address too. Anna didn't call to let me know she told mom where I was - I found that out when Basil told me my mother was on the phone and wanted to speak to me.

I replied, "My mother doesn't have your number," to which he replied, "Well, she does now, because she's on the phone." I couldn't think of what I was going to say to mom, but it turned out I didn't have to say anything. The second I said, "Hello," she told me she was coming to get me, and that I should get ready and meet her outside. I was so embarrassed and dreaded having to explain everything that happened. I also wasn't happy about having to leave Derrick.

Being the caring and protective mother that she was, mom's main concern was my well-being. Mom was also concerned that I might have had internal head injuries, so when she came to pick me up, she was upset that I didn't go to the hospital when it happened. She drove me straight to the hospital against my wishes, because I did not want to get any stitches. Mom didn't care what I wanted at that point, I had to go whether I wanted to or not.

Off course, as grown as I was, mom came into the hospital room with me. I felt bad when I saw the look of distress on her face, when I had to explain to the doctor in front of her, what had happened. After the doctor bathed my wound, he told me I needed stitches. The doctor couldn't force me to get stitches even though he strongly encouraged

it – so I opted to let my head heal naturally, against both the doctor and mom's wishes.

After we left the hospital, I had to go home with mom, and that was when she informed me, I wasn't going back to Brockton to live. I called my landlord to tell her I had to break the lease, but was surprised when she told me how sorry she was about what happened. I didn't have to explain why I was breaking the lease because she already knew. She told me she saw it in the newspaper which left me bewildered as to who informed the press.

Mom made arrangements with one of her friends to help with the move a few days after. We noticed Reggie had already moved his clothes out, which was good, because I was paranoid that he might show up while we were there. While gathering my belongings, I noticed my passport and green card were missing. Reggie had taken them knowing I needed them, because his plan was to try and use them to get to me.

It didn't take long for him to find out I was back with mom, so he came over to apologize once again, but I didn't want to see him. When he showed up at the house, my stepfather searched him before he was allowed to come through the front door. He was told to sit in the living while I was called downstairs, but I refused to speak with him. That was until mom told me to listen to what he had to say, so I could get my passport and green card back.

He told me he was moving to New York and asked if I would come with him. He must have lost his mind to even ask me such a ridiculous question. Knowing mom, she must have been listening outside the living room door, because she came in and interrupted our conversation. When she obviously heard him say he was moving to New York, she interrupted us, and told him he needed to return my documents.

He returned that evening with the things he took from me. After he apologized to mom and me for what he did, we said our goodbyes. Once he walked through that front door, I never saw or heard from him again. Anna later told me that he was forced to move out of state by the same friends that had warned him not to put his hands on me again. Anna's husband was one of them, so when Reggie stuck her up with his gun, he sealed his fate.

Apparently, he was given an ultimatum - He was given one week to leave town or else. I guess he thought he was going to get away with what he did and still have friends. So, my four-year ordeal with Reggie finally came to a bad and abrupt finish. In the end, the dream aunty had the night before our wedding came to pass. She did say I would be in danger, and that the marriage wouldn't end well.

Chapter Eight:

Midnight Fire

There are going to be times in life when we experience material loss. When it happens, some of us tend to be emotional and heartbroken. We eventually have to accept the loss, pick up the pieces and keep moving forward. Always remember that so long as there is life, there is always hope. Hope that the material things we lost will be replaced. Many times, the replacements turn out to be much better than what was lost.

It took a few weeks to get settled in at mom's since I was once again subjected to her rules and curfews, even though I was twenty-four years old. It was good to be back home though; being in a peaceful, emotionally safe environment and smothered by mom's love was exactly what I needed. Even though my recent trauma lingered beneath the surface of my mind, coming home from work every evening to see mom cooking in the kitchen with a smile on her face as she greeted me, was the cure I needed to put past hurts behind me.

I bounced back quite quickly, not allowing my experience to cripple me mentally. Instead, I was relieved it was all over and behind me and having a bright future to look forward too. Mom never brought up those traumatic experiences in conversation, and I never mentioned them either. If she was disappointed in me, I would never know because she only showed me acceptance and unconditional love.

I wanted to tell her about Derrick, and although she already knew, I was afraid of what her response would be. I knew she wasn't going to be happy about me having another man in my life so soon, so I held

off for a few weeks. I usually went to visit him some evenings after work, or if I took my brother and sister out during the weekend, I would meet up with him, and we all hung out together. I swore them to secrecy if they wanted to continue going out with me, which worked, because they never did tell mom.

When I finally found the courage to tell mom about Derrick, she didn't want to meet him, but I was able to convince her that she would like him. It took some convincing, but she eventually agreed to allow him to attend our family barbeque. Mom acted as though she wasn't interested in meeting him when he arrived, although I watched her observing him every chance she got. Everyone took to him right away, especially mom, although she tried to pretend that she thought he was just okay.

Derrick being family oriented and always willing to help, ended up assisting mom with the grilling and cleaning up afterwards. He had won mom over, and in turn, mom took advantage of his willingness. She invited him over for dinner the following weekend with an ulterior motive. She needed things fixed around the house, so Derrick ended up being the handy man. Not knowing his mother or father, Derrick longed for the love of a mother. Well, mom certainly showered him with motherly love, and so he stuck to her like glue.

It wasn't long before Derrick accompanied mom to Haymarket on Saturday mornings, as well as everywhere else she needed to go. They became inseparable and loved each other as mother and son. All my family members who met Derrick loved him, so he ended up having the family he longed for. Derrick came to visit just about every day over the six months I lived with mom, until I decided it was time to move out on my own again.

Not wanting me to leave home again, mom tried using her manipulation skills to get me to stay. When that didn't work, she tried convincing me to find an apartment nearby. She wasn't happy when

she found out Derrick and I was going to be living together because we weren't married. She was even more upset when she found out I rented an apartment in Salem, New Hampshire. It was only a forty-five minute car drive from Boston, but it was too far away as far as mom was concerned.

I really liked it in Salem because it was very clean, quiet and peaceful. Every evening after work, I looked forward to venturing out into the woods and trails nearby. Mom was right, the distance became a burden. It took nearly double the expected time to get back and forth to work during rush hour. The rent was pretty expansive for the average prices back then, which was also another burden. So, in the end, we only stayed there for six months before I decided to move again.

I found a small apartment in Lynn, Massachusetts, with a reasonable rental fee and decided to take it. I wasn't fond of Lynn at all, but I did like Nahant Street where the apartment was located, as well as having a beach to walk too at the end of the street. Mom wasn't happy that I didn't move closer to her, because Lynn was also approximately a fourty-five minute drive away from her. Not having a car at the time made my visits to mom via bus and train very time-consuming, so I didn't visit as often as she would have liked.

Unfortunately, we were only living in Lynn for about three months before a sudden and unexpected catastrophe happened. I was working at USTrust, Corp. at the time, in the marketing department of the bank, and they were very strict about being on time for work. I mentioned this because that was the reason I told Derrick to leave me alone when he was trying to wake me up on that dreadful night. I made it very clear to him that I had to be up by six o'clock in the morning and didn't want to be disturbed under any circumstance.

I went to bed a few minutes before midnight and immediately fell into a deep sleep, shortly after which Derrick woke me up. I heard

him saying something, but I was so tired that I fell right back to sleep. I had only closed my eyes for what seemed like a few seconds when I felt him shaking me vigorously and said, "Get up now." I responded by saying, "I don't care if the building is even on fire, just leave me alone so I can sleep."

When Derrick pulled me off the bed, I was angry and ready to fight. In a daze, I glimpsed at the clock next to me and saw it was shortly after midnight. Still a bit shaken up, I wondered why in the world Derrick was running around like a crazy person shoving his clothes in garbage bags. When I asked him what he was doing, he shouted, "How many times do I have to tell you the building is on fire." "What! "What are you talking about?"

"Hurry up and pack what you can," he shouted, as he continued rushing around, throwing things into large black garbage bags. I paused for a few seconds in disbelief, before I realized the living room was filling up with thick black smoke. That's when I jumped out the bed, but instead of packing, I ran to the front door so I could see what was going on. I noticed the hallway wasn't visible with the smoke that had filled it up. I must have been in shock when I attempted to walk down the hallway to see if I could make it to the entrance of the building.

The smoke was just too thick to go any further than halfway, so I quickly turned around and made my way back to our apartment. Upon reaching the front door, I remembered there was an elderly lady living next door. I thought she might need help getting out, so I called out to her, but heard no response. I started banging on her front door, but still no answer. I then decided to try kicking the door down, but the door was too heavy.

Derrick heard me kicking the woman's door before he came outside to tell me once again to pack my clothes because he believed the elderly neighbor had probably already left. I was confused, not

having any idea what to save, because I had so many things. While Derrick opened the windows to let out some of the smoke, I decided to call mom. When my sister answered the phone, she wanted to know why I was calling so late. After explaining what was happening, she didn't believe me - Instead, she asked why I was calling to tell jokes so late at night.

It wasn't until she heard the fire alarm in the background that she believed me and called mom to the phone. "Pat, what's wrong?" mom asked. I responded by telling her the building was on fire and that I was going to die because there was no way out. It didn't dawn on me at the time how devastating it must have been for her to get a call like that in the middle of the night. I could hear the panic in her voice when she told me to run to the front door and get out of the building. Once I informed her that was not possible, she then told me to go out the window.

When I explained to mom that escaping through the window was not an option, she wanted to know why. It sounds like a stupid excuse now, but I told her I couldn't find any of my shoes, so I couldn't jump because there was broken glass on the ground outside the windows. I was afraid my feet were going to get cut or my legs would break, so I refused to jump, although she insisted that was what I needed to do. It was at that point I felt my feet getting warm and realized there were sparks of flames coming up through the carpet. After telling mom the floor had begun to catch fire, she told me to stand on the bed and call Derrick to the phone.

I didn't give Derrick the phone right away because speaking to mom made me feel safe in the midst of the danger. When the sparks began to spread, I became hysterical as I yelled out, "The apartment floor is on fire." I don't remember everything mom said next, but I do remember her rebuking the devil. I interrupted her to say, "Mom, I can't believe I am about to die, and you are busy rebuking Satan?"

"You're not going to die, put Derrick on the phone, I want to talk to him now."

I hesitated at first before giving him the phone, I wanted to continue my conversation with mom, but she kept insisting I give him the phone. While Derrick and mom were talking, I was too busy trying to figure out what I should take with me, although by that stage, it was too late, because it was difficult to see anything. I didn't hear their conversation, but I did hear when Derrick said, "No, mom, yes, mom," and then he handed the phone back over to me.

Mom told me she was leaving the house to come to get me, but before I could remind her that she did not know the address, she had already hung up. Derrick tried taking hold of my arm when he said, "We have to leave now because if we wait any longer, we won't be able to get out." I responded by asking about his plan for escape, to which he said, "We have to jump out the window." I made it very clear that I had no intention of jumping out that window, even though he kept insisting we had too.

I knew time was of the essence, with no more to waste, but I still had no plans of going out the window. Derrick decided to lure me to the window by telling me to at least sit on the window sill so I could get some fresh air until the fire department arrived. His plan worked, but I refused to sit with my legs hanging out the window like he wanted me too, at first. When I looked below and saw all the broken glass bottles, I thought, "if Derrick is planning on jumping, I'm going to wait right here."

He opened up the window next to me and started throwing his bags out. He surely didn't waste any time packing his stuff, and when he asked where my bags where, I had none. He then somehow managed to convince me to put my legs outside the window while we waited for the firemen. It took some convincing, but I finally did, not knowing he had an ulterior motive. The moment I did as he

suggested, he pushed me right out, then shouted, "Mom told me to push you out the window, if you didn't want to jump yourself."

To my great surprise, I landed on my feet, and although I was barefooted, I felt as though I landed on sponge. I didn't feel the broken glass beneath my feet which covered the ground like a carpet. Whilst examining my feet in amazement, I discovered my ankles were not sprained, neither were there any cuts on my feet. Suddenly I realized that I had left my purse with the rent money in it on one of the tables in the living room. Derrick was about to jump when I told him about my purse, which, thankfully, he was able to retrieve.

Meanwhile, other tenants were hanging out their windows; some were screaming, while others were also throwing items out. It was such a traumatic experience for all of us, but especially hard for those people on the top floors who were trying to find a way to climb down. It was a crippling feeling when I observed one woman screaming that she didn't want to die. Trying to reassure her help was on the way, was the only thing I could do to help. Before I finished speaking, it was a great relief to see two firemen turning the corner with their ladders.

One of the firemen asked if Derrick and I were okay, before directing us to go to the front of the building, where it was safer. He also informed us that we should go get help from the Red Cross, who had apparently arrived at the same time as the fire trucks and ambulances. Upon arrival at the front of the building, I was astonished to see the large crowd of people who had already gathered. Some of them were tenants who had escaped before we did, among which was our elderly neighbor.

I was in a state of shock, along with everyone else who stood there observing the building engulfed in flames. At the time, I couldn't even fathom that I had lost everything I owned. I needed a cigarette to calm my nerves, so Derrick and I walked to the store with my bare

feet. The store owner told me I couldn't enter bare footed, but after I finished explaining what had happened, he didn't charge us for what we bought.

By the time we got back to Nahant Street, it was so crammed with spectators, which caused us some difficulty maneuvering our way through the crowd. As we got closer to the burning building, I thought I saw mom standing in front of the Red Cross tent. It had to be my imagination, I reasoned with myself. My inner questioning wanted to know if it really was mom I had just saw. If it was mom, "How did she get here so fast, and how did she know the address?" I was eager to find out, so I decided to put some pep in my step to reach the Red Cross tent as quickly as I could. It seemed like an impossible task at the time, as there were so many people in the way who came out to see the drama.

Upon finally reaching our destination, pushing our way through the crowd, to my great relief, it really was mom was standing there waiting for me. My mom had come to my rescue, causing me to feel a sense of peace and happiness in the midst of my turmoil. The only thought running through my mind at the time, was how in the world she found me - but I guess a mother's love will cause her to move mountains to help her child. After she finished squeezing the breath out of me, she said, "I thought you were naked, so I bought you some clothes to put on."

A man from the Red Cross interrupted our conversation to ask Derrick and I, if we were victims of the fire. After telling him we were, he asked us to come inside the tent because they were giving out supplies. When we finished getting supplies such as toothpaste, soap, and sneakers, etc., I couldn't wait to get back outside to finish talking to mom. I was eager to know how she knew the address, and how she knew the way to Lynn.

Mom explained that after I called her, and she hung up the phone, she called 911 to report that there was a fire in Lynn, but that she didn't know the address. The operator told her that a few people had already called and reported the fire, so she asked them for the address, and they gave it to her. Her friend's son was staying with her for the weekend, so she woke him up and had him drive her and my sister to come get us. We stayed at the scene until five o'clock that morning, watching the forty-unit brick building burn up in flames.

"One of the worst fires in Lynn's history," the representative from the fire department told us, when Derrick and I returned later that day to see what we could retrieve. We were told that our apartment was the most damaged because the fire was set in the basement directly underneath. They didn't believe anything was left to retrieve and informed us that the living room had no floors. I found that hard to imagine, so I had to see for myself. They didn't want us to go inside, but I wasn't taking no for an answer, so they had us sign a form.

The form would relinquish any claim against the fire department, if we entered the building and anything happened to us. We were going in against their advice and at our own risk, but we were willing to take that risk. When we entered the building and walked slowly through the long hallway, it looked so creepy and haunted. It was very dark inside, and the only light shining, came from the flashlight the firemen were carrying. I became nervous when we approached the front door to our apartment, and waited anxiously for them to open the door so I could see inside.

I was in disbelief when I realized they weren't exaggerating about there not being any floors. The only thing we saw were pipes where the living room floor used to be. The first words that came out of my mouth was a stupid question. "Where is all my furniture?" I asked, and then I began to weep when one of the firemen told me everything fell through the floors into the basement below.

I couldn't go inside, because there wasn't anything to walk on except for pipes. I held on to the door frame and stretched my body inside as much as I could, so I could see as much as I could. There was nothing to see, because the living was gone and everything that was in it. I wanted my passport, green card and photo album, and I was praying that at least they were saved. They were in the Chester drawer in the bedroom, but the only way to get there was to walk on the pipes.

Derrick volunteered, but after he stepped on the first pipe, it began to move, so the firemen told him not to go any further. Being the man that he is, he was willing to conquer any obstacle, so he continued to proceed to the bedroom against their advice. I shouted to him and told him not to put himself in danger and to come back, but he went ahead anyway. He insisted he could make it, and he most certainly did.

When he entered the bedroom, a sigh of relieve came over me when he shouted out, "The Chester drawer is still here?" I told him where to look for my documents and album, and he found them. I had some fur coats and gold jewelry in the room and asked him to get them for me while he was in there. My happiness quickly turned to sadness when he told me the closets were all empty, and that everything else in the room, including the bed, dressing table and side tables, were all gone.

The two firemen told Derrick he was very brave to have gone in there, and did it with such skill. As we all walked out of the building, the firemen told me how lucky I was that the most important things I wanted were the only things left. I was happy and sad at the same time because everything else was gone. Everything I worked for and owned, had literally gone up in flames. I had no insurance, so it was devastating knowing I had to start all over again.

Once again, I had to move back to mom's, but this time Derrick came with me. We weren't allowed to sleep in the same room, but surprisingly enough, he was allowed to stay. When I called my employer to tell them what happened, my boss told me to take a week off from work to get myself together. The company also gave me two hundred dollars to buy clothes to wear for work. Considering that I worked for a bank, I expected them to give me more than two hundred dollars to help with clothes, but it was better than nothing.

I bounced back quite quickly from my adversity, after thinking about the fact that it wasn't my life that was lost - it was just material things that could easily be replaced. Mom called me and Derrick to the kitchen one evening, about a month after moving back home. We both wondered what she wanted to talk to us about, not expecting she was going to tell us that one of us had to move out. She and my stepfather weren't comfortable with both of us living there at the same time, because we weren't married.

Derrick loved being home with my family, and I wanted to be free to do as I pleased, so I volunteered to be the one to leave. I ended up renting a room from Anna's mother's house up the street from mom. Every evening after I left work, I stopped at mom's first for dinner. Unless I had other plans, my mother's house was where I hung out until late evening. It turned out that the longer I spent away from Derrick, the more I decided I wanted to remain single.

After being on my own for a couple of months, Derrick asked me to marry him. I did love him, but I wasn't in a rush to get married again. I was enjoying my single life too much to be tied down again with anyone. Derrick was a good man, but I wasn't thinking about spending the rest of my life with him or anyone else at that point. Although he had good moral values, along with a great personality, he was too clingy. I didn't need to take time to think about it, so I told him I could not marry him.

He was highly upset and was convinced that I had found someone else, and refused to believe otherwise. He couldn't wait to tell mom I didn't want to marry him, and when he did, she was upset with me also. She wanted Derrick to be her son-in-law, and so she began her mission to try and get me to marry him. I had to remind her of how she convinced me to marry Reggie, and so I informed her that she wasn't going to succeed this time around. I made it clear to her that I didn't want to spend the rest of my life with Derrick and that was that, as far as I was concerned.

Unable to withstand the pressure from my family about marrying Derrick, I decided to show them all how serious I was. I ended our relationship all together and we went my separate ways. We separated for about six months, but he was still very much a part of my family. Even though he had moved out from mom's, he visited every day, so I still saw him on a regular basis.

Although other women wanted to be with him, he refused. He chose to hold out and wait for me, with the hopes that I would change my mind. Mom even played match maker for him, but he still refused to date anyone else. Mom then joined forces with Derrick again, and so they both began asking me to marry him every chance they got. Mom even went as far as calling aunty in England for her assistance in helping to convince me. I held out and ignored all of them for over a year, but ended up giving in and decided to marry him.

Chapter Nine:

Wrong Reasons

As the saying goes, "The definition of insanity is doing the same thing over and over and expecting different results." Sometimes we know better, but we still do the wrong thing. We really need to learn from previous mistakes, but there are times we don't. Why do we continue down the same path that leads us to a dead end?

I think mom was quite proud of herself, knowing she managed to manipulate me into doing as she wanted. She made all the arrangements, bought the food and did all the preparations. We had a lovely Sunday wedding after the morning service at a friend of our family's church. My family in New Jersey along with some of our friends came, as well as the church members who stayed after the service to attend the wedding. The reception that followed, was held at mom's house with friends and family. Mom even went as far as to find an apartment for us, which was only a ten-minute drive from her house.

It wasn't until our wedding night that we officially moved into our apartment. Our clothes and furniture were already there, but we decided to wait until we were married to actually move in together. Mom was happy that she was close enough to show up unexpectedly any time she wanted. And she most certainly took advantage of the fact that we were in close proximity. Every Saturday morning, she arrived bright and early for Derrick to go shopping with her, which I didn't mind because that allowed me the space and alone time I needed.

I knew Derrick would be a good father and mom knew that too, that's why she kept hinting she was ready to have grandchildren. I

wanted to conceive naturally and prayed that God would open my womb. After a year of trying, I knew it was time to revisit the fertility clinic. I kept my medical records, the x-rays and tests I had already done, in hopes of not having to repeat them. And so, my search began for a doctor that would perform the operation.

I was elated when I found a doctor that thought it unnecessary to do further testing when he saw my x-ray. According to him, the x-ray was all he needed to schedule the surgery. He did leave me a bit worried when he told me he did those operations on a daily basis and could do mine with his eyes closed. I was desperate to have the surgery done, so I proceeded as planned without hesitation. The first available date for surgery happened to be the following week, which was music to my ears. My dream was about to come true, which gave me something exciting to look forward too.

I wanted to surprise mom, so after discussing it with Derrick, I convinced him to keep it a secret until after the surgery was completed. Elated at the thought that I would finally be a mother, I anxiously looked forward to my big day. I was still working at USTrust when I informed my supervisor that I would need a few days off during the following week. After receiving the approval for my days off, I began counting down the days with great excitement.

Just four days before the surgery, I received a call at work from mom. I figured it had to be some sort of emergency because mom knew I wasn't allowed personal calls. After asking mom what was wrong, she replied by asking me a question. "What kind of operation are you planning to have?" I was dumbfounded at first, not knowing how to answer her question. I was convinced Derrick went behind my back and told mom about the operation, but I continued to play dumb, just in case he had not told her anything.

Mom asked again, "What operation are you planning to have?" but instead of telling her, I responded as if I had no idea what she was

talking about. I wanted her to come out and say Derrick told her, but it blew my mind when she told me how she found out. She replied by saying, "You can hide from man, but you can't hide from God." "Mom, what are you talking about?" That was when she told me my stepfather had a dream the night before, and then went on to tell me what happened in his dream.

Mom had me so intrigued that I totally forgot I wasn't allowed to have personal calls, although, by that point, I really didn't care. From what mom was saying, it seemed that my whole world was about to fall apart. I just knew from mom's tone of voice that my plan of having the surgery, was about to fall apart. I was so dreading the words that were going to come out of her mouth next, but with great suspense, I waited. She continued by telling me that my stepfather dreamt he was in a church listening to a sermon being preached by a woman pastor.

The sermon was about Hannah, who was barren, but after she petitioned the Lord, He opened her womb. Hannah first gave birth to Samuel, who became a great prophet, but God blessed her womb again, and she ended up having a total of six children. After the sermon was finished, the pastor called my stepfather to the front of the church and said, "Your stepdaughter desperately wants to have children, so she is planning to have an operation. But tell her that God said, if she goes through with that operation, she might not wake up."

She then gave my stepfather a glass bottle filled with yellow fluid and told him to give it to me to drink. Mom went on to tell me that the pastor gave my stepfather another message to give me in the dream, which was, "God will do it in His time, and God said, I must wait on Him." When I hung up the phone, I realized Derrick obviously had not told her. Even though I tried to fight it, I knew deep down that my stepfather's dream really did come from God.

I immediately felt paralyzed when I hung up the phone. I could not move from where I was standing because I was crushed. The shock left me speechless for some time as I tried to make sense of what I had just heard. I couldn't think straight; it was as though the world had stop spinning, time stood still, and my whole world came crashing down. As hard as I tried to hold back the tears, it became impossible to stop them from flowing.

I wanted children so badly, so much so that I couldn't imagine my life without any. After collecting my thoughts, I said to myself, "If I have to wait on God, this means I won't be having children any time soon." My hopes were shattered as my secret longing was obviously not going to be fulfilled within my desired time frame. When I saw a pregnant woman, my heart would weep, wishing it was me. When my friends had children, I would be happy for them but sad for myself.

I walked around with a broken and heavy heart for such a long time, carrying my secret pain wherever I went. Mom was the only one who could see beyond my smile and see my weeping heart. She felt my pain, which led her to research and gather every consumable plant root or herbal drink that was yellow in color for me to drink, in efforts to mend my broken heart. Nothing worked, so the only thing left for me to do, was to hold on to God's instruction to wait on Him.

I was left with no other choice but to keep my faith and believe that God would come through for me. I knew nothing was impossible for God, so I put my faith into action and decided to wait for Him to grant me my heart's desire. I held on to the hope that He would do it for me, just as He did for Hannah, Sarah and Rebekah, whose stories are told in the Holy Bible. Meanwhile, although I was broken, I still looked forward to the day I would finally become a mother.

After three years of marriage to Derrick, I felt as though I was experiencing the seven-year itch people talk about. Among other things, there was no sexual satisfaction from the beginning of our

relationship, and although I tried to over-look it, it was beginning to take a toll on me. It eventually reached the point where I had no interest in being sexually intimate with him. Even though I did love Derrick, I realized I was not in love with him.

I finally built up the courage to tell him I no longer wanted to be in the marriage, but he refused to accept that. He asked many times what he could do to make me happy, but there wasn't anything he could do. I explained to him that he just wasn't the person I wanted to spend the rest of my life with, as I did tell him before we got married, but that went in one ear and out the other.

I told him we would always be friends, but he didn't want to hear that. He wanted me to stay in the marriage whether I was happy or not. He claimed he loved me too much to ever live without me. I went into the marriage thinking that so long as he was a man of good character and possessed all the qualities of a good husband, sex wasn't as important, but I found out firsthand that wasn't true.

I realized that sexual gratification was very important in a marriage, and without it, a person would be more likely to stray, and I didn't want to do that. Even though I was loyal, my eyes started wondering, which led to me admiring other men. I came to the conclusion that maybe I just needed a change of scenery and people to clear my head. Feeling pressured and smothered by Derrick, led me to book a flight to go back home to Nottingham, especially because I had not returned since I left.

I went to Nottingham for three weeks during the Christmas season, and I was having the time of my life. It was very special being back for the first time since leaving ten years prior. The fact that the atmosphere of Christmas was in the air, made my trip even more spectacular. I spent my time back and forth between staying with aunty and daddy and Bev. I was so happy to be back amongst the people I loved and was enjoying every minute of it.

During the night of Christmas Eve, Bev and I went to a dance at the Marcus Garvey Centre. She told me I was going to see a lot of people I knew there, but I had no idea I was going to see just about everyone I grew up around. I was ecstatic to see old friends while experiencing emotions I felt in the past when Bev and I got dressed up to go out. Being out with Bev that night brought back memories of the fun and excitement we had during our teenage years.

I was reliving those years with Bev by my side, and I loved every minute of it. They say, "Time flies by when you're having fun." Well, it most certainly did that night, because before we knew it, morning had arrived, and it was time to leave. They say, "All good things must come to an end," but in this case, my feelings of total bliss came to an abrupt end. As soon as Bev and I arrived back at her house around five o'clock that morning, the phone started ringing.

It was as though the person on the other end knew exactly when to call. We were startled at first, wondering who was calling that early, but the last person we expected it to be was Derrick. We were both surprised when Bev answered the phone and heard his voice on the other end. I didn't want to speak to him, so I told her to find out what he wanted. He was complaining to her that I wanted a divorce and was going to leave him.

But that wasn't the worst of it, he then told her he was going to hang himself because he knew I was going to find another man while I was in Nottingham. Bev tried to console him to no avail, after which she handed me the phone and told me I needed to speak to him. I was upset because we had just come in from having such a great night out, and then he had to call and spoil the mood. He told me I needed to come home right away, otherwise he was going to hang himself. Out of frustration, I responded by telling him to go ahead and hang himself if that was what he wanted to do, before I hung up the phone.

Bev felt sorry for him and was upset with me for hanging up on him. She wanted me to call him back, but I knew he was just playing with my emotions. It was something he did on a regular basis, so I was used to it. I decided I would deal with him once I returned home, but in the meantime, I had every intention of enjoying every moment I had left in England. I had two more weeks left in England, and I wasn't going to let him spoil my fun, so I continued with my vacation and visited family and friends.

While I was away visiting, Derrick continued to call Bev, complaining that I didn't love him and begging her to convince me not to leave him. He was beginning to be a pest, so I called him and told him not to call back unless it was an emergency. A few days later, my brother called to tell me that Derrick had gone crazy and tried to hang himself in the bathroom with one of my stockings. He told me that I really needed to come home because he and my sister had to spend the night with Derrick to make sure he didn't try it again.

I surely did want to file the divorce papers when I returned home, but I couldn't. I was too afraid that if I left him, he would kill himself for real, and that would forever be on my conscience. He held mehostage, by playing on my emotions, and I fell for it. I asked why he wanted to be with me, when I clearly didn't feel the same way he did. His response was, "Does that means you're leaving me? It was quite clear I wasn't getting through to him, so I decided not to say another word.

I began resenting Derrick because I wanted out, but was kept hostage by his treats of suicide if I left, which was driving me insane. He was like a private investigator - he listened to all my phone calls, and he followed me every chance he got. If I even stayed in the bathroom too long, he would try to come in so he could see what I was doing. Whenever I went to the club with my friends, I would tell him I was going somewhere else, but he always found me. I couldn't

get any space from him unless I was at work, and it was really getting to me.

Every man he saw me talking too, he claimed I was sleeping with them because I wasn't sleeping with him. He started calling all my friends, even the ones he barely knew, and asked them to talk to me because I wanted to leave him. The more he complained to mom, the more I told him I wasn't in love with him, and nothing he did or didn't do was going to change that.

I tried in every way to get through to him, but nothing worked. Hoping this would work, I said, "If you really love someone, and you know that person is not happy in the relationship, true love allows them to go and be happy. Otherwise, trying to hold on to a person who is miserable because you don't want them to leave, is not really loving that person." I knew it made no sense to try and reason with someone who had no sense of reasoning, but I still had to try.

Derrick ended up telling mom that I had stopped sleeping with him and was having an affair. When mom approached me regarding Derrick's allegations, I was so angry with him. I wasn't comfortable having those kinds of conversations with mom. Mom didn't care, all she wanted to know was why I had stopped being intimate with my husband. After telling her that I didn't enjoy sexual intimacy with him, and that I wasn't going to continue doing something I didn't enjoy just to please him - she told me it was my duty as a wife.

I didn't expect that response from mom, I thought she would have understood, but she didn't. Trying to get her to understand how miserable I really was, I told her I would rather be dead than stay in a marriage I wasn't happy in. Mom then reminded me I was in my second marriage, so I needed to stay and make it work. Her words sent me into what I call a great depression. The thought of having to spend the rest of my life in misery was too unbearable to fathom.

After weeks of deliberation regarding my predicament, unable to focus on anything else, I came to a decision. I had done my best to please mom and do what she wanted, but I no longer could. I had finally reached a place in my mind where I decided enough was enough. I was no longer going to continue living my life pleasing others by doing something which caused me to be unhappy.

One afternoon while returning to work from my lunch break, I met a guy who stopped me in the lobby to ask me a question. While answering his question and checking him out, I thought to myself, "He's cute." I wondered where he came from as I had never seen him before, but then I went about my business without giving him another thought. It just so happened about a month later, when I reached home from work, I saw him in the apartment building where I lived.

When he stopped to greet me, I found out he was visiting his son, whose mother lived in the apartment on top of mine. Tony and I started bumping into each other quite often after that, and eventually, we became friends. He was easy to talk to, and the more we talked and spent time together, the closer we became. As the months passed, the closer we became led to us getting involved on an intimate level.

Whenever I had a day off, Tony and I spent the day together, enjoying every moment of each other's company. He wanted me to think of him as a breath of fresh air, and he most certainly was. I was getting the romance and passion from Tony I wasn't experiencing with Derrick. Derrick planted a wider wedge between us every time he picked random friends and family members to call and tell our personal problems to. He was pushing me further into someone else's arms, and in this particular case, those arms belonged to Tony.

Whenever I spent time with Tony, it was fun and exciting, especially when we went on our secret rendezvous. I felt so happy and vibrant whenever we were together, a feeling I didn't have when I was with Reggie or Derrick. Being with Derrick felt like I was with

my brother, but when I was with Tony, it felt like I was with a lover. He was someone I was passionate about, and the chemistry between us was electrifying.

We couldn't get enough of each other, which led to him eventually wanting me to leave Derrick, but that was something I couldn't do. I couldn't leave one man for another. I needed to leave Derrick, but not because I wanted to be with another man. Tony and I continued to see each other for a few more months, but it wasn't the same after he thought our relationship had no future. Tony eventually told me that he couldn't continue being the man on the side. He couldn't continue watching Derrick and me together, while he had such strong feelings for me.

Being young and naïve at the time, I didn't understand what he was feeling, so I didn't take his words seriously and ended up just brushing it off. Even though Tony knew I wasn't sleeping with Derrick, he eventually was unable to deal with the fact that we were still living together. He didn't like having to meet secretly either, so he decided the relationship between us needed to come to an end. So, in the end, I was left with a broken heart after falling in love with a man that I couldn't be with, and being stuck in a marriage I didn't want to be in.

I regretted it for some time, not taking the opportunity to be with Tony when I had the chance. I regretted it even more after Derrick started showing me his true colors. Derrick apparently had a daughter but had lost contact with her mother. I encouraged him to keep looking and not give up when he threw in the towel, convinced he wasn't going to find her. At the time, it had been about seven years since he had last spoken to his daughter's mother, and out of the blue, a friend of his called with her number.

It was a relief when he found out she was not too far away after all, because she was living in New York. I was just as excited as

Derrick was upon receiving the news, because I couldn't wait to meet her. Derrick arranged for her mother to bring his daughter to Boston to spend a week with us, so he could spend time reacquainting himself with her. He had not seen her since she was an infant, and she was already eight years old when he found her. The closer it got to her arrival, the more excited I was, but never in my wildest dreams did I expect her visit to turn out the way it did.

For the five years we were together up until that point, I paid the rent, bought food and took care of all the bills. He wasn't able to work, so I paid for everything. Two weeks before his daughter came, he got a job and received his first paycheck. I went with him to the supermarket because for the first time he was buying groceries. At the supermarket, I picked up a box of cornflakes for myself, while he bought the other groceries he wanted to stock the fridge and pantry with.

The following morning, I picked up the box of cornflakes to have for breakfast, but got a rude awakening. To my surprise and shock, Derrick told me to put the cornflakes back because he bought them for his daughter, not me. After all the years I took care of him and sacrificed my happiness for his, this man actually told me not to touch the cornflakes. The hurt I felt was deep, but I never said a word. Instead, I carried on with my day and consoled myself, knowing that being with him would not last forever.

Anyway, that evening he and his friend Dave went to the station to meet Nadine (his daughter's mother) and his daughter. I didn't go with them, instead, I went to spend the night at my mom's. I left so they could reminisce and get reacquainted in privacy. Unbeknownst to me, my sister didn't like the fact that I left my apartment for them to be alone, so she told mom early the following morning. Mom came stomping up the stairs, busted through the bedroom door and woke me up to ask why I wasn't in my own bed, so I told her why.

When I informed her that I left Derrick and his long-lost family to have their privacy, mom was highly upset. She asked if I had lost my mind and wanted to know how I could leave my husband in the house with another woman. It didn't matter to me either way, because I had no intention of being with him anyway, so I couldn't care less. Mom wasn't having that, so she made me get up and go back home. My sister wanted to come with me, so we left and went back to my apartment to meet Nadine and his daughter together for the first time.

My sister didn't like Nadine when she met her, although I found nothing wrong with her a first. We all went to the mall even thou Derrick didn't want me to join them. While walking through the mall, Derrick stopped in front of a perfume store and asked Nadine if she wanted a bottle of perfume. I was unable to resist when I said, "What?" In all the year's I have taken care of you, bought you everything you need, you get your first paycheck and never thought of buying me anything, but you plan on buying your baby mother perfume?"

Derrick then asked me what I wanted, to which I replied, "I want absolutely nothing from you." He ended up buying Nadine a bottle of perfume and a pair of shoes. My sister then insisted he buy me a pair of shoes too, because what he did was disrespectful. I didn't want the shoes, although I really liked the sandals my sister picked out. While he was at the cash register, my sister insisted he buy it against my will. I refused to take the bag with the sandals he paid for, so my sister took it and carried it instead.

Once we got back to the apartment, the atmosphere was gloomy to say the least. It wasn't long before Derrick, Nadine, and their daughter had disappeared, while Dave, myself and my sister were in a deep conversating in the kitchen. It was about midnight when Dave decided he was hungry and took a pack of chicken out of the freezer to defrost and fry. He began sharing his disappointment in Derrick's behavior, when he suddenly realized Derrick, Nadine and their

daughter had been missing for quite some time. Dave asked where they were, to which I responded, "Your guess is just as good as mine."

I didn't really care, because as far as I was concerned, Derrick was hanging himself by giving me more reason to put an end to the marriage. Dave insisted I go check to see where Derrick was, and made it known that whether or not I was leaving him, he was showing no respect. The only place they could have been was in the bedroom, so I went to check. Sure enough, the bedroom door was locked when I tried to open it. I knocked, but there was no answer, so I returned to the kitchen and sat down.

Dave enquired what they were doing, but I nonchalantly informed him they were in the bedroom with the door locked. He became enraged, with his voice raised as he made it clear he didn't give a damn if the door was locked. Considering Dave was Derrick's friend, he sure wasn't partial. Dave, being upset that Derrick was being disrespectful because of Nadine, insisted I go back and kick the room door down if need be.

I continued to bang on the room door until Derrick finally opened it. He was rubbing his eyes as if he had just awakened from sleep. Apparently, the three of them were sleeping, because Nadine and the daughter were still under the sheets when I looked in. All hell broke loose when an argument erupted, because Derrick was upset that I was disturbing them. Nadine jumped up out of bed and informed me that she was going to leave first thing in the morning and take her daughter with her.

I walked back to the kitchen with Derrick and Nadine trailing behind me. Nadine tried to pretend she was sorry her presence was causing a quarrel between us, before she mentioned again that she was going to take the first Greyhound bus back to New York that morning. This was when Derrick began insulting me, which was something I had never experienced from him before then. He told Nadine, in front

of us all, that I was jealous of her because she had a child for him, and I didn't because I was incapable of getting pregnant.

I was embarrassed and speechless, as well as livid. And to top it off, Nadine was smiling, obviously enjoying every minute of it. My sister turned out to be right as she was convinced Nadine was trying to show off on me, but then Derrick certainly gave her a good reason too. For the sake of the child, I asked Nadine to let her stay because she wanted to spend time with her father, and I didn't want to come in between that.

In the end, she allowed her daughter to stay and promised she would be back the following weekend to pick her up. Two days after her mother left, his daughter had chicken pocks. Derrick insisted he couldn't leave his job to stay home with her - Nadine didn't want to come back and get her, so I had to end up staying out of work for a week to take care of her. I took care of that child as if she were my own, while Derrick went about his business as usual.

When I returned to work the following week, Derrick still insisted he couldn't take time off to stay with his daughter. I ended up having to take her to mom's on my way to work and pick her up in the evenings. On weekends Derrick and I took her out to enjoy herself, and she had a great time, so much so that she did not want to go back to New York. Every time I called Nadine to find out when she was coming for her child, she would say, "I'll be there next week." Well, her meaning of next week turned out to be a month later.

When things were back to normal, Derrick tried apologizing for what he said, but I told him that some words, once spoken, could not be taken back. He had already shown me his true colors, and an apology couldn't change that. I resented him even more, and what made it even worse, was the night he called my stepfather of all people. He called him at midnight no less, to tell him that he needed to talk to me because I had stopped having sex with him. I thought I

was going to die from embarrassment, but that was the night I decided I had reached my last straw.

We were sharing the same space, but that was about it. The only communication between us, was when necessary. Other than that, he went his way, and I went mine. Derrick met someone named Sharon and convinced her to move three doors away from where we lived. Apparently, they were already together during the time I was with Tony. Derrick spent most of his time at Sharon's house and told me they were just friends, but I really didn't care, so I never said anything about it.

I had no idea Sharon was pregnant by him, until aunt Gweny, who came to visit from Jamaica, informed me. Aunt Gweny, was one of mom's elder sisters, who had a gift of seeing. Anything she saw was always on point, and whatever she said was going to happen, would happen exactly how she said it would. Mom didn't want to believe it when aunt Gweny told us that Derrick had another woman, and that the woman was pregnant. When we questioned Derrick about it, as expected, he denied it at first, but eventually he admitted to it after Sharon had a miscarriage.

As usual, Derrick was at Sharon's house visiting with her and her five children, which was never a bother to me, because I was quite content by myself. But one particular night when he came home sometime after midnight after visiting Sharon, I happened to be on the phone speaking with my sister. He thought I was on the phone with another man and refused to believe it was my sister, although I told him to take the phone and see for himself. He began cursing me and saying some horrific things.

The words that came out of his mouth were extremely shocking - things I wouldn't even wish upon my worst enemy. I can't repeat the things he said, but his words cut me to the core, and it was at that point I decided I wasn't going to let one more day pass without putting an

end to the charade. That was the night I made up my mind that the marriage had to be severed immediately. I needed to get away from him as soon as possible, because after the things he said, there was no way I could feel safe sleeping under the same roof with him.

The following morning, I called my supervisor to say I would be arriving an hour or so late for work. When I left home that morning, I headed straight downtown to the probate court and filed for a divorce. Approximately two weeks after filing for divorce, I started looking for an apartment and found a townhouse. I didn't waste any time signing the lease and arranged for one of my friends to help me move, while Derrick was at work.

Derrick obviously felt it in his spirit that something was going on, because he returned home in the middle of the move, even though I never let on what I was doing. When I asked why he left work and came back home, he told me he felt that I was leaving him. All the begging and crying he did had no effect on me at that point, it was over. I had taken more than my fair share, and I was done. I didn't care what anyone thought, it was my life, and I refused to live another day in torment.

Mom wasn't happy about it, but I was, and that was all that mattered as far as I was concerned. Derrick and I stayed in contact with each other, as he would call and ask me if I would take him back. After months of asking, he finally realized I would never take him back, so he finally decided to move on with his life. He eventually moved in with Sharon, and they ended up having two children together.

Derrick continued calling to see how I was doing, but one specific evening he called to vent about Nadine. I couldn't believe he had the nerve to call me complaining about her, after he told her I was jealous of her. I tried to interrupt to let him know I wasn't interested in what he had to say, but in the end, I was glad I listened. I thought I was

going to fall of the couch with laugher when he told me Nadine called to tell him that the daughter he disrespected me for, wasn't really his.

He was busy telling me how much she hurt him, when I interrupted him to say, "What goes around, comes around! After you disrespected me by telling her I was jealous because I couldn't have any children of my own. You were showing off on me after everything I did for you, so it serves you right." He got upset and hung the phone up on me, but I kept laughing because that news truly made my day. That was another situation that proved to me that when you treat others wrong, the same comes right back to you.

That didn't stop Derrick from continuing to call, and to this day, he still does. Although he and Sharon ended up having two children together, their relationship never lasted. He ended up with someone else and has been with her for nearly fifteen years now, but he never remarried. He still calls now and again, and has never missed calling me on my birthday every year since we split up. I guess we will always stay in touch, but we were not cut out to be husband and wife, although, to this day, he still disagrees.

Chapter Ten:

Heartbreak and Sorrow

Cherish every moment you have with the ones you love because tomorrow is not promised to anyone. You never know when you will see them for the last time, so always treat them as such. In order to eliminate regrets, do what you can today, so you don't regret not doing it tomorrow. Always tell your loved ones how much you love them while they are still with you. Don't wait until someone has passed to tell them how you feel, because it is too late then. Give them their flowers now while they can enjoy them, because they can't enjoy the flowers which lay on top of their graves.

The same year Derrick and I parted ways, mom was diagnosed with colon cancer. This happened within months of my brother being arrested and sentenced to seven years in prison. Since the day of his sentence, mom was never the same again. Some parents sense things about their children, especially when they are in danger. Even though parents try to warn their children, nine times out of ten, that child doesn't listen. My brother happened to be one of them because he refused to take mom's advice when she told him not to leave the house on that ill-fated evening.

He was only seventeen years old at the time, and the evening he got in trouble, mom sensed it. Although she begged him not to leave, he kept insisting he was not a child and should be able to go out with his friends. On that particular evening, mom didn't want to take no for an answer, so she continued to demand that he stay home. When my brother proceeded to go out the door, mom begged him and held on to him, but he pulled away and left anyway with his friend.

A few hours later, my mom and stepfather got the dreaded call that my brother was arrested. The following morning, mom and my stepfather had to go bail him out of jail. My brother thought he had problems before, but then he added a court case to the list. Everyone started praying for him as mom gathered all her church brothers and sisters to pray for favor in his case. My family kept their faith alive believing it was going turn out in his favor.

On the day of the trial, I was unable to attend with the rest of family and friends, because it was my second day at a new job. I had given one of mom's friends the phone number to my office, so she could call and update me throughout the day as to what was going on. When she first called me, she told me things were looking good at the beginning and that she would call me with verdict in a few more hours. The verdict came in, and I got the call just a few minutes before the workday ended.

My anxiety was finally over as I waited for her to tell me the good news. It never occurred to me that it could go the other way, so I definitely wasn't prepared to hear what she was about to tell me. "They gave him seven years," she said. "What! are you sure that's the verdict?" then she began to cry. I was dumbfounded and couldn't speak, when she asked me if I was still on the line. It took a while for me to answer, and then I asked again, "Are you sure that's the verdict?" She tried to convince me that it was, but I refused to believe.

After I hung up the phone, I went to the supervisor's office and told her I had to leave right away because I had a family emergency. She asked if I would be back the following morning, and as I thought about it for a moment, I realized there was no way I would be able to handle coming back to work the following morning unless it was a prank. I told my supervisor I was sorry, but I didn't think I would be able to return the following day.

On the way to mom's, I convinced myself my brother would be there, because they were trying to trick me. I knew for sure when I arrived, they would surprise me, and Andrew would jump out from hiding. Upon my arrival, the first question I asked was where Andrew was, but no one answered. I then asked where he was hiding, but everyone was sitting around the dining room table, looking like doom and gloom. I still did not want to believe, so I kept telling myself it was all an elaborate act, and he was going to jump out from behind a door.

I continued to wait for Andrew to show himself and shout, "Surprise," but that didn't happen. The house was quiet until my sister said, "Pat, it's not a joke, Andrew really was found guilty." It was only about six thirty in the evening when mom said she was going to bed, but it wasn't until then that it began to sink in. He was really locked up, but I decided not to believe it was going to be for seven years - that was too long for me to comprehend or accept.

We were very close even though there was a twelve-year age difference between us. He and his friends hung out at my place on weekends, and sometimes I took him with me to parties, so I couldn't handle him not being around for that length of time. I followed mom upstairs and tried to say everything I could think of to comfort her, but nothing worked. She wanted to be alone, and I figured it was the perfect opportunity to ask if I could borrow her car.

She asked where I was going, so I told her the truth. "I needed something strong to drink," I replied. I told her I was going to the liquor store on Washington Street, and then my sister and I were going over to my place. When mom's only response was to tell me to be careful, I knew she wasn't in her right mind. There was absolutely no way mom would approve of me drinking, and definitely wouldn't approve of me using her car to go to the liquor store.

Mom didn't care how old I was, she just didn't want her children to drink. So, when she said, "Just be careful," I felt my heart break, because I knew hers was broken. When my sister and I left the house and went to my place, I called mom, but she wouldn't answer the phone, so I began to cry. I let my sister have a drink, and all night I drank the alcohol I bought and cried, then drank some more and cried some more, until morning.

There was a black cloud in the air that seemed to follow all of whom were mourning my brother's absence. When I returned mom's car the following morning, to my dismay, I noticed all the beautifully thriving plants in the house looked as though they were dying, and by the end of that first week, they were all dead. Not even the plants could bear the heartbreak and depression that was lurking around in the house. I felt empty inside, as though a part of me was missing, and I couldn't stop thinking of how my brother must have been feeling.

"Would he be safe? How will those guards treat him? How was he coping? What kind of thoughts were running through his mind," were some of the questions I found myself asking over and over. I couldn't even imagine what was going through mom's mind, because she wasn't speaking much. Her joy and laughter had gone, and she was no longer the cheerful woman I was used to seeing. I could actually feel her brokenness inside, and there wasn't a thing I could do to lift her spirits.

The first-time mom and I went to visit Andrew, I remember we were so excited to see him, until we actually got inside the prison, and saw for the first time what a correctional facility actually looked like. Our laughter turned to sadness, and our smiles turned into frowns. We knew it wasn't going to be a pleasant place, but just never imagined it to be that unpleasant. Andrew was safe and in good spirits, but mom's spirit was broken again when visiting time was over.

It was such a painful experience for us both when we had to leave him, although I knew it was much worse for Andrew when we had to say goodbye. Every visit mom and I made was the same, we were happy to see him and devastated when visiting time came to an end. If only Andrew had listened that night, it could have all been prevented. He and his friend were now dealing with the repercussions of their actions. If they had thought about the consequences of their actions before they acted, they wouldn't have ended up in such a dilemma.

Six months after our first visit to see Andrew, mom was diagnosed with colon cancer. I was in denial at first, not taking it seriously because mom looked so healthy and strong. There was absolutely no doubt in my mind that she would not overcome her temporary illness, and so I believed our lives would be back to normal in no time. Mom's outward joy slowly returned, but I knew she was still secretly missing and pining terribly for her only son.

I was pinning too, and there wasn't anything anyone could do to lift my spirits either. I never returned to the job I left when the verdict came in, and I ended up in a great depression and stayed there for ten months. A girlfriend of mine decided enough was enough and didn't stop until she convinced me it was time to get on with my life. It was hard for me to get out of the mind set I had fallen into, and I just didn't care about living a joy-filled life, if my mother and brother wasn't.

My friend brought me various job postings which were of no interest to me, but then she found one she thought I would be perfect for – and she was right. She came by one morning and insisted I come with her to her sister's house and work on my resume. I went with her only because she wouldn't stop bugging me and refused to take no for an answer. The job I applied for was Planner, at Action for Boston Development, Inc. (ABCD, Inc.), and a few months after, out of the blue, I got the call that I was hired.

I had a great boss, and loved the job and people I worked with, which made life more bearable, during those times of deep sadness. Mom's spirits were lifted a bit when I told her how great my job was. My spirit was also lifted a few months later, when mom told me she was going to have an operation to remove the cancer. The anticipation of a successful operation brought joy to the family, but when we found out the doctors were unable to remove all the cancer, sadness took over again.

The cancer started spreading quickly after she had the operation, so prayers went up from all around the world, but mom continued to get worst. The strange thing about it was, she never lost any weight and continued to look radiant and healthy, so it was unimaginable that she wouldn't get better. During this time, mom still ran her day care and assisted my stepfather in running the church they had in Roxbury.

In the summer of 1997, my mom and stepfather ran a revival at the church and invited a guest speaker who was a Pastor from Trinidad. During the revival, he was prophesying to many of the people who attended, telling them things that they were going through or things that would happen. I at least knew the things he said to my friend were true, and was afraid when he called me out, because I thought he was going to reveal my dirt, but thankfully he didn't. He did tell my sister she was going to lose someone very close to her, so of course, mom asked if it was her, but he didn't respond.

Unbeknownst to me, he asked mom for my phone number and called me one morning in December, just as I was headed out the door to go to work. I was very curious and anxious to hear what it was he had to say, but never in my wildest dreams did I expected to hear what I did. "God wants you to know that He is not going to heal your mother. He is going to take her instead, and she will go peacefully in her sleep, next summer." I felt the room starting to spin, which led me to find the nearest seat to sit on, because my legs started feeling as though they were turning to jelly.

My heart was beating rapidly to the point I thought for sure it was going to jump out of my chest. "Are you okay?" He asked. It took a while for me to answer, but I didn't want to speak to him or anyone else for that matter, so I told him I had to go. As I sat there trying to properly digest what he said, I entered into my own little world, where time seemed to stand still. Apparently, it didn't because when I looked at my watch, two hours had pass by.

My mind, body and soul were in distress, so I called out from work and sat in solitude for the rest of that day, just thinking. I couldn't lose mom - there was no way I could live without her, so I decided I was going to change God's mind. I couldn't keep that news to myself, it was too heavy to carry, so stupid me went and told mom what he said. I knew it would break her heart, but I wanted her to know, so she could fight harder.

I told her we were going to have faith without any doubt and come together in agreement that she would get her miracle. Mom's physical appareance didn't look like that of a person who was sick. She was still glowing as she always did, and sure didn't look like the average person with stage four cancer. She went about business as usual and continued running her daycare until the spring of 1998. That's when she started to deteriorate on the inside, while looking very healthy and glowing on the outside.

During one of my daily evening visits to mom after work, she was anxious to tell me about a dream she had. She was a passenger on a bus among many other people, but when the bus stopped, everyone got off except for her. She then said the bus went underground with her still on it, and then it stopped. The meaning of that vision was very obvious to me, but I didn't want to reveal what it meant. Maybe she did know what it meant, but I knew the people on the bus with her were the people traveling with her to her burial. The bus driving under the earth was her being buried in her coffin.

I sat there trying to take it all in, thinking of how final death was. It's hard enough having to say goodbye to loved ones, like it was for me when I was leaving England. Even though I had no idea when I was going to see them again, at least I knew they were alive. Even though it hurts having to part, you know you can always see them again, even if it takes years. When you have to permanently part with a loved one because of death, it's extremely difficult to wrap your mind around it.

The finality of it - not ever being able to see or speak with them again, due to the fact they no longer physically exist. A loved one who only continues to exist through memories or pictures, is so very hard to accept. Mom was facing the reality of what was happening, but I was still partially in denial. She was getting her house in order and was concerned about my existence after she was gone. Mom was so concerned about my stability, so she suggested I buy a house.

In order to try and make her happy, I bought my first house, three months after she suggested it. I bought a two-family house in Hyde Park, Massachusetts, and was very excited the day I picked her up, so she could see it. The house had equity in it, which enabled me to refinance just six weeks later, and got cash out of it. I bought mom everything she wanted, and used the rest of the money to remodel the house, because mom wanted to come and stay with me.

When the remodeling was in the works, mom was back and forth from her home to the hospital, so I wanted to do something in the meantime, that would cheer her up. I knew she was missing Sydney, who was the dog I bought for her as a birthday present two years prior. After she had taken ill, he ran away when she let him outside to pee. Mom claimed I was the reason Sydney ran away. I always came to take him for the weekends against her wishes, so mom was convinced Sydney ran off to find me, as it wasn't his first time doing so.

I knew she was in no condition to take care of another dog, but I decided to get one and bring the dog with me in the evenings after work when I went to visit her. She wanted to be a grandmother, and because I was unable to give her the grandchild she so desperately wanted, I decided a dog would be the next best thing. That was the best idea I could come up with at the time, so I went to an animal shelter to look for a dog.

I called them ahead of time to find out if they had any small fluffy dogs, and was happy when they told me they did. When I arrived and walked through the kennels, I didn't see any that was as small as I had in mind, so I was about to leave disappointment. That was until I saw a dog jump sideways on the wall with all four paws as I was passing by his cage. He was obviously trying to impress me, and he most certainly succeeded. I thought, "Wow, he must have been trained to do stunts."

He ended up being the dog that I picked, which was a nine-month-old Rat Terrier. He was found wondering the streets with the name Max on his name tag. The attendant told me I would have to walk him around the grounds first, so she could see how we got along. He was so obedient when we walked around which made me think he was some sort of show dog or very well-trained. I told the attendant I definitely wanted Max, and was ready to start the adoption procedures. Someone interrupted our conversation, and when the attendant turned to talk to the person, I felt something warm running down my leg.

When I looked down to see what it was, in total shock, I realized Max was peeing on my leg. My first reaction was to slap him, but I couldn't because the attendant was right next to me. Instead, I gave him a good telling off. The attenant quickly turned around to see what was going on and asked what Max did. When I informed her that he peed on my leg, she laughed and told me he was marking his territory. She went on to explain that he did it because he liked me. and was

telling me that I belonged to him. My response was, "Oh really, couldn't he have found another way to tell me he likes me, other than peeing on me on my leg?" and when I said, "That's men for you," we both started laughing.

I forgave him once I knew his reason for doing what he did and was therefore eager to get the adoption finalized. The attendant then informed me that I had to meet the director before the adoption could be approved. It turned out the director didn't want me to get Max and tried to come up with all sorts of excuses for why Max wasn't the right dog for me. One reason was, Max was a dog that someone would want to steal, so unless I had a house with a fenced yard, I couldn't get him.

I reassured him my yard was fenced and large enough for Max to run around in, but he was still hesitant. I was beginning to get frustrated, but then the attendant came to my rescue. She told the director how Max peed on me, and I wasn't even upset. little did she know I was very upset that I had to leave there smelling like dog pee. After spending approximately twenty minutes convincing this man Max would be safe, he finally agreed to let me adopt him. Excited to take Max home after signing all the necessary paperwork, I was then told I couldn't take him that same day. I had to wait another two days so Max could get all his shots done before he was allowed to leave.

Once I left the shelter, I went on a spending spree to buy everything Max was going to need. I laid out his new bed and toys for him, while anxiously awaiting the time to come so I could go pick him up. I was overwhelmed with joy when the day came for me to go get him, as I counted down the hours at work until the workday ended. Getting Max brought some sunshine into my life, in the midst of the storm my family was experiencing. I didn't get to take him to meet mom right away, because she was in the hospital, so I took him home instead, so he could see his new place of residence. He was

very happy to be out of his cage, and I was happy to have a new companion.

Once we got to the house, I felt sorry for him after thinking how boring it was going to be for him to be home alone when I was at work. That's when I decided Max needed a companion, which meant I needed to get another dog to keep his company. I didn't want to wait, so I took him with me to the pet store the following evening after work so he could get a playmate. All the puppies where adorable, and I had no idea which one to pick as the attendant so diligently observed.

The attendant came to my assistance, suggesting I pick a few puppies I liked, then she would put them in the play pen with Max. The plan was that once they were all in the play pen together with Max, he would choose which one he liked. It worked out the other way around, because one of the puppies chose Max. He was an eight week old Maltese with a price tag of eight hundred dollars. It wasn't so much that Max like him, he was the one who liked Max.

As soon as the Maltese saw Max's leech, he held on to it with his teeth and wouldn't let go. It was a funny sight to see, because even though Max ran around trying to shake him off, he held on while being swung up and down and sideways of the floor. I knew then he was the one we were taking home, and couldn't believe I was actually paid eight hundred dollars back then for Max to have a brother.

Mom was back home that day, and I couldn't wait to get there so they could meet their new grandma. What really touched my heart and got me all chocked up, was when we arrived, and I took them upstairs to meet mom, the first thing mom said was, "You brought my grandkids to meet me." I was amazed and wondered how she could have possibly known my thoughts. It brought tears to my eyes and still does to this day, every time I think about it.

Her intuition was still razor sharp and I realized there was still nothing I could hide from her. When I introduced them and told her

I wanted her to name the Maltese, she named him Fluffy, so I told her I would call him Fluff for short. Mom wanted me to return Max, because she thought he was too big and would hurt Fluff being he was so tiny at the time. She was also upset with Max, because he drank all the water from her glass that was sitting on the coffee table.

Mom found the way Max looked at her very disturbing, as did many other people, not knowing it was because of his intelligence. In mom's mind, Max was not a normal dog, so she insisted I take him back to the animal shelter, but I had no intention of doing that. Max and fluff settled in wonderfully together, so I had one less thing to worry about, which was Max being lonely when I wasn't home. Every evening after work, I picked them up and brought them with me to mom's. She enjoyed their visits, although she still wasn't too keen on Max at first, but he eventually grew on her.

About three weeks later, on August 11th, 1998, to be exact, I woke up with a bad feeling in my stomach which left me feeling nervous all day. Mom was in the hospital again, and as usual, I went home first after work so I could let Max and Fluff out before I went to visit her at the hospital. Unbeknownst to me, the carpenters that were taking their sweet time to finish the remodeling, had already let them out and left them to run around the driveway. In a rush, I sped into the driveway once I turned the corner of my street, and as soon as I did, I felt something tumbling underneath my car.

The carpenters were outside, and were pointing towards the bottom of my car while shouting at me. My windows were up, so I couldn't understand what they were staying. I quickly turned the car off and jumped out to see what I ran over. I heard one carpenter say, "He must be dead." "Who must be dead?" I inquired, and felt my stomach jump when he replied, "Max." I was so afraid to look under the car when one of them told me there is no way he could have survived, because he saw when the two left tires ran over Max's neck.

I nearly died from fright when I heard that, but Immediately after he said that, we saw Max exiting from under the car, and sped into the house. I ran after him and found him in the bathroom throwing up. Max was in shock, and so was I. I expected to see him injured and bleeding, but he wasn't as far as I could see. I quickly picked him up and ran outside to put him in the car. I then grabbed Fluff so I could rush Max to the nearest animal hospital, convinced that he was suffering from internal injuries.

Although he looked fine, I was afraid he wasn't going to make it. I thought it impossible for him not to have injuries after being run over that way. I sped the entire way there and must have looked like a crazy woman when I rushed to the reception area with Max under one arm and Fluff under the other. The receptionist looked astonished when I approached her in a state of panick. She tried to calm me down, but I quickly explained it was an emergency and insisted Max had to be seen right away.

I guess I was speaking too loud while insisting Max be seen immediately, because the veterinarian came out to see what was going on. It was a female doctor who did not delay in escorting us to the examining room where she could conduct a physical examination of Max. After what I considered to be a very short examination, she told me nothing was wrong with Max. I insisted she check him again, sharing my concerns that he was suffering from internal injuries. I insisted she do an x-ray, even though she informed me it would cost four hundred dollars, but I didn't care.

She refused and actually got upset before she asked if I was questioning her knowledge. She then continued by informing me she was skilled in her profession. She was offended, but I only wanted to know how she could be so sure Max had no injuries, if she had no x-ray to see what was going on inside his body. In order to appease me, she examined him again. During the reexamination of the areas she checked, she took the time to explain the physical evidence and

what Max's reaction would be if there were injuries. She went on to explain that she had many years of experience and would know if he was injured.

The visit ended with the doctor telling me I should count my blessing and be happy that Max had no injuries even though I ran him over. While driving home, the incident kept replaying over and over again in my mind. I questioned how Max could have come out of such an ordeal unscathed. Suddenly it hit me, "If Max was spared, then mom must be leaving us soon." I don't know why, but for some reason, my explanation of why Max didn't die, was that God wanted to spare me from a double heartbreak. After I returned home with Max and Fluff, I left to go visit mom at the hospital.

The nervousness I felt in my stomach became stronger the closer I got to the hospital. When I arrived, mom told me she wanted to have a serious talk with me. I asked her what she wanted to tell me, not expecting to hear the words that came out of her mouth. "Pat, I can't hold on any longer, and I have asked God to take me home, so I need you to release me now and let me go." How does one respond to something like that? I'm usually never lost for words, but I sure was in that moment.

Although I knew she was suffering, I wanted her to stay and hold on, not realizing how selfish that was of me. I struggled with what she said, wanting so badly to tell her to hold on and keep the faith. I paused for a few moments, then I remembered what the prophet told me the year before when he said, "God was going to take your mother next summer, and she would die peacefully in her sleep." Well, it was next summer, so with an extremely heavy heart, I said, "Okay, mom, if that is what you want, I will let go."

I don't think I had ever fought so hard to hold back tears. Tears that were bubbling in the back of my eyes which were caused by the sharp, unbearable pain that struck my heart. Immediately I began to

pray, hoping it would help to hold back my tears as I asked God to let His will be done. But instead, my tears began flowing like a waterfall. My inner being was consumed with an overpowering and insufferable sadness which caused my entire body to feel weak. Knowing that mom's time here on earth was about to be over, made me feel as though my heart was broken beyond repair. It was so hard accepting the fact that mom's life's journey was about to come to an end, and there wasn't anything I could do to prevent it.

I sat next to mom's bed, anxiously steering into space, trying to accept our fate, while also trying to anticipate what laid ahead. I tried to imagine what my life would be like without mom and how I could possibly cope in a world without her in it. The more my mind wondered, the more I felt as though I had entered a dark tunnel consumed with bitter sorrow, and heaviness of heart. I couldn't stop thinking of what it was going to be like once her last breath was taken, when her presence would be no more.

Mom laid there observing me as I was temporary lost in my thoughts. Once I held my head up and looked into her eyes, it was as though I could see what she was feeling. It was such a sad moment, but I knew I had to be strong for her because I didn't want her to worry about me. I tried to compose myself, and once I did, mom proceeded to tell me things she wanted me to know and do. She talked about lessons she had learned in life and reiterated on the things I should and should not do.

As I sat there listening, I kept thinking how I wished it were all just a terrible dream. She was so concerned about how I was going to manage without her, being the mommy's girl that I was. Knowing she had more than enough to think about, made me want to somehow convince her I would be okay. Mom spoke about God's goodness every day, so I reminded her of what she taught me, when I responded, "God will take good care of me. I'm going to be just fine, so you have nothing to worry about."

Mom then voiced her concern about Andrew, worried that he would not give his life to the Lord so she could see him again. Attempting to give her some peace, I made a promise that I would make sure he repented and turned his life over to the Lord, so she could spend eternity with him in heaven. But after I thought about what I had promised, I realized I had a very difficult task ahead to accomplish. Andrew was still locked up at the time and was angry with God, so I began worrying about how I was going to fullfil my promise to mom.

Once mom became too weak to visit Andrew, it seemed as though the heartbreak she felt penetrated her soul. Her joy disappeared, knowing she was unable to see her only son again. I tried to imagine her mental anguish and pain, which had to be slowing killing her. Mom longed to see Andrew just one more time, so she could say her final goodbye. Because she wasn't able to get her desire, she gave me a message to give him instead. "Tell Andrew how much I love him. Tell him to keep his head up and be a good man and make me proud."

I had so many things I wanted to say to mom, and yet I was lost for words. Nothing came to mind because my heart was too overwhelmed with sorrow. We sat in silence for a while, just absorbing every second we had with each other. Then she told me something I thought very strange considering the many other lessons she could have left me with. She told me to be careful whom I ate from. She knew that people have hurt others through food, and I knew that too, but I didn't take it very seriously until she mentioned it that night.

It was about two o'clock in the morning, when mom looked at the time and informed me how late it was. I had a long drive home, and she was concerned about that, so she wanted me to leave before it got any later. I told her God had my back and would take care of me, so she had nothing to worry about. Even so, she reminded me I

had to go to work that morning and needed to get some sleep. I kissed her on her forehead and told her I would be back later that evening. As soon as I got into my car and closed the door, the tears came flowing like a river.

When I arrived home and took my shower, I sat on my bed thinking about the conversation mom, and I had. When I thought about mom saying she asked God take her, I began to cry profusely. I cried uncontrollably to the point I thought it was going to be impossible for me to stop. There was a void inside me, and up until that night, I never knew it was possible to feel that empty inside. It hurt so bad recollecting the sorrow I saw in mom's eyes, and even more so, knowing I was unable to do anything to help her.

I cried myself to sleep and woke up with butterflies in my stomach. I had a very bad feeling come over me, which left me thinking she had passed. I immediately called the hospital to make sure she was still with us, and was relieved when the nurse told me mom was fine. I went to work and left early because I was unable to shake the nervous feeling I had in my stomach. I was anxious to get back to the hospital, but had to go home and let Max and Fluff out first. Once I did that, I rushed to the hospital to visit with mom.

I was surprised to see I wasn't the only visitor. My sister, whom I hadn't spoken to in a few months, was sitting beside mom's bed. I greeted mom and my sister, but before I could pull up a chair to sit at the opposite side of her bed, mom told me to go back home and get some clothes. She told both my sister and I that she wanted us to spend the night with her, and had already arranged it with one of the nurses. Hearing mom's request made my stomach turn even more, because deep down, I knew it meant mom was living her final hours, and I believe she knew it.

I had no intention of giving my sister a ride, but mom made sure that I took my sister with me. I had no idea at the time it was mom's

way of getting my sister and I to reconcile. I later found out that mom had planned to have us meet up at the hospital at the same time, because she did not want to leave this world before we had sorted out our differences. We stayed for an hour before we left, but my sister and I didn't say much to each other until we left the hospital.

As soon as we walked out the hospital room, I asked my sister if she realized mom was about to leave us. I explained why, after she asked what brought me to that conclusion. In silence, we both walked through the hospital corridors, the reception area and out the front door. It took a few minutes to find where I had parked my car, as my mind was overwhelmed with what I knew was about to happen. Once seated in the car, again, I was unable to control my tears which made it difficult to see the road ahead while driving.

I needed a drink, and so I stopped to buy something strong enough with the hopes of numbing my pain. We stopped at mom's first so my sister could get her clothes, then headed to my house. We had a few drinks, restored our friendship, cried and filled each other in on what had been going on in our lives over the four months we had not spoken to each other. We were so caught up in conversation that we had not noticed the time. It was passed midnight, and we should have returned to the hospital hours before.

We expected mom to be sleeping, but she was still up waiting for us to return. Mom held her head up, and said, "You reached," then she smiled, and laid her head back on the pillow. Knowing mom had to be wondering what took us so long, I explained why we returned so late before she asked. I told her that my sister and I went back to my house, and while we were busy catching up on the four months we had not spoken, we weren't paying attention to the time. Shortly after, mom's nurse entered the room and politely asked my sister to follower her.

I was curious as to what was going on, and so I asked. That's when I was told my sister would be sleeping in another room, but I would be sleeping in mom's room. The bed was already made up for me and placed right beside mom's bed. After changing my clothes, I spoke to mom for a while, but I was extremely tired and coupled with the alcohol I was drinking, I fought to keep my eyes open. I wanted to sleep, especially because I didn't sleep the night before, but at the same time, I did not want to close my eyes.

The fact that mom requested I spend the night with her, along with the nervousness I felt in my stomach all day, left me convinced that mom's time left on earth was rapidly dwindling down. I knew deep in my heart that night was going to be the last I spent with her, and it was just too painful to try and comprehend. I laid in bed with my mind running wild, but when I finally closed my eyes to sleep, I was knocked out and slept like a baby.

At some point in the early morning hours, I woke up for a few moments and heard mom telling the nurse her tea was too cold. I remember smiling when I thought, "Even in the hospital bed, mom is complaining as usual that her tea is too cold." I fell back to sleep until I felt someone shaking me. It was mom waking me up to ask if I wasn't planning on getting up. I laid there for a few moments and observed mom steering at me in deep thought. I wondered what she must have been thinking, but what ever it was I knew it consisted of a mom's deep love for me.

Mom told me again to get up and call my job because it was late. When I called Chris, being the compassionate woman she was, she told me not to worry about coming into work, instead, she suggested I enjoy every moment with my mother. I stayed with mom until noon, when she suggested I go home and let Max and Fluff out. She told me take care of what I needed to do, and then I could come back later. I did not want to leave her side, afraid I might not see her again, and so I tried to delay my departure. My sister, on the other hand,

was pregnant at the time and kept urging me to get up so I could take her home.

I wanted her to take a taxi, so I could stay, but mom insisted I take her so she could get something to eat and take a shower as she wanted. Needless to say, I was very upset because I felt she was hindering me from spending more time with mom. I couldn't shake the gut feeling I had that once I walked out that hospital room, I would not see mom again alive. That feeling consumed me, and so I tried to be stubborn and not move from where I was sitting. Mom and my sister kept urging to get up, so reluctantly I did.

I kissed mom on her forehead and told her I would be back by half past three. Upon exiting the hospital room, I turned to take another glance at mom before I walked through the door. I felt as though that black cloud had surrounded me as I cried again all the way home. I found it impossible to shake the heaviness in my heart that was weighing down. My sister didn't show her emotions as I did, mainly because I think she believed mom still had time. After I dropped my sister off, I rushed home so I could take my shower, take care of Max and Fluff and head back to the hospital.

When I arrived home, the carpenters were outside waiting for me to let them in. I was too broken to hold a conversation with them, so I just let them in, let Max and Fluff out in the yard, and went straight to my bedroom and took a bath. When I got ready to head back to the hospital, I found myself sitting on my bed, just steering into space, with Max and Fluff by my side. I was in such a daze that one of the carpenters who passed by my room door, asked what was wrong with me, but I was still too broken, to answer.

I looked at the time and realized three o'clock had just past and Debbie had not called yet to tell me she was ready. I proceeded to call my sister to see if she was ready, but she beat me to it and called me first. Assuming she was ready, I told her I was about to leave out

and come get her. When she didn't respond, I assumed she wasn't ready and so I asked. I wasn't expecting she called to give me devastating news. "Pat, mom's gone," "Gone where?" I asked. "Pat, mom died at three o'clock in her sleep."

Those words felt like someone had pushed a knife through my heart. Once it actually sunk in that mom was now gone, I started crying uncontrollably. The prophet's words came back to my remembrance, and so I thought, "Wow, God really did take mom peacefully in her sleep. He was also right when he told me God would take her in the summer, because she died on August 14th. Knowing that 2 Corinthians 5:8 says, "…. to be absent from the body is to be present with the Lord," at that time, was of no comfort to me.

All that was running through my mind was the fact that mom had passed, and I didn't make it back on time to see her before she left. All hell broke loose when the head carpenter heard me crying and came rushing in my bedroom to find out what was wrong. When I told him mom had died, he made the mistake to say, "Why are you carrying on like that when you knew she was sick and was going to die." I don't know what possessed him to tell me that, but I can't even repeat some of the words that came out of my mouth.

I had a few choice words for him before I told him to get the hell out of my house, and to take his crack-head workers him. I made it clear to him that he wasn't to come back, even though he kept telling me the job was not completed. When I thought about the fact that mom was unable to come and stay with me because they took so long to finish the work, I became even more enraged. I started rushing them out the door because they were taking too long to leave. The carpenter thought I was too distraught to notice he was stealing all the tools I paid for, so when I ran after him and told him to put all my tools down, he was quite startled.

Thinking about it now, that moment was quite funny as I recollect the expressions on their faces whilst chasing them out the back door - not to mention how crazy I must have looked. After they were gone, I mentally shut down. I didn't want to see or speak to anyone - I just wanted to be alone with Max and Fluff. It seemed as though my world had come to an abrupt end, because I felt as though my life no longer had purpose. This was the first time I experienced what it felt like to believe life wasn't worth living.

At the time, I just couldn't see that it was possible to go on with my life, if mom wasn't in it. She was my foundation, my teacher, my defense. She taught me wrong from right, she taught me everything I needed to know about God and his love for mankind. A love so strong that He sent His only begotten son, Jesus Christ, that whosoever believeth in Him should not perish but have eternal life. She taught me the importance of having a good character, good moral values, and showed me by example of what a good mother should be. She was my friend, my comforter, my motivator, my protector, she was my mom.

We talked every day, a few times a day in fact, and even then, I still went straight to her house after work. My dinner was always ready when I got there, and she would even call me at work to find out what I wanted for dinner. If I ran out of my carnation evaporated milk to make my tea, she would drive and bring me a couple of cans. Anything I needed, no matter what time of the night it was, mom would get in her car and bring it to me. "How I'm I going to make it without her," I asked myself, and so I became knob inside the more that question played in my mind.

She loved me unconditionally no matter how many times I failed or disappointed her. I used to complain about how strict she was, I complained about her curfews, I also complained how she would tell me I couldn't wear certain clothes I bought with my own money. I was upset when she told me I had to go back to college if I was going

to live in her house, and I complained that she wanted to run my life, not knowing everything she did, (with two exceptions, and that was convincing me to marry Reggie and Derrick) was for my own good.

My heart melted even more when I remembered her asking me a few weeks before she died, if she was a good mother. I looked at her in astonishment, and said, "Mom, you've been a great mother, and God don't make them better than you." I realized I no longer had the fear of dying, because if mom passed over to the other side, then I could too, knowing she would be there waiting for me some day. I sat in my room wondering how mom felt when she woke up and realized she was no longer in the land of the living.

I wondered what was going through her mind, was she afraid? Was my grandmother waiting on the other side?, along with the rest of our loved ones that made it into heaven, who had gone on before her. I was torturing myself is what I was doing, and I drove myself crazy with all these thoughts and questions that wouldn't stop circulating my mind. I couldn't handle it, so I finally opened the bottle of Jamaican white rum I kept as a souvenir, and poured myself a glass, mixed it with cranberry juice, hoping it would help to drown my sorrows.

Although I drank glass after glass, it had no effect on me, in fact, it was as though I was drinking water. I didn't go to sleep that night - I couldn't, my mind was overworked, and I was feeling too much heart ache to sleep. I refused to answer my phone which wouldn't stop ringing. Instead, I just sat on my bed with Max and Fluff by my side who were steering at me until they finally fell asleep.

Aunty and daddy came two days after mom died, and although their presence was comforting, I still felt broken beyond repair. Going over to mom's house and her not being there was devastating enough, but when I had to pick out a dress for her to be buried in, that made matters worse. During the days leading up to the funeral, it all

felt like a bad dream which I was hoping to wake up from. That was until the morning of the actual funeral, when I had come to terms with the fact that it wasn't just a bad dream after all.

Mom had a great send-off, with hundreds of people in attendance. The church was packed to its capacity, which left many who had to stand throughout the service. Family and friends came from all over the world, some that I had never met before, and so many people that I had not seen since childhood. I knew mom had touched many lives, but it wasn't until that day, I realized mom had touched much more lives than I could have ever imagined. I knew mom was deeply loved by many, but it blew my mind that day when I realized how many people so dearly loved and was going to miss her.

Going back to work didn't even enter my mind after the funeral. I basically didn't care about my job or how I was going to pay my bills. I didn't even call my boss to say I wasn't coming to work - it just didn't matter to me when I was in that state of mind. Only a couple family members called to ask me how I was coping. Each only called once, and when they did, they broke down and expected me to pick their spirits up. I ended up going into solitude, during which time I kept remembering things mom told me.

I remembered mom telling me that after she was gone, time would heal my broken heart, so I tried to use those words as my comfort. About a week after mom was buried, one of the directors from the job called me to find out how I was doing, and when I was returning to work. I was still the Planner at the time, and the quarterly reports that I was in charge of producing, were due. The deadline was close, so they needed me to come in and get it done. The problem was, I still had no intention of going back to work, and I didn't care whether or not the reports were submitted to the state on time.

When Mike asked me when I thought I would return to work, I so rudely responded by saying, "How dare you call me about coming

back to work when I'm mourning my mother?" I can't even imagine what he was thinking when I said that to him. I then informed him I had no intention of returning to work, so they would have to do the report themselves. Mike responded by asking how I was planning to pay my mortgage and bills, to which I replied, I didn't know and neither did I care.

Mike must have been saying to himself, "Hilary as gone raving mad." He probably told my supervisor, Chris, that too. It was probably the reason she never called me during my absenteeism. Mike, asked once again, how long I was planning on staying out from work. "I told you already that I am not coming back," I responded. "Okay, Hilary, I will call you later in the week to see how you are doing." Before he hung up the phone though, he asked me what I had been doing. I didn't hide what I was doing, I told him the truth. "I'm drinking white rum."

I guess Mike knew I was experiencing temporary insanity, so he decided to end the conversation by telling me to careful and to take care of myself. Sure enough, a few days later, he called again and asked, "When are you coming back to work?" "Didn't I tell you already, I am not coming back." He paused before he said, "Hilary, I know you are really hurting, but you still have your life to live and coming back to work will help." That's when I told him, I wanted to die and join my mother, and if that didn't happen, then I was going back to England.

He realized he was getting nowhere with me, so he told me again that he would call me the following week, and made sure to tell me not to do anything stupid. Each day that past seemed like weeks as I sat in my room going through a severe depression. The only time I saw the sun or got fresh air, was when I opened the back door to let Max and Fluff out. My days consisted of drinking and listening to music, as I continued wallowing in my sorrows, while trying to figure out how I was going to manage in a world without mom.

Mike called again, but before he could ask when I was returning to work, I asked him kindly, not to bother me anymore, and told him I was resigning. Mike always told me that I wore my heart on my sleeves and that I always went out of my way to help others - so I guess he decided to use that knowledge to his advantage. He then decided to use a different tactic, right when I thought I had gotten him to leave me alone in my misery.

Mike then said, "Hilary can you come in for just one day and help us with the report?" I first responded by saying, "No." "Please, Hilary, help us one last time, and I won't bother you again. Just come for one day and help us out, and you can do what you want after that." One day seemed doable, so I agreed and said, "Okay, just for one day." He wanted me to come in the following morning, but I couldn't bring myself to do it. I agreed to go back to work the following Monday morning, which would still give me enough time to get the report done.

In total, I stayed out of work for one month, and when I walked into the office that Monday morning, everyone welcomed me back with loving arms. Staff from various departments rallied around me, with the intention of trying to help heal my broken heart. Chris Sieber, who was my supervisor at the time, allowed me to leave work every single time I needed to go and be with mom. She has no idea how much that meant to me. Even now, I will forever be deeply grateful to her for her compassion and understanding.

Michael Vance, refused to allow me to continue drowning myself in sorrow, because he knew that was exactly what I was doing. I was so rude to him when he kept calling, when all he was trying to do was help me. He could have had me fired if he wanted too, even though I said I quit. But Mike knew me, and knew it was just my brokenness talking. He understood my pain and showed me such great compassion, and I will also be forever grateful to him too for what he did.

As usual, things never work out the way I plan them. My co-workers at Action for Boston Community Development Inc., (ABCD) somehow managed to change my plans and helped me to overcome from my sorrows. Being back at work around people who cared about me, was the cure I apparently needed. Even though I went to work every day with a very broken heart, they helped me through it. And so, it turned out that even though I only agreed to work for one day, I ended up staying for an additional eight years with that organization. Two years after my return, I became the Executive Director for one of the subsidiaries, and stayed in that position for six years.

As I am now reflecting on the entire ordeal, it brings tears to my eyes as I relive that season in my life which brought such sorrow and grief. I also shed tears of joy because of the compassion I received from the executives; Harold Mezoff, Chris Sieber, Mike Vance, John Drew and my co-workers, especially Lesley Cayton. I was especially fond of Harold Mezoff, the Executive HR Director. I had grown to love and have the utmost respect for him over the years, not only because he was so very good to me, but because he was a man of great integrity.

Without ABCD, Inc., I think it would have been impossible for me to pull through that devastating time in my life. Action for Boston Community Development, Inc., (ABCD) and its subsidiaries was formed to empower low-income individuals and families in Boston and its surrounding neighborhoods to become self-sufficient, stable and successful, through its numerous programs, services and resources. Without this organization, the thousands of families and individuals whom they have served throughout the years, would never have made it without them. Because of all they have done for me, I will forever hold a special place in my heart for this very distinguished organization.

Chapter Eleven:

Operation Rescue Max

Mom always told me I could do anything if I put my mind to it. Well, she was right, especially in this next episode of my journey. The task at hand seemed impossible to achieve, but failure was not an option. It was a matter of life and death, so remembering mom said I can do anything, played a major role in my determination to achieve the goal. It is important to encourage your loved ones and give reassurance that anything is possible once they put their mind to it. You never know how the seed you plant in their mind can grow and become fruitful. There is also another lesson to be learned – DO NOT make decisions when you are emotional, as you read on, you will see why.

I was tired, depressed, and angry at the whole world because I was missing mom terribly, although it was nice to have Max and Fluff. They were my immediate family as far as I was concerned, in lieu of a human family. They were the shoulders I had to cry on at the time. Max and Fluff were a great help during my healing process, and I looked forward to seeing them every evening I returned home from work. On one particular evening when I arrived home, Max and Fluff were at the front door waiting for me as usual. However, as soon as I shut the front door, Max immediately grabbed onto my hand with his teeth and wouldn't let go.

With my mind already distraught and racked with grief, I was convinced Max was trying to attack me. The more I told him to stop, the more he would jump up and start attacking my hand. He didn't actually bite me or break my skin, but he would not stop grabbing my hand. This seemingly docile, kind and comforting puppy, in my mind was now displaying aggressive behavior. He continued doing this for

a while, until he pushed me to my breaking point. It was at that point I decided I had no other option than to return him to the shelter where I had gotten him. Once we arrived at the reception area of the shelter, I had second thoughts, but being as agitated as I was, I continued with Max's return as planned. There was an elderly lady sitting in the waiting room who overheard me telling the receptionist that I was returning Max. She immediately jumped up out of her seat, moving quickly towards the counter where I was standing. She interrupted the conversation between the receptionist and myself, so she could inform me that if I left my dog, they would put him to sleep. I had no intention of leaving him if they were going to do that, so I asked the receptionist if that was true.

She told me it wasn't true, reassuring me I had nothing to worry about, because Max would be put back up for adoption. She then handed me a form to fill out, but I did not take the time to read the fine print at the bottom of the page. The elderly woman being persistent, tried to convince me not to leave Max and to take him back home with me. The receptionist got upset and told me not to listen to the lady. and the elderly lady was telling me not to listen to the receptionist, so I didn't know who to believe.

I decided to make my decision based on how crazy the elderly woman looked, so I chose to believe the receptionist. I learned a valuable lesson after, to never judge a book by its cover. With a heavy heart, I said goodbye to Max, then Fluff and I went back home. On the way back to the house, I started missing Max, and wondered if I had done the right thing. I noticed Fluff steering at me from the passenger seat, as though he was confused and wondering why I left his brother behind.

The house felt empty without Max, but I tried to dismiss my emotions whilst taking my shower and continued getting ready for bed. It took quite some time to fall asleep, because now that Max was gone, the atmosphere did not feel right. I started thinking about mom,

then burst into tears, when I noticed Fluff next to my bed steering up at me with a sad look on his face. I looked down at Fluff and said, "Max was a bad boy because he tried to bite me, so I had to take him back. I rubbed Fluff's tummy until he fell asleep, then I basically cried myself to sleep.

I woke up to my alarm going off, realizing I had overslept, which wasn't good because I had a nine o'clock staff meeting I couldn't be late for. In the middle of rushing to get dressed and ready to leave out the house, I heard my phone ringing. I tried to ignore the ringing and not answer the call, but I couldn't ignore the strong urge that persuaded me to answer. It was a good thing that I did, because it was the director from the animal shelter where Max was. I wasn't perplexed for too long, because he didn't waste any time in informing me of the purpose for his call.

He told me he was calling out of courtesy to let me know that Max would be euthanized at nine o'clock. I knew what euthanized meant, but in that moment, it felt as though my brain had automatically shut down once his words hit my ears. "What do you mean exactly?" I asked. His words were still not registering in my brain when he replied by saying, "Your dog will be put to sleep in less than an hour." My brain was still in malfunctioning mode when I then said, "I don't understand what you are saying." This was followed by silence, during which time I remembered what the crazy looking lady told me the night before.

I think all the wires in my brain immediately snapped back into place right before I said, "You better not touch my dog, because I'm coming to get him." The director responded by telling me that Max was no longer my dog. "Do you want to bet? If you touch my dog today, watch and see what's going to happen," was my response. We were arguing back and forth for about two minutes, when he asked if I still had my copy of the form I had signed the night before. When I

informed him that I did, he told me to go it and let him know when I had it.

Once I returned to the phone, he wanted me to read out loud the small print at the bottom of the page. I don't remember exactly what it said, but it read something to the effect of once I surrendered Max to the shelter, all my rights to him had been severed. Needless to say, the director thought that once I was aware of what I signed, it was going to be a closed case, but he made a big mistake. He therefore proceeded to say, "Well, there you have it, that dog no longer belongs to you, and therefore he will be put to sleep in, oh! now it will be in thirty minutes."

The only thing that came to mind was to say, "Well, I didn't read the fine print last night before I signed it, and I'm not giving up my rights - he's my dog, and I am coming to get him." I then mentioned that I was warned by the woman sitting in the waiting room that if I left Max, he would be euthanized, even though the receptionist informed me that was not true. The director then explained that putting a dog to sleep wasn't the shelter's usual procedure, unless the dog had bit someone. He went on to further explain that because I wrote on the form that Max was trying to bite me, he had to be put to sleep.

According to him, the Massachusetts law stated a dog that bites someone had to be put to sleep within ten days, or something to that effect. Anyway, I made it clear to him that I didn't really care what the animal law stated. He hung up the phone on me when I told him I was about to leave my house to come get my dog, and he had better be alive when I arrived. I called him back and he answered. It seemed as though he enjoyed taunting me by repeatedly saying Max would be put to sleep at nine o'clock.

The more he said it, the angrier I got. Meanwhile, I felt as though I received a blow to the head. The pressure that was building up,

caused me to feel as though the room was spinning with me in it. I had less than thirty minutes to save Max's life and make it to the staff meeting on time, and the director obviously had no intention of budging from his decision. We ended up getting into an argument again, once he insisted that I wasn't getting Max back.

I started to cry at the thought of possibly causing Max's death, if I was unable to rescue him on time. The more I thought about the impact it would have on me, I knew losing him was not an option. I didn't have much time left to figure out how I was going to save Max's life, so the pressure was on. I had to think fast, superfast, as a matter of fact, as to what I was going to do. I think the fact that I had to be at the staff meeting at the same time, was causing what felt like extreme and unbearable pressure.

I had to figure another way out, without having to call my boss for time off again. She gave me so much time already to take care of mom, so I couldn't bring myself to ask again. Not to mention I was out of work for the entire month, just two months prior. When I got into my car, I called the director again, this time pleading with him not to kill my dog, but he hung the phone up. He was causing my anger level to rise very high, and so I kept calling until he answered. He obviously knew it was me, because before I was able to say anything, he said, "You said the dog was trying to bite you, so that makes him a vicious dog."

He then explained that if he returned Max to me and he bit me, I could file a lawsuit against them, so he basically could not return Max to me. I then responded by saying, "I am coming for my vicious dog, so he better be alive when I get there." I turned his own words back on him and said, "If Max is a vicious dog, then you are the one who gave me a vicious dog in the first place. I'm going to call my lawyer so I can sue you for giving me a vicious dog in the first place, if you don't give him back to me."

I was so hopeful that what I said would cause him to reconsider euthanizing Max, but instead, his last words before hanging up the phone on me again was, "He is not your dog." I was frantic, fearful and just not operating from a place of logic at that point. Basically, I was acting like someone experiencing temporary insanity. I must admit that I turned into a raving mad woman on a rescue mission to save her dog. Either the wires in my brain snapped, or maybe it was because I watched too many action movies.

Me and my crazy self, decided the only way to rescue Max, was to drive to Toys R Us and buy a toy gun. My plan was to go into the shelter, stick up the director with the toy gun and demand he give Max back to me, and that is exactly what I set out to do. It didn't even cross my mind that not only would the police have been called, but they probably wouldn't have known it was a toy gun until after they most likely shot me or arrested me. On top of that, I would have definitely lost Max.

As I began speeding through traffic, I kept watching the time and saw I only had ten minutes left to save Max and to make it to the meeting. Max was more important than any meeting, so I headed to Toys R Us. The only problem was I couldn't find Toys R Us, although I passed it every day. I realized after I retrieved my senses, that God Himself was the one who confused me, so I couldn't find the toy store. Even though I knew exactly where it was, God was saving me from my own self.

While in the state of panic and frustration, I remembered how I had a praying mother, and how she taught me that prayer changes things. Remembering what mom would have done, caused me to do the same. I began to call upon God to help me and reveal to me how to rescue Max. When I finished praying, I wiped some of the tears from my eyes, and a thought instantly popped into my mind. What came to me was that I should call the administrator of the shelter.

My first thought was, "The administrator is not going to answer the phone, and I will probably have to leave a message, and it will be too late." But God knows all things, and I knew it was He that was leading me to call, so He must have known she would answer. Sure enough, when I called, the administrator was the one that actually answered the phone. I was crying so hard that she was unable to understand what I was trying to tell her. After she calmed me down a little, I explained everything that happened and told her the director was going to kill my dog in less than five minutes, if she didn't stop him.

When I looked at the time and saw I only had three minutes left to save Max, I became hysterical again. She tried to reassure me she would handle the situation and would call the director right away. She was still talking, when I began rushing her off the phone, so she could call him before it was too late. Before she hung up, she told me to call her back in ten minutes, and we would take it from there. Such a weight was lifted, but then doubt came back, because I kept thinking maybe she was too late, so that ten-minute wait was petrifying.

The moment I arrived at the office and my boss saw my face, she asked what was wrong. Once I explained what happened, she told me to leave right away and go deal with Max because that was more important than the meeting. How can one not love a boss like that? I truly had favor with Chris - she was just so good to me, and I can't thank her enough for all the things she did for me. As soon as I left the office and got in my car, I called the administrator, and to my great relief, she told me Max was okay and that I needed to call the director.

When I called him, he was so upset that I called his boss, and so he asked me why I called and got him in trouble. Under the circumstances, I thought that was a very stupid question. "You were planning to kill my dog and refused to give him back. I had to save him, so what else did you expect me to do?" With an angry tone in his voice, he told me to come and get my dog. It was like music to

156

my ears when I heard those words. The happiness that replaced my sadness was overwhelming. This time around, the tears I shed during the drive to the shelter, were tears of extreme joy.

The director was already stationed in the reception area, awaiting my arrival. By the expression on his face, I could see he was still upset with me, but not as much as I was upset with him. He then informed that me he needed to go over a few things with me before he was able release Max back into my care. The first thing he told me was that after speaking with Animal Control, he found out Max was not licensed. He then let me know that after he spoke to a representative from Animal Control and told them how I showed so much passion and love trying to save my dog, they decided to overlook the rules, and allow Max to be returned to me.

There were two conditions I had to meet. I had to agree to get him licensed and trained. I couldn't wait to see Max, and when he brought him out, Max ran to me and grabbed onto my hand as he had done before. The director asked me if that was what Max did, which caused me to return him. When I told him it was, I felt like the biggest fool on the planet when he told me that Max was still a puppy and was only trying to play with me. He let me know that from the time I dropped Max off until I picked him up, he was very gentle and sweet.

I felt so stupid when driving home, thinking how I nearly got Max killed, not realizing he was only playing with me. When I arrived home, and Fluff saw Max walk through the front door, his tail waggled so fast when he jumped all over Max. My mission was successful - I was victorious thanks to prayer, which mom always told me could change my circumstance, and it most certainly did. God came through for me that day and brought back some joy and happiness to my life. It was the first time I experienced a sense of happiness since mom's passing.

I went back to work with a big smile on my face after dropping Max off back at the house. It was a proud moment when I was able to tell my boss and co-workers that my mission was accomplished. Whilst sitting in my office recollecting the morning's events, I realized this incident happened because I was grieving, miserable, and emotional. I acted irrationally and nearly caused the death of Max who turned out to be one of the greatest loves of my life. Although I used up most of my brain cells that morning trying to save Max - I certainly went to bed that night relieved and contented with a big smile on my face.

A couple weeks after my rescue mission, I had another scare, but this time, it was much different. As usual, when I got home from work, I would let Max and Fluff out in the back yard for a while. On this particular evening, when I called them to come inside, I realized they were not in the back-yard. In a panic, I ran down the driveway looking for them, but they were nowhere in sight. I frantically ran down to the main road, hoping they weren't trying to cross the street, and was relieved that they were not there, nor were they hit by a car.

Suddenly, fear took over as I thought someone may have stolen them, but then another thought came to my mind to check the park that was at the other end of the street. I did take them there most evenings, so I was hoping that was where they went. Upon reaching the park, to my pleasant surprise, there they were, but messing with a dog much bigger than them. They were at a distance from me, so they couldn't hear me calling them. I didn't feel like walking all the way to where they were, but I had no choice.

As I got closer, I realized the dog they were messing with was a Pitbull. Fear took over again, but this time, my legs felt like they had turned to jelly when I was trying to run towards them. My heart was racing fast out of fear that the Pitbull might attack them. If that had happened, I would have had to end up in the middle of a dog fight. As for Fluff, I knew it would only take one bite to finish him, so I was

really frightened. I continually shouted their names as loud as I could, and when they finally heard me calling and looked towards my direction, they stopped what they were doing.

Immediately they began running towards me, but then the Pitbull started running after them. It was at that moment I thought my heart was going to jump out of my chest. When Max turned and saw the Pitbull behind him, I noticed he picked up speed. As for Fluff, I had no idea his little legs could move so fast until that evening. I didn't want Max or Fluff to stop when they caught up to me, because I knew I couldn't fight that dog, so I made a U-turn and started running in the direction of the house. When I turned and saw that Max and Fluff were right behind me, and the Pitbull was right behind them, in a panic, I shouted, "Don't stop, run past me and run to the house."

I can just imagine what the other people in the park were thinking when they saw and heard what was going on. Off course, Max and Fluff had no idea what I was saying, but I was hoping in that moment, they could miraculously understand the words that were coming out my mouth. Instead, Max headed right towards me, and so did Fluff. "Oh my God, you're going to cause me to have to fight with a Pitbull," I blurred out. I had no choice but to stop running and braced myself for the fight I was about to get into.

Neither Max or Fluff was big or strong enough to defend themselves, so I was going to have to fight the Pitbull in order to save them. It was obvious Max and Fluff were also afraid, because when they caught up to me, they hid behind me, so I could protect them from the trouble they got themselves into. Thank God we were saved in the nick of time. Right when the Pitbull was about two feet away from reaching us, his owner called out to him. I was so grateful he was an obedient dog, because he immediately turned and ran back to his owner.

Max, Fluff and I, had many memorable times while we lived at that house, but we were only there for three years, before I lost it due to foreclosure. I wasn't the best at money management, due to my love of spending. My love for spending, coupled with the refinance I got that had an adjustable rate, so I could remodel were the main causes I lost the house. The auction was held in front of my driveway, which was not only an unpleasant but a very embarrassing experience.

When I looked outside my living room window the morning of the auction, I was heartbroken when I saw so many people eager to bid on my home. Especially so, when I saw a woman from church who pretended she was a friend. Prior to mom passing, she kept telling me to make sure I made my mortgage payments on time, even if it meant doing without something I needed. That was the only time I was glad mom wasn't around, so she couldn't see that I lost the house – especially because I did exactly what she told me not to do.

The person who won the bid at the auction was unable to get a mortgage loan, so the house ended up staying on the market for over a year. When it was finally sold, my attorney was able to get me twenty thousand dollars from the sale - so considering I only put down three thousand dollars when I bought it, I didn't end up doing too bad after all. The new owner wanted me to stay on for a couple of months and insisted I take my time finding someplace else to live, but I wanted to move on to a fresh start.

Approximately ten neighbors came to bid me farewell when they saw the moving van parked in the driveway. There was one young man though, who lived across the street, that left me in awe. The fact that he didn't seem friendly at all and barely spoke, left me surprised when he came to talk to me. He told me he didn't believe that animals were blessed until he observed Max and Fluff. After inquiring what he meant, he said, "I've been living on this street for years and have seen many people move in with their dogs but moved without them,

because they were hit and killed by the cars, but your dogs, are truly blessed."

I inquired again as to why he thought they were blessed, to which he replied, "I have seen your dog's miss being hit by speeding cars so many times, when you were at work. There were a few times I thought for sure they did get hit, but somehow, each time, the cars missed them." I was bewildered by what he was telling me, but he had more to say. He continued by saying, "They somehow got out on the days you left them in the back yard, but it was as if they knew when you were coming, because they always went back in the yard right before you got home."

I thought that was all, but he still had more to say. "They roamed the streets, went to the park, and that little one, (meaning Fluff) must have nine lives. It's a miracle that they are both still alive to be leaving with you. Because of your dogs, I now believe God really does bless animals." It took a few moments to digest what he shared with me, not having any idea Max and Fluff were roaming the street every day and came so close to losing their lives. It did confirm that God was answering my prayers, because I included them in my daily prayers and asked God to protect them and keep them from all dangers both seen and unseen.

I was very thankful to God for sparing their lives. God certainly knew I would not have been able to handle the additional heartbreak if anything were to happen to them back then. It was a bittersweet moment once everything was packed into the moving van and it was time to finally leave. I glanced once more at the house through my rear-view mirror, while backing out of the driveway, thinking of the memories we had there. I did feel better when I realized I wasn't actually leaving the memories, because I was taking them with me.

Chapter Twelve:

Unexpected News

Sometimes we take the people most precious to us for granted, which is something we should never do. We don't know what tomorrow holds, so we should make the most of today and cherish those who are dearest to us. Make the most of the times you spend with loved ones, and tell them you love them every chance you get. Do special things together, so your memory bank will be filled with precious memories you can retrieve when you need them.

Apparently, the foreclosure was not reported to the credit bureau, but was in fact, reported as paid in full. Because of that, I only ended up staying in the apartment I rented for six months and was able to buy my next home. This time around, I bought another two-family house in Canton, which was more of an upscale neighborhood. Both units were rented when I bought it, and the agreement was that one tenant would stay and the other would move out before the closing date, so I could move in.

I was very excited to get to my new home after the closing and looked forward to meeting the tenant that would stay on. But to my great surprise, when I arrived, both tenants were moving out. I went into to a panic because I not only had to figure out how I was going to pay the mortgage by myself until I found a new tenant – I also had to figure out how I was going get enough money to make it to Bev's wedding. I couldn't miss her wedding under any circumstance, plus I was going to be the maid-of-honor.

After paying the first mortgage note of thirty-four hundred dollars, I had no money left for anything. The following months mortgage was due the same week I was supposed to leave for England, so I had

no idea what I was going to do. I had already booked the flight before I bought the house, so that was a big load of my chest. But, I still needed my dress, spending money and all the other things I needed for the trip. I was supposed to arrive in England a week before the wedding, but when the time came, I had to push back the flight because I still had not come up with enough money to travel with.

I used my paycheck to buy everything I needed, but I couldn't travel without any money. I really started panicking when I only had three days left to make it on time, and still had no money. As a last resort, I called a girlfriend of mine that I had lent two thousand dollars too, so she could pay her daughter's school fee. Over a year had passed since I lent her the money, so I asked her if she was able to give me at least two hundred out of what she owed me, because I really needed it.

To this day, whenever it crosses my mind, I'm still in awe of how she responded to my request. All I asked for was two hundred dollars, and she said, "If you were really a friend, you wouldn't have asked me to give you back any of the money, because my other friend that lent me five thousand dollars, told me I didn't have to pay her back." "Your other friend obviously could afford to give you that amount of money, but I can't, was my reply. I then said, "From the day I lent you the money, I never asked for a penny until now, and I'm not asking for the whole thing, I just need at least two hundred dollars, if you have it."

She got upset and told me she would bring it to my office the following morning. She did end up bringing it the following morning, but instead of giving it to me in my hand, she put it in an envelope and pushed it under the office door. The two hundred helped, but it still wasn't enough because I was going to be in England for two weeks. I then had only two days left to get to England, and so I became a nervous wreck. The only other thing I knew to do was pray,

and so once again, I called on the Lord to help me so I could have more money to travel with.

I had to come to terms with the fact that if the Lord didn't come through for me, I would have to go with the little money I had. But once again, the Lord came to my rescue, because that very evening, I got a call from a man who needed an apartment to rent for one month. It so happened that he was a friend of the tenant who was living on the second floor, who had moved out the day of the closing. She gave him my number because he needed a temporary place to stay and needed to move in as soon as possible.

Off course, I didn't even hesitate to tell him he could have the apartment. Within the hour, he showed up with thirteen hundred dollars cash in hand. Denzil, whom was a friend and employee of mine, volunteered to care for Max and Fluff for me while also keeping an eye on the new tenant, especially because I knew nothing about him. All my stress melted away that evening, and I was able to finally focus on what was most important to me, which was making it to my best friend's wedding on time.

It wasn't until I arrived at the airport and was seated on the plane, that I felt a sense of complete relieve. Excitement replaced the stress I was experiencing, not only because I was headed back to England for Bev's wedding, but I was going to be with the people who had a very special place in my heart. On any other occasion, the length of the trip would have made me irritable, especially having to take a train from London to Nottingham, after my six-hour flight. But not this trip, I was relaxed, happy and looking forward to my two weeks of pure bliss.

The train pulled into Nottingham station around midnight. I could see Bev and Paulette, her sister, on the platform waiting for me to exit the train. They didn't wait for me to come to them, they were standing right there at the door when it opened. I was overwhelmed with joy

as I thought, "Right in the nick of time, but I made it." I was home again and was going to be surrounded by people I so dearly loved. The people who could make me forget all my cares when I was with them.

Bev looked beautiful in her wedding dress, and the wedding turned out perfect. The attendance of so many friends I had not seen in years, made the day that much more special. It was well worth the stress trying to make it on time, and worth every penny it cost to get me there. My two weeks flew by way to quick, because before I knew it, it was time for me to return to reality. I certainly did forget about all my problems as I was busy living life as though I didn't have a care in the world during my stay.

Two years had passed by after my return home from Bev's wedding, when I decided it was time to take another trip. This time around, it was to visit aunty and daddy. Aunty and daddy along with aunty Davis and her husband, uncle Raphel, sold their houses in England and returned to Jamaica to enjoy their retirement years. Aunty and aunty Davis made sure to buy their land close to each other, which turned out to be about a seven-minute drive. They moved back to Jamaica a year after mom died, so this was the second trip I made to visit them since their migration.

It was a good feeling being with my loved ones who raised me, and it was extra special getting to spend quality time with daddy as I did in the past. Nothing had changed with him, he was the same mentally and physically, and although he was up in age, it was a great feeling knowing he was still in good health. As usual, we sat and talked, and he updated me on all the news with family and friends, as he always did. He happened to remind me that the following week was mom's birthday, which would make the trip that much more special.

I wanted to go to Kingston to visit uncle Lloyd, mom's younger brother, but aunty refused to let me go by myself. Daddy didn't want me going to Kingston by myself either, but luckily for me, Denzil, came to Jamaica for a week to visit his mother in Kingston. When he called to say he was in Jamaica, my first question was to ask what he did with Max and Fluff, because I left them in his care. It turned out he decided to leave Max and Fluff with another staff member without asking me if it was ok.

I was glad Denzil showed up though, because he was the person that would rescue me, so I could go to Kingston to visit uncle Lloyd. I hadn't seen Uncle Lloyd since my first trip to Jamaica, when I was ten years old, so I was really looking forward to seeing him. Denzil was headed to Kingston the day he came to visit, and to my surprise, aunty allowed me to go with him. We made arrangements to meet my uncle, but unbeknownst to aunty, he wanted us to meet him at a bar.

Aunty wanted me back in the house by ten o'clock that night, which I knew was not going to happen. I secretly packed an extra set of clothes to take with me, and decided to deal with the consequences when I returned. I was so happy - I felt like a child going to an amusement park for the first time. Not only was I finally going to Kingston, which was somewhere aunty would not let me go during the last trip I made to Jamaica, but I was finally going to see my uncle after twenty-nine years.

On the way there, Denzil stopped in his old neighborhood to meet up with friends at a bar. I was so happy to be out of the house, feeling as though I had just been released from house arrest. Since I was a foreigner in Jamaica, it was assumed I had money, especially with my British accent. Because of that, people were asking me to buy them drinks, which I gladly obliged. Suddenly I spotted a young man who stood out from all the rest, when our eyes met as he passed by. He was tall, handsome and trendy, and I couldn't keep my eyes off him.

He came over and sat next to me and introduced himself as Michael. During our conversation, he asked how old I was, and I told him I was thirty-nine. The music in the background was loud, so when he asked my age, and I asked his, I thought he said thirty-eight, which I found out later was not so. Anyway, we were having a good conversation while flirting with other, until Denzil came and told me it was time for us to leave. Michael asked for my number, but I didn't see the point, so I didn't give it to him.

I had no idea the time had passed by so quickly, because when I viewed the time, it was already past ten o'clock, which was past the curfew aunty had given me. I told Michael I had to leave and said my goodbyes, then followed Denzil and the driver to the car. Michael ran behind me and handed me a piece of paper with his phone number on it, and asked me to call him. I slipped it into my bag with the intention of throwing it away later, but never did.

When we arrived in the area we were supposed to meet uncle Lloyd, I spotted him walking on the other side of the street. It was a good thing I saw him, because we weren't able to find the bar where we were supposed to meet. Although I had not seen him in so many years, I recognized him from photographs. Even if I never saw a photograph of him, he was easy to recognize, because he resembled mom.

It just so happened it was mom's birthday that day, so after we hugged and kissed and I told him it was mom's birthday, he started crying in the bar. He began reminiscing on their childhood and memories of the past, which caused me to start tearing up. We were both a mess, while drinking and weeping at the same time. I was afraid to call aunty and tell her to lock up because I wasn't coming back that night, so, I had uncle Lloyd call her instead.

Surprisingly, aunty didn't make a fuss about it, although she did want to know where I had planned to spend the night. Once I got

167

aunty out the way, I was able to totally enjoy myself. I no longer needed to worry about getting in trouble when I got back, as I did back in the days when I was a teenager. I don't even know how many rounds of drinks we had night, but it was a lot. The atmosphere was perfect, with the lover's rock playing in the background, which was my favorite kind of music.

We had such a good time and didn't leave until about five o'clock the following morning. After saying our goodbyes, Denzil, the driver and I, headed back to Ocho Rios, after stopping on the way to have breakfast. Denzil had booked a hotel room in Ocho Rios, located approximately twenty minutes away from aunties house. By the time we arrived at the hotel, it was after seven. Since Denzil had two beds in his room, I shared the room with him, instead of getting a room for myself.

We were on the ground floor directly on the beach, and I loved it. As soon as Denzil entered the room, he was knocked out and fast asleep. I, on the other hand, sat on the patio under the beautiful palm trees, watching and listening to the sounds of the waves. The white sands were calling me, so I got up and walked around in the sand and sat down by the water's edge for a while, lost in my own little world, enjoying every moment. When I came back inside the room, Denzil was up and asked if I had called aunty yet, which hadn't crossed my mind to do so.

I was hesitant at first, because I certainly wasn't ready to leave, and I didn't want aunty to tell me I had to come back to the house. Once I built up the nerve to call and tell her where I was, I was told I could stay but had to be back by dinner time. That's what I wanted to hear, and so after lunch, I went out and bought a swim suite, and headed back to the beach. After swimming, we went jet skiing, and then Denzil paid for us to go parasailing which was absolutely exhilarating. Later I laid on the beach, order tropical drinks and didn't get up until it was nearly time to leave.

Once the sun began going down, it was my cue to get ready to leave, although I didn't want too. I couldn't call aunty and tell her I was staying another day, plus I had no more clothes to change into, so I had to get my stuff together so they could take me back to the house. Thanks to Denzil for making that happen, because I had so much fun that day, a day that will always be cherished. Getting to visit my uncle, along with the day at the beach, was the only chance I got to go out and really enjoy myself during that trip to Jamaica.

The last week I spent was basically in the house, and the only time we went anywhere was when daddy drove us to the market or when we went to visit aunty Davis. I made the most of it though, because any time spent with them was special. Knowing that time was short, caused me to make sure that I made every moment with them count. When the time came for me to leave, it was like old times when I was heartbroken to have to leave them. Daddy drove me to the airport, and aunty Davis came along for the ride. I kissed everyone, said my goodbyes and told them I would be back to visit the following year.

Nine months later, I booked a flight to return to Jamaica. I wanted to spend my fortieth birthday with daddy, which fell on Father's Day that year, so I thought it a perfect time to go back to Jamaica. I called aunty to inform her I was coming for my birthday, to which she responded, she had something to tell me when I arrived. Aunty sent a driver to pick me up at the airport, and although I wondered why she and daddy weren't the ones who came to meet me, I didn't think much of it.

I made arrangements with the driver to pick me up the following morning which was Saturday, so he could take me to Dolphin Cove and pick me back up in the evening. I was so excited that I was going to fulfil my dream of swimming with a dolphin, and spending my birthday on Father's Day with daddy, was going to make my birthday extremely special that year. As usual, I was eager to get to the house to see aunty and daddy and became excited when the two hour drive

169

from the airport had ended, and we finally arrived in front of the driveway.

Just as I always did in my younger years, when I arrived at the house, I ran inside to hug daddy and not wanting to let him go. Something about him was different this time though; he just wasn't the same. Although he was happy and smiling, he didn't speak much upon my arrival, and that was not like him. His unusual behavior concerned me, because he wasn't the man I had known my whole life. When I pulled aunty aside to ask what was wrong with daddy, all she told me was that I should wait and see for myself.

Her response was unexpected as it gave me absolutely no hint as to what was going on. It puzzled me as to why she didn't want to talk about it, but I decided to do as she suggested and wait until I found out for myself. In the past, daddy was the one who always filled me in first as to what was going on whenever we spoke on the phone, or when I visited. I always spoke to him first when I called, so by the time aunty got on the phone and started telling me stuff, she would always say, "So Lester had to go tell you that already."

The tables had now been turned, because anything aunty told me in the past would be old news. Daddy would have already filled me in, but this time around, it was aunty telling me everything. It all felt so strange - I could see daddy was just as happy to see me as I was to see him, but something just didn't add up. I sat there starring at him, wondering why he wasn't his usual self, but I was not prepared for what aunty ended up telling me later that night.

Out of the blue, she just blurted it out. "Lester isn't remembering things like he used to, because he is in the beginning stages of Alzheimer's." My heart felt as though it was drowning, along with the sadness that quickly enveloped my soul. Her words were hard to swallow, but once I digested the words she spoke, I knew I had to adjust my mind to the change. I had to enjoy every moment with him

because the day would come when he wouldn't remember me, although the thought of that was difficult to comprehend.

The unexpected news changed my plans of visiting family as well as the excursions I had planned. Well, all except for one, which was to swim with the dolphins at Dolphin Cove. This was something I wanted to do for a long time, so having the opportunity to do it for my birthday was my special birthday present to myself. Aunty had no nothing to say when I told her that I would be spending the following day at Dolphin Cove and that her driver was coming to get me.

Like a child, I was ecstatic that my dream of swimming with a dolphin was about to finally come true. I went to sleep with dolphins on my mind and woke up bright and early with anticipation of the fun day that laid ahead. Dressed and ready to go, I rushed down the stairs to greet daddy and aunty, who was in the kitchen making breakfast. If I didn't know better, I would have thought the driver timed me, because he arrived just as I finished eating breakfast.

The moment he walked through the door, I grabbed my bag, which was packed with my swimsuit and towel, and headed for the front door. Aunty told me to hold on a minute, when she asked the driver if he was going to stay with me at Dolphin Cove. Neither the driver or myself thought anything of it when he told aunty he had already made other arrangements, but he was going to take me to Dolphin Cove and pick me back up in the evening. Had we known what the outcome of his honesty was going to be, we would have planned to tell her what she wanted to hear.

To my great horror, aunty told him I couldn't go if he wasn't going to be staying with me. Not only was I shocked and totally embarrassed, but I was also extremely upset. When aunty left the kitchen, I pleaded with the driver to say something to help me out, but he was obviously intimidated by aunty, and didn't want to get involved. When aunty returned to the kitchen, she told him that he

might as well leave without me, because if he wasn't going to stay at Dolphin Cove with me, then I couldn't go. Even though he told her I would be safe and that many other tourists would be there, she still insisted I couldn't go by myself.

Daddy came downstairs and asked what was going on, to which I replied by telling him that aunty wouldn't let me go to Dolphin Cove. Thinking daddy was going to stand up for me as he always did in the past, all he said was, "If Valda don't want you to go, then you shouldn't go." I was so upset that I told them I was going to call the airlines and change my flight, so I could go back home. At that point, the driver knew it was a losing battle when he told aunty he had to leave, then began making his way to the front door.

I ended up walking with him to his car, at which point he said, "You should have told me to tell her I was staying with you." "How was I supposed to know she was going to say I couldn't go, when I am a grown woman," I replied. Although he told me how sorry he was, as well as voicing his disbelief of what happened, he definitely found the scenario quite amusing. It was evident with his outbursts of laughter - while I, on the other hand, was fuming. Like myself, he probably will never forget the day he witnessed a grown woman being told by her aunt that she couldn't go to Dolphin Cove by herself.

After he drove out the gate, I stood in the driveway in total dismay while trying to regain my composure before I went back into the house. I ran past aunty and daddy, who stood in the kitchen observing me in silence and watched when I ran up the stairs to my room. As soon as I sat on the bed, I burst into tears. Acting upon my emotions, I called the airlines with the intention of cutting my stay short and changing the date of my return flight. During the time the airline had me on hold, I suddenly remembered something.

I remembered when I called to tell aunty I was coming, I started reminiscing on the 'good old days,' wishing I could relive my teenage

years as I did when I was living with aunty and daddy in England. "Wow!" I thought, once I realized I got what I wished for. Aunty was sure treating me the same way she did when I was a teenager, and so my wish came true. I couldn't possibly continue being upset with aunty after that thought, which ended up turning my tears into laughter.

My mission was redirected from changing my flight, to making it my task to enjoy and cherish every moment I had left with them. I went back downstairs with a completely different attitude, and it was then that aunty explained why she didn't want me to go by myself. A week prior to my arrival, a young woman who went to Jamaica for vacation, was kidnapped, raped and killed after going for a walk by herself. I then understood why aunty was so adamant about me not going unless the driver was staying with me.

The following morning aunty and daddy came to my room and woke me up. When I opened my eyes, they were standing next to my bed, and aunty started singing "Happy Birthday." They both had gifts in their hands, which was a very special yet an unexpected moment that I will always cherish. Aunty made my favorite food for breakfast, and the three of us enjoyed a special morning together as we did in years past. The fact that it was also Father's Day made it that much more special. Daddy and I spent most of the morning together, but once again, he was smiling but not saying anything.

Later that afternoon, once I had spoken to my cousin who came to visit, I joined daddy on the veranda so I could give him his Father's Day gift, and read the poem I wrote for him. The poem explained how much he meant to me, the love and respect I had for him, and to let him know there has always been a place in my heart that only belonged to him. While observing the lack of visible emotion on daddy's part as I read the poem, I was left puzzled. But my heart shattered into pieces when I realized nothing I said had registered.

When I finished reading the poem and gave him a kiss, all daddy said was, "I don't like it when you and Valda argue." Those words were daddy's last sentence spoken to me. It happened so instantaneously, because his memory as I had known it, was gone. I had heard other people talk of how painful the experience was when watching a loved one go through the phases of Alzheimer's, but I was not prepared for the severity of the impact, and how deeply wounded I would be. There was nothing anyone could have told me that would have mentally prepared me for such a devasting experience.

It turned out that instead of calling the airlines to shorten my stay as I had planned to do the day before, I ended up calling to extend my stay an additional week. During my last week, I spent the entire time in the house. I didn't mind because aunty's house was big with six-bedrooms, four-bathrooms, and three large verandas. Her beautiful garden and varity of fruit trees were added amenities, so I had no problem getting my quiet private times when I needed them.

I spent the majority of my days sitting and talking with daddy, although they were one-sided conversations, because I was the only one talking. I spent the last moments with daddy on the morning I was leaving, hoping he would say something, but he didn't. When I kissed aunty and daddy goodbye, I was stricken with fear that the next time I saw him, things would be worse. As the driver loaded my luggage in the car, I took the opportunity to hug aunty and daddy once again before I left. As the car pulled out and I waved goodbye, daddy waved back with only a big smile.

I thought about daddy throughout my entire flight as I took a long trip back down memory lane. I thought about all the wonderful times we had, and all the wonderful things he did for me that I can never forget. Tears flowed from my eyes, when I remembered the night Bev, Marie and myself went to an all-night stage show that started at midnight. It was the first of its kind in Nottingham, so it was a big deal. Entertainers were there from Jamaica, and people came from

London, Birmingham, Bristol, Huddersfield, Leicester, Derby, etc., to attend.

I was looking forward to the show the entire week leading up to it, and when the night had finally arrived, I couldn't wait to get there. I had asked aunty for money to buy a new outfit and new shoes, so I was dressed to the T, and knew I was looking good. When we arrived, the place was crowded. There were handsome guys everywhere, dressed in suits and beaver hats, looking very dapper. We were in our late teens at the time, so checking out all the guys was forefront on our minds.

I was wearing my heavy sheepskin coat, but instead of leaving it with the coat attendant as soon as we arrived, we decided to go up stairs to the balcony, so we could check out all the unfamiliar faces first. Half-way walking back down the stairs, which was lined off with some really good-looking guys, I tripped and fell. Marie and Bev were so embarrassed, although not as much as I was. In order to cover my shame, I pretended to be hurt, but that didn't stop Bev and Marie from insisting I get up.

I tried to take my time in order to get some sympathy and avoid laughter from onlookers, but Marie told me to get up quickly before more people saw that I fell. Once I was up on my feet, I held my head down so no one could see my face. When I continued walking down the steps, one of my feet felt higher than the other. It was then I realized that the heel from one of my shoes was missing. Instead of leaving the heel behind as Bev and Marie suggested, I went looking for it. It so happened that I spotted it on one of the steps laying behind a guy's foot. I had to ask him if he could move his foot, so I could get my shoe heel.

After scolding me for embarrassing them, Bev and Marie quickly ushered me to the bathroom so we could figure out what we were going to do about the situation I found myself in. We couldn't fix the

shoe, so the only other alternative was to call daddy and ask him to bring me another pair. Bev was tasked with calling daddy about one 'o'clock that morning from the phone box outside. Aunty answered the phone in a panic, thinking something had happened to me. Once Bev explained what happened and asked to speak to daddy, aunty didn't want to give him the phone.

Daddy had only arrived home from work about half hour before Bev called, and aunty knew Bev was going to ask him to bring me a pair of shoes, so she gave Bev a message to give to me. Aunty told Bev to tell me that Lester was not going to come out his bed to bring me any shoes, so she suggested I either stay there with one shoe, or come home. Daddy overheard the conversation, and being the compassionate father that he was, he took the phone from aunty and asked Bev which shoes I wanted him to bring for me.

Daddy got out of bed, found the shoes I wanted, and drove to meet Bev, who was outside waiting for him. If it was up to aunty, I really would have had to stay there with one shoe, or go back home and miss the event of the season. It turned out that we had such a good time that night, and didn't leave until around seven o'clock that morning when the show was over. Because of daddy, I got to enjoy myself and had a wonderful time. What daddy did for me that night was such a big deal to me, that even now, I still cherish his act of compassion.

Daddy had done so many unforgettable things for me, so the thought of him not even being able to remember me, was something very hard for me to comprehend. The pain in my heart was killing me, as I tried to cope with the fact that his memory would most likely never return. I had so many wonderful memories with daddy in them, so it was hard to accept that we would no longer be able to reminisce.

I had to finally come to terms with the fact that this too was another unexpected blow in life that I was going to have to deal with, and try to overcome. I continued my visit down memory lane right

up until the plane was about to land. I knew then that I would have to prepare myself to make more frequent visits to see aunty and daddy. Although she tried to hide it, I knew aunty was having a hard time dealing with watching her husband of fifty years go through those phases. I had to be there to help her, and so before I even landed, I was planning my next trip to Jamaica.

Chapter Thirteen:
Living With Regret

Never put off until tomorrow what you can do today, because tomorrow may never come. You may never get another chance to do something you should have done, when you had the chance to do it. It could be a missed opportunity that will never come again, which you may regret for the rest of your life, just as I am still doing now.

A couple months after my return from Jamaica, I bought a lake-front house. Everyone called it my muti-mansion, because it had five bedrooms, four bathrooms, and marble floors throughout. After seeing the six-seater jacuzzi in the master bedroom with the view of the lake, I knew I had to have that house. The back of the house was all glass, so no matter what room I was in, a view of the lake was visible. When my staff knew I bought the house, they insisted I have a house-warming party. Maria's birthday was coming up, so the rest of the staff and I secretly planned her birthday party at my house, but led her to believe it was just a house-warming party.

Maria, an adorable Hispanic woman who was also one of my staff, was just one month older than mom, and she treated me like the daughter she never had. We had a great relationship, so I wanted to take the opportunity to do something very special for her. I invited all my employees because we were close and very open with one another. They were not afraid to let their hair down, so to speak. We were like family, so no one would feel shy and could just be themselves. Because of that, when I invited them, they invited their immediate families.

I told my brother Andrew to come and bring my nephew Aqueil with him, and so Andrew decided to bring his best friend also.

Because the event was turning out to be much bigger than I had originally planned, I woke up before daybreak to start the food preparations. I spent the entire morning in the kitchen making various dishes, and didn't finish until the first guess arrived, who happened to be Anna, my administrative assistant.

When my brother Andrew, Ron and Aquiel arrived, he was a couple months away from his seventh birthday. After his exploration of the house, Aquiel ran up to me and said, "Wow, aunty Pat, I didn't know you were rich." I chose not to make him any wiser. If it made him happy thinking his aunty was rich, then I wasn't going to burst his bubble. Way more people started showing up than I had planned for, and when I called Denzil to find out where he was since he was in charge of the music, he told me he was about to pull into the driveway.

Two cars pulled in behind him, along with a large truck. Curious to find out who and what was in the truck, I couldn't believe my eyes when I saw a group of men and women, along with big speaker boxes being unloaded. Instead of bringing his CD player, Denzil hired a DJ with a sound system, and the DJ invited his friends. So, the house-warming/birthday party turned out to be a much bigger event than I had imagined.

Although the twelve houses on the lake were spread apart, I was afraid of what the neighbors would say about the loud music. It was for that reason I told Denzil and the DJ that they couldn't hook up the speakers, but they didn't pay any attention to me. They hooked the speakers up anyway, when I went upstairs to get changed. Upon my return, I noticed everyone certainly felt at home as they were helping themselves to what they wanted.

Maria, who brought her husband, started crying when we presented her birthday cake along with gifts and starting to sing Happy Birthday. The day turned out perfect, with the loud music and

all. Everyone enjoyed themselves to the fullest, and not one of the neighbors complained, so we all had a blast. The music wasn't turned off until close to midnight, even though everyone had close to a two-hour journey back home. I was pleased how the day turned out, and even more so because my nephew was able to take part in the festivities.

Aquiel called me the following day to tell me how much he enjoyed himself and wanted to come back and spend some time with me, Max and Fluff at the house. Aquiel was born just two months after mom died - It was so sad because mom did not live long enough to see her first grandchild, which was her heart's desire. When he was an infant, my sister would drop him off at my house to spend time with me sometimes, but it wasn't often, because she and I weren't getting along.

After the party, Aquiel and I spoke often. A few months later, he called one night to tell me his jaw was hurting him. When I asked my sister what was causing the pain in his jaw, she told me the doctors believed it was most likely a cyst and gave him antibiotics to take for seven days. After a week of taking the antibiotics, the cyst had not gone, but the pain got worse. One day after the antibiotics had finished, Aquiel, called me late that night crying and asked me to pray for the pain to go away, because he couldn't sleep.

After I finished praying for him, he told me it felt better, although I don't know if it really did, or if he was just telling me that to make me feel better. Anyway, he called me the following night to pray again, and that's when I told my sister she needed to take him back to the doctor, because the antibiotics he was taking should have already worked. She took him to Children's Hospital the following morning, where he stayed all day undergoing various tests. My sister called me that evening when I was on the highway driving home, to tell me what happened and to inform me of the test results.

I felt a sharp pain in my heart when she told me that the cyst wasn't a cyst after all, but it was cancer. "This couldn't possibly be happening again," I said, but unfortunately for us, it was. "First mom, and now Aqueil," I mumbled, as I fought to hold back my tears. I was a nervous wreck while driving and got pulled over shortly after by a state trooper for speeding. That's when I first realized it's not a good idea to listen to disturbing news while driving. By the time the trooper came up to the car, I felt like I was having a nervous breakdown.

The officer could see I was distraught and asked me what was wrong. When I told him the news I had just received, he was compassionate and told me to pull over for a while before I continued my journey home. By the time I got home, I was drowning in tears and could scarcely fathom that this was happening all over again. After collecting my thoughts, I called Aquiel to speak with him, which made me feel a bit better when I realized he was still in good spirits.

My sister then took the phone to continue the conversation we were having while I was driving. She informed me that within that week, the cancer had spread rapidly, causing his jawbone to be replaced by the cancer. His jaw looked no different than it usually did; it was in perfect form, with no deformities, so it was hard to comprehend. By the following week, the cancer started protruding through the inside of his jaw, which caused the doctors to immediately operate.

Once again, like I was with mom, I went into denial - I knew many children had been diagnosed with cancer, and my heart went out to them, but I thought to myself, "Aquiel can't have cancer, he's my only nephew, and he is only seven years old." I consoled myself by believing he was strong and would pull through his illness with flying colors. My sister didn't want Aquiel to take chemotherapy treatments and therefore sort a holistic doctor in Honduras, Dr. Sebi, to provide treatments through herbal medicine.

The first trip to Honduras was basically for a consultation, so Aquiel didn't have to go with her, although she wanted him to. Aquiel insisted on staying with me, Max and Fluff, even though my sister tried to convince him that he would have a good time in Honduras. She told him he could enjoy days at the beach, but he told her, "Aunty Pat as a lake." She then told him he could hang out in the jacuzzi at the hotel, but he told her, "Aunty Pat has a jacuzzi in her bedroom." She gave up after realizing there was nothing she could say or do to persuade him, since his mind was made up.

It afforded an opportunity for a deeper bond between us, during the three weeks he spent with me, which was something I valued dearly. On the days I went to work, I took him with me, and in the evenings, we did whatever he wanted to do. It was summer, so the evenings were warm and bright, which was perfect to enjoy activities together without having to worry about it being too cold. There was a farm and petting zoo across the street from where I lived, which also held horse shows and offered horse riding classes.

Aquiel, and I left out one evening to see one of the horse shows, and just as we were leaving, he asked if Max and Fluff could come too. I was hesitant at first because I didn't want Max or Fluff to go there and start barking at the horses and disrupt the show, but I didn't want to disappoint Aquiel either, so I took them with us. Max and Fluff didn't end up barking after all, they seemed spellbound upon seeing horses for the first time. Aquiel enjoyed the show so much that he asked if he could take horse riding classes.

The following day after work, Aquiel and I went to the farm to find out about the requirements for the horse riding lessons. We were both very excited about it because we planned to take the classes together. Whilst we were there, I wanted Aquiel to meet Olive. Olive was the loveliest donkey I ever met, and was well acquainted with her, as I visited her quite often. That particular evening, Olive wasn't in her usual spot, so I went looking for her. I ended up spotting her

in the back of a truck with some other animals. Aquiel and I walked over to the truck so he could meet and pet her, but he refused to touch the donkey.

I told Aquiel, Olive enjoyed getting her head and face rubbed and tried convincing him to pet her, while reassuring him it was safe because Olive was a very gentle donkey. No matter what I said, Aquiel refused to touch Olive as he was convinced the donkey would bite him. Even though I told him Olive would never bite him because I came to visit and pet Olive nearly every evening, and she had never bitten me, he said, "No way, aunty Pat." I decided to show him that he had nothing to be afraid of, so I started stroking Olive's head and face like I always did.

Right when I was about to remove my hand from Olive's face, she grabbed hold of my little finger and started to bite down on it. The pain was so excruciating that I started screaming for help. I then started shouting at the donkey, telling her to let go of my finger, as if that was going to make her stop. Meanwhile, Aquiel found the scenario very entertaining, because he couldn't stop laughing. I cried out for the attendant to come help, but when no one showed up, I told Aquiel to run and find someone to help me before the donkey took my finger off.

The more I struggled, the more Olive bit down on my finger. Aqueil came back and told me he couldn't find anyone, but made sure to point out that my face had turned red, in between his laughter. Aquiel then said, "I told you, aunty Pat, I told you the donkey would bite me." I was so desperate for help that I told Aquiel to stop laughing and help me get my finger out the donkey's mouth. When he asked how he was supposed to do that, I told him to help me pry the donkey's mouth open, so I could pull my finger out.

I will never forget Aquiel's response when I told him to help me pry the donkey's mouth open, so I could pull my finger out. He said,

183

"Aunty Pat, the donkey is biting your finger off, and you want me to put my hand in her mouth to help you, so she can bite mine too?" Aquiel laughed so hard that day, but while he was laughing, I was screaming for help, but still, no one came. By that point, I was convinced Olive had already bitten my finger down to the bone.

Since help was not coming, I had to take the chance and use my left hand to try and pry the donkey's mouth open, so I could get my finger back. I had no idea Olive's jaw was that strong, but finally, after many attempts, I was able to get her mouth open just enough to retrieve my finger. Even when I got my finger out her mouth, the pain was so intense that it felt as though she was still biting down on it. Thank God my skin or bone was not broken, although it sure felt as though it was.

Aquiel looked at my finger, which was as red as a tomato and said, "And you wanted me to pet that donkey." I stood there feeling so much pain, not knowing if I would ever be able to move that finger again. Finally, when it was all over, a young lady that worked there showed up and asked what was wrong, because she heard screaming. When I told her Olive nearly took my finger off, she started laughing and said, "This isn't Olive."

"What? What do you mean this isn't Olive?" She then told me Olive was somewhere else for the day. "But this donkey looks just like Olive," I said, to which she responded, "Yes, they look very similar, but this donkey is not as friendly as Olive." When Aquiel and I heard that, we looked at each other and both burst into laughter, and continued laughing during our walk back to the house. Aquiel was going through so much with his illness, and as painful as it was nearly getting my finger bit off, it was well worth the pain I experienced that day, just to see him laugh so much.

After watching what I went through with the donkey who turned out not to be Olive, Aquiel decided he no longer wanted horse riding

lessons. He wanted to go see the movie Cars instead, but I didn't want to go, so I put it off and told him we would go at a later date. That was something I will forever regret not doing, when I had the chance. This is one of the reasons I say, "Don't put off until tomorrow what you can do today, because tomorrow might never come."

The cancer in Aquiel's jaw caused him to spit a lot which was very frustrating for him. While preparing our evening meal a few days after nearly getting my finger bitten off, Aquiel asked me the dreaded question. "Aunty Pat, why did this happen to me? Why do I have to go through this?" "Oh my God! How in the world am I going to answer that question," I questioned. I felt the tears bubbling up in my eyes, but did not want him to see me cry. Instead, I quickly excused myself and told him I needed to use the bathroom, so I could shed the tears without him seeing.

After washing my face to cover the fact that I had been crying, I returned to the kitchen and attempted to answer that painfully loaded question. I had no idea what to say, so I told him the truth. I told him I had no idea why God allowed that to happen to him, but God had His reason, a reason we don't understand. I explained that God wouldn't give us anything we could not bear, so God knew he was strong enough to get through it. I also told him that when he needed to talk about what he was going through and I was not around, he should get on his knees and talk to Jesus, the same way he would talk to me.

Our three wonderful weeks together came to an end when my sister returned, and it was time for him to return home. He left, and I still had not taken him to see the movie 'Cars' because of my own selfish reasons. I was so concerned with my own self-gratification, thinking I wasn't going to like the movie, instead of making it about what Aquiel wanted. I chose not to go because I thought the movie wasn't interesting enough for me to sit through. When that

opportunity left, I had no idea at the time it was going to be the one and only chance I would have to fulfil my nephews wish.

Chapter Fourteen:

Saying Goodbye

Having to goodbye for the last time to someone you love, knowing you will never see them again on this earth, is nothing less than devasting to your heart and soul. It feels as though your heart is being ripped out while your mind is in extreme agony. Oh, how I wish we did not have to experience such grief and despair during our travels through life. Unfortunately, there is nothing we can do to stop such occurrences when the time comes. Instead, all we can do is brace ourselves and try our best to stay afloat and not drown in the insufferable sea of sorrow.

The house didn't feel the same after Aquiel left - I missed his company but figured we would have many more quality times to spend with each other. I had not called to check up on daddy during the time Aquiel was with me, so I called aunty to see how he was doing. Instead of answering the question, aunty told me she needed my help, and that I needed to come and see for myself how daddy was doing. Because it was daddy, I dropped everything once again and booked a flight to leave the following week, so I could go see what was going on.

The day before I left, I called aunty but didn't tell her I would be there the next day. I asked her to put daddy on the phone, but he didn't speak in full sentences, so I wasn't sure he if understood what I was telling him. I told him that I would be there the following day, explaining that it was a surprise, so he wasn't to let aunty know. I called Aquiel to tell him I was going to Jamaica to see aunty and daddy and that I would see him when I got back.

When I arrived in Jamaica, I took a taxi to the house and found that the front gate and kitchen door was opened, which enabled me to enter unannounced. Aunty was sitting in the living room chair with her back towards me, so I walked up to her and hugged her from behind. The expression on her face, was a memorable one. "Are you trying to give me a heart attack," she asked, with joy written all over her face. Daddy walked around the corner to see what the excitement was all about, and when he saw it was me, he started laughing.

I was so happy to see daddy when I ran towards him with open arms, so I could hug and shower him with kisses. What touched my heart, was when aunty told me that a couple days prior, leading up to my arrival, she noticed something unusual with daddy. She told me he kept opening and closing his glasses case, so he could view something he had inside. When her curiosity got the better of her, she had to find out what was inside the case.

My heart leaped when aunty told me that when she took the case from daddy to see what he kept looking at, it was a picture of me. It was one of my pictures in my school uniform when I was around ten years old. Daddy had neatly folded the picture so it could fit securely in his case. Tears came to my eyes as I looked at him, realizing our bond was not broken by his loss of memory, because the love we had for each other was forever.

After aunty got over the shock that I was there, she looked at daddy and said, "So you knew Pat was coming." She told me that when daddy had hung up the phone with me the day before, he said, "Pat's coming tomorrow." Although he didn't keep the secret, luckily for me, it didn't spoil the surprise, because aunty didn't believe him. For the rest of that evening, daddy had a big smile on his face and followed me around the house, but he started calling me by my mother's name.

I was happy to be with him but sad to see he had lost a bit of weight since my last visit. He was still the pleasant man he had always been and through it all, he was looking very happy and joyful. I was heartbroken that we couldn't sit and have conversations like we use to in the past, but I still tried even though he wasn't responding. Seeing firsthand how Alzheimer's affected its captives, was overwhelming to say the least. When daddy did have something to say, most of the time, he didn't make much sense, except for when speaking of people and places from his past.

I found it strange when aunty told me she wanted my help, as well as wanting me to accompany her to daddy's doctor appointment. Even though I thought it odd, I didn't think too much of it during the drive to the appointment, which was already scheduled before I arrived. It was a two-hour ride to the doctor's office, but we had a good time on the way there. It reminded me of old times, when the three of us went on our weekend outings, so I tried to every moment of that trip.

My feelings of nostalgia abruptly vanished, once I found out why aunty really wanted me by her side. The doctor was in the reception area when we arrived, so aunty introduced me by telling him I was the niece she had told him about. I had no idea they wanted me in the examination room, until aunty told me to get up and come with them. It seemed like a basic check-up at first, when I observed the doctor checking daddy's weight and blood pressure, etc.

I secretly thought, "Is this why aunty wanted me to drop everything and come? It was then that aunty told the doctor to explain to me why she wanted me to be present at the appointment. I thought I was going to fall of the chair when the doctor said, "Your father has lung cancer." I looked at aunty and said, "What! No way! You've got to be kidding me, because this can't possibly be happening. You mean to tell me daddy really has cancer on top of everything else, and you didn't tell me?

After I blurted out my thoughts, I became silent while resonating on what I had just heard. The room seemed as though it was getting smaller, while my brain felt like it was collapsing. That familiar sense of gloom filled the atmosphere before I zoned out to what was being said in front of me. "Pat, Pat! Are you alright? Did you just hear what the doctor said? What do you think I should do?" "Uh? What should you do about what?" I replied. "Didn't you hear what the doctor just said?" aunty asked, "No, I didn't hear anything, I was in another dimension".

The doctor asked if we wanted a biopsy done on daddy's lungs. I don't know why he bothered to ask, if he was going to advise against it. His reasoning being the procedure would be a too painful and uncomfortable for daddy to undergo at his age. Both aunty and I agreed with the doctor not to put daddy through that unnecessarily. At that point and stage, a biopsy would have been of no use any way, because they already knew the cancer was stage four. I became angry with life and upset with aunty for not telling me ahead of time, instead of letting me find out at the doctor's office.

All sorts of thoughts ran through my mind that day. I couldn't help thinking, first mom, then Aquiel and now daddy. I wondered how I was going to handle such devasting news and still be strong for both aunty and daddy, but I had no choice. "During the two weeks I spent with them, I knew daddy was not going to be with us much longer. Having to say goodbye when it was time to leave, was one of the hardest things I had ever had to do, in fear that daddy might not be alive when I returned.

Before I left, I made an offer to aunty, suggesting I pack up and move out to Jamaica, so I could help her with daddy, but she was strongly against that idea. I couldn't bare being so far away from them, knowing what they were going through. I then decided I would make those plans, regardless if she agreed with it or not. When the time came for me to leave for the airport and say my farewell's, I

kissed daddy goodbye and told him I would return soon to see him, but as usual, he didn't answer, he just smiled.

When I reached home, all I could think about was Aqueil and daddy, and what they were going through. I wasn't the cheerful, outgoing person I usually was - I was vulnerable and heavily burdened, which was visible for everyone to see. I was in a somber mood, thinking about life, the evening I decided to make a phone call I will forever regret. I decided to call Michael, the one whom I met in Kingston while traveling with Denzil on my way to see uncle Lloyd.

I ended up keeping his number which I should have thrown away. He was happy to hear from me, and I actually felt much better after our two-hour conversation. Speaking to him took my mind off my problems for a while, and by the time we ended our conversation, we made plans to meet the next time I returned to Jamaica. Unbeknownst to me at the time, I had no idea it was going to be the following month. Just five weeks after leaving Jamaica, aunty called and told me I needed to come right away.

Aunty was concerned because daddy was getting worse, and she needed me by her side. Once again, I didn't hesitate. The moment I hung up the phone with her, I began looking for flights and found myself back in Jamaica by the end of that week. Michael picked me up from the airport and took me to the house, but I didn't invite him inside to meet aunty. Under the circumstances, I didn't think the time was appropriate, plus I didn't know him well enough to introduce him to anyone. When I went inside the house, aunty was very happy to see me, and daddy laughed and greeted me with a smile.

Daddy looked quite well, but aunty told me he wasn't doing well at all. I was worn out and tired, just wanting to shut down, but I had to be strong because they needed me. Aunty was heartbroken as well as fearful at the thought of losing her life's partner. I couldn't imagine

191

how emotionally devastating that was for her, but I knew it was heart wrenching. Daddy was holding a very big piece of my heart, and the thought of losing him was slowly killing me, so it was hard to imagine how bad it must have been for aunty.

I was drenched with the memories of losing mom, as well as what Aquiel was going through, so it all weighed so heavily on my heart. I wanted to scream - I needed to release all that was bottled up inside of me. I needed to be in an atmosphere where my spirit could be lifted, so the following day I called Michael. I told aunty I wanted to go to the market and asked if she needed anything, that way, I was able to get an opportunity to see Michael.

After aunty gave me her shopping list, I met Michael on the main road, and so we went into town together. It gave me a chance to breath as well as the chance to spend some time getting to know him better. I felt comfortable with him, as if I had known him for years. He was a good listener and a shoulder to cry on, which I needed. When I was with him, he helped me to forget my woes, even if it was just for a little while. That was what I needed, and I sure made the most of it.

When it was time to head back to the house, he didn't want us to part so soon, but I had to get back. I was already gone for a few hours and was trying to come up with a good excuse to give aunty as to why I took so long. Michael tried his best to persuade me to tell aunty about our friendship, but I refused. That was until the following week when I eventually gave in and told her about him. I didn't tell her how we really met, instead, I told her I had met him in America.

Aunty wanted to meet Michael and told me to invite him to Sunday dinner, which was music to his ears. When aunty met him and realized he didn't look as old as she thought he should be, she wanted to know his age. She wasn't happy at all that he was eleven years younger than me, when she publicly verbalized her opinion. Aunty spoke her mind and did it right in front of Michael, but daddy,

on the other hand, kept smiling and laughing - maybe it was Michael's gold teeth that daddy found so fascinating.

Dinner went well, but I noticed family members were arriving more than usual that day, only to find out that aunty called them to come see Michael. At the time, Michael seemed to be a blessing in disguise. He came to visit just about every other day, although aunty didn't mind because he helped around the house. She even had him cooking, because he was such a good cook. During my stay, Michael's presence helped a great deal with lightening my heavy heart.

When time was close for me to leave, I had a bad feeling in my stomach. I couldn't shake the feeling that I wouldn't see daddy again after I was gone. The feeling was so strong and familiar that I ended up changing my flight to prolong my stay for an additional week. I called my staff and dog sitter, to make sure everything was fine, but I wasn't doing so good. I was finally coming to terms with the fact that life as I had known it, would soon change again, and so I fell into a depressed state.

At night after I said goodnight to aunty and daddy, I sat on the veranda outside my bedroom and thought about life, along with all the ups and downs that came with it. I thought about mom and how much I missed her, wishing she was still with me. I thought about my childhood growing up in Nottingham and all the wonderful times I had, thanks to aunty and daddy. I also thought how time flies by so quickly, and how nothing in life was permanent. My thoughts led to me realizing I needed to come out of my depression and make the most of the time I had left with them.

My time was up, and I had to leave them again, but this time around was much harder than times past. That gut feeling was so familiar - it was the same dreadful feeling I had when I was about to lose mom. I didn't want to leave, but I had to get back to work - I

had a life to get back to, and bills to pay, but daddy was more important, so my mind was conflicted. I was stalling in agony as to what I should do. Aunty knew the thoughts running through my mind, when she said, "You have to leave."

I couldn't tell her I was afraid I wouldn't see daddy again, I had to keep that to myself. The driver was waiting to take me to the airport and kept urging me to hurry up, if I planned on making it to the airport on time. Aunty and daddy stood in the driveway, whilst the driver loaded the trunk of his car with my luggage. When the trunk was closed, I burst into tears, knowing I was about to say my final goodbye to daddy. I held on to him tightly, not wanting to let go. My legs couldn't move, my body froze, and my heart, mind and soul were drowning in despair.

History was repeating itself. The memory of saying goodbye to mom for the last time, overwhelmed my thoughts. The difference with mom, was I thought I was going to make it back to see her again, but with daddy, I knew I wasn't. It was such a crippling feeling. My heart felt extremely heavy, as though it was being weighed down by an anchor. "Give me one more minute," I said, when aunty told me I had to go. I kissed daddy on his cheek, and told him how much I loved him and how he would always have a permanent place in my heart.

Daddy smiled while aunty, with tears in her eyes, told me to hurry up and come back. I got into the taxi and jumped right back out and into daddy's arms. "I love you daddy with all my heart. Thank you for being the best daddy in the world. Thank you for everything you have done for me." I kissed him again and held on to him. Daddy had no idea why I was so distressed, which was a good thing, because the experience would have been so much worse.

When the taxi driver insisted once again that it was time for us to leave, I had to hug and kiss daddy one last time before I got into the

taxi again. I cried all the way to airport, and was not in the mood to hold a conversation with the driver, who was obviously trying to cheer me up. Michael met me at the airport, and when we hugged and said our goodbyes, he told me he wanted me in his life permanently. Not knowing how to respond, I told him I would call him when I reached home.

I was totally devastated during the flight back to Boston, but was looking forward to seeing Max and Fluff. I had been away from them for three and a half weeks, and was missing them very much. When I went to pick them up from the dog sitter, they were obviously upset with me for leaving them for so long, because they totally ignored me. They never ran to greet me like they usually did, in fact, they acted as though they never knew me.

During our hour and a half drive home, I thought about what Michael said at the airport. I was holding out for my soul mate this time around, and had refused to even consider getting into a serious relationship with another man, unless he was the one that the Lord had chosen for me. I was getting older, so I figured I had no more room for mistakes by getting involved with the wrong person. I needed a good man with integrity and a good character. I wanted someone I was in love with this time, and who was in love with me.

Our love had to be unconditional, someone who wanted me for me, not because of what I could do for him, or what he could get from me. I wanted someone who would make me feel like I was on top of the world when we were together. I needed someone who was faithful, affectionate, and family oriented. I wanted a man who when we were apart, we would both feel as though half of us was missing, and when we were together, we would feel whole again.

I wanted the fairy tale this time around, I wanted my prince charming, with great chemistry and passion between us. I was never the kind of woman to want a man for what he had, he just had to be

making an honest living. We could build our empire together from scratch, if need be, but I knew Michael was not that man. I had made two mistakes already with Reggie and Derrick, so I told myself that if there was to be a next time, the man would have to be my soulmate. I was adamant about not settling, and for years I refused to settle for anyone less.

I called Michael that night after calling aunty to let her know I arrived home safely. When I called him, he began telling me all the things I wanted to hear, but deep down, I knew he was what I considered to be a "No Go Zone." I should have listened to my inner voice that never steered me wrong, but I didn't. Michael wanted to be with me, and I, like a fool, told him I would. After having my mind made up to wait for Mr. Right, I turned around and gave in, because of the unknown.

The unknown of not knowing how long it would take for my soulmate's path to cross with mine, or even if there was a soulmate out there for me in the first place. So, in the end, I convinced myself that although I knew Michael wasn't my soul mate, I probably didn't have one. I came to the conclusion that if I did, I would have met him already. The thought weighed heavily on my mind, "should I, or shouldn't I?" Because I was already contemplating on moving to Jamaica to help aunty anyway, I thought, "Why not."

Chapter Fifteen:

Family Feuds

I've heard people talk about feuds when family members have passed, but I honestly thought my family was exempt. Never in my wildest dreams would I have imagined this could have happened to us. I usually hear of arguments about who should be in charge of funeral arrangements, but mostly I hear about people fighting over the will or inheritance. I don't understand why people allow these things to cause division in the family, because at the end of the day, everyone leaves this earth the same way they came, with nothing.

Four months after leaving Jamaica, I got the call at work that unforgettable morning. "Uncle Lester died this morning," my cousin said. The news left me speechless for a moment as I tried to let it sink in. I asked to speak to aunty, but when she came to the phone, all she said was, "Pat, your daddy is dead." When I heard the words come from her mouth, I couldn't hold it back any longer, and I burst into tears. I didn't get to ask when, where or how, because the next words I heard were, "Come now," before she ended the call.

Once again, I was searching for a flight so I could leave as soon as possible. I made all necessary arrangements that same day, and booked my flight to leave two days later. It was a good thing I had trained my assistant well, because an important report was due, and I could not stay to finish it. Aunty needed me, and I had to go, so I gave my assistant instructions, and left her in charge until I returned.

Michael met me at the airport accompanied by two of his friends. By the time we pulled up in the driveway that night, it was already after eleven. Aunty was sitting in the living room waiting for me along with Keisha, who was a young woman aunty took in. The

moment I greeted aunty with a hug, tears started flowing from both our eyes, as she said again, "Pat, your daddy is dead." I was knob inside and lost for words. I didn't know what to say to comfort her, because I was just as broken as she was.

Michael was saying goodbye, when aunty interrupted and told him it was too late for him to travel back to Kingston, and suggested he spend the night. Michael and I were both speechless when we turned and looked at each other with surprise. It was at that point I knew daddy's death not only affected aunty's heart, but her mind also. If it were under different circumstances, there was no way aunty would have told Michael to spend the night. Aunty didn't have to tell him twice, because he sure didn't hesitate when it came to accepting her invitation.

Aunty and I sat in the living room and talked for a while, and then I gave her the Youth Dew, Estee Lauder perfume set I bought for her. I thought it would be a nice surprise, with the hopes of cheering her up a little. I knew it was her favorite perfume when I was a child, because she always wore it, and made sure to buy another bottle before the one she had ran out. She couldn't get it in Jamaica, so I was hoping to put a smile on her face. Even though the smile was only for a short while, it was nice to see that my mission was accomplished.

She was in a somber mood, as was I, so we both sat together in silence, holding each other's hand, until she wanted to go to her room. I offered to stay with her, but she wanted to be by herself and quite frankly, so did I. I needed to let it all sink in, because from the moment I received the news, I didn't have much time to let it digest. Having to make plans and implement them so quickly, left me exhausted, with no time to really sit and comprehend our loss. Aunty didn't tell me how or where he died before she went to bed, so I didn't ask, not wanting to cause her any additional pain.

Michael slept downstairs while I slept in my usual room upstairs, unaware that he had woken early and began preparing breakfast for everyone. I was in a deep sleep when aunty came to wake me up, insisting I hurry up and get ready, because she had my day planned out for me. We were going to Brownstown that morning to the funeral home, so I could view daddy's body, which was something I was not looking forward too. When I was up, bathed, dressed and had breakfast, aunty told me to go in daddy's wardrobe and pick one of his suits for him to be buried in.

It was beginning to finally sink in when I went in aunty and daddy's bedroom and closed the door behind me. I sat on their bed, and for a short while, I found myself back down memory lane. I was so lost in my own little world, not realizing how much time had passed until I heard aunty calling me. A feeling of dread came over me, when I walked towards daddy's wardrobe. Seeing all his clothes caused me to cry, knowing he would never wear any of them again, other than the suite I would pick.

One suit stood out among the rest, so I didn't have to deliberate for very long. There was something about this one particular suit which I thought would be perfect. It was a traditional British suit that I like very much, so that was the one I chose. I picked a shirt and tie to match, along with matching socks and shoes, and laid them out on the bed. Just as I had finished laying everything out, aunty walked in the room. The moment she saw the suit, she started crying. When I asked what was wrong, aunty said, "You picked out Lester's favorite suit," then she left the room.

I, too, started crying when she told me that. It was the first time since hearing the news, that I really let out what I was feeling inside. I cried until I was weak and sat back down on the bed, staring at his suit. I snapped out of it when aunty came back in the room, so she could tell me to hurry up and bring the clothes, because the driver was downstairs waiting. Two carloads with family members were

accompanying us to the funeral home, but some family members, along with Michael, stayed behind.

It was my intention that Michael leave and go back to Kingston that morning, but aunty had other plans for him. Instead, she told him to stay and left him with chores she wanted done while we were gone. Uncle Lloyd, and I, were not pleased with the list of things aunty gave Michael to do, which including mopping all the tiled floors as well as re-doing the wallpapering on one of the living room walls. Michael didn't seem to mind, even though I did, but under the circumstances, it was best not to voice my disapproval.

Once aunty Davis arrived, we set out for the hour's journey to Brownstown. It seemed as though we arrived in no time, but I was delaying getting out of the car, dreading the inevitable of viewing daddy's lifeless body. Aunty hurried me out the car and took daddy's clothes from me, so she could give them to my cousin who owned the funeral home. Someone led me to the room where daddy was laying, but aunty didn't go in with me, instead, she insisted I go in by myself.

Daddy was in a small room, laying on a bed with white sheets, looking as though he was sleeping peacefully. Oddly enough, once the door shut behind me, I was no longer afraid. I stood by his side and told him how much I loved him, thanked him for all the wonderful memories he left me with, and for being the best father a girl could ever ask for. I then kissed him on his forehead and said goodbye. While making my way to the door, I turned to view my daddy one more time.

While I stood there staring at his face, I thought to myself, "I only have aunty, and aunty Davis left as parental figures in my life, now that mom and daddy have gone." A crippling feeling took over me, as my thoughts lingered on the fact that mom and daddy were never going to come back. I wouldn't be able to see or talk to them again here on earth, and it left me in a state of desolation. It was in that

moment, I realized that life, although at times can be so very sweet, it also comes with times of great bitterness.

During the drive back to the house, I thought about how I had expected to get a call that daddy had died, but never thought it would have been so soon. It dawned on me that no matter how much you try to prepare yourself, it doesn't help with relieving the pain in your heart once you hear the news that a loved one as passed. Preparation in one's mind doesn't make the mourning, heartbreak, or missing them any easier. I began experiencing those familiar feelings I had seven years prior when mom passed, but this time around, the fear of also losing aunty started creeping in.

When we got back to the house, before aunty went upstairs to her room and closed the door behind her, she decided to take her frustration out on Michael. Aunty was a very meticulous person, so she got upset when she noticed the streaks on her tiled floors. She started shouting at Michael when asking what he used to clean the floors. She embarrassed him when she scolded him for not using vinegar on the floors, as she instructed him too. All of us in the kitchen were standing in shock at the way aunty spoke to Michael, but uncle Lloyd, spoke up in Michael's defense.

He told aunty that Michael did not have to do anything in the house, but was kind enough to help, so she had no right to treat him that way. Aunty then went into her room and slammed the door behind her. Michael was humble and never said a word after aunty disgraced him. Instead, he got the vinegar and cleaned all the floors from upstairs, down, all over again. When he finished, aunty came out of her room, checked the floors and returned to her room and never came back out until later that evening.

A family member asked aunty why she allowed Michael to stay at her house, when she knew nothing about his background. What that family member didn't realize, was that aunty was going to repeat

what was said, and who said it. The next morning, aunty came in my room and told me Michael had stayed long enough, and she wanted him to leave. She then told me her cousin was coming from Kingston, and he and his wife were going to stay in my room, so I needed to find somewhere else to sleep.

I reminded aunty that I came all the way from America, and her cousin was only traveling from Kingston. I wanted to know why I had to come out of my room, when she had so many other spare rooms. Aunty didn't care about my feelings at that point, and gave me no explanation before she left the room. Shortly after, she came back and told me to change the sheets and take my suitcase out of the room. I was so hurt and confused and couldn't understand why aunty was treating me that way.

When I asked her where I was supposed to sleep, she told me I had to sleep in her room and share a bed with my other aunt, and if I didn't want to do that, then I should sleep on the floor. I put my suitcase in her room, but I chose to sleep downstairs in the living room on the couch instead. Our relationship started going downhill after that, especially after her cousin showed up with his mistress and not his wife. On top of that, he had no intention of staying at the house. He had property in Ocho Rios, and was already planning to stay there.

The original plan was that once her cousin arrived, we were all going to drive back to Brownstown to my cousin's funeral parlor, so aunty and I could pick out a coffin for daddy. Two carloads of family went again, but when we got there, aunty didn't ask me to pick out a coffin, she asked her cousin's mistress which one she liked. At first, I thought I must not have heard aunty correctly. "I know I didn't just hear aunty ask this woman, which coffin she liked.

Daddy raised me, not her, and who the hell is this woman anyway. She's not even family, and I dropped everything to take a flight and come help you, and you turn to some stranger," were the words I

grumbled to myself. I was livid, to say the least, so much so, that when I saw aunty weeping on the woman's shoulder, I walked out. A few minutes later, when I returned, I noticed aunty actually decided to get the coffin the woman picked, which was not the one I wanted for daddy.

I stayed silent during our car ride back to the house, unable to speak with anyone because of how angry I was. Aunty treated me with such contempt, which caused my inability to keep my thoughts to myself any longer. I followed aunty upstairs to her room and asked her if she cared about me at all, but she didn't answer. I brought up the past, how she treated me when I first returned to England after I had married Derrick. I reminded her how she put me out of my room, so she could accommodate her rich friend, whom she told me meant more to her than me.

When I reminded her of what she said to me, she turned around and said, "Yes! Dorrine did mean more to me than you." My spirit became grieved, I couldn't believe aunty was really treating me the way she was. Daddy was gone, and this was the outcome. Aunty and I were at war with one another, and for what reason I did not know. I couldn't understand why at a time when we should have been comforting one another, she was attacking me instead. I tried to tell myself she was just taking out her sadness on me, but it turned out not to be the case.

There was so much activity going on in the house, including jealousy from other family members who knew I was the only one that would inherit aunty and daddy's possessions. After overhearing a relative telling another relative that aunty shouldn't leave anything for me in her will, I was unable to pretend I didn't hear the conversation. Not only was I astonished that such a conversation was being held, but it opened my eyes. I was able to see that my family was not exempt from thinking about what they thought they were entitled too, during such sorrowful times.

I became so irate when I bluntly gave that person a piece of my mind. He was busy talking about what aunty should leave for him, and she wasn't even the one who died. That family member then had the nerve to tell me that I didn't live in Jamaica, and was not there to check up on aunty, but he and other relatives were there for her, so they should be the ones on the will. I had to remind him that aunty was still alive and kicking, before I asked if it had ever occurred to him that he could die before she did.

I then said, "When aunty and daddy were raising me in England, I heard about family members of which your name was never mentioned, so I don't even know if you are even really related to us." He then changed the subject and said he didn't know why aunty was carrying on the way she was over daddy's death, which was a very big mistake on his part. For the first and only time in my life, I disrespected an elder. I wanted to knock him out when I rushed after him. As old as he was, he moved so quickly out of his seat and ran into the bathroom, before I could get to punch him in his mouth.

Immediately after, I went upstairs to tell aunty the things he said, because I wanted her to tell him to leave. It didn't work because it seemed that everything I said, went in one of her ears and out the other. My other aunt, who was in the room with her, told me not to come in the room and tell aunty anything that would upset her. Meanwhile, she was in the room upsetting aunty, because the moment she went downstairs, aunty told me she was getting tired of her trying to run everything and wanted her to leave.

I couldn't wait for that day to end because it felt like total chaos in the house. People were coming and going, some drinking and telling jokes as if someone had not just died, and I wanted everyone gone. It turned out to be a very long day, and I just wanted everything to be over with, so I could go back home. I was surrounded by family whom I barely knew, because they grew up in Jamaica and I in England. Aunty was the one I wanted to spend time with, but I guess

I was delusional to think she was going to come around and realize we needed each other. But oh no! instead, she started treating me like an outsider.

I wanted to read the eulogy, but aunty wanted her cousin to read it instead of me. When he declined, she asked the daughter of one of her other neice's to read it. I wasn't involved with anything else other than picking out daddy's suit. I felt crushed on the inside, but I continued to show a smiling face, while aunty continued to reject me. It was far from being the experience I expected when I saw aunty turn to others instead of me, and I had no one to turn to other than Michael.

Once I realized that some family members were only hanging around because of what they could get, or thought they were entitled to, I just wanted to leave. The following day, aunty went out without me, so my other aunt and myself stayed at the house. It was only the both of us left, so we ended up having a conversation which led to her telling me how aunty does not forgive and will hold a grudge for years. She told me she had done something to aunty when she was eighteen years old, and yet aunty still had not forgiven her.

Right when the conversation was getting quite interesting, the phone rang, but I didn't want to answer it and disrupt the gossip I was hearing. My aunt insisted I answer the phone, which turned out to be the cousin from Kingston whom aunty had kicked me out the room for. He was calling to see how aunty was doing and how everything was going, because he had already left and went back home. I thought that was all he had called for, but to my great surprise, he said he wanted to talk to me, because he didn't like what he heard.

I fell silent at first, wondering what it was he heard about me. I had no idea what he could have possibly heard, but I certainly wasn't expecting it to be what he ended up telling me. He told me he heard that I met a stranger at the airport and spent the week with him. He went on to tell me that I needed to be careful because I could have put

myself in danger by going off with a stranger, and that was something only a prostitute did. "WHAT! What are you talking about, what stranger, and who in the world told you that lie?" I questioned.

When he said aunty told him, I literally felt pain go through my heart. Once again, I was livid and enraged, with all sorts of thoughts running through my mind. I then realized whoever told aunty a lie like that, was clearly trying to put a wedge between us. That individual went out of their way to try and turn aunty against me, and it was working. My aunt wanted to know what was going on when she overheard parts of the conversation. When I told her who called, and what was said, she also was very upset.

My aunt was more upset with aunty for spreading such a rumor, then she was with their cousin who called. She then suggested I no longer stay at aunty's home if that was the way I was going to be treated. Therefore, she suggested I go spend the rest of my stay with Michael. I voiced my concerns about her suggestion, knowing that it would drive a bigger wedge between me and aunty. My aunt, on the other hand, insisted it was the best thing for me to do. Her reason was I should show aunty that I was not going to allow her to continue treating me the way she was.

Getting away from all the drama sounded tempting, so I agreed, but decided I would wait until aunty returned, so I could tell her I was leaving and why. My aunt insisted I leave before aunty returned and informed me that she would tell aunty she was the one who told me to leave and explain why. Once she observed I was still pondering on the matter, she told me to call Michael and tell him to come get me, and to do it right away so I could be gone before aunty returned.

The more I thought about it, the more her suggestion made sense, but I had a bad feeling about this plan. My gut feeling told me to stay, but my heart said, maybe it was a good idea after all, because I needed to get out of that house. I packed my stuff, called Michael and told

him to come get me as soon as he could. When I was leaving, my aunt told me to come back the following day, so I could confront aunty about the false rumors she had spread about me.

Michael was happy because he was now able to spend some quality time with me, which was what he wanted all along. Once we arrived at Michael's place, I sat on the porch, and I cried. All the emotions that were bottled up inside of me came pouring out. Michael prepared dinner, but I couldn't eat, and although I appreciated him going out of his way to make me feel comfortable, I was unable to be a good companion, because I was wallowing in sorrow.

The following afternoon, I was very eager to return to aunty's, so I could confront her about what she said about me. I entered through the kitchen, but before I could take another step, there was aunty rushing around the corner, ready to tell me off. "Oh, so that's how you deal with me, you packed up and left, and couldn't even wait until I came back home to tell me you were leaving." I asked her if her sister didn't tell her why I left, and she said, "No."

I didn't believe that my other aunt didn't tell aunty, so I called my aunt to the kitchen and asked her in front of aunty. "What are you talking about?" she replied. "Uh! What do you mean what am I talking about?" You were the one who told me I shouldn't stay in aunty's house because of what she told her cousin and because of the way she is treating me. When I wanted to wait until aunty got back so I could tell her myself, you convinced me to leave and said you will tell her why I left, and would tell her that you were the one who told me to leave."

When she denied it and said, "Me and you never had no such conversation, so don't get me involved in you and Valda's argument." I was flabbergasted. I was so deeply hurt by what she did, and began wondering if she, too, was trying to drive a wedge between aunty and

myself. Things were bad enough between me and aunty, so for someone who I thought was an ally to do that to me, left me in dismay. I looked at her in disbelief, while feeling my already broken heart, being shattered.

Needless to say, aunty believed her, so I was seen as the liar. I didn't know what to say at that point, as I was basically left traumatized. I felt like my heart was drowning in tears, when aunty cursed me off and said all manner of hurtful things to me. I couldn't stay a moment longer, I had to leave, because my mind couldn't take any more. The plan was to call Michael when I was ready to leave, but for some reason, he must have known that visit wasn't going to end well. He ended up not leaving and was parked outside waiting for me.

After telling him what happened, he tried to console me, but it wasn't working. Only mom could have consoled me at that point, and all I kept thinking was, "I wished mom was here to see all this." It was a bitter pill to swallow, but I had to begin accepting the fact that my relationship with aunty would most likely never be the same again. There were too many ruthless people hanging around for what they could get, and they didn't care who they hurt in the process.

I was dreading the morning of the funeral, and while I was getting dressed, it started to sink in that I was about to see daddy for the last time here on earth. An ocean of thoughts flooded my mind, which left me weary, broken and disheartened. I thought about when I came to visit daddy for my birthday, and aunty wouldn't let me go to Dolphin Cove. I remembered that the last thing daddy ever said to me was, "I don't like it when you and Valda argue."

This was a time that aunty and I should have been close to each other. We should have been comforting each other, but instead, we were arguing, which was the one thing daddy did not want us to do. I sat on the edge of the bed and thought, "Never in my wildest dreams,

would I ever have thought that aunty and I would end up like this." I wanted Michael to come with me for moral support, but he didn't want to be around all the drama that was going on, and I couldn't blame him. I understood his reasoning, and although I really wanted him there for support, I had to go on my own.

I took a taxi, and when it pulled up in front of the church, I was hesitant before I got out. While standing in front of the church entrance peeking in, it all seemed so surreal. I couldn't believe I was at daddy's funeral. Daddy was loved by so many people, and the packed church revealed it. I had to look hard to find somewhere to sit, because at first glance, it looked as though all the seats were taken. I saw aunty, aunty Davis, and some of the family members sitting on the front rows, but there was obviously no space left for me.

I felt like a fish out of water, alone in a difficult and uncomfortable situation. Eventually, I found one available seat located in one of the middle rows which I sat in, surrounded by strangers. As I sat there in despair and looking around to see who I recognized amongst the many people who attended, it was heartwarming to see some of aunty and daddy's friends from England, whom I grew up around. I felt so alone and rejected, along with all the other emotions I was experiencing, while watching my cousin's daughter give the eulogy.

Apparently, it turned out that I was listed on the program to recite the poem I had written for daddy, but I wasn't listed as a family member, which nearly killed me. As I gave my speech, I looked at aunty as she gave me nothing but dirty looks. Because I wasn't listed as family, I made sure to let everyone know daddy raised me. I also made sure to inform everyone there who didn't already know, that although he wasn't my biological father, he was much more than that, because he was my daddy.

When the service was over, uncle Lloyd told me to ride with him to the burial ground. The burial spot happened to be land daddy's

parent's bought, which was where he was born and was raised as a child. I was surprised to see four police escorts leading the way through the traffic to the burial ground, which was an hour's drive away. With the somber mood I was in, it seemed like way more than just an hour before we finally arrived. After greeting family and friends who came from England, I went to talk to aunty, but she totally ignored me and walked away.

There were family and friends around who knew the relationship aunty and I once had, so it was obvious to them that something was terribly wrong. Various people questioned me as to what was going on between aunty and I, but I was not in the mood for explanations at that time, so I just simply said, "She's not talking to me." The land daddy was laid to rest on had many acres, so there was a vast amount of space for me to find somewhere secluded, so I could sit by myself.

Anyway, that was my plan, but every time I tried to slip away, someone came running up to me to ask where I was going. It turned out that I became the center of attention, because all those that didn't know me, wanted to meet me. I didn't get to go off and sit by myself because various people tried to keep me occupied by including me in their conversations. When someone came to tell me that a relative spoiled the large pot of soup by adding a pack of Kool Aid thinking it was seasoning, I laughed for the first time in quite some time.

It turned out not to be such a somber occasion after all. Daddy sure had a good home going, and it seemed no one was in a rush to leave, as everyone socialized and hung around until night fall. The person uncle Lloyd and I rode with had already left, and I sure wasn't going to drive back with aunty. What a relief it was when uncle Lloyd came to tell me that I was going to drive back with him and other relatives I met for the first time. On the way back to Ocho Rios, uncle Lloyd had convinced everyone to stop at a bar we were passing, because he wasn't ready to go back to aunty's house.

Apparently, they didn't think they drank enough at the burial site. I just wanted to get back to my destination and was not happy at first that they wanted to stop. But in the end, I made the most of it, and enjoyed the opportunity to get acquainted with the family members I used to hear aunty talk about when I was a child. They were much older than I, but they made me laugh a lot, so I ended up joining them by ordering a few rounds of drinks myself. I drank the same strong drinks the men were drinking, hoping the liquor would numb my pain, but as usual, that never helps.

Michael met us in Ocho Rios, and if it was up to uncle Lloyd we would have stopped again to have more drinks, but I was tired and worn out and just wanted to go to bed. Funny enough, once I arrived at Michael's, I didn't want to go to bed. I wanted to sit out on the veranda by myself, so I could just think about everything. Michael tried to lift my spirits, but nothing he said or did helped me to feel any better. I knew I had to travel the emotional roller coaster on my own, and therefore attempted to begin working on the healing process.

I spent four more days in Jamaica after the funeral, and went to visit aunty Davis before I left. We had a very long talk which in turn led me to learn things I otherwise would never have known. I guess I was finally old enough for aunty Davis to have a grown-up conversation with me, because she had never before been so open with me as she was that day. Apparently, I wasn't the only one that aunty had highly upset, but we kept our private talk to ourselves, and I never repeated what was uncovered that day.

I also went to say goodbye to aunty, but the only thing she said when she saw me was, "What are you doing at my house." I was hoping her attitude had change, so I could leave on a peaceful note, but she chose to continue her hostility towards me. I said, "Goodbye," but left with a heavy and grieving heart. The next stop was the airport, and it was also time to say goodbye to Michael - but before I did, he asked me again to marry him, and I like an idiot, told him I would.

Chapter Sixteen:
I Should Have Said No

It's not wise to make life changing decisions when you are in a vulnerable state of mind. Making those decisions are easy to do, but dealing with the consequences that derive from the decision isn't so easy to fix. If I had followed my head instead of my heart, I wouldn't have fallen off the garage wall, because I wouldn't have been there in the first place.

Nine months after daddy's funeral, I went back to Jamaica and married Michael. I saw the big red flag that said, "No Go Zone," but once again, I ignored it, and entered any way. Now, when I am asked why I married him, I just say, "I was experiencing temporary insanity." It was a small ceremony in a church, with his parents, his younger sister, two of his cousins, along with Brian, who was Michael's best man, and Brian's girlfriend. His mother and father were not together at the time, so the only time they spoke to each other was when they greeted each other in the church.

After the ceremony, Michael's dad suggested a restaurant for us to go eat, although he was unable to join us. We had a fairly good time eating, drinking and telling jokes, after which, excluding his mother and sister, the rest of us headed back to the all-inclusive hotel, which was booked for the weekend. Unbeknownst to us, only paid guest could enter the rooms, so we hung out on the third-floor parking garage deciding what to do next.

Michael went to the room ahead of me, and I stayed with our guests. We decided we would go out and have some drinks, then head to a club to enjoy the rest of the night. Nearly an hour had past, and Michael did not return, so I went to the room to find out what was

taking him so long. To my surprise, Michael was knocked out and in a deep sleep. I tried to get him up a couple of times, but he kept telling me to give him ten more minutes. It turned into an argument, so I left him and went outside to tell Brian that Michael wouldn't get up.

We were all standing by a wall in the parking garage, talking and watching the people beneath coming and going, when I decided to get comfortable and sit on the wall. A few minutes later, we saw Michael on the ground floor walking towards the entrance of the hotel grounds, but when Brian called out to him, Michael didn't hear him. We all watched in dismay has Michael got into a taxi and left. At that moment, I knew it was the beginning of the end, while wishing I could have turned back the clock a few hours and canceled the wedding.

Not only was I stunned, but was very angry, which is probably why I refused to pick up my cell phone and call him. At the time, I thought, "To hell with him then," as I decided I wasn't going to let his absence stop me from going out and having a good time. I told Brian and the others I was going to change out of my wedding dress and come right back, but then we started talking about Michael's behavior. Still sitting on the wall, like a child, I began swinging my legs back and forth, and the next thing I know, I found myself slipping backwards. Brian tried to grab hold of me, but I slid so quickly, so he was unable to get a strong grip.

The sudden intense feeling of fear that took over me was terrifying, especially when I turned amid the fall to observe the distance to the concrete ground beneath me. I remember thinking, "I can't believe this is happening to me and that I'm going to die this way." During the midst of my fall, it felt like it was happening in slow motion, like a scene from a movie. Only two thoughts entered my mind; I was going to either be dead upon impact, or all the bones in my body would be broken once I hit the concrete.

When I finally landed, the back of my head hit the ground first with a crash. The sound was so loud it left me convinced that my head was split open. I felt my lower back hit the ground next, after which I felt nothing. I was traumatized, weak and felt as though my life was slipping away, while wondering at the same time how much blood I was laying in. I laid peacefully with my eyes closed, ready to give up my spirit, during what I thought were my final moments of my life.

When I faintly heard my name being called, I thought I was already dead. It wasn't until I repeatedly heard my name, increasingly louder each time, that I realized I could open my eyes. I was startled when I saw Brian and the others standing over me, asking me at the same time, if I was okay. "I'm I dead?" I asked, and saw Brian laugh, before he answered and said, "No, you're not dead." "Well, if I'm not dead, how much blood do you see? Is it a lot?" I question. "What blood are you talking about? There is no blood." Brian replied.

"What! Look good, there is blood underneath my head because my head is split open." When Brian insisted there was no blood, I didn't believe. Even after telling Brian to lift my head and check, it took much convincing before I believed my head wasn't split open. The mind as such powerful capabilities, I learned that night. I say this because, once convinced that I was fine, I felt revived, energized and quickly jumped up on my feet.

I was in awe, when I looked up to see from where I fell, observing the distance and knowing that God spared my life yet again. I should have been dead upon impact, especially with my head hitting the ground first, and yet I didn't even have a headache. My back was a bit sore, but it wasn't sore enough to stop me from going out to party as planned. I had them wait for me while I went to the room so I could take a shower and change. Brian, his girlfriend, and I, headed to club and drove Michael's cousin's home on the way.

Although I was rejoicing that I came out of my ordeal practically uninjured, there was still a feeling of emptiness inside me. I felt alone, and my spirit was disturbed after realizing I had made a terrible mistake that day. Trying to overthrow my thoughts by guzzling down a few drinks and singing along to the familiar songs being played, didn't make it easier to fully enjoy the vibe like I wanted too. I was bewildered and unable to dismiss the fact that I was spending my wedding night with my so-called husband's best friend and his girlfriend, instead of the man I had just married a few hours prior.

Brian could see the unhappiness on my face even though I tried hard to mask it. He tried to help me forget my woes, but to no avail. I was lost once again in my own world, watching on as others were enjoying themselves, while I stood there emotional, reliving the day's events. We stayed at the club until around six o'clock the following morning, at which point I just wanted to go back to the hotel and rest. I wasn't sure how I was going to feel after I had gotten some sleep, so I told Brian I would call him when I was ready for him to pick me up.

I sat on the bed, lost deep in thought, thinking how the day before started off with joy, but ended with deep sadness. Before I dozed off, I put my phone on the table next to me, and once my head hit the pillow, I was out. I woke up after only sleeping for approximately three hours, with an urge to run to the bathroom because of all the alcohol I drank. This was when I realized that going out dancing after the kind of accident I had, was a very, very bad idea. I couldn't move,I couldn't even sit up on the bed, which caused me to believe I was paralyzed.

An intense and excruciating pain, unlike anything I had ever felt before, consumed my body. I compared it to being hit by a speeding truck that crushed every bone in my body. Fear invaded my emotions and left me thinking I would never be able to move or walk again. My hope revived once I remembered the power of faith and knowing that even if it was as small as mustard seed, it could move mountains.

I then started rebuking the thoughts of being paralyzed, even though it sure felt like I was.

I observed the time on the clock, which was hanging on the wall in front of me, so I knew an hour had passed since I had awoken, and still was unable to move. I wanted so badly to relieve my bladder, and being unable to move even a limb, was pure agony. It was such a scary feeling, which lead me to think about all the people who were really paralyzed. It wasn't until that moment that I was able to relate to the crippling shock and fear they must have experienced when receiving the news they would no longer walk again.

Compassion filled my heart, and I no longer thought about what I was going through, but instead, I was more concerned with those who were permanently disabled and what they were going through. As I sat there thinking of the mental anguish, depression and loss of hope, these people most likely experienced, my train of thought broke when I heard my cell phone ring. I struggled to reach my phone, which was laying in arms reach, but I was unable to reach it. It was hard to accept what was happening to me, because it was so sudden and unexpected.

The pain wasn't subsiding, even though two hours had now passed. I laid there fighting my emotions while feeling petrified, unable to even get my phone to call for help. Keeping the faith was like a tug of war in my head. Trying to subdue the negative thoughts that kept popping up in my mind and replacing them with positive thoughts, was tiring. I kept telling myself that this to was going to pass and that the paralysis throughout my body was only temporary. Finally, after nearly three hours, suddenly, I was able to move.

What a relief it was to finally empty my bladder. The strange thing was, that once I was able to move, I no longer felt any pain, not even soreness. I decided to take a shower and freshen up, when I heard the phone ring again. It was Brian calling, wanting to know

why I didn't answered the phone when he called me earlier. After explaining what happened, he suggested he come and take me to see a doctor, but I wasn't interested in going to see a doctor. I wanted to get my suitcase from Michael's house, because as far as I was concerned, the marriage was over.

Once I was bathed and dressed, I sat on the bed waiting for Brian and his girlfriend to arrive. Swarmed with many thoughts, I wanted to kick myself for being so stupid. Being so stupid to have married Michael instead of waiting for the right person. I knew then and there I wasn't going to try and make that marriage work. My mind was made up - I was going to reverse the foolish decision I made, and get an annulment as soon as I returned home.

When Brian arrived, I was eager to leave, but he insisted I tell the hotel manager what happened. When I found the manager and informed him that I had fallen from the parking lot wall the evening before, I can't help but laugh every time I remember his response. "Who told you to go sit on the wall?" "Nobody told me to sit on the wall," I answered. "So why are you telling me this for,? If you chose to sit on the wall and fell off, that has nothing to do with the hotel." I couldn't believe how rude he was, although, I had to laugh when I thought about it, because he was right.

My next destination was to Hamilton Mountain, so I could get my suitcases from Michael. Brian made me promise I wasn't going to start any trouble when we got there, because he knew how angry I was with Michael. Once I convinced Brian I would be on my best behavior, he agreed to take me. Upon arrival, Brian got out and left me and his girlfriend in the car, while he spoke to Michael in private. He then motioned us to come, at which point Michael greeted Brian's girlfriend, but said nothing to me.

I didn't say anything to Michael either when I passed him and went into the room where my suitcases were. Michael followed

behind me to see what I was going do, then an argument erupted when he saw me pick up my luggage. He told me I couldn't take them, and if I was leaving, then I was going to leave without them. I was infuriated when I told him he could not stop me from taking what belonged to me. I went on to inform him the marriage was over, as well as telling him of my plans to get an annulment once I returned home.

I guess I should not have told him my plans, because things got heated when I grabbed my suitcase and tried walking towards the door. Brian saw what was coming, which was the reason he suggested I leave the suitcase and come back later, but I had no intention of leaving without them. Michael grabbed the suitcases out of my hand, and when he did, I pushed him, and so the fight started. I have no idea how we ended up on the bed throwing punches at each other, but when that happened, Brian jumped in, trying to break it up.

Brian was trying to get me off Michael, and when he did, he held Michael down on the bed. Brain then told me leave, but instead, I jumped on top of Michael and started punching him. Michael then began punching both of us, so when Brian's girlfriend jumped in, we were all on the bed, rolling around. It was a day to remember, because with all that pushing and punching, I still had to leave without my suitcases. Brian somehow managed to convince me it was best to leave and come back after the waters had settled, so to speak.

Michael certainly fought to keep my luggage at his house that day, knowing that if I had left with them under those circumstances, he would never see me again. Brian was upset with me and voiced his displeasure with my actions, once we were in the car. His girlfriend back me up though, reminding him I had all right to take what belonged to me. We ended up laughing about it all when we revisted everything that unexpectedly happened. What we found most amusing, was when they both ended up on the bed trying to break up the fight.

Brian drove me back to the hotel that evening, with the plan to pick me up the following morning. When morning came, I was ready to make another attempt at retrieving my suitcase, but Brian didn't want to take me back to Michael's house. Michael must have thought long and hard after our fight, because when we arrived, he apologized for everything, and explained why he didn't want me to take my suitcase. I already knew the reason, but it didn't change anything, because I knew our marriage was still over.

We talked and eventually made up, after which he left with us to go hang out in the town. It was our first activity together as a married couple, with Brian and his girlfriend included. I still had one day left of my hotel stay and did not want my money to go to waste. Michael returned with me to the hotel that evening, but was not allowed to go to the room, because he threw away the wristband he was given, which showed he was a paid guest. I was not going to waste my last night, so I ended up staying by myself, and he went back home.

So, it turned out that I ended up spending our honeymoon weekend in the hotel by myself and spent the days and evenings with Brian and his girlfriend. After four days of marriage, we finally spent the fourth night together. I had one more week left in the country, which did turn out to be a lot of fun. Michael made me breakfast in bed every morning, cooked all my meals, and even washed my clothes by hand. But although I was leaving on good terms, as far I as was concerned, the marriage was still nonexistent.

Michael wanted me to extend my stay because of my plans to move to Miami, Florida, but I had a lot to accomplish, and little time to do it in. I also wanted to see Aquiel, before he left for Honduras, so I told Michael I would return for Christmas, after I moved to Florida. I went to visit aunty and aunty Davis before I left, but aunty did not welcome me, in fact, she asked again why I had come to her house. Because of the way she greeted me, I apologized for coming to her house, wished her the best, then turned around and left.

When I got back home, I found out Aqueil's cancer was spreading quickly, but it didn't seem to affect his spirit, because he was as cheerful as he always was. A month after I returned, he left for Honduras for a few weeks of holistic treatments, during which time I was making plans to leave the state. I had been in Boston for over eighteen years and needed a change - Life in Boston just wasn't the same without mom. Every winter I went into depression, until summer came, and I was tired of the same old routines.

Tired of shoveling snow, tired of the freezing cold weather - I was just basically tired of everything. I wasn't sure where I wanted to go at first, but I knew it had to be somewhere that was warm all year round. After a long deliberation, I finally chose Florida as the state I wanted to move too, although I had never actually been there before, other than walking through the Miami International Airport. I chose Miami for what some people would say was a crazy reason. My decision derived from having a connecting flight in Miami, one winter when traveling back to Massachusetts from Jamaica.

There was a three-hour layover, so I decided to spend it touring the Miami International Airport. After walking around, I ended up in the parking lot, which left me mesmerized when I looked over the wall and was able to see the scenery outside the airport. Once I saw all the beautiful palm trees swaying back and forth in the warm breeze, I wanted to leave the airport so I could explore, but couldn't. I wished Miami was also my destination, when I saw people leaving the airport and getting into taxis, when I had to go back to the cold weather waiting for me in Boston.

After remembering my three-hour layover in Miami with the tropical feel it had, I decided Miami was the place I wanted to live. I made plans to leave by November of that year, hoping I would be gone before the snow came. I resigned from my position as Executive Director, which was a very bittersweet task. When I told my staff I was leaving, they didn't take the news very well. They knew I wanted

a new adventure and change of environment, but they didn't want me to go.

Aquiel came back shortly before I left for Miami and spent a day with me. He looked really good, even though my sister told me the cancer had spread throughout his body. My sister also informed me that she too was moving out of state, but didn't tell me exactly when she was planning to leave. About two weeks before I left, Aquiel wanted to spend the weekend with me, but I put it of that weekend, because I had so many errands to run, and didn't want to overexert him.

I planned to take him the following weekend, so that way Aquiel and I could spend quality time together. During the following week, my sister called to tell me that she and Aqueil were leaving the next day. I was speechless at first because it was so sudden. I was at work and asked her to bring him to my office, so I could see him before they left, but she didn't. So once again, I lost the chance to do something with him, that has left me with regret.

If I had known that the weekend Aquiel wanted to spend with me, was going to be the last chance I was going to get to spend with him, I would have put everything else on hold. This experience has impacted me greatly, and as taught me a valuable lesson I will never forget. It is so easy to take life for granted - We put things off without realizing a loved one can be here today and gone tomorrow. In my case, tomorrow never came, because I never got the chance to ever see or speak to Aquiel again.

Chapter Seventeen:

Not What I Expected

If you ever decide to move out of state or the country, think it through and plan your move wisely. Don't do what I did at the spur of the moment, and rush without planning it carefully. It did work out for me in the end, but only after I went through hell first.

I said my goodbyes to my brother, co-workers and friends in Boston, then Max, Fluff and myself started our long journey to our new home in Miami. My friends repeatedly voiced their concerns about me driving that distance by myself. They always said I had no sense of direction, so they were worried, but joked and said if I drove by myself, I would most likely end up in another country. I left my BMW with my brother, rented a SUV, and followed the direction given to me. I was told to stay on the I 95 heading south, and not to get off until I reached Miami.

By the time I reached New Jersey that evening, which took me five hours, I was tired of driving. It was the first time I drove that distance by myself, so I ended up renting a hotel room and stayed there for two days. I wasn't in a rush, so I decided to enjoy my cross-country drive, and make the most of it. I called my cousin and told her when I was about to pass through South Carolina, so she insisted I stop and visit with her, before I continued my journey.

Four days into my journey, my new landlord called to ask if I had gotten lost, and if not, why was it taking me so long to reach Miami. After reassuring him I was fine, I told him I would probably arrive the following day. He was concerned because he expected me to arrive three days prior, and I had only reached to Georgia on day four. I hung up the phone with the intention of driving non-stop to Miami

other than stopping for potty breaks and coffee, but that didn't happen.

However, I did drive non-stop until I saw the sign that read "Welcome to Florida." With great excitement, I shouted out to Max and Fluff, "We made it, we are Floridians now." Once I entered Jacksonville, I couldn't resist stopping to sightsee. Signs to the beach stood out and were luring me in its direction, so I automatically followed. We ended up staying at the beach for a few hours, as the beach was Max and Fluff's favorite place.

After hanging around on the beach, I wasn't in the mood to continue my drive to Miami that day, so I decided to stay in Jacksonville. I wanted to stay at a beach front hotel, so I set out to find one that would allow pets. It didn't take long to find a strip of hotels located in front of a beach, but they looked quite expensive from the outside. I decided to go to each hotel so I could inquire about the prices and find out if they allowed dogs, but I chose to skip the first hotel I saw.

The first hotel along the strip not only looked expensive, but I was sure they didn't allow pet's, so I didn't bother to go in and inquire. One after another, I received the same response, "We do not allow pets." My heart started beating fast with anxiety upon walking up to the front desk of the only hotel left. "Sorry, we do not allow pets." That was it, my hope for staying in a hotel on the beach was shattered. I don't know why I bothered, but I asked the receptionist if she knew of any hotel nearby that did allowed pets.

I didn't want to settle for a hotel that wasn't on the beach, but I had no choice. When she told me the first hotel on the strip was the only one that allowed pets, I was totally amazed. It was the only one I chose not to try, assuming for sure they would not. That was another instance where I learned not to judge a book by its cover. I was

delighted when I went inside and saw the lovely interior, and even more delighted when I realized the rooms were price reasonably.

I wanted a room over-looking the ocean, but none were available except for a suite, so I took it. The suite was two hundred dollars per day, with an additional thirty-six dollars each for Max and Fluff. I had no intention of paying seventy-two dollars for Max and Fluff's stay for one night at a hotel, so I decided to pay for Max and sneak Fluff in. I paid the hotel fee and went back outside to get my bags and to figure out how I was going to carry Fluff without him being seen.

I had a Louis Vuitton traveling bag that was perfect to hide fluff in, so I put him in it and told him to be quiet. I passed the front desk clerk with Max and tried to move quickly towards the elevator without looking suspicious. Fluff was trying to pop his head out the bag so he could see what was going on, so I was nervous about getting caught. Once in the elevator, I made a sigh of relief. Fluff was good and didn't make a sound, leading me to believe I had pulled it off. I was happy because we had the elevator to ourselves, so I thought.

Right, when the elevator door began to shut, someone came and pressed the button, and the doors opened up again. I was relieved when the gentleman who walked in wasn't an employee. But then the woman who walked in behind him, was. Not only was she an employee, she was the other lady behind the front desk when I paid for the suite, and she heard when I said I only had one dog. I started to panic, hoping that Fluff wouldn't give me away, but that was wishful thinking. The moment the elevator door shut again, Fluff popped his head out the bag, so he could be noisy.

She looked startled at first, not expecting to see a dog's head pop up out of my bag. Her smile then turned into laughter when she observed the look on my face, which read, "Busted." She knew what I did, but she didn't say anything. Once in the hotel room, I became

nervous every time I heard someone talking outside the hotel room door. I kept expecting someone to knock on the door to ask me about sneaking Fluff in the hotel, but no one did.

It didn't dawn on me until it was time to take Max and Fluff out to pee, that I would have to hide Fluff in my bag each time and fret about being caught. It was at this point I regretted not paying the extra money for Fluff. It would have been much easier to just pay for him, because I could have gone in and out freely, without having to worry about Fluff being seen. Another lesson learned in this scenario was that it doesn't pay to be dishonest.

Thinking back now, if anyone was paying attention to me, I must have looked pretty suspicious walking in and out of the hotel with that big bag. Luckily for me, Fluff never once barked or made a sound. Other than being seen in the elevator because he was being noisy, no other employee saw him, so I ended up getting away with only paying for Max's stay. I wanted to get every penny's worth of my stay, so I didn't leave before check-out. When we did finally leave, I decided I wasn't going to stop again until we made it to Miami.

I had no idea it was going to be another eight hours before I got to Miami. As tired as I was, I was determined to keep going, plus the landlord kept calling to see how far I had reached. Excitement took over me when I finally saw the sign, "Welcome to Miami." I felt a sense of accomplishment. I had done something I had never done before, and although a twenty-four-hour drive, took me six days, I drove by myself from Massachusetts to Florida.

I had reached my destination, and my adventure was about to begin. I was on the eve of a new beginning, and great opportunities were about to unfold, so I thought. I was looking forward to good things happening in my life, meeting new people and seeing new places. The world was now my oyster, and my possibilities would be endless. I truly believed that the latter part of my life was going to be

greater than my beginning. But during that season of my life, it all turned out to be wishful thinking. Instead, it turned out that moving to Miami was the beginning of my trials and tribulations.

When I arrived at the studio I rented, I was stunned to see that it was really a remodeled car garage in Miami Shores. I couldn't tell from the pictures I saw before-hand, so it turned out to be quite disappointing, but I decided to look on the brighter side. Regardless of the fact that I gave up a beautiful home to live in a garage, it was still a new beginning, and I was looking forward to great things happening.

My new landlord was a very pleasant Cuban gentleman, who greeted me with a big hug. It was evident that he was very happy I had finally arrived safe and sound. He made me feel welcome and talked a lot while he helped me unload the car. He also waited until I was settled in, before he left on his dinner date that I caused him to be late for. The following morning, he came over and told me where the supermarket was and how to get to South Beach, suggesting I familiarize myself with the neighborhood.

I really had no intention of leaving to go anywhere that day. As far as I was concerned, I had done enough driving and decided to stay inside for two days, before I went to explore my new surroundings. I wasn't happy with the fact I was living in a car garage, but the neighborhood was clean, scenic and quiet, which did please me. I figured I would stay there until I found some place more suitable and would take my time to look around, after I returned from my trip to Jamaica.

I booked a flight to spend Christmas and New Years in Jamaica, because I wanted to visit aunty so I could see if her attitude towards me had changed. With all my planning, it never occurred to me that I had no sitter for Max and Fluff and didn't know anyone in Miami that I could leave them with. I searched the internet for a pet sitter,

which ended up costing me five hundred dollars for their three-week stay.

When I arrived in Jamaica and exited the airport, it was apparent that Michael was very happy to see me. He kissed and hugged me as though he didn't want to let me go, mean while I was thinking, "Get all the hugs you can, because you are soon to be my ex-husband." He was afraid he wasn't going to see me again, he explained when I asked why he was holding me so tight.

Michael wanted the marriage to work, but I, on the other hand, had no intention of trying to save what I considered to be a disfunctional and crazy union. We ended up having a perfect two weeks of marriage bliss, which left me thinking that maybe I had been too hasty in deciding to put an end to the marriage. That was until New Year's Eve, when he and his cousin Robert went out together before Robert left the country to go live with his new wife.

I didn't want to go with them - I just wanted to enjoy a quiet evening by myself. I sat on the balcony of the hotel as I enjoyed a glass of Bailey's and listened to the music playing in the streets below. It turned out Michael was jealous that Robert was leaving, and he wasn't, so when he returned that night, he took his frustrations out on me. The other side of him came out to the light when he showed me how ungrateful and materialistic, he really was.

I was deeply hurt as I listened to his ungratefulness, because I knew he was speaking what he truly felt. One thing I have learned over the years, is that when someone has been drinking, they speak what is truly in their heart. I never said a word to him, I just listened and took it all in. After he finished complaining, I left to go sit outside on the balcony so I could bring in New Year's by myself. I watched everyone in the streets shouting "Happy New Years" and having fun, while I sat contemplating my next move.

I always heard people say that whatever New Year's found you doing, that is what you would end up doing that year. So, the fact that we didn't see the New Years in together, was another sign for me that we would not be together that year. When I went back in the hotel room, Michael was already sleeping, but I couldn't sleep. I couldn't shake the things he said out of my mind. Morning seemed to arrive quickly, and I was up bathed and dressed, before Michael had woken up.

I couldn't wait to address the things he had said the night before, and so when I did, he told me I was lying because he never said those things. I didn't bother to argue because there was no point. Instead, I decided I would let him say what he wanted, and I would just leave it at that. The atmosphere had changed, and nothing he said or did could make up for the things he said. I just looked at him knowing it was really going to be the last time we spent together.

Even though my intention of traveling to Jamaica was to visit aunty, I kept putting it off, because I was trying to avoid the rejection I knew I was going to receive. I had only a couple days left, and although I had already visited aunty Davis a couple times, I couldn't bring myself to visit aunty. After much deliberation, I decided to go, only because aunty Davis convinced me to go visit, even if it was just to say "Hello."

Aunty was in the back yard with two of her friends when I arrived, but she didn't notice me. She was bent down tending to her flowers, when her friends greeted me with smiles and hugs. Aunty then got up and turned to see whom they were greeting, but obviously did not realize it was me at first. I say this because aunty also greeted me with a smile, but that quickly changed when she realized who she was smiling at. I wasn't surprised by her reaction when I said, "Hello aunty," and she responded by saying, "What are you doing in my house, I don't want to see you."

Her guests were appalled, as I could tell by the looks on their faces. Her friend, who was a nurse, did not hold back her disgust at the way aunty dealt with me. She made me laugh, when she grumbled something and gave aunty some dirty looks, after which she voiced her disappointment in aunty. Aunty didn't care what anyone thought, and I, on the other hand, was not shocked by her response. Aunty had already said and done so much to hurt me, so it didn't surprise me.

I stood there, not knowing what to do, until she told me to leave her house. I said, "Goodbye," to her friends and immediately left the premises. It was a good thing I told the taxi to wait for me just in case I wasn't welcomed, because it turned out that I wasn't. I wondered around town for a while, did some shopping, then spent some time at the beach before I headed back to the hotel where Michael was waiting for me.

I was in a daze, my heart was heavy, and I wanted to spend the last two days by myself, but I couldn't get rid of Michael. I didn't want him around, and after the rejection I got from aunty, I was disgusted with them both, and wanted to be left alone. I spent most of my last two days in the hotel room in depression. I felt unhappy, rejected, unwanted, unloved and alone. I was kicking myself for coming back to Jamaica in the first place, and couldn't wait to leave.

I was also kicking myself for getting involved with Michael against my better judgement. I also regretted allowing aunty Davis to convince me to visit aunty, when I knew she would reject me. I had to accept the fact that our relationship might never be repaired, and that was a hard pill to swallow. I started missing Max and Fluff and was longing to be with them, knowing that they were the only ones who could bring me some joy in the midst of my sadness.

Those last two days seemed to pass by so slowly, but finally, the day came for me to leave. I was up bright and early that morning, anxious to leave and get to the airport. Michael tried very hard to get

on my good side, but there wasn't a thing he could do to change my mind. I wanted to go to the airport by myself, but he insisted on accompanying me. The tension between us was visible, and I think he knew it was over, even though it wasn't mentioned.

After checking in my suitcase, I still had plenty of time before boarding my flight, so Michael wanted to know why I was in such a rush to get to the boarding area. He wanted me to spend as much time with him as I could, but I couldn't wait to be rid of him. I told him goodbye and pulled away when he learned over to kiss me. The disappointment I felt with the marriage overwhelmed me, which led to tears rolling down my cheeks.

Michael told me not to worry, reassuring me that we would see each other soon. He had no idea my tears represented me knowing it was over between us. He hadn't the slightest inclination that I had no intention of ever seeing him again. When I turned and walked away, I didn't look back. He was now a part of my past, with no place in my future. He was obviously unaware when he called out to me to blow me a kiss, and said, "See you soon."

I didn't answer him, instead, I gave him a look to tell him without words, that he will not see me soon, because I'm done. Once again, I walked away without looking back. I wanted him to get the message that I no longer had any interest in him. If I looked back and waved, it would send the wrong message, and I wanted him to leave the airport knowing I didn't want anything else to do with him.

On the plane ride back, I couldn't shake the emotions I was feeling. My thoughts seemed to keep piling up, my emotions were running wild, and my heart felt like it was sinking. The fact that it was over with Michael didn't bother me as much as how aunty had rejected and hurt me again. I had no one left - all the important people that were a part of my life since childhood were absent, except for aunty Davis, Bev, Shaun and Andrew. I couldn't get over the fact that

it felt as though aunty had ripped my heart out, and never give it a second thought as to what she was doing to me.

When the plane landed, I remembered I at least had Max and Fluff close by, knowing their love was unconditional, so I was very eager to see them. When I went to pick them up, Max ignored me for leaving him so long, but Fluff ran to me when he realized it was me at the door. An hour later, we were back in our little garage, and I needed to think what my next move was going to be. It was hard concentrating on anything else other than aunty and Michael, for the simple fact that they were the main cause of my heartbreak.

I couldn't get over what a fool I had been for marrying Michael, after swearing I would wait for my soul mate the next time around. I started thinking about the way things used to be when mom and daddy were still alive. All the happy and wonderful memories of the past, and all the fun I had growing up in Nottingham. Now my family unit was broken and could never be repaired, because mom and daddy were permanently gone, and aunty wanted nothing to do with me.

I was like a rolling stone, not knowing what direction to take. I was depressed and confused and was so very lonely. Max and Fluff were great companions, but when I spoke to them, they didn't answer back. I was unable to sleep for days after I returned, tossing and turning all night long. I spent my nights thinking, worrying, and wondering if the situation between aunty and I would ever get better. I had to get out of the mind frame I was in, which was hard to do, but I had to find work and begin settling down so I could move on with my life.

I searched the job sites and applied for various positions, but got no replies. When time came to return the rental I had, I went and bought a used BMW convertible for eight thousand dollars. I drove around for weeks looking for a job, but was having no luck at all. When my money started running low, I decided to sell the car and get

something cheaper. Apparently, the car had a sticker on the side of the door, which I did see, but had no idea what it meant, and off course, the dealer failed to tell me.

The sticker meant that the car was totaled in an accident and was rebuilt, which automatically depreciated the value, so I was basically ripped off. The highest offer I got for it was two thousand five hundred dollars, less than two months after buying it. That was another big disappointment which left me crying all the way home. I thought I was going to get at least seven thousand dollars and was planning to get something cheaper until I found a job. Unfortunately for me, I was unable to buy anything else at that point, because I still needed to pay rent and eat, and I was having absolutely no luck in finding employment.

Chapter Eighteen:

Unforeseen Circumstances

There will most likely be a point in life when it seems as though there is no light at the end of the tunnel. During that phase, it is so easy to lose hope of a brighter future or change in circumstance. I have learned that so long as you have life, there is always hope. Instead of thinking about the week, months and years ahead, just think about making it through the day you are currently in. No matter how dark and hopeless the situation I found myself in, there was always light at the end of each tunnel.

Three months after arriving to Miami, the landlord announced he was selling his house, and asked me if I wanted to buy it. "Yeah, right," I thought, I was down to my last thousand dollars and still had to pay for the rental I got after I sold the car. I was panicking because I was sure I would have found employment quickly and never foreseen my money running out before I got a job. I did happen to come across an advertisement seeking a partner for a cleaning company that stated living accommodations were included, so I jumped at the opportunity.

The employer set up a time for us to meet for the interview, which was held in a condo on Miami Beach. When I arrived, I was surprised to see the person was a young black man named Darrel, who was in his mid-twenties. The interview, if I can even call it that, was held in a very luxurious high-end condo situated right on the beach, which happen to be the living accommodation that was included. The job requirements were simply to find companies and homeowners that needed cleaning services and provide the service through people he had already hired.

To cut a long story short, I was hired and was told I could move in right away. I had to give my landlord notice, so I told Darrell I would arrange to make the move the following week. He wanted me drive to Kendall with him to meet someone he said was another business partner who also happened to be the owner of the condo. Max and Fluff came with me for the interview, so they were also with me when I drove behind Darrel to Kendall to meet the owner of the condo.

The owner was a good looking Italian male around my age, named Roberto. He was pleasant and quite friendly, but seemed a bit strange to me. While giving me a tour of his home, he asked me a few questions about myself, and then told me a bit about his background. He was divorced, and a dog lover who bragged about his guard dog that went through the same training as police dogs. He talked about his four other houses, his tenants across the street whom he wanted to get rid of, as well as and the businesses he owned.

When I was leaving, he told me he hoped to see me again soon, and added that he was looking forward to me helping with the business. Something just didn't feel right with the whole scenario, so I decided to proceed with caution. I wasn't comfortable with the opportunity presented to me, but I knew time and money was running out. During the drive back home, I thought long and hard about what I should do. I didn't want to get involved with Darrell or Roberto, so I convinced myself a more suitable opportunity would present itself right in the nick of time.

I went to bed that night hoping and believing something good would happen, because there was no way I could have left my executive position in Boston, to end up having to work with them. A few days past, and still no response came from any of the positions I applied for. When I became discouraged, Darrell called to find out when I was going to move in. I didn't want to give him a definite answer just in case, so I decided to string him on a little while longer.

I was very anxious but tried not to panic, although I was feeling the pressure of the circumstance, I found myself in. I didn't want to go back to Boston after giving up my job, my home, and selling all my furniture to begin a new adventure. If I had to return, as far as I was concerned, I would have returned as a failure. Time was of the essence with the impending sale of the landlord's house, and yet I still received no job offers. To add to the pressure, Darrell was becoming more and more impatient with me.

After Darrell's fourth call to find out if I was still interested in the job, I could tell he was upset from the tone in his voice, when he complained that I had not contacted him since our last conversation. He wanted a definite answer, and so I told him I would take the job. Once I gave him the reassurance he was looking for, I told him I would be there in a few days. I called the landlord to tell him I was leaving prior to the date I had given him, and he was nice enough to refund some of the rent I had already given him.

I was still hoping a miracle would happen within the three days I had agreed upon to move. But I was left saddened when no other opportunity opened up. I met Darrell to get the keys for the condo, then Max, Fluff and I, moved from the renovated garage to our new beach front residence, which was more to my taste and liking. I was given the first day to settle in and tour around and familiarize myself to the neighborhood. The first evening, me and my boys basically hung out on North Beach, which was located directly behind the condominium.

The second day, Darrell came over and brought me a cell phone that he wanted me to use for the business. It wasn't until then that I found out he was also going to be living at the condo. That was disappointing, but it was no comparison to what he told me next. He told me the cleaning business wasn't the primary business, but was only something they did on the side. Anxiously awaiting to hear what

the primary business was, I told him to get to the point, when I saw he was hesitating.

I nearly collapsed when he finally came out with it and told me what kind of business it really was. "You got to be kidding me, you must be crazy if you think I am going to run your prostitution business," I said with great outrage. He tried to quiet me down, concerned that the neighbors might hear me, but I did not care who heard me. He then tried to justify it by telling me it wasn't prostitution, but an escort service. "What is the difference?" I asked.

I interrupted him and said, "There is no difference," when he tried to explain. Those women are prostitutes, and there is nothing you can tell me to justify me setting up appointments for horny men and whores, so they can fulfill their sexual pleasures." The conversation began to get heated, with both of us being highly upset. His concern was not wanting the neighbors to overhear our conversation, but that was least, as far as I was concerned.

All I cared about was the fact that he deceived me and was not forthcoming about what he was really hiring me to do. I had already given my notice to the landlord and moved out, so I was now stuck in a bad situation, and I was extremely angry. It all boiled down to him telling me I either had to do the job, or he would have to find someone else. Without thinking, I told him to find someone else, after which he reminded me of my situation and asked where I would go considering my present circumstance.

I had no place else to go - I had only a few hundred dollars left and still had to return the rental, so I was stuck. I unwillingly agreed, but I had an ulterior motive. I saw it as an opportunity to single handedly do a great job of destroying their escort business. He and his nineteen-year-old Chinese girlfriend put advertisements on Craigslist, and where using fake pictures of women they found that looked nothing like the woman they really had. They posted the

pictures along with the number to the phone he gave me, so I could set the appointments when the men called.

Darrell explained that when the men called and asked for one of the girls in the advertisement, I was supposed to tell them that particular woman wasn't available. I was to then suggest they meet with someone else who was available. They were charging one hundred and twenty-five dollars an hour and kept fifty dollars as their fee. I couldn't believe the woman agreed to give up their bodies for seventy-five dollars an hour. I felt sick to my stomach to be around such filth. I felt disgust and shame knowing I gave up my prestigious job in Boston to move to Miami and end up in such a predicament.

I was consumed with anger and bewilderment, unable to think straight and trying to suppress the fear and depression I felt myself falling into. I told myself that this was only a temporary situation, I was a survivor and could make it through anything. I had Max and Fluff to care for, so I encouraged myself by convincing myself that this, too, would pass. That same night the phone started ringing around eleven o'clock, when I was trying to get some sleep.

I was so upset when I heard a male voice say he was calling to set up an appointment with Hot Chocolate. I told him I had no water or electric, so I was unable to make him a cup of hot chocolate. He called right back after I hung up the phone, so I then told him to repent of his sins otherwise, he was going to hell. Sure enough, he never called back, but someone else did. The next man that called asked for Candy, so I told him I didn't sell candy and suggested he go to the candy store. I hung up, and he also called back, so I gave him the same speech as the first guy.

Darrell apparently heard the phone ringing and knocked on the room door to ask me if I had set an appointment. I lied and told him the person specifically wanted the girl in the advertisement and wasn't going to settle for anyone else. Once I realized Darrell could hear

237

the phone ringing, I turned the ringer down, but all morning right up until around five o'clock, the phone kept buzzing. I told some men they had the wrong number, and told others they were calling a church. I cut the rest of the callers off before they could ask anything.

The second night, Darrell told me that I needed to market the girls better. He wanted me to convince the men that they would be pleased with the ones that were available. The phone started ringing earlier that night before I went to bed, so Darrell was in the living room with me, listening to what I was saying. It so happened that the person who called really did only want the woman shown on the advertisement and didn't want to settle for anyone else. That particular person actually helped me out, because I put him on speaker so Darrell could hear.

Because of that one conversation, Darrell believed me when I said the men didn't want to settle for the women he really had. When I went to bed, the phone started ringing back to back. I gave the same speech to every caller by telling them that Jesus was coming soon, so they needed to repent of their sins, then I ended the call. That went on for a few days, until Darrell started getting frustrated because he wasn't making any money. I, on the other hand was proud of myself because I was accomplishing what I set out to do.

Darrell ended up turning to his side business and got a job to clean a doctor's house in South Beach and wanted me to help him. I thought to myself, "I certainly didn't get my master's degree to clean people's houses," but I had no choice, so I went with him and made one hundred dollars that day. While we were out together, we were talking and getting to know each other better. I wanted to know why he chose to run an escort business instead of a legitimate business. I also asked him why he didn't go back to school and learn a trade, so he could better himself.

He told me he was originally living in North Carolina and was learning a trade, but didn't have the money to finish, so he ended up moving to Miami with one of his friends. I also found out that it was his girlfriend, Kimlee, who suggested he start the escort business so he could make a quick dollar. Kimlee's parents had money and owned a Chinese restaurant, so I couldn't understand why she wanted to be involved in such a business. He also informed me that her parents didn't know she was dating him and had no idea she was helping to run an escort service.

As he continued speaking, I found out that if her parents knew what she was doing, she would be disowned, and her allowance cut off. Darrell and Kimlee, were trying to raise enough money for a down payment, so they could buy Roberto's condo. He was selling it for four hundred and fifty thousand dollars, and gave them three months to come up with the down payment. I changed the subject and began speaking to him about his soul, to which he responded, I sounded like his mother.

I found it very interesting when he told me his mother was always praying that the Lord would send someone to witness to him, so he would change his life around. It wasn't until that moment I realized why the Lord allowed me to fall into such a predicament. It was then apparent to me that I was on an assignment, because I was the one the Lord sent to answer his mother's prayers. Although I wasn't happy with where I was, I saw everything in a different light after our conversation. I had a job to do, and I was going to make sure I did it well.

I was going to do whatever necessary to put an end to that business. I had to get through to Darrell that the path he was on, was only going to lead to his destruction. When Darrell and I returned to the condo that night, the phone didn't even ring once, which enabled me to get a good night's sleep for the first time in days. Although I knew I was on an assignment, I was still worrying about what I was

going to do and where I was going to end up next. I felt it in my spirit that my time there was winding down.

I knew I wouldn't be able to keep up the false pretenses, because of the woman that I am. I was pleased with myself though, knowing I managed to prevent any appointments from happening for an entire two weeks. That was until, unbeknownst to me, while I was at CVS one evening, Darrell's girlfriend, Kimlee, manage to set up an appointment for one of the women. She then called and told me to call the escort and let her know where she was supposed to meet her customer.

I was angry to say the least, so instead of calling the young woman to tell her where to meet, I asked her why she was taking that kind of a risk with her health and her life. I tried to talk her out of going, but she insisted she needed the money. I then asked her if she thought her life was only worth seventy-five dollars. When that didn't work, I tried to scare her out of going by saying, "If this man turned around and kills you, would you still think it was worth it?"

I couldn't believe she still insisted that she had to go, and told me she was going anyway. That was her plan, but I had other plans for her, so I gave her the wrong house number. About ten minutes later, she called to tell me that no one came to open the door. With a smile on my face, I told her she should take that as a sign and not persist on going to the appointment. A few minutes later, Kimlee called to ask me what was going on.

"What do you mean?" I asked. "Why hasn't she gone to the appointment I set up for her?" "I don't know, why don't you ask her,"I replied. Kimlee then asked me to come back to the condo as soon as possible, because she needed to speak with me right away. "Here we go!" I said to myself, knowing the conversation I was about have, wasn't going to end well. When I arrived and opened the front door,

Kimlee was standing in the middle of the living room with Darrell by her side.

Before I was able to close the front door, that crazy little girl started shouting at me, which was a big mistake. I tried to stay calm as long as I could when she told me I was obviously doing something to jeopardize their business. She wanted to know why she was able to set up an appointment after one call, and yet I had been there for two weeks and wasn't able to set up one. She continued by telling me I had better start making some appointments, or I needed to leave.

Darrell didn't get involved in our conversation, he just stood there looking back and forth at the both of us. He allowed her to do all the talking, but before she could say another word, I was unable to keep my cool any longer, and so I basically snapped. "Who the hell do you think you are talking too, little girl?" were the first set of words that came from my mouth. "I am a grown woman, and you are a little girl as far as I am concerned, so you talk to me with respect."

I was so angry and unable to contain myself, so I just let it all out. "Yes, you are right, I was jeopardizing your prostitution ring. "It's not a prostitution ring," she interjected, "Yes, it is," I continued… I told some of your callers they had the wrong number, and the others, I told them they were going to hell if they didn't repent and turn from their dirty ways." You and Darrell are going to end up in jail or in hell with them too, if you don't stop what you are both doing."

She became speechless and couldn't say anything else to me. Darrell obviously didn't want to get involved in our argument, so he kept his mouth shut. In the heat of my anger, I told her I was leaving first thing in the morning, so she was free to get someone else to run her prostitution ring, because I sure as hell wasn't going too. On that note, I called Max and Fluff, and told Darrell I was taking them outside for a walk and go sit on the beach for a while. I slammed the front door behind me and walked slowly through the hallway.

I decided to wait for the elevator instead of taking the stairs as I usually did. I was absolutely devastated at that point, having no idea where I was going to go. I had no friends or family in Miami and had no clue what I was going to do. I sat on the beach in a bewildered state of mind, while Max and Fluff ran around enjoying themselves. I looked up to the sky and said, "Lord, I need a miracle. You see my situation, so if you don't come to my rescue, I guess I am going to be homeless tomorrow and will have to live out here on the beach."

I lost track of the time while sitting on the beach for hours crying, praying, and wondering what was going to happen to me, Max and Fluff the following morning. I was trying to contemplate what was going to happen if the Lord didn't show up and deliver us out of our predicament. I dreaded going back to the condo and tried to delay the inevitable, as well as the uncomfortable feeling once back inside. I certainly wasn't looking forward to being in the same space with Kimlee, after what had just happened.

It turned out to be a pleasant surprise once I returned to the condo and saw that Kimlee had already left. It was an even greater surprise, when Darrell told me he was waiting for me to get back so he could give me some good news. Apparently, Roberto had called while I was gone and was upset because he had no idea Max and Fluff was living in the condo. The security happened to see Max and Fluff on camera when we were waiting for the elevator and called the association.

The association called Roberto to informed him my dogs were not allowed to live there without prior approval, which they obviously did not have. I had no idea Darrell didn't tell Roberto that Max and Fluff was living there with me. I just assumed he would have known that, especially because they were with me when I went to meet him. Being seen on the security camera worked out in our favor, and so the Lord delivered me right on time.

Because Max and Fluff were not allowed to stay there, Roberto told Darrell to tell me that I should pack my stuff and me and my dogs should move to his home in Kendall, first thing the following morning. I was blown away, never expecting the Lord would come to my rescue that quickly. While I was praying, the Lord was already working on my way of escape. The following morning bright and early, I packed up all my belongings, put them in the rental, and moved to Kendall.

Roberto welcomed me with a smile and helped me carry my things to the room upstairs that I was going to stay in. After reassuring me that I need not worry about paying him for my room and board, he then told me I could stay there until I got back on my feet. There were three other tenants whom he rented out the other rooms too, all of whom were men. One was a pilot, one was a tennis pro from South Africa and the other, an Engineer from Canada. They were all friendly and couldn't wait to question me, after Roberto left the house.

All three tenants were curious as to who I was, and thought I was Roberto's girlfriend, because of the way he dealt with me. After assuring them that was not the case, they began opening up and told me stories of things they saw him doing. They told me he was mentally unstable, and how unbearable it was living there before I moved in. Because of that, they all asked me to promise I wouldn't move out before they did, claiming Roberto was a changed man since I moved in.

The house Roberto owned across the street was rented to three people from the Czech Republic. When I got to know them better, they also told me how crazy Roberto was, and how he threatened to put their Cocker Spaniel in the microwave and cook him, because he didn't like him. It wasn't funny, but I couldn't help but laugh when they told me Roberto told them he would let his Rottweiler eat their dog, if they didn't pay him the money they owed.

I tried to convince them he was only trying to intimidate them, because there was no way he would really do a thing like that, but they were convinced he would. After hearing that, I thought, "Okay, I really have to get out of here." Roberto treated me very well though, and thank God he liked Max and Fluff because they found favor with him. That was one less thing to stress over, not having to come in one day and find that they were in the microwave or eaten by his dog.

Roberto didn't always stay at that house, he stopped by for a few hours some days, and sometimes he spent the night, but he preferred to stay at one of his other houses located in Broward County. He told the other tenants that I was the woman of the house, so he left me in charge whenever he was gone. The other tenants and I always celebrated whenever he left, knowing we were free to just be ourselves, as we were much more comfortable without him around. Although Roberto had issues, he really did make me feel welcome, which in turn helped me not to fall into a great depression.

One day while sweeping and mopping the house, Max came and sat next to the mop bucket and stared at me. A strange feeling came over me when he did that - I felt as though telepathically he was saying, "What are you doing? Why did we leave our beautiful home in Massachusetts to come live like this?" and so I began to weep. It was so weird the way he came up to me and looked at the mop, then looked at me, and just sat there staring at me. I felt so ashamed as I thought to myself, "Even Max is wondering what has become of me."

I still had the rental but was overdue with returning it. I had accumulated a debt of nine hundred dollars that was owed, but decided to use the money for the rental to buy a cheap car instead. I searched the web and found someone selling a Ford Taurus in West Palm Beach, so I made arrangements to go look at it. I called the rental agency and told them I would return the car to the West Palm Beach location, and so I set out on my two-hour drive to West Palm Beach with Max and Fluff.

244

I returned the car and put it on my debit card, which had a zero balance, but the Bank let it go through. That was a great relieve and burden lifted, because if the bank didn't let the payment go through, I wouldn't have had enough cash to pay the total owed. I called a cab to take me to the location of the man selling the car, but the first two taxi's that came, told me dogs were not allowed inside the car. I had to beg the third taxi driver and convince him that Max and Fluff wouldn't bark or have any accidents in his car, and so he eventually agreed to take us to our destination.

When I arrived at the housing complex, I called the seller, who seemed to appear out of nowhere. He started the car, which sounded okay to me, then opened the hood and showed me the engine, which also seemed fine. I asked him if the car had any problems, to which he replied, it did not. He even went on to tell me that the car ran very well. Even though I had a bad feeling about it, I went ahead with the purchase, because I needed a car to get around. I told him I was short on the cash he wanted, so he settled for six hundred instead of the eight he was asking for.

As soon as he got the cash, he left in a rush and turned the corner, so I had no idea which house he went into. I wasn't able to even make it more than fifty feet, before the car started overheating and shut off before I exited the complex. I kept calling the phone number of the crook who had just sold me the car, but off course, he wouldn't answer. It was no time to get emotional, because I had to figure out how in the world I was going to make it back to Kendall, and sixty dollars left to my name.

In utter dismay, I sat there trying to come to terms with what had just happened to me, when a security guard pulled up alongside me and asked if I was okay. After explaining what just happened, he told me to open the hood of the car, so he could take a look. Once he finished his inspection, he told me it looked as though the radiator needed replacing. Because it was already late evening, I decided I

would try and make it to Kendall, to which he reiterated that I should not attempt to go on the I95 with the car in that condition.

He left to get water to fill the radiator, and when he did, I started to cry. Upon his return, he filled the radiator and gave me his cell phone number. He informed me that all the mechanic shops in the area were closed, so I should wait until morning and get the car checked out. For some reason, I guess he knew I had every intention of trying to make it back to Kendall, because he told me again, not try it. He told me his shift did not finish until four o'clock the following morning, but I should call him if I needed his help. After thanking him for his assistance, I decided I had no other choice but to try and make it to the highway against his advice.

I didn't have money to fix the car anyway, so what else was I going to do? I made it out the complex and to the main road, where I had to stop at the red light. While waiting for the light to change, the car started overheating again, and shut off in the middle of the road. It was so embarrassing holding up the traffic, and listening to everyone blowing their horns. It just so happened that a police officer was passing by and came to my assistance. He ended up pushing the car to the gas station across the street, and told me I would have to stay there until morning, when I could get a mechanic to look at it.

I called the security guard and told him what happened, so he told me he would come check on me, when he finished work. I went to the gas station attendant and explained what happened, and asked if I could stay in the parking lot until morning. He told me it was fine, then offered me something to drink because it was so hot out that evening. He was in the store by himself and must have been lonely because he wanted to talk, but I was certainly not in the mood.

I asked for a cup, so I could get something for Max and Fluff to drink out of, then returned to the car and began to cry again. I was so uncomfortable and hot, and on top of that, the air conditioner wasn't

working either. I felt as though I was on fire the entire time, so every so often, the three of us got out the car and walked around. After I found a wall to sit on, I stayed there, lost in space for a few hours.

The security guard did show up as promised when his shift was over. He asked if he could buy me something to eat, but food was the last thing on my mind at the time. I had already bought food for Max and Fluff, but I sure wasn't hungry, although I hadn't eaten. He gave me the address of someone he said was a good mechanic, whose shop, luckily for me, was located on the same street I was stuck on. He filled the car up with more water, and told me to go the mechanic shop at nine o'clock when they opened.

He stayed with me for about thirty minutes before he left, but before he did, he told me to call him and let him know how things worked out for me. I thanked him for his kindness, and when he drove off, I started crying again. I must have cried for hours because I knew I had no money to pay the mechanic to fix the car, so I was panicking. The time seemed to fly by quickly, because before I knew it, nine o'clock had arrived, and it was time to leave.

I found the mechanic shop easily and met the owner, who was a very pleasant Puerto Rican man named Juan. I told him what happened to me, and thank God he was compassionate and considerate of what I was going through. Juan insisted I call the crook who sold me the car and tell him he needed to give me back my money or I would call the police. I kept calling, but he refused to answer. When Juan was able to check the car and told me it had more issues than just the radiator, I tried my best not to break down.

He went on to say it wasn't worth fixing, but out of curiosity, I still wanted to know what the cost would have been. After hearing it would cost around fifteen hundred dollars, I felt all the blood rush to my head. Juan then suggested I continue to call until the man answered, but because he knew my number, Juan gave me his phone

to use instead. Sure enough, the crooked seller answered to Juan's phone number. I told him what I thought of him before mentioning that if he didn't give me back my money, I would call the police.

He was surprised that I was able to trick him into answering his phone, so he quickly came up with a lie to tell me. He told me he bought the car from a friend and didn't know anything was wrong with it. He had the nerve to tell me he could get me a better car, but I would have to pay an additional two thousand dollars. It was at that point I came out of character when I totally lost my temper, and unable to control my tongue in front of the other customers sitting in the waiting room.

I called him every bad word I could think of, then told him I would let the police handle him. Although I had no idea what house he came out off, I wanted to put some fear in him. He asked me not to get the police involved and that we could work something out, to which I told him I had no intention of working anything out with a crook. Before I hung up on him, I told him he would burn in hell for what he did, and that everything he tried to accomplish would fail because of what he did to me.

When I ended the call, I tried to hold back the tears but couldn't, so my tears just came pouring down like a flood. One of the customers who was in the waiting room, came up behind me and put his arm around my shoulders, and told me it would be okay. "Okay!" I thought, when I'm stuck in West Palm Beach and don't have enough money to get home. Juan and some of the other customers also came to console me, and told me I should just use the experience as a lesson learned.

Juan then said, "Sometimes in life, bad things like this happen, so just roll with the punches and move on." He also suggested I call a company that bought junk cars and sell it to them, stating it was my only option. He gave me the number, but when they came to pick the

car up, they only offered me seventy-five dollars. It all felt like I was in a bad dream that I couldn't wake up from. I sat in the waiting room traumatized, when Juan came and told me he would drive me home when he closed up the shop, because luckily for me, he also lived in Kendall.

That was a big blessing and a great relief, as I thought, "At least God as provided a way for us to get back to Kendall." It was a long day and drive home through rush hour traffic, but Juan and I talked all the way. Juan was going through some hard and difficult times himself and wanted to share some of them with me. Listening to him, helped to take my mind of my own problems, and before I knew it, we had arrived at Roberto's. I thanked Juan for his kindness and wished him the best with his endeavors.

When I entered the house, Roberto was sitting at his computer, wanting to know where I had been all night and day. I was ashamed to tell him what happened at first, but when I did, the first thing he wanted to know was why I went all the way to West Palm Beach to buy a car. He was angry with me for not telling him I was going to buy the car in the first place, and wanted to know where the crook lived that sold me the car. He got even more upset when I told him I had no idea where he lived, because I didn't see which house he went into.

He asked for the address listed on the title and said, "I'm going to drive down there and permanently put his lights out." I hesitate because I was afraid to tell him I didn't remember the address on the title. Roberto looked at me and said, "What are you waiting for, give me the address." Finally, I confessed that I didn't look at the address and plus I had already given the title to the company that bought the car. After Roberto told me how crazy I was, along with telling me he thought I had more sense, I had to listen to him scold me for about an hour.

After everything I went through, I was extremely tired, especially because I was unable to sleep the night before. I was mentally and physically drained, but Roberto didn't care. He made me stand there and take my scolding before he told me to go to bed and get some sleep. I stood in the shower for quite some time, when I remembered I had not called the security guard who helped me, to inform him of what happened. After calling him, I got in the bed, assuming I was going to fall asleep right away, but I couldn't.

Upon waking up the following morning and remembering what happened, I just stared at the wall, wondering what my next move should be. I continued looking for work, but nothing came up, which left me very discouraged and frustrated. I ended up staying at Roberto's house in Kendall for five weeks, before he moved me to one of his other houses in Pembroke Pines. Roberto was trying to evict his tenants across the street, and because he knew we were friends, he didn't want me around them.

I didn't want to move, but I had no choice, although I did keep in touch with his tenants unbeknownst to him. The new house was next door to famous ball player. Roberto's house was really nice, but then again, all his houses were. Everything was good except for the fact that there was no bed in my room. Roberto offered to buy me an air bed, but I refused. He had done enough already, and I didn't want to be more indebted to him than I already was. I chose to spread my sheets on the floor and slept there instead.

Roberto had tenants living at this house also. Two young men from Mississippi who were in Florida to attend culinary school, and a young couple who were about to have a baby. These tenants also thought I was Roberto's girlfriend, because he would always address me as the woman of the house. They didn't believe I wasn't his girlfriend at first, so it took some convincing before they finally believed me. They wanted to ask questions about Roberto, but they wanted to make sure they could trust me first.

250

The first question they asked was if I thought Roberto was crazy, to which I smiled but did not answer. A couple weeks after living there, the two tenants asked me again to tell them why Roberto acted and talked as though he was crazy, but I still didn't answer. I wasn't sure what it was they heard him saying, so they told me to listen for myself when he came back to the house at night. I listened out for him that night, and was troubled when I heard him say, "God take me, so I don't have to shoot everyone in here."

The following day, one of the tenants asked if I listened and heard for myself. When I told him I did, he informed me that Roberto said that every night he came in. The tenant's became fearful, and told me they were going to start searching for some place else to live, just in case one night Roberto really did decide to shoot everyone. The following morning before Roberto left, I jokingly told him that whenever he decided to shoot everyone, to please let me know first, so I could take Max and Fluff and run.

Roberto wasn't amused with what I said, in fact, he looked quite startled, as if he was unaware anyone had heard him. After I said that to him, I never heard him say it again whenever he came home at night. During this time, I was going through a severe depression. I had given up all hope of ever getting back on my feet and living the life I was use too. I couldn't find a job, I had no money, and was hungry the majority of the time. Because of pride, only two people knew what I was going through. I didn't want anyone else to know, because I was too ashamed.

The only two people that knew my situation were Denzil, and my cousin Urceline. They both help out now and again when they could, but I needed a job to sustain myself. Sometimes Denzil paid my phone bill, and Urceline sent me fifty dollars when she was abled too, which helped to buy toiletries and food sometimes. On the days when starvation felt like it was killing me, I put my pride aside and asked Roberto to loan me twenty dollars here and there. When Max and

Fluff were hungry, my heart ached on the days I had nothing to give them to eat.

I would search the fridge when the tenants were gone and take what I could, so I could feed Max and Fluff. I couldn't take enough for all three of us, so I would let them eat, and I went hungry. For the most part, I felt as though we were suffering, and I just wanted to die. I didn't see any point in praying, because I thought God wasn't listening. Once my hope was gone, I didn't want to continue living in that dreadful state. I couldn't bear to see Max and Fluff go hungry, but even in the midst of it, God was watching over us.

One of the tenants surprised me with a bag of dog food, and when that finished, Roberto brought his killer dog to live at the house. That was a weight of my shoulders, because when Max and Fluff's food ran out, I was able to take some of Roberto's dog's food to feed them with. I did have my tea, so I drank that in replace of food and continued searching for work, even though I felt I was stuck on a dead-end street. On the days that I wanted to give up, it took everything out of me to keep on going.

I had to keep pushing because I had Max and Fluff to think about. Things started looking brighter when I came across a position that seemed as though it was made just for me. The job description was an exact replica of the Executive Director position I left in Boston, but this new position title was President/CEO. I applied immediately and was delighted when I got a call from the director of human resources telling me that I was a perfect match for the job. I was so excited and was finally able to see a light at the end of the tunnel.

That was until the following week when she called to tell me that the interview process wouldn't start for another two months. It seemed that every time something good was about to happen, a disappointment followed. I was too tired, drained and broken, and so I had lost all hope again. Two months seemed too long to wait, and

there was no guarantee that I would get the job anyway. I fell back into depression and despair, and started asking God to take me, Max and Fluff.

I wanted God to take us peacefully in our sleep, because I couldn't bear the fact that they might suffer if I was gone. Later that very same day when I asked God to take me, Roberto knocked on the room door and handed me a radio. He told me he was giving it to me to keep my company, so I should turn it on because I had no television to watch. I was crying out to God and asking Him why He was allowing this to happen to me, and was led to open my bible.

When I did open the bible, the page it opened at was Isaiah 61:1-3, which reads:

1. The Spirit of the Lord GOD is upon me, because the Lord hath anointed me to preach good tidings unto the meek, he hath sent me to bind up the brokenhearted, to proclaim liberty to the captives, and the opening of the prison to them that are bound.

2. To proclaim the acceptable year of the Lord, and the day of vengeance of our God; to comfort all that mourn.

3. To appoint unto them that mourn in Zion, to give unto them beauty for ashes, the oil of joy for mourning, the garment of praise for the spirit of heaviness; that they might be called trees of righteousness, the planting of the LORD, that He might be glorified.

I knew what the verses meant, but I could never figure out the overall meaning of those three verses. It wasn't the first time I prayed and got that scripture, because I got it time and time again. That evening though, I asked the Lord to reveal the overall meaning of those three verses in one word, "To give people what? I asked. I already knew I had a calling on my life since I was a child, and I knew that scripture was pertaining to my ministry. As I pondered on it, suddenly, it hit me, as though a light bulb turned on in my head.

I heard a voice in my head say, "To give people HOPE." At the time, it made no sense to me because I had lost all hope, so how was I going to give hope to anyone, I questioned. Being sarcastic, I said to the Lord, "Okay, so You expect me to give hope to others, when I have lost all hope myself. Right now, I don't even want to live anymore, much less giving anyone hope." Every time I got on my knees to pray, and asked the Lord when I was going to stop suffering, all that came to my mind was, "When you write the book!"

Anyway, after reading the verses in Isaiah 61, and talking to the Lord, I decided to search the radio for something to listen too, before I went to sleep. Although my heavy heart felt a little lighter, I was still in a distressed state of mind, and would have preferred that God just put me out of my misery, once and for all. As I searched the channels, to my amazement, I heard a man say, "There is a medium built brown skinned woman listening right now who doesn't want to live anymore, but have you considered Job? because you are going through a Job like situation."

The book of Job in the bible is an epic story. Job was a righteous and just man, who was also very wealthy. God gave Satan permission to test Job's faith, by stripping him of not only all his wealth, but his ten children, and eventually his health also. Job lost everything in one day, and yet he said, "Thou He slay me, yet will I serve Him." He never cursed God, or complained or lost his faith, but continued to worship and honor God throughout his terrible ordeal. Eventually, in the end, God made Job's latter days greater than his beginning and gave him back ten children, and double what he originally lost.

Now that I think about it, that's probably where the saying comes from, "Double for your trouble." Well, after hearing the preacher on the radio, I knew he was talking about me, and because it was a live program, I knew for sure it was me. He gave the number to the station as he was closing out, so without thinking about it, I quickly called

254

the number. As soon as the pastor answered my call, I told him I was the woman he was talking about.

We talked for a while before he invited me to his church, but when I told him I had no ride to get there, he offered to pick me up. I felt much better by the time the call ended, being reassured that God was still with me and had a purpose for what I was going through. Sunday was only two days away, so I was looking forward to attending church and hoped the pastor was a man of his word. It turned out he was, because when Saturday came, he called to arrange to pick me up the following morning.

During the service, he called me out and told me that God was going to give me a five-fold blessing, and when I got it, I should not forget the Lord. I had no idea what a five-fold blessing was, so I asked him. He told me I was going to get the job I wanted, and God was also going to provide me with a car and all the other things I needed. That certainly made my day and revived my hope. I finally had something to look forward to, which made a world of difference in my outlook on life.

I began attending his church, and after the third week, the pastor invited me to the radio station to be his co-host. Before I left that evening, I told Roberto where I was going, and told him to listen to the station that I was going to be on. I didn't actually think that he would listen in, but he did. When I got back to the house that night, Roberto was very impressed with me and told me that I should try and get a job on the radio. His reason for his suggestion was that I had a good voice for radio, and sounded much better than my co-host.

It so happened that the next day, I got a call from the human resources director of the company I applied to, for the President/CEO position. She called to inform me that I now had some very impressive competition. I was going to be competing against a politician, a doctor, and a lawyer. The news dampened my spirits,

and even more so, when she informed me she had received over nine hundred applicantions for the job. "Great, I really needed to hear that, now that I was starting to feel so much better." I thought to myself.

The news caused me to begin losing hope I would get that job, but then I remembered what the pastor told me. I tried to keep my faith alive, although I started thinking, maybe he was talking about a different job. That same day, Roberto came in to tell me he had rented my room. I had three weeks to find somewhere else to live, because the new tenant was coming in three weeks. "What is going on?" I asked God. "I can't deal with this anymore, why are you torturing me like this?

I called the pastor and told him of my new predicament, which led him to find someone who was willing to take me in, but she wasn't allowing me to bring Max and Fluff. Once I made it clear to him that separating with Max and Fluff was not an option, he got upset. He asked if I was really going to give up the opportunity for a place to live because of my dogs, but I didn't care what he thought. I tried to explain to him the love and bond I had with Max and Fluff, but it was like talking to a brick wall. In the end, I thanked him for his help, and told him God would open another door.

He tried to convince me that the lady who offered to take me in, was the only door God was opening for me. I became upset when he told me that God was not going to open up any other door, if I turned that down. My faith returned when I told him God had not failed me so far, so He would work it out. God knew how much I loved Max and Fluff, and knew that only death could part us. If I didn't know anything else, I knew for sure God would provide someone who would welcome all three of us.

My upbeat frame of mind didn't last long, once I had a vision of Aquiel a few days later. I dreamt that I went to visit Aquiel, but was astounded to see him so thin and covered with tubes. I went in the

room he was lying in, took him up of the bed and sat him on my lap. I was only with him for about two minutes when he told me God had come for him, so it was time for him to leave. I begged him not to go, when he said, "I have to go now, aunty Pat, because God is waiting for me." When I woke up, I looked at the time, and it was quarter to six in the morning.

I waited until I thought Andrew would be up and called to see if he heard anything about Aquiel. As far as Andrew knew, Aquiel was doing okay, but I told him I knew Aquiel was leaving us soon, because of the vision I had. My soul was now in greater distress, not being in a position to go see my nephew, who was back in Honduras receiving treatment. Knowing that my visions always came to pass, left my mind in torture, knowing he would soon be gone. What made it worse, was I was unable to speak with him, because I had no way of contacting my sister, so the only way I knew what was going on with my nephew was through Andrew.

Each day that passed was a gloomy one. I was broken before the vision, but now I was greatly distressed. Every day I called Andrew to find out if he heard any news, but each time I called, he told me he had not. On the seventh day after my vision, I walked to supermarket with Max and Fluff, but stopped in a wooded swamp area of the main road to cool off. While using a fallen tree as a seat, I heard my phone ringing. I wondered who was calling while I searched around in my hand bag to find my phone.

I was happy to see it was Andrew and quickly answered. He asked what I was doing, and so I told him I was chilling with Max and Fluff, trying to cool down before we continued back to the house. When I asked him what was up, he paused before giving me the news. "Aquiel died early this morning." I don't have to tell you how I felt and how much I cried. I couldn't let go of the fact that I couldn't visit him or get to speak with him before he passed. I was devastated once again and could not be consoled.

For a few days, I just shut down mentally, not answering my phone and closed myself off to the world outside. I knew it was going to happen, but I was still in shock. Aquiel was only eight years old, and I couldn't get over the fact that he was now permanently gone. I wasn't going to see him or speak to him again, and I couldn't wrap my mind around that. I went into mourning and could not be consoled, but at the same time, I had to get it together, because Roberto had rented the room, and I needed to find somewhere else to live.

I called Denzil, in Boston, because I knew he had friends in Florida. I asked him to make some calls to see if he could find somewhere for me to go. He sure did find me someone, who turned out to be a friend of a friend, but at first, this person didn't want any dogs in his house either. After speaking with him and letting him know they were small dogs, who were clean and didn't make noise, he agreed to let them come. God did open another door for me, and I couldn't wait to tell the pastor, who was literally speechless and probably ashamed.

My move was planned the following week, but Denzil's friend Danny, lived closer to Roberto's other house and couldn't drive all the way out to Pembroke Pines, to come and get me. Roberto drove me back to Kendall to meet Danny, and when we finished loading the car with my luggage, Roberto hugged me. I thanked him for his compassion and kindness towards me, after which he repeatedly told me to keep in touch, and to come back and visit him whenever I got the chance.

Chapter Nineteen:

When I least Expected

"...Weeping my endure for a night, but joy comes in the morning."
Psalm 30.5 - When restoration arrives, we no longer feel the pain and
heartache which we once endured. Once my tears were replaced with
joy and laughter, I looked back and said, "Wow! this didn't seem
possible when I was going through my adversities."

It was an awkward feeling driving with Danny, who was a total
stranger, but he was friendly and talkative, which made it less
uncomfortable during the ride to my new unknown residence. I
questioned him about Patrick, whose house we were headed too, as I
tried to find out as much as I could about him before I arrived. I was
nervous when we pulled up in the driveway, but as soon as we did,
Patrick came out the front door with a big smile on his face and
greeted me with a hug.

The moment he saw Max and Fluff get out the car, he immediately
fell in love with them. He showed me around his house and took my
luggage into my new room. I was pleased to see the room was large,
clean and decorated nicely. It was a plus to see the room had its own
bathroom, which gave me the privacy I wanted. Once my luggage
was in the room, Patrick, myself and Danny sat outside on the back
patio. We all had a drink while Max and Fluff ran around the back
yard familiarizing themselves with their new surroundings.

Patrick and I began getting acquainted by asking each other
questions, while we drank and listened to the music playing in the
background. Danny cut in now and again, but for the most part,
Patrick and I were doing most of the talking. Although I was relieved
I had somewhere to stay, I was brokenhearted that I was with yet

another stranger and couldn't stop wondering what it was going to be like living with him. I tried but was unable hold back the tears, as I thought about how I was moving from one place to another, having no stability.

Patrick assured me everything was going to work out and reassured me that I would be comfortable living there. He also told me that I didn't have to worry about paying him anything until I got a job. When he told me Max and Fluff had to stay outside in the back yard though, my heart sank into my stomach. I couldn't bear the thought of them having to stay outside at night. They had never done that before, plus I needed them in the room with me. As we sat there talking, I secretly asked God to touch Patrick's heart so he would allow them to stay in the room with me.

I knew I wasn't going to be the only one with a broken heart if we couldn't be together. Max and Fluff would have been heart broken too, and I couldn't allow that. Within the hour of me asking God to touch Patrick's heart, to my great astonishment, my prayer was answered. Just as we were about to go inside, Patrick told me he had been observing the love between me, Max and Fluff, and couldn't bring himself to part us. He therefore decided it was best that they stay in the room with me.

Patrick was a painter and wasn't getting much work at the time, so there were days when the food supply was short. Sometimes we only had enough for one small meal per day, which I had to share with Max and Fluff. I continued searching for work during the days, and during the evenings, Patrick and I would sit and talk about all sorts of things. We got along very well, and whenever his girlfriend came over, I saw it as an opportunity to go in my room and seclude myself, as I had so longed to do.

I tried to keep a smile on my face, when deep down I was very unhappy. I did my best to hide my emotions by pretending that I was

fine, when asked. One of Danny's friends owned a dry-cleaning business and needed someone to help out, so he referred me for the job. When I went to meet with the owners, they wanted me to start the next day. It was paying only eight dollars an hour, but I had to take it because I needed the money. The position required me to stand up all day, which after a few hours, my back became very sore.

The owner saw me rubbing my back and suggested I stop working, so I didn't cause myself any additional injury. When I told him I was fine, he told me I was moving too slow, and continued to say it had to be because of my back. I wanted to work until the end of the day, so I could at least get the full day's pay, which was only thirty-two dollars. Luckily for me, I only worked for three and a half hours and still received a full day's pay, but no longer had the job.

I left there saying, "Thank God that was over with," because I hated standing all that time, ironing clothes and arranging them on hangers. Although at the same time I was angry at what I had to resort to, in order to have a few dollars in my pocket. I felt even worse when I remembered I was twenty years old when I last made eight dollars an hour. I kept thinking, "I can't believe I have a master's degree and had to work for eight dollars an hour."

I returned to the house saddened and depressed, but was also happy I had money in my pocket to buy dog food, and food for myself to cook. As far as I was concerned, I had hit rock bottom. It was hard to imagine my life could get any worse during this period of feeling worthless and low. "How did my life reach to this point? Why did I leave my good job in Boston to move to this place to suffer?" Those were the questions I asked myself on a regular basis. I told myself I was lower than low, and in fact, I felt so low that I couldn't comprehend myself ever being on top again.

Although the pastor told me I would get the job I wanted, I no longer believed. My faith then started to waver because I was unable

to see beyond my dire circumstances. I knew that real faith was believing what isn't as though it is, and I knew I had to speak it into existence, but I had already lost all hope. In the midst of having lost all hope for a brighter future, it seemed like the unexpected came out of nowhere.

Talk about getting something when you least expect - I got a major surprise, and on my birthday, no less. Just three days after leaving that dreadful job at the dry cleaners, approximately five weeks after moving to Patrick's home, I received the call that changed my circumstance. It was the human resources director who called to inform me that I was one out of ten candidates chosen to interview for the President/CEO position.

My birthday turned out not to be as bad as I thought it was going to be, because I was ecstatic after hearing the news. The interview was set for the following week, which instantly revived my faith and hope. Although I had great expectations, I was still both anxious and nervous at the same time. I couldn't stop wondering if I would actually get that job after waiting four months just for an interview. To put my mind at ease, I began to pray that God would give me favor over the rest of the candidates.

"What was I going to wear?" I wondered, once remembering I had given away all my suites to a client who had a few interviews lined up before I left Boston. At the time, I figured my suits were too warm for Florida anyway, and had planned to buy more suits once I arrived. But as usual, nothing I ever planned worked out the way I expected. Instead, I wore a dress I bought at Saks Fifth Avenue in Massachusetts, to wear to one of ABCD's annual awards dinner.

I wore a jacket over it with a pair of opened toe high heeled sandals, which wasn't the proper attire to wear to an interview for a position of that caliber. The dress was quite sophisticated, as well it should be, considering the price tag was one thousand three hundred

dollars. I remember when I picked out the dress, I glanced at the price tag and I saw one hundred and thirty dollars, but when I got to the counter, and the cashier rang it up, that's when I got a very big surprise.

Interestingly enough, before I started shopping for an outfit that day, I asked God to lead me to a nice dress that I could afford. The cashier was an elderly lady who was compassionate when she saw how badly I wanted that dress. After I told her I had nowhere near enough money to buy that dress, she decided to help me out. My prayer was answered that day because even though the price tag was nine hundred dollars more than I had, God worked it out to where I was able to buy it with the money I had.

That cashier, whom I will never forget, first took thirty percent of the price, and when that was not enough, she used her employee discount and brought the price down even further. The price was still too much, so she ended up searching for discount coupons which she applied to the price and ended up bringing the price down to one hundred and nineteen dollars. It turned out to be my favorite dress, and I wore it with confidence the morning of my interview. I knew that if the position was for me, I would get it regardless of what I was wearing.

It took me four and a half hours travel time by bus and train to get to the interview. I was quite relieved when I got there in time to rest and collect my thoughts before I was called in. I was the last person to be interviewed and had no idea I was going to be questioned by seven board members. I became terribly nervous when I walked into conference room and saw them all sitting there, staring at me. Although the interview only lasted twenty minutes, I thought it went quite well, as I was able to answer all the questions articulately.

I left the conference room feeling confident, until the human resources director stopped me on my way out of the building. She

told me that everyone else interviewed for forty-five minutes and because mine only lasted twenty minutes, she believed that was not a good sign. She basically told me I didn't get the job and gave me a few web sites to search for another position. I had gotten so use to being disappointed, which was probably the reason her words didn't affect me immediately.

What the director told me started to sink in when I sat down at the station waiting for the train. My hope of getting back on my feet depended on that job, because without it, I didn't see it to be possible. Once the shock and sadness saturated my soul, I began to weep, after which I became numb. I didn't feel sadness or disappointment anymore, I just didn't feel anything. I stared through the window of the train, wondering what was going to become of me. Was disappointment after disappointment going to become my fate in life?

I dreaded having to tell Patrick I didn't get the job, especially because he too was confident that I was going to get it. It was close to ninety five degrees that day, so after walking for forty five minutes from the bus stop to the house, I was too hot, too tired, and too worn out to think anymore. I just wanted to get inside the house, take a shower and withdraw into my shell. Right when I reached the front door, the phone rang. I didn't feel like talking to anyone, but I had the urge to see who it was regardless of how I felt. "What does she want," I said aloud, when I realized it was the human resources director.

"I'm calling to congratulate you, Hilary!" "Congratulate me for what?" "You got the job, Hilary!" "What?" That was the only thing I could say in response. I can't even find the words to express the shock, and immense joy which immediately consumed me. I was down in the valley one minute, and in the next, I was on top of the mountain. "How comes I got the job when you already told me I didn't? I eagerly inquired.

She began to explain that the board members really liked me and were very impressed with my experience and capabilities. Apparently, the board members told her they picked the woman, but she didn't think the board meant me. She assumed they picked the woman with the doctorate degree. When she asked which one of the women they were referring to, they said, "The woman with the British accent." The board ended up choosing the attorney and me because they wanted both of us.

After relaying the good news, she told me she would call me the following morning to go over the details. The moment I hung up the phone and the news fully registered, my eyes were filled with tears of joy. I didn't know what to do with myself - I felt as though I was going to explode from the excitement. Patrick must have heard me from inside the house, because he rushed out the front door thinking something had happened.

When I told him I got the job, he became overwhelmed with joy himself. He wanted me to come inside and give him all the details about the interview, but I, on the other hand, wanted to go into my room so I could be by myself and take it all in. It was finally over - I was no longer going to struggle. I was going to be back on my feet again, and it felt so good. Before I could take my clothes off and take a shower, the human resources director was calling again.

"How comes it took you four and a half hours to get back to the house?" she queried. I thought that was a strange thing to ask, but I explained that was how long it took by public transportation. She responded by telling me that could not work, because I needed a car for that job. "The president cannot be taking public transportation," she said. "Here we go," I thought, waiting for her to tell me I couldn't get the job without a car.

I certainly wasn't expecting what she said next. "I have three cars in my driveway, you can use one of them, and pay me a small monthly

fee to cover the insurance, until you are able to buy your own car." My eyes started bubbling up with tears again, as I became speechless. After she confirmed I was still on the phone, she then asked why I didn't wear a suit to the interview. When I told her the reason, she surprised me again. Talk about "When it rains, it pours!" because blessings were pouring down on me that day.

She said, "On Sunday, when I get out of church, I want you to meet me at the mall in front of Dillard's at two o'clock, so I can buy you a few suits and appropriate shoes. You can pay me back when you get your paycheck." After thanking her and confirming I would meet her, she called me back again to ask if the Board had informed me of the salary. "Come to think of it, no, they didn't, and I didn't even think to ask," I replied. "Your starting salary is going to be hundred and three thousand dollars."

I thought for sure I felt my heart move. I couldn't believe it, I thought I was in shock before, but when she told me my salary, I thought my heart was going to jump out of my chest. I didn't know how to thank her for all she was doing for me, because just saying thank you didn't seem to be enough. After telling her what a blessing she was to me, and how grateful I was for what she was doing, she ended the conversation by telling me too just be a good boss.

I must have been loud because Patrick came knocking on my room door to find out what was going on. When I told him about the new developments, he also shed a few tears. He was aware of my heartbreak, and witnessed my sadness, so he also felt my joy. He tried so many times to lift my spirits to no avail, when he saw how broken I was. By him witnessing my sudden manifestation of blessings not only gave him joy, but hope that things would turn around for him also.

Happiness filled the air that evening - Patrick was probably celebrating the fact that he would now have money in his pocket,

because I would finally be able to pay for my room. I was bursting with joy and trying to contain it. I wanted to scream and shout it on the roof top that my deliverance had finally come. Patrick decided to play music and took out a bottle of wine he had, to celebrate. We went out on the patio and stayed there for hours, talking and singing along to songs we knew, until it was time to go to our beds.

"I've gone from zero dollars to a hundred thousand," I thought. Everything that had transpired that day, was mind blowing and hard to comprehend. It was more than my mind could handle, especially because it all happened when I least expected it. I then understood what the pastor meant when he told me I was going to get a five-fold blessing. When I remembered what he said, I decided to call him and tell him that his prophesy had come true.

Sunday came around, and I went to meet the director as planned, in front of Dillard's. I ended up with three suits and two pairs of high heel pumps, that I had difficulty walking in. I didn't want to get them, but she insisted I get them and practice walking in them. We then stopped at the hair store, where she told me to pick out a wig. I didn't want to wear a wig, I wanted to get my own hair done. But, she insisted I needed a fresh sophisticated look, which was true, although I still didn't want to wear a wig.

Since she insisted I get a wig, I went with the flow, and picked one that had gold streaks in it, but when she saw it, she said, "Absolutely not." I am not a fan off wigs, but the one I picked was short and sassy with lose curls. I liked it, but she wouldn't allow me to get it. I felt like a child trying to get a parent's approval for something. She thought gold streaks was not appropriate for my position, so I picked the same style with burgundy streaks. She wasn't too happy about that one either, but she did end up giving her approval and bought it for me.

I was so thankful for what she did, considering she was a total stranger, although I was also going to be her new boss. Monday morning came, and I went to meet the chairwoman of the board at her office in downtown Miami, as instructed. The purpose of the meeting was to go over details of the position and to be given my start date. The attorney, who was also hired, had an appointment to meet with her first and was about to go in when I arrived.

When he came out of his meeting, he told me he would wait for me to finish with my meeting, because he wanted to speak with me. The chairperson was a somewhat pleasant woman, who congratulated me when I greeted her. She informed me that because the board were undecided as to which one of us to hire, they decided to hire both me and the attorney. Even though I was already aware, I was told by the HR director to act as though I was hearing it for the first time.

The chairwoman informed me that the attorney had intentions of going into politics and would only be with the company approximately six months. Therefore, she suggested I network with him and familiarize myself with the people he knew before he left. She wanted me to learn as much as I could from him, so I could take over once he left to pursue his political career. I was quite surprised when she told me there was only enough money in the budget for one of us.

Apparently, we were going to have to find a way to increase the revenue, in order to pay both our salaries. Immediately after telling me all this, she then gave me the disappointing news. Because I was new to Miami, the board decided to give the position of President/CEO to the attorney and make me Vice President. I was still elated I had the job, but my spirit did not take to that attorney. I intuitively sensed deception from him, so I didn't want to work with him, and I definitely didn't want him to be my boss.

After the meeting was over, the attorney was sitting in the lobby waiting for me. He suggested we go out to lunch so we could talk and get to know each other, but I didn't have money for that, so I made up an excuse as to why I was unable to go. My spirit was uneasy in his presence, and after speaking with him for a few minutes, I just knew he was deceitful. Before we parted ways, he asked me why I wanted the job and what my plans were to help the community. When I gave him my answer, I had no idea he was planning to steal my ideas.

A couple days later, the HR director called to tell me the attorney bought a card to thank the board for hiring him. He asked her to forward it to them, but she read it first. She read it to me, and to my disgust, I realized that he wrote everything I said about why I wanted the job as well as the plans I had. I had told the HR director beforehand what he asked me, and how I responded, so she knew those were my words and wanted me to be aware of him.

She advised me to be very careful of him, although I had already come to that conclusion. I also knew he was going to be problematic and was going to make my job difficult, so I was not looking forward to working with him at all. He wanted to start a week before me, so he made up some reason as to why he should start prior to me, and the board went along with it. I was upset because I had been waiting too long to get back on my feet, and desperately needed the income, yet he was delaying my progress.

The week that he worked on his own, turned out to be a blessing in disguise. He ended up making so many bad moves and was unaware he was hanging himself. The first bad move he made, was hiring his girlfriend as his secretary, even though he knew there wasn't enough money in the budget. He then visited various job sites to meet with the employees, and announced that the vice president would be conducting layoffs. He made sure to set me up to look like the enemy before I even started. He didn't just stop there, he started making changes that would hurt the company instead of helping it.

Every time he did something wrong, the HR director called to let me know, and so I was very nervous as to what was going to happen when I started. The day before I started, she called to inform me that the new president refused to get his background check done. He also gave a state of Virginia driver's license with a Florida address. Those were red flags to the board, which led to them to give him until midday on Monday, which was my start date, to produce his background check.

Monday came and I was dressed up in one of my new suits, my designer heels, and my new wig. I was stepping out proud with my head held high, giving God all the glory for what He had done for me. It was as though the Lord picked me up out of valley, and placed me on high ground, and I couldn't thank Him enough. I arrived to work bright and early, but felt intimidated at first when meeting all the staff in the corporate office who were whispering to one another.

I then was taken to meet with that deceitful devil who was president. When I walked into his office, my only thought was, "Wow!" The office resembled the kind that belonged to a bank executive. It was large and very impressive with its luxurious office furniture and seating. While meeting with him, he told me there was no office for me, but I could use the small room next to the storage closet, until an appropriate space was found for me.

When he walked me to my temporary office and opened the door, my heart sank at what I saw. It was a tiny little room next to the storage closet, with an ugly old desk and no computer. I sat there for a moment and thought, "Lord, what is this? Look what this man has done. Is this what I am going to have to go through? He has basically put me in a closet, and all the other staff here have offices, except for me." But then I thought about what I had been through and where I was at that moment.

Immediately, my mind set changed, and instead of complaining, I said, "Lord, I thank you that I have this job. It's not going to be nice working with this man, but I thank you for what you have done for me. Even though my office is an ugly, small closet, I thank you anyway because I now have a job and an office, so Lord, I give you thanks." After I finished giving God thanks, the president walked in and put a ton of budgets and contracts on my desk, and told me to review them and let him know what I found by the time he got back.

When I asked him where he was going, he told me he was going to get a cup of coffee, which was around ten o'clock at the time. When he decided to return, it was approximately three o'clock. Shortly after, the HR director ran into my office to give me the news, "He's about to be fired," she said. That piece of news certainly uplifted my spirits, and filled my soul with joy. The board fired him because he was unable to produce his background check, which was a requirement for the job.

Meanwhile, I pretended I didn't know what was going on, when I went into his office to voice my concerns about what I found. When I asked him why he was packing up his stuff, he told me he decided the job wasn't right for him, so he quit. I thought, "Yeah right, serves you right, you deceitful devil." When he walked out the back door, I went back into my tiny office and started to laugh. I began praising God again, because He once again answered my prayers and came to my rescue.

At four o'clock, the director of finance came into my little room and asked why I was still sitting there. I didn't know what to say, so she grabbed my handbag and told me to bring the budgets and contracts and follow her. She took me into my new executive office and said, "You are the President and CEO now, so this is where you belong." When I sat in that seat, she left and closed the door behind her. I looked around in disbelief, and you know what came next, yes! I started to cry. In the space of six hours, the Lord had turned my

situation around and promoted me to President/CEO, and I was left in awe.

The following morning, one of the board members who was not present during my interview, came to the office to meet with me. He questioned me about my background and wanted to know what caused me to make the decision to leave Boston and move to Miami. After we spoke for about ten minutes, he said something that left me quite astonished. "Why are you being disobedient?" he asked. I was offended by his question at first, thinking to myself, "This man doesn't even know me to be asking me that."

I had no idea what he was talking about, when I asked, "What do you mean disobedient, and who am I supposed to be disobedient too?" "You know God told you to write that book, and yet you haven't done it." I was dumbfounded at his response. I was astounded that the Lord used him of all people, to tell me that. We talked about it for a bit, during which he suggested I record what I wanted to write and have someone else type it for me, but I knew I had to do it myself. I decided at the time that I would not put of writing my manuscript any longer,well, that was the plan anyway.

During that same week, revelations began to unfold of financial debts the company had incurred, which were not revealed earlier. By the time Friday morning came around, I got my first surprise when I was told there was no money to make payroll. The accountant told me they went through this every week when payroll was due, and that the company was in a deficit. By the end of that day, I managed to make the payroll for the four hundred plus employees, but the stress I endured doing so, was not something I wanted to go through on a weekly basis.

The following week I visited the company's five workforce sites to introduce myself and explain my goals for the company. I started with the largest site first, and was welcomed with stares, whispering

and dirty looks. It was quite intimidating at first, but I held my head up high and did my best to ignore them. I had forgotten I was made out to be the enemy by the devious attorney who had told them I was going to lay people off.

Before I could explain my plans for the company, they didn't hesitate to voice their concern about who I was going to lay off. The only thing I could do was to reassure them I would do my best not to lay anyone off. During my visit to that same site, I met a woman named Rita, whom my spirit was drawn to the moment I laid eyes on her. She was a cheerful woman, so it was impossible not to like her. I just knew there was something special about her the moment we met, but I had no idea she would play an important role in my life later on.

There were days that I came to work, and I would receive an email from Rita with words of encouragement. What was strange about her emails was that she always sent me one just before something devastating happened. Her words of encouragement always came in time to strengthen me and help pull me though. If it wasn't the bank or vendors calling with threats to take us to court for overdue payments, it was employees doing something treacherous.

Every day it was something else – sometimes it was evil employees trying to jeopardize the company, or employees in the corporate office doing things behind my back even though I clearly forbade it. Employees were signing my name to documents or trying to get me fired when I didn't do as they wanted. The bills were sky high, and it took a few months before the accounting department was upfront with me regarding the extent of the deficit, which was over half a million dollars. No one would help because of the deficit, and every day there was a problem.

Three months after getting the position, I started looking for a place to live closer to work, which was in North Miami. Patrick was

upset that I was leaving, but when I found somewhere, he had the nerve to tell me to leave Max and Fluff with him. He should have known better to even ask me such a crazy question. I couldn't believe how upset he was when I told him I could not part with them. Because I wouldn't let him keep my babies, his entire attitude changed towards me.

I ended up finding a nice townhouse in North Miami with a dock and a canal located in the back. It felt so good to be in my own place again, and my neighbors were friendly and inviting. The street was quiet, clean and peaceful and I absolutely loved it. I bought furniture which I ordered from Italy and bought myself a red convertible Mercedes Benz. I was living again, and life was great - I had everything I wanted, and Max and Fluff did too. We traveled everywhere together and went to south beach just about every evening after I left work.

Well, the happy life lasted for two and a half years – the deficit was so bad, that when the board found out about all the issues the company really had, they told me to close it down because they didn't want to be liable for any debt. They told me they knew the company had problems when they hired me, but had no idea how bad it really was. Instead of helping, they suggested I give up the contracts and dissolve the company. After going through all I had been through and thinking I had a stable job, this was how it was going to turn out.

Chapter Twenty:
Saying Goodbye to Fluff

God created animals not for us to mistreat and abuse, but to love and care for them. "The righteous man regards the life of his beast: but the tender mercies of the wicked are cruel." (Proverbs 12:10) This biblical verse shows two distinctive types of people: Those who are "righteous" and just show kindness to their animals, and those who are "wicked" are cruel to the animals that are in their care. Which one are you? Are you a loving caregiver to the animals that God created for our companionship, or are you the wicked person who uses, abuses, and kills innocent animals for pleasure?

During my trying times, I was so grateful that I had Max and Fluff to come home to, knowing they were a great help in taking my mind of my troubles. I looked forward to them greeting me at the front door every day, with their tails waggling and searching my bag when I put it down so they could see what I brought for them. But the eleven years of love and joy the three of us shared, came to an abrupt end. We usually went out on weekends, but this particular weekend, I decided we would stay home instead.

I didn't feel like cooking that Saturday, so I bought Chinese food. After Fluff had eaten some, I noticed his stomach got very large. I was worried about it at first, but when his stomach went down to its normal size, I thought nothing of it. The following day, while sitting outside on the dock speaking with Bev, I watched as Max and fluff were running around. In the middle of our conversation, I noticed that Fluff's stomach was bloated again, but this time it was touching the

ground. His stomach was very hard when I touched it and I noticed he was also having difficulty walking.

Fear, worry and panic took over me all at the same time. After telling Bev what was happening with Fluff, we agreed I would hang up so I could find a veterinarian and call her back with updates. I couldn't find a clinic that was open because it was Sunday, so I decided to do what I could to help him until morning. Fluff wouldn't eat or drink any water, so I knew something was terribly wrong, because he loved to eat. I was waiting and hoping that his stomach would go back to its normal size as it did the day before, but it didn't.

Fluff was panting very hard during the night and because I knew he was hot, I put the air conditioner on for him, even though Max and I were shivering from the cold. I stayed up during the night watching Fluff as he laid next to my bed, but it seemed as though he was getting worse. By the time two o'clock came around, I couldn't hold out any longer when I realized Fluff was unable to stand up by himself.

I decided to put him in the car and keep driving until I found an open veterinary clinic, no matter the distance. I drove down the US 1 and after driving for about a half hour, I noticed that one was opened. He charged me two hundred dollars to look at Fluff, just to tell me Fluff had an infection and a temperature of one hundred. He told me to leave Fluff with him, and suggested I come back around seven o'clock that morning to get him.

I didn't like the vet because he had a very cold demeanor and he was not gentle in handling Fluff, so there was no way I was going to leave Fluff with him. I drove back home in tears, with a broken heart because I had no idea where else to take him at that hour. As soon as morning arrived, I was up and out the front door. My neighbor Nancy came out as we were leaving and told me to take Fluff to Hollywood Animal Hospital, so that's where I headed.

Fluff looked so helpless in the car as he stared at me with his loving eyes the whole way there. I drove with my left hand on the steering wheel and laid my right hand on Fluff, so I could comfort him on the way there. When we arrived at the animal hospital, the technician took him right away after I informed her that he had a fever. She took him in by himself at first and called me in shortly after to join him. The vet was in the room with Fluff when I entered, but I didn't like the look on her face.

I then asked what was wrong other than his high temperature. After a long pause, she said, "Let me show you, instead of trying to explain it." She showed me two x-rays: one of Fluff, and one belonging to another dog. She proceeded to explain that the x-ray of the other dog was what a healthy dog's heart is supposed to look like. Then she told me that Fluff's x-ray showed that his heart, lungs and liver were attached to each other. After which she explained it was nothing but a miracle that he was still living in that condition.

I really didn't care about the thousands of dollars I assumed the operation would cost, because losing Fluff was not an option for me. I never expected her to tell me there was nothing they could do to save him. "What do you mean nothing?" I ask. I just couldn't understand what she was trying to tell me. Then again, I guess I refused to accept what she was trying to say. She then told me that even if his condition was something that could be fixed, Fluff wouldn't be able to undergo an operation and make it out alive.

My next question which under the circumstances was a stupid one. "Isn't there any medicine you can prescribe for him?" Instead of answering, she decided it was time to break the news in a way I could clearly understand. "I'm so sorry, but we have to put Fluff down, he is suffering and there is nothing we can do to save him." Before my brain collapsed, causing me to totally lose my composure, I felt as though the room was closing in on me. I then shouted out, "No, Fluff cannot be dying, not my baby."

Even as I am writing this and reliving that dreadful day, I feel the emotions all over again, as if it was yesterday. It was another one of those day's that a piece of my heart was ripped away. I was in major denial because I couldn't imagine my life without him. Although I knew he had to go one day, I just didn't want it to be that day, or any day for that matter. I couldn't handle the shock - that dark cloud came over me again, and my heart felt like it was getting heavier by the minute. I was numb inside, to the point that I couldn't speak or move for a while, as I sat in that room, staring at Fluff.

When it finally started to sink in, my tears started flowing like a river, before I began crying out loud, and couldn't stop. I saw different people rushing through the door to see what was happening. One person after the other, and all of them trying to calm me down. I couldn't stop crying until the vet reminded me that Fluff not only could hear me, but could sense the heart break I was feeling, which would in turn cause him to be heartbroken too. I knew that was true, so I tried my best not to let Fluff see what I was going through.

I tried to keep my spirits up for him, but that only lasted about a minute before I started crying again. The news was so sudden, and I just couldn't accept that it was going to be the last day I had with my baby. As I looked into his beautiful eyes, and he stared back into mine with nothing but love, my tears felt heavier. "How in the world am I going to live without him," I asked myself. I couldn't imagine life without him. All I kept thinking about was the eleven years I had him, but I wasn't ready to let him go.

Losing him so suddenly was something my mind just couldn't digest. I told the vet I was taking Fluff home because I didn't bring him to the hospital to be put to sleep. "I thought I was coming to get medication for him, and I am not prepared to say goodbye, I just can't do it, this is too sudden." She then suggested I take him to his favorite place, spend a few hours with him and bring him back. The vet

reiterated Fluff was suffering, and insisted I bring him back so he could be put out of his misery.

I agreed, although I had no intention of taking him back, but I told her what she wanted to hear. Because I was still hysterical when I was leaving, the vet didn't want me to go through the waiting room area for the other customers to see, so they escorted through the back door. The vet was also concerned about me driving home in the condition I was in, and wanted me to call someone to pick me up instead. I reassured her I would be find, because I really just wanted to get home so I could have my mental break-down in privacy.

The moment I started the car, my neighbor Nancy happened to call to find out what they said about Fluff. I burst into tears again, so she knew the news was bad just from my response, and insisted I not drive in my condition. She wanted me to wait until I calmed down, but I knew I wasn't going to calm down, so I figured I might as well get home as soon as I could. She then asked me if there was something she could do or get for me, so I told her I was going to need a bottle of Appleton Rum. I didn't actually mean it, but it was my first response because I wanted to drown my sorrows. But sure enough, when I got home, Nancy was outside waiting for me with a bottle of Appleton Rum.

I was crying hysterically when I told Nancy what the vet said, and could see she was heartbroken too, knowing she also loved Fluff. I called Bev to tell her my baby was dying, and I also called my friend Rose who suggested I do as the vet said and take him back, so he wouldn't suffer any longer. I knew it was selfish on my part not wanting him to be euthanized, but I couldn't do it because I felt as though I would be killing him. It was total doom and gloom in the house with thoughts of everyone I had lost up until that point. I remember thinking I thought the feeling would be different when losing a pet, but to me it wasn't. I felt the same familiar feelings of heartbreak and devastation crushing me all over again.

I walked around the house with Fluff in my arms telling him how much I loved him, while Max sat on his bed watching me. I thought of taking Fluff to his favorite place as the vet had suggested, which would have been the beach, but neither one of us were in any condition to go to the beach. I took him outside for a while and sat on the dock with him instead. I decided he would be more comfortable under the air conditioner, so I brought him in my room and laid him on the bed.

I sat next to him rubbing is tummy and continued to tell him how much I loved him and thanked him for all the joy he brought to my life. My friend Rose called to ask if I had remembered to give him water to drink, which I hadn't, so I took him to his bowl, but he only took a sip. I went back into my bedroom with him, and as I sat there with him in my arms, I was wishing his health would miraculously change.

A couple hours had passed while sitting with Fluff in my arms, then I noticed Max came in the room and looked at me and Fluff, then he turned around and went back to the living room. Rose then called again to tell me I should try giving Fluff more water to drink. I had put some water in the fridge for him so it would be cold the way he liked it, and so I went to get it for him. When he saw it, I was surprised to see his sudden burst of energy as he nearly jumped in the bowl to drink the cold water.

He took three quick sips of the water and then his body immediately stiffened. It was strange because I felt his spirit leave his body, right before his head dropped down and his body laid lifeless in my arms. I shouted, "Fluff, no, don't leave me," right before Max came running into the room to see what was going on. I stayed in the same position for a few minutes still holding Fluff in my arms. I just sat there on the bed staring at him in disbelieve that my baby had died so suddenly in my arms.

When I eventually laid Fluff on the patio, Max followed. He walked up to Fluff and sniffed his body then walked back into the living and laid down. I went straight into the kitchen and opened that bottle of Appleton Rum that Nancy had bought me and started drinking as though it was going to ease the deep pain I felt in my heart. I went back outside with my glass and sat with Fluff, just staring at his lifeless body in disbelief that he had really gone and left us.

The phone wouldn't stop ringing as friends were calling to see how Fluff was doing, but I didn't want to talk to anyone. My friend Ken who was on the phone listening when the vet told me I had to put Fluff to sleep, happen to also call, so I answered for him. When I told him Fluff had just died, he told me he was on his way. I told him to hurry up as I felt as though my heart was getting heavier and heavier. Although Ken lived nearly an hour away, in no time he was at the front door.

My landlord Dino also called to let me know how sorry he was, because he too liked Fluff. Apparently, Nancy had called and told him what was going on. He told me where to take Fluff to be cremated, but I wanted to bury him in the back yard. He reminded me that I still had Max and told me not to show my depression too much, because it would affect Max who was also mourning Fluff.

Ken insisted I cremate Fluff and made it very clear that he wasn't going to be the one to dig the hole to bury him. Although it took some convincing to cremate Fluff instead of burying him outside, I finally agreed. When Ken, myself and Max arrived at the place where Fluff was to be cremated, I didn't want to get out of the car. My legs, heart and every other part of my body felt as though they were getting weaker and weaker. Once my legs gained some strength, I tried my best to delay the inevitable.

I tried walking as slow as I could behind Max and Ken who kept telling me to come on. I started crying again when I reached the

reception desk, unable to speak so Ken did the talking. I wanted Fluff cremated by himself, but Ken thought that was absurd. He asked why I would want to pay an extra hundred dollars to cremate Fluff by himself, insisting that was a waste of money. I planned to do it anyway until he called me aside. He asked, how could I be sure they wouldn't take the money and cremate Fluff with other animals anyway.

After thinking about what he said, I figured he had made a good point, so therefore I decided not to do it. When I paid and was given my receipt, the attendant followed us back to the car to get Fluff. I had put Fluff in one of my backpacks, so when the man took him out of the trunk and proceeded to walk away with Fluff, I stopped him. I needed to look at Fluff one last time, trying again to delay the inevitable. I unzipped the bag, looked at Fluff with tear filled eyes and told him goodbye and how much I loved him one last time.

I cried all the way back home. It was a good thing Ken was with me to do the driving, because I most certainly was not in the right state of mind to be driving at that point. Once we got back home and I opened the front door, my heart felt as though it had been smashed into a thousand pieces. Fluff was never again going to be standing at the front door wagging his tail waiting for me. Ken stayed and had a few drinks with me, but I didn't want to speak. I welcomed his company but wanted it in silence.

After Ken left that evening, Max and I sat outside on the dock for most of the night. We were both mourning Fluff's absence until daybreak when we finally went inside and went to bed. Once in bed, I laid there in deep thought thinking of all the wonderful memories the three of us had together, which would be no more. The void and emptiness that covered me once again, felt unbearable. I couldn't help but think, one by one, I was losing those who meant the most to me. My only comfort was believing that one day I would see him again in heaven.

I stayed out from work for three days before I was able to pick up the strength to return. My staff placed a large vase filled with twenty-four red roses on my desk, along with a sympathy card, which was a lovely gesture. My spirit was already in distress but even more so, when I realized all the company problems were waiting for me return. It certainly wasn't something I wanted to deal with during my time of sadness, but duty called.

There were all sorts of issues to deal with; complaints from vendors not getting paid, bank account overdrafts, payroll, and human resources issues. A year and a half had already passed since I started running the company with the deficit, and every day more problems would arise. I started having panic attacks, and when I finally accepted the fact that the company was too far gone, I decided to take the boards advise and shut it down.

I held a meeting with about one hundred and fifty staff members, to let them know the decision the board had made. When I informed them that the company was too far gone to salvage, there was an uproar in the auditorium. One angry director insisted I couldn't do that to them, suggesting I keep the company open and fight. Everyone else joined in, some talking and some shouting at the same time, begging me to keep it open.

The staff tried to convince me that if I kept the organization open, they would all get together and fundraise in order to save it. They could see I still was not convinced, so one of the directors got up and addressed the staff. He asked those who wanted the organization to stay open and would be willing to fundraise, to raise their hands. Basically, all hands were raised, but I still was not moved.

One of the accountants decided to stand up and inform me that I was responsible for the well-being of all the staff and their families. Another employee made a good point, when he reminded me that we would all end up on unemployment, and asked if that was what I really

wanted. Just the mere thought of reliving the adversities I had already previously experienced, caused me to rethink and recant the decision.

I told the board that I was going to try and save the company, so the board chair sent a financial analyst to evaluate if there was any possible way to keep it going. When the analyst came back with his findings and evaluation, he wanted to know how in the world I had kept the company going that long with such a major deficit. He suggested that if I knew what was good for me, I would close the company as soon as possible. I decided to try and save the company against the advice of the board and the analyst, which I ended up regreting.

The boards tenure was over anyway, so I brought on new board members, who claimed they could help with the fundraising but didn't. So, when things got worse and the debts continued piling up, I had to go to court a couple times for old debts that existed before I even took the position. The IRS also told me I had to pay taxes for previous years for which I wasn't even living in Florida at the time the debt occurred.

The same staff who said they would help fund raise, called the labor board because we weren't able to pay for accrued vacation time. A couple months after, some employees called the labor board again, this time to complain that the health insurance had lapsed, which basically became one giant mess. That's what I got for trying to help those ungrateful people who begged me to keep the company open because they had families to feed.

The debts the company had were over a half a million dollars, and because no one wanted to help while it was in a deficit, cause me extreme stress trying to keep it afloat. My family kept telling me to close the company, and tried to convince me that it wasn't worth making myself sick over. It got so bad that I ended up having to lend

money to some staff when payroll was short, and pay some of the vendors out of my own pocket.

Finally, I said, "Enough is enough," and made the preparations to close it down. The faithful employees that were left, wanted me to file bankruptcy and keep it open, but we didn't even have the money to do that. When that couldn't work, they suggested I start a new company and begin a fresh, but at that point, I was done. I knew if I started another company, I wouldn't have had any intention of hiring most of the employees that were left anyway.

I did manage to keep it going until the contractual obligations we had left were fulfilled, but once I fulfilled our obligations, it was time to bring it to a close. Although most of the staff were walking around in misery, I was relieved that the stress was finally coming to an end. I had hopes that another door would be opened once we closed, so I kept hope alive and keep my spirits up.

My spirit was lifted even higher because of what happened the week prior to the company closing its doors. It was my administrative assistant, Barbara's last day on the job and she was getting ready to leave early to go for her mammogram appointment. My interest was piqued while walking through the hallway when I overheard her sharing with other staff that she was afraid to go because of what the doctors would find.

What I heard troubled me, so I went into her office to inquire what was going on with her. She informed me there was a lump on her breast which had been there for nearly five months. Being the curious person that I am, I wanted to see what the lump looked like and so I asked her to show me. I wasn't expecting the lump to be as large as it was, so I was taken aback at first. My inquisitiveness led me to touch the lump which caused me great concerned because of how hard it felt.

I then asked why she waited so long before she made an appointment. Her emotional honesty caused my compassion to be aroused when she shared with me that she was afraid it might be cancerous. It was also the first thought that came to my mind when I touched it, but I didn't say anything. I was led to pray for her, so I placed my hand on the lump and started commanding the lump to dry up and leave her body by the following day, in Jesus name.

When she was ready to leave, we hugged and said our goodbyes, knowing we would probably never see each other again, as we were all about to go our separate ways. Before she walked out the door, I told her to call me and let me know what the doctors had to say. I didn't think about it again until that weekend, when I heard a voice in my head say, "Barbara's lump has gone." I was in the middle of watching a movie, and Barbara was the last thing on my mind, so it puzzled me all day.

The following morning when I arrived at work, everyone was extremely busy, due to the fact it was our last week, and so much more still had to be done. We were all concerned about our immediate futures. Although no one voiced their thoughts, it was clearly evident on everyone's faces. I wanted a cup of coffee and needed to get away for a few, so I walked to Starbucks. I decided to sat down and drink my coffee there instead of taking it back to my office, as I usually did.

As I sat there with my head down lost in my train of thoughts, I felt someone's presence in front of me. Upon lifting my head to see who it was, I was astonished to see it was Barbara. "What are you doing here, I asked." After informing me she went to the office to see me, and one of the staff told her where I was, I asked another question. "Why did you drive all this way to come see me, when you could have just called?"

"I had to tell you in person, not over the phone," she replied. "Tell me what?" Never in my wildest dreams did I expect to hear, "Hilary

my lump is gone." I was so surprised by her unexpected reply, that I ended up spilling some of my coffee. Surprise turned to excited when I asked her to give me all the details. I wanted to know everything that had happened within the six days I had last seen her. Barbara explained that once the monogram was done and the doctor physically examined her breast, he too believed the lump was cancerous.

The doctor then called for an oncologist, and he too after examining her believed it was cancerous. They also wanted to know why she waited so long and allowed it to get to the size it. Because of the urgency, an appointment was set for the following morning to do a biopsy. When she arrived to have the biopsy done the following morning, to the amazement of the doctor and herself, when they went to examine her again, the lump was nowhere to be found.

I was speechless, and elated at the same time, which left me feeling as though I was the one who received that miracle. Barbara was very humbled when she told me she couldn't thank me enough for praying for her lump to be removed. I chuckled when she gave me a list of names of friend's she wanted me to pray for, now that her faith had been ignited. Although I was elated, I wasn't looking forward to leaving Starbucks and having to return to the office to face all the work that was waiting.

There was so much to do in order to wrap up the closing of the organization, and everything had to be completed by the end of that week. Only four staff members including myself were left to organize, pack and move all the equipment, furniture, files and everything else. Items that weren't donated to other non-profit organizations, were placed in storage. Friday finally came, and it was time to say our goodbyes. After running the company on a deficit for two plus years, we closed the doors and went our separate ways.

Chapter Twenty-One:
Wilderness Journey

When things get rough and you feel like giving up, keep on going, keep pressing through. All sorts of things happen to us throughout our time spent here on earth. For some people it seems as though life is always sweet, and for some of us, it seems as though most of time life is bitter. But when you have ridden with the waves, and made it through the storms of life, and remember the moments and events that took place, as I am doing now - you will see that all the disappointments, heartbreak and loss we experience, are just segments in the adventures of our life.

I tried to find other employment, but once again, I was getting no responses and ended up filing for unemployment. I can't even describe how I felt when I found out they only paid two hundred and twenty-five dollars a week, when I was making that amount per day. During the start of my new trials, I kept my hope alive because I strongly believed I would find employment quickly, therefore everything would work out just fine. That was until one day as I was walking to my bedroom, I heard an inner voice say, "I will be El Shaddai in your life."

"What does that mean exactly?" I asked myself. I went straight to the internet and looked up the meaning of El Shaddai, although I already knew it meant Almighty God, but I wanted more details. Well, the sight that I found said it meant, your provider through affliction and suffering. "Oh no, not again," I said out loud. I didn't

even want to entertain that thought, so I chose to ignore what I heard and continued to believe a breakthrough was on its way.

I was relieved when a member at church referred me to a friend of hers, who happened to be the hiring manager at Department of Children and Family Services. The position was for the director of emergency services, which I was qualified for, so I was quite excited about it. During the interview, I was asked why I wanted a position I was overqualified for.

I could not see how I was as overqualified as she made me out to be, so I gave all my reasons of why she should hire me. The interviewer was honest enough to tell me she didn't feel comfortable giving me the job, because she believed I would leave as soon as I found something more appropriate. There was nothing I could say to convince her that would not be the case, so I wasn't offered the position. Needless to say, I was saddened but I still had hope that another opportunity would arise.

I spent part of my days looking for work, and the other part seeking the Lord through fasting and prayer. The more I fasted and prayed, the more I became closer to the Lord. My dependance on Him, in turn, led me to see Him as my source. My first executive assistant named Jill, whom Barbara had replace, told me that God was going to use all my experiences for my ministry. I didn't want to hear or believe that at the time, because I had no intention of going through any more negative experiences.

Jill was convinced God would end up using me to help others who were experiencing trials and adversities, and had lost all hope. I on the other hand, was too busy trying to prevent myself from reliving those experiences. Weeks turned to months and as they passed by, I found myself falling back into depression when my money began running low, and my bills started falling behind. I searched like crazy

for work, trying to prevent history from repeating itself, but I could foresee it happening all over again.

Six months had passed and still I found no work, plus the landlord was complaining about his rent, which made matters even worse. I successfully hid from him, until the day I accidently bumped into him. I wasn't expecting him to tell me he didn't want me to leave. He suggested if I couldn't find the job I was looking for, I should try getting a job at a strip club, because he thought I had nice legs. Appalled at his suggestion, I asked him if he would want his daughter to work at a strip club. Since he refused to respond to my question, I then told him, "What you wouldn't want for your own daughter, don't wish it on someone else's."

I was so angry with him for what he said, but I forgive him because I knew he wanted so desperately to keep me as his tenant. The following week, he came by again to find out if I had any luck finding a job. When I told him I had not, he got upset and said, "Your expensive taste is the reason you're in the mess you're in. Your car is expensive, your furniture is expensive, your clothes are expensive, and you even bought expensive things for your dogs." He was outspoken and sure wasn't afraid to say what was on his mind, whether I liked it or not.

A few more weeks went by, and I still was unable to find another job, so my landlord then suggested I go stay with one of my family members, until I was able to find a job. I had no family in Florida and moving back to Boston wasn't an option for me either. By that time, I was backed up on the rent and car note, so the landlord told me he had to start making plans to put the property up for rent, because he was losing income.

What savings I had was depleted, and although I was paying something towards all my bills, I was unable to keep up with them all. The electric was one payment I didn't want to fall behind on because

I needed the air conditioner. During one of the hottest days that summer, ironically enough, as I was sitting in the room being grateful for the air conditioner, the electric went off. When I heard the door to the electricity meter box being closed, I ran to kitchen window. When I saw the electric van outside, I realized it was turned off for non-payment.

I walked back to my bedroom with a heavy heart and got down on my knees. I cried out to the Lord and sarcastically asked, "Is this what you meant by being El Shaddai and taking care of my needs?" As soon as I finished questioning the Lord, I saw that the electricity came back on. I heard the door to my kitchen knocking, so I slowly crept up to the door, so I could peep through the glass to see who it was. I wasn't expecting it to be my neighbor Nancy, whom I was hoping didn't see when the electric was turned off.

I notice too that the van was still parked outside, which puzzled me. She knocked the door again, but I didn't answer, not realizing she could see my shadow through the glass. Nancy then said, "Hilary, I can see you through the glass, put some clothes on and come outside." I was so embarrassed that she could see me, but I was more curious as to why she wanted me outside. I wasn't in the mood to speak to anyone, but I was obedient and did as she requested.

She told me she was in her kitchen and saw when my electric was being turned off. I thought "Great, that's exactly what I didn't want to happen." What I didn't know was that she paid the guy twenty dollars to turn the electricity back on, and reassured him that the bill would be paid in full, by the end of the day. I was grateful, but embarrassed, especially when the guy told me he wished he had a neighbor like mine. Nancy then told me to go get the electric bill and meet her back outside.

Even though I had no other means of paying that bill by the end of that day, I tried to tell her I could not allow her to pay the bill.

Nancy knew it was my pride talking, so she paid no attention to me. Instead, she insisted I get the bill because she had given the man her word. Not only did Nancy take me to the store and pay the bill, but she paid more than the required amount. It turned out that the Lord did take care of my needs after all, and it was done right on time in a way I least expected.

After the electric bill was sorted out, the car finance company told me they were going to repossess the car because I was behind two months with the payments. My landlord told me I could park it at his house so they couldn't find it, but I decided to sell it instead. I put down fifteen thousand dollars cash as a down payment when I bought my car. I only owed five thousand, so I was not about to let them repossess it and cause my money to go to waste.

When I told the finance company that I was going to sell the car, they told me that according to the contract, I could not. I decided they would then have to wait until I could pay what I owed, because I wasn't about to let my thirty thousand go down the drain. My stepfather suggested I come back to Boston, and offered to pay for my flight. When I told him I couldn't carry all that I had on the plane, he told me I had to leave them behind.

"Definitely not," were the first thoughts that entered my mind. There was no way I was going to leave everything I worked for a second time. One of my cousins suggested I come stay with her in South Carolina, but when I seriously thought about it, she was going through her own drama, so that was a sign for me to stay where I was. My greatest fear was the shame of being evicted, and my possessions put out on the street, if something didn't come through for me on time.

I kept praying for direction, asking God what I should do, and where I should go. I would pray and open the bible to see what scripture my eyes would land on, and every time I did this, I got the same scripture. ".... For they shall not be ashamed who wait for Me."

(Isaiah 49:23) Patience was not one of my virtues, and the lack of it caused me much anxiety. Although I was believing the Lord would come through for me, I was upset because as far as I was concerned, God was taking too long.

I knew my landlord didn't want to evict me, but he had already given me two months free from paying my rent which was eleven hundred dollars a month. Dino forgave my debt hoping it would help me to catch up with my other bills. Although I was able to catch up on some bills, I knew without a job, I would not be able to keep up. Eventually, my landlord finally told me he would have to end up evicting me, if I didn't find a job or someplace else to live. In the same breath, he kept telling me to look harder for work, because he didn't want me to go.

Deep down I knew my time there had come to an end, but I was fearful not knowing where Max and I were going to end up next. I had no other choice but to leave it in God's hands and decided to trust Him to would work it all out. Two weeks later, the landlord came back and told me he was giving me until the end of May to either find a job, or I would have to move. The end of May at the time, happen to be two weeks away. Up until the final week, I still found no opportunities and to add to my stress, the landlord kept calling every day to find out if I found a job.

He gave me until that Friday morning, and told me he would have to bring the eviction notice. The week seemed to pass by so quickly and by the time Wednesday came around, the electric was cut off again. There was no sense in having it turned on, because I only had two days left there anyway, and I still had no idea where I was going. When Thursday came and no doors had opened up, I sat outside on the dock that night with Max by my side.

I looked up at the stars and asked the Lord if He was going to come through for me, because it sure didn't seem like it. I couldn't

shake the thought that what I feared the most, seemed like it was about to happen - All my stuff was going to get put out on the street, and I knew I wouldn't be able to handle the shame. I remembered the scripture I got, that I wouldn't be put to shame if I waited on God, but my faith was wavering. Doubt began to set in, and when it did, I started to panic, so I called my cousin Urceline, in California.

As usual she tried to comfort me by reminding me of all the times God had come through for me in the past. She tried her best to reassure me that God would come through for me again, but I was doubting. "You already know how God works in your life, He always waits until the very last possible moment to show up, but comes through right on time." When our conversation ended, I continued to sit on the dock looking at Max who was staring at me, as if he knew something was wrong.

I was missing Fluff and still heartbroken that he was not with us. A flood of tears came rushing down, when I said to Max, "I have no idea what is going to happen to us tomorrow." I knew I was undergoing another great test of faith, but I didn't want to go through it. I stayed up most of the night sitting outside on the dock with Max by my side, wondering what my fate would be. I tried to hold on to my faith, but it sure did waver back and forth all night.

All sorts of thoughts flew in and out of mind, that caused me to be temporarily crippled with fear. I just couldn't shake the notion that my belongings might be put out on the streets the following day, if God didn't show up and deliver me. I think the shame of such an occurrence was what bothered me the most. As much as I tried not to, I kept struggled back and forth with those thoughts. I wanted to please God by trusting Him, and yet at the same time, I kept wondering what if?

Morning came and I badly needed my cup of tea, but there was no electricity to make it with. I decided to drive to Rita's house to make

a cup of tea, so I took Max with me. Rita was the woman I met at the job who used to encourage me all the time, and so we did become very good friends, as I had envisioned. Surprisingly enough she knew I was coming and therefore had my favorite dish prepared for my breakfast.

Although food was the last thing on my mind, she insisted I eat it. While trying to force myself to eat, I broke down into tears and told her how afraid I was. I sobbed and complained as I shared how petrified I was to go back to the town house. I was convinced I would find the eviction notice taped to the front door when I returned. That's when I started saying "God should just take me and put me out of my misery." Rita then got upset and told me to shut up and stop talking nonsense.

Less than five minutes after Rita told me to shut up, her phone rang. When she answered, she told me the call was for me. "How can the call be for me, if no one knows I am here, plus, nobody I know even has your phone number?" Her reply was, "Just get up and come take the phone." I was hesitant and didn't get up fast enough for her, so she then raised her voice and said, "Hurry up and come take the phone." When I took the phone and said, "Hello," I was confused when the person said, "This is Dana."

I knew Dana was Rita's friend, but I was baffled as to why she would want to speak with me. Before I was able to ask, she explained that Rita had contacted her a few weeks prior about renting me a room, unbeknownst to me. She thought about renting me her son's room, but there was a possibility he would return home. She didn't get the confirmation that he wouldn't be returning home until a few minutes prior to her call. Dana then explained she just happened to be calling Rita to find out from me if I still needed a place to live.

While standing in the same spot speechless, I glanced over at Rita and saw she was smiling. Dana had to ask me if I was still on the

phone, because it took a while for me to respond. Once I was able to confirm my interest in taking the room, Denise caused me to be speechless again, when she told me I could move in that very same day if I wanted too. In amazement, I turned to look at Rita but before I could even thank her for what she did for me, I burst into tears.

I was overwhelmed with extreme joy. The lord blew my mind the way in which He came to my rescue, right in the nick of time. Once I was able to compose myself, I couldn't thank Rita enough for what she had done. I was no longer in fear of being put to shame, and no longer bewildered as to where myself and Max were going to end up. My appetite immediately returned, and so I was able to finish my favorite breakfast, which was ackee and saltfish with fried dumplings, and I certainly enjoyed it that morning.

I no longer dreaded going back to the townhouse to confront my landlord Dino, who happened to be knocking on the front door with a piece of paper in his hand when I pulled up. He proceeded to stick a piece of paper on the front door, when he turned and realized it was me. Eager to get out the car and relay my good news, I walked up and told him he could take his notice down, because I had found new living arrangements.

With a delighted look on his face, Dino decided he was going to give me an extra week to pack and schedule my move. I sat in awe after I went inside, and thought about how fearful I was the night before. My fear was all in vain, because the good Lord did show up on time. His word did end up coming to pass, because God didn't allow me to be put to shame. I did feel ashamed of myself though, knowing I doubted God and did not continue to believe He would come through for me, when my situation began looking hopeless.

What a relief it was not having to stress anymore over where I was going to end up. Rita came over to help with the packing and even found and paid for the movers. It was a bittersweet moment on the

day of the move. I was uneasy having to move again, especially because I was once again having to share space with a practical stranger. I found myself yet again in that same familiar circumstance, going to the unknown and not knowing what to expect or what the future had in store for me.

Dana and her teenage sons welcomed me and Max with opened arms, which made my transition less unbearable. It was a pleasant surprise to see that the house she lived in was modern and very clean, so that helped to make me feel comfortable being there. Max was allowed to stay in the room with me which was also a great relief. Having Max by my side tremendously helped to ease my inner heartbreak. Even though I was unhappy, I did have somewhere clean and safe to lay my head, but it wasn't the situation I wanted to be in.

Dana was older than me but close in age, so we had some things in common. Everything was flowing smoothly, at least for the first four months anyway, before things started going downhill. Dana was involved with a married man who came to the house every evening after work to visit with her. She happened not to be home one evening when he came, but he decided to come in anyway and told me he would wait. Once inside, he began telling me how much he liked me and even tried to convince me to visit him at his house.

As soon as Dana arrived that evening, I pulled her aside and told her what he said, expecting she would address the matter with him. But to my surprise, her only response was that I should ignore him if he tried it again. I began feeling uncomfortable living there after that, but it got even worse. I noticed boxes addressed to Dana were arriving on a weekly basis, which required a signature. It just so happened that when these boxes arrived, I was always the only one home to sign for them.

After accepting the first two packages, I told Dana I wasn't comfortable signing for them anymore especially not knowing what

the contents were. She assured me the contents was nothing for me to be concerned about, and asked me to continuing signing if I was home. Shortly after, I overheard a telephone conversation between Dana and her ex-boyfriend Malcolm regarding the boxes. It wasn't until then that I realized the boxes I was signing for contend marijuana.

I immediately approached Dana about her involvement and putting me at risk. She pretended she knew nothing other than her son kept the boxes for Malcolm until he was able to pick them up. About a week later while everyone was home another box came, but off course I stop signing for anything that arrived at that house. Her son signed for it while Dana and I sat in the kitchen observing. We noticed the box was already opened and wondered if someone from the delivery company had opened it.

Dana called Malcolm and told him someone had tampered with the box, but I wasn't there when he came to pick it up. A few hours later when I returned to the house, I heard screams coming from Dana's room. Her room door was ajar, so I poked my head in to see what was going on. I noticed her sigh of relief when she realized it was me and signaled for me to enter. After telling the person on the other line to ask Hilary, she immediately handed me the phone. I had no idea who she wanted me to speak with, but when I took the phone, it was Malcolm on the other end.

He asked me if I was there when the box arrived and asked me who opened it. I told him it was already opened, but he thought I was covering up for Dana and her son. Malcolm then told me that I should get in my car with Max and leave the house right away, because he was going to come over and shoot everyone in the house. He told me he didn't want me to get hurt, therefore he suggested I get in my car and leave before he arrived. Because Dana heard what he was saying, it was quite difficult to calm her down when she became hysterically.

Dana begged me to stay and not leave even though I had no intention of leaving anyway. Since Malcolm didn't want me to get hurt, I decided I would have to stop him if he really did come over. The uneasiness in the home could be felt in the atmosphere that day. Everyone was in a panic, and I had no idea what to do. Malcolm called Dana's phone again about an hour later, but she was afraid to answer, so she came to my room and asked me to answer instead. When he heard my voice, the first thing he asked was why I had not left the house yet.

The anger in his voice scared me, but I realized someone had to maintain their equilibrium, which was going to have to be me. Trying to talk some sense into him wasn't working, and trying to convince him that whoever opened the box didn't live in that house, wasn't working either. He didn't want to hear anything I had to say, instead, he ended the conversation by telling me once again to leave the house before he arrived.

At that point, I started panicking myself. The only thing I could think of to do at the time, was to go in my room and get on my knees and pray. I began asking God to stop Malcolm from coming over, and to reveal who really did opened his package. Everyone sat in suspense waiting to see if he would show up that evening, but he didn't. The following morning, he called again to threaten Dana. He told her he was giving her one more chance to tell the truth, and if not, he would come for sure that evening. Instead of answering him, Dana gave me the phone.

When he heard my voice, he inquired why I was still there after he told me to leave. I replied by telling him I hadn't left because I knew for a fact that nobody in the house opened his package. Before he ended the call, he gave me a message to give to Dana. He was giving her and her son until evening to come clean about the contents stolen from his box. I immediately went into my room and prayed

again, begging the Lord to reveal to Malcolm the person who really opened his package.

That very night, something happened which was revealed to us the following day. Malcolm didn't show up as promised, but he did call the following morning. This time it wasn't to leave death threats as he did before, instead it was to apologize to everyone in the house. Malcolm informed us that the truth was finally revealed by the sender of the package. Because of a tragedy the sender experienced, he decided to come clean.

The sender's girlfriend gave birth to their baby boy the previous night, but the baby died a couple hours after his birth. The sender became ridden with guilt and blamed himself for his child's death. He was convinced that the baby died because of what he did, and therefore called Malcolm to confess. He was the one who sent the box partially opened, and made it look as though someone else had tampered with it. He didn't send the amount Malcolm had paid for, so he had to find a way to make it look like someone else stole some of the contents.

The sender's deceitfulness nearly caused the lives of innocent people to be lost, but instead he was the one who ended up with a devastating loss. A few days later, I happen to be walking through the living room and saw when Malcolm paid Dana for allowing the packages to be delivered to her house. That was the last straw for me, when I realized she was getting paid for allowing the boxes to be delivered to her house, but pretending she knew nothing about them. It became increasingly uncomfortable as each day past, and so I was eager to move out as soon as I could.

After living there for four months, I ended up renting a room from Ken's mother. In case you forgot, Ken was the one who was there for me when Fluff died. I couldn't wait to get out of Dana's house, so I didn't waste any time in giving Ken's mom, Ms. G, the deposit. Once

I informed Dana I was planning to move out, I didn't expect her to get as upset as she did and stop speaking to me.

I knew she depended on the income she was receiving from me, but when she found out how quickly it was going to end, she became very angry. Although the room I was going to rent was very large, it wasn't large enough to hold all my furniture. It already had a king size bed which Ms. G., wasn't willing to move out, stating she had no place else to put it. I was unable to take my king size bedroom set with me, so I gave it to one of Dana's friends, who had ten children.

I had a lot of expensive furniture which were stored in Dana's garage, but wasn't sure I would get the help I needed to move everything right away. The moment Dana came home and saw me sorting out my belongings, she made sure to tell me that I needed to take everything with me that same day, and not to leave anything in her garage. Ken's best friend, Femi, lent me his truck and I was able to enlist the person I wanted to help me move.

I was so grateful Dana wasn't home when I started moving my stuff out, because she was unaware her sons were helping to load the truck. If she was there, she definitely would have stopped them from helping, so her not being there worked out in my favor. It took a couple of trips back and forth to move everything, and by the time the last load was on the truck, Dana was home. Although it was awkward, I thanked her for letting me stay at her home, and told her goodbye, but she totally ignored me.

Chapter Twenty-Two:
Feelings of Despair

Sometimes we think the grass is greener on the other side, and then we find out it isn't. You might be better off staying where you are until a better opportunity comes along. In my case, I thought the first situation wasn't ideal, but the second place I moved too was way worse. Eventually, I did realize there was a purpose for me being there.

My expectation for a better environment didn't turn out to be what I had hoped for. It was mayhem in that home from the moment I stepped foot through that front door. During my first night's stay, Ms. G., the landlord, came home from the club at four o'clock in the morning and woke me up just to say, "Hi." By the following morning, I was left babysitting a five week old baby who belonged to her youngest son. Another one of her son's kept knocking on my bedroom door all day long, asking for one thing or the other, then by day three, he stole my mercedes benz.

During the two and a half years that I ended up living there, the landlord's younger son's stole my car quite a few times. One of them broke into my room and stole my fifty-inch flat screen television, my money as well as packages that Bev sent to me from England. I was living in a nightmare. So many bad things happen while living there, but they are too many things to list. During that time, I thought long and hard about going to New Jersey where my aunt and cousin's lived, or back to Boston, but in the end, I still refused to return as a failure.

I missed my family, especially aunty whom I called now and again. She was still unforgiving and each time I called her, she insulted me in one way or the other. I didn't give up though, I continued to call thinking one day she would eventually come around, and we could revive the relationship we once had. One day while feeling blue, aunty ran across my mind, so I decided to call and see if her attitude towards me had changed.

She asked me how I was doing, which was a surprise and I foolishly thought she actually cared. Once I told her I was doing good, she responded by telling me that even if I was suffering, she wouldn't help me. I reminded her I had never asked her for anything, and was only calling to see how she was doing. When she hung up the phone, I had vowed never to call her again as long as I lived. That conversation sent me into a deeper depression, since I was already feeling worthless. I had no hope for a brighter future, so talking to aunty certainly didn't help the situation.

A couple days went by with me feeling down in the dumps, until Ms. G., called me downstairs. I wasn't in the mood to hear anything she had to say, but I had to see what she wanted. It turned out to be a pleasant surprise, when she informed me that a friend of hers had offered her a job to take care of an elderly man. She was unable to accept the offer, and wanted to know if I would take the job. Without hesitation I gladly accepted, and the necessary arrangements were made.

The client's name was Roger, a ninety-five-year old retired colonel from WWII. His wife had died, as well as both his son's who died from drug overdoses before they turned 40 years old. He was accustomed to living by himself, and did everything for himself without asking for help, even when he needed it. Trying to maintain his independence led him to climb one of his fruit trees, but he fell off and fractured his hip bone in the process.

Although he was having great difficulty moving around, he still wanted to live alone and didn't think he was in need of assistance. Four Certified Nursing Assistants were hired, me being one of the four, although I had no such certification. The workday was split into four shifts, so I took the morning shift. There wasn't much to do, other than prepare his meals, and change his colostomy bag, which I had no idea how to change. I had to pretend I hurt my hand one evening, and asked the person who was reliving me, to change the bag for me, so I could watch how it was done.

I confided in Roger and told him I wasn't a CNA, to which he responded he did not care, because he enjoyed my company. He was very laid back and easy to get along with, and I enjoyed listening to his war stories, while he sure enjoyed telling them. He told me that when he was a pilot, most of them drank a glass of scotch to stay awake while they were up in the air. When I questioned him about that, he explained scotch didn't cause hangovers, so they were allowed to drink it before flying.

I was astonished when he told me he still had unopened bottles left over from the war, stored in one of his spare rooms. It wasn't until he sent me to get a bottle that I realized he had dozens of boxes filled with scotch which were labeled army issued and dated 1964. He insisted we have a drink, but I didn't want him to drink scotch at his age, especially after also being told he also had cancer. Even though I tried to deter him from drinking, he insisted I give him a glass, so I did.

I had no idea he also smoked cigars, until he sent me for his cigar case so he could have one with his glass of scotch. I was concerned about it, so I called his nephew and told him Roger was smoking cigars. His nephew however, told me to let him smoke and drink when he wanted, because he wasn't going to get better. I thought, "Well then, if that's how they look at it, I guess there is nothing else for me to say."

Every day Roger smoked a cigar after his meals, but oddly enough, he only did it when I was there. One evening after giving Roger his evening meal, he asked for a cigar as usual, and began smoking it while I was in the kitchen washing the dishes. When I finished in the kitchen, I went back into the living room to take his glass and move the ashtray. I happened to notice the shirt he had on looked strange, but I couldn't figure out what was wrong at first glance.

I eased him up out the chair while trying to straighten his flannel shirt, but was puzzled as to why it seemed as though half of the shirt was missing. It took me a while before I realized Roger had literally burned up half his shirt and burned the arm of his new leather recliner. I was so afraid to look at the t-shirt he was wearing underneath. I was so convinced it to was burned, as well as his skin. Once I finally built up the courage to take a look, to my astonishment, neither his t-shirt or his skin was burned.

"That was a miracle," I told him, but I was still afraid because when his nephew and the supervisor found out, I would be fired. I sat in the chair facing Roger, looking worried and distressed, and unable to speak. Roger knew I was upset when he asked me what my problem was. "What my problem is? I'm going to be fired because you burned up your shirt along with arm of your new recliner." Roger replied, "So what if I burned the shirt, I didn't like it anyway."

I wanted to laugh when he said that, but I was too upset to do so. He then said, "This is my house, and if I want to burn it down that is my business, because I am the one who bought it, not my nephew." "Well that's all good for you, but I'm still going to get fired, I responded. Roger tried his best to reassure me, I wasn't going to get fired, but that didn't ease my worry one bit.

I called Ms. G., and told her what happened, so she told me to wrap up the shirt and throw it in the garbage. I couldn't hide the burn

on the chair arm, so I knew I would still have to explain how that happened. I made the mistake to confide in the man who relieved me that night from my shift. I told him about the incident, but I didn't tell him wear I put the shirt.

It was just my luck that he and the supervisor were friend's, and he couldn't wait to call and tell her what happened. The supervisor called Roger's nephew and insisted he meet her at the house the following morning. She searched and found the shirt in the garbage and showed it to the nephew. She tried her best to convince him to fire me, but things did not turn out the way she had hoped.

When I arrived to work that morning, the supervisor had an attitude and didn't speak to me when I show up to relieve her. The nephew was already there and called me outside to speak with me in private. He told me how the supervisor called him to come see the shirt, and as I expected, she told both him and Roger to fire me. He then told me that Roger made it clear to him and the supervisor that he liked me, and if anyone should get fired, it should be the supervisor.

Roger also told the supervisor to leave me alone and mind her own business. I couldn't contain my inner laugher upon hearing what Roger said, and apparently neither could his nephew, because he began laughing with me. It was during our laughter that the supervisor walked outside and saw us. Her facial expression said it all, she was extremely angry. I on the other hand, was extremely happy, and so I gave her a smug look as she walked past me.

After the first month, I requested to change my shift from the morning to the evening, so I could bring Max with me. Roger had three cats and because Max hated cats, I had to leave him in the car until I put Roger to bed around eight o'clock. One evening when I went outside to get Max, I stepped back in fright when I opened the car door. It looked as though a massacre had happened inside my car.

There was blood everywhere and I was bewildered at first as to what happened, because Max was alive and standing there looking at me.

Max was covered in blood, and so were all the seats and mats. This was by far the greatest shock I had ever experienced. After examining Max, I realized the blood was coming from his nose. I hadn't a clue what could have caused it, and so I panicked all evening long. After I washed him off, along with the car seats as best I could, I wanted to leave and take him home, but I was still on my shift, so I couldn't leave. I counted down the minutes for when it was time to go home, and appreciated the fact that the person who came to relieve me, was actually on time that night.

Once we arrived home, Max's nose started bleeding again, but it wasn't as bad. I panicked all night, wondering what was wrong. I kept watch all night, unable to sleep in fear it might happen again while I slept. Max slept in increments of two hours and then woke up with nose bleeds, and it was heart breaking seeing him that way. Not knowing what was wrong and being unable to stop the nose bleeds, caused me great distress. I looked forward to sunrise so I could take him to the vet, believing there would be a simple cure for his ailment.

I waited anxiously in the waiting room of the veterinary clinic for the results of the blood test, certainly not prepared for the news I was about to receive. I was called into the examination room, but upon receiving the devastating news that Max had cancer, I thought for sure I was going to faint. The news took some time to infiltrate my brain, but when it did, I started having a panic attack. "There is no way my Max has cancer, there's just no way, you need to run the tests again." After being reassured the tests were correct, I sat in the chair like a statue unable to move.

I just sat there and starred at Max and in that moment, it felt as though the world had stood still, once again. I couldn't cry because my entire body felt numb. After trying to console me to no avail, the

vet walked out and shut the door behind her. I assumed she was giving me time alone to digest the news. I felt like the room was spinning and as the news began sinking in, I went straight into denial. Upon her return, she prescribed pain medication for him, but I left the vets office in unbelief, not wanting to believe she was right.

I went back to the house devastated and sat with Max thinking I had to enjoy every moment with him, because I had no idea how much time he had left. I watched each day as Max's hair began falling out in patches, along with the spontaneous nose bleeds which when they started, didn't seem like they would stop. Because of his condition, I didn't want to leave him at the house with Ms. G., and her sons by himself, so I brought him to work with me every day.

It was a good thing I had changed from the morning to the evening shift, because when I put Roger to bed, I could bring Max in the house unbeknownst to Roger. Roger began deteriorating himself, which prompt the doctor to suggested Roger receive hospice care. His nephew didn't want to send him to a facility, instead he hired two hospice care nurses to come to his home. That meant two of the CNA's had to stay and two had to be laid off.

I thought for sure since I had no certification, I would be one of the two that had to leave, but I was wrong. Roger and his nephew insisted I stay on and even raised my pay. It was just my luck that the two who stayed on with the hospice nurses were me and the supervisor. I worked with one hospice nurse, and the supervisor worked with the other. That was when my shift changed again, but this time I worked from midnight to eight o'clock in the morning which I didn't like, but it worked out better for me.

I was able to let Max stay in the house with me throughout the night, because Roger was already sleeping when I arrived. One night I left out to get coffee and left Max in the couch, but when I returned, the couch and carpet were covered with blood. Not only was I afraid

by what I saw, I was panicked, not having any idea at first how I was going to stop Max's noise bleed. On top of that, I had no clue how I was going to remove the blood stains out the couch or the carpet.

I spent that night scrubbing the floor and the couch, then I brought out the fan to dry them. Thank God that once Max's nose stop bleeding, it didn't start again after I had finally gotten everything cleaned. By the time my shift ended, there was no trace of blood anywhere. No one found out, not even the hospice nurse who was in the room with Roger. She had fallen asleep, so she had no clue as to what was going on in the living room.

As Roger continued to get worse, I knew the job was coming to an end. I tried networking to find something else before Roger passed, but to no avail. The supervisor asked me to cover for her one weekend, but I didn't want to work a straight forty-eight-hour shift. In the end I had no choice because someone had to be there with the hospice nurses at all times, so I couldn't refuse. Max was with me in the house at all times, unless someone came to visit. When visitors came, I would put him in the car until they left.

Before I left at the end of that weekend shift, Roger told me how much he enjoyed my company and loved my style. He explained that he loved the way I walked, talked and dressed. I thought it odd at first, as he went on to say that I was the only one who enjoyed listening to his war stories, and the only one who asked questions. I told him he had beautiful eyes, and we had a good laugh when he replied by saying, "Why didn't you mention this before, because maybe I would have married you."

I kissed him on his forehead and told him I would see him on Wednesday, which was the day I was scheduled to return to work. The following afternoon after running some errands, my phone rang, just as I returned to the house. It was Roger's nephew calling to inform me that Roger had passed that morning. It explained why he

said the things he did before I left the day before. He probably knew he wasn't going to see me again. I knew he didn't have much time left, but I didn't think he would have died only three months after meeting him.

I now had more time to focus on Max and spend as much quality time with him as I possible. It was impossible for me not to fall back into a deep depression as I watched Max who seemed to deteriorate more each day. I didn't answer my phone when anyone called, and I didn't listen to any messages for weeks. The only time I left my room was when Max needed to relieve himself. For weeks, I ask God to heal Max because I didn't want to live without him.

I eventually became lost in my own dark little world, trying to find my way back to the light for Max's sake. I continually thought about what Max must have been going through, and so I tried to stay alert for him. He was the only reason I tried to keep pushing on, but he was getting worse by the week. The more I watched him deteriorate, the more pain my heart endured which felt like all my internal organs were being crushed.

Whenever I took Max downstairs and someone saw him, they insisted I put him down, because he was suffering. I knew he was, but I couldn't bring myself to do it. I found myself reliving the same emotions as I did when Fluff was dying. I felt as though I would be killing him, and I just couldn't do it. I made up my mind that when it was his time to go, it would have to happen naturally, therefore I refused to listen to what anyone had to say.

The more I was told to put him down, the more I continued asking God for a miracle, because I didn't want to accept the thought of having to live without him. We had been together for thirteen years, and I couldn't bear to lose him too, so I continued to pray. When he began having seizures, I managed to stop them every time they happened. I became fearful after the seizures started, because I knew

if he had one when I wasn't around, he wouldn't make it. That was the reason I insisted I wasn't going to Ms. G.'s warehouse with her on the evening of June 10th 2012.

When she came upstairs and told me I needed to get out of the house, and insisted I go with her, I adamantly refused, but she refused to take no for an answer. She tried convincing me to go by telling me her customers were asking for me. I told her I didn't care about any of her customers who were asking for me, but she still wouldn't quit telling me to get dressed. I just wanted to be left alone with Max, but nothing I said made a difference.

I tried to be frank without being rude, by telling her I really wasn't interested in seeing anyone, especially her customers at the warehouse, but she still didn't seem to get it. She then begged me to come with her for a couple of hours, and promised she would let me leave early. After her continued persistence, I finally agreed to my everlasting regret. I took Max outside before I left and tried to make sure he was comfortable until I returned.

When I was ready to leave the warehouse, Ms. G., wasn't, and I couldn't get a ride back to the house, so I was highly upset. Every time she said she was leaving in a few minutes, she found something else to do, and then ended up playing dominoes with her friends until four o'clock the following morning. When she finally decided to leave, I was so angry I couldn't speak.

As soon as we arrived back to the house, I ran upstairs to check on Max and found that he was lying still on the floor. I called his name, but he didn't move. I knew he was dead, but my heart couldn't accept it. He was stiff when I picked him up and ran downstairs with him in my arms screaming, "My baby is dead." I felt as though my brain literally exploded and my heart dropped into my stomach. I then ran back upstairs with Max and was crying profusely, unable to stop.

Ms. G., with no compassion, came upstairs and told me to take Max outside, but I became numb again and couldn't move. My entire body felt weak, especially my heart. I started blaming myself for for Max's death by letting Ms. G., talk me into the leaving him in the first place. I immediately began resenting her for insisting I leave the house, and I was highly upset at her lack of compassion.

When I was finally able to move, I brought Max downstairs and laid him on the grass, under the ackee tree. I pulled up a chair and sat out there with him and wept. After about an hour had passed, Ms. G., told me to come inside the house, but I refused. She once again refused to take no for an answer, so she stood in front of me and repeatedly told me to go to bed, until I finally got up and went upstairs.

I wanted to drown my sorrows as I did when mom and Fluff died, but it didn't work those two times, and it sure didn't work with Max. I sat on the bed and cried all morning, and as soon as it was light outside, I went back to sit next to Max, wondering where I was going to bury him. Ms. G., said she didn't want him buried in the back yard because the cats would dig him up, so I called Mr. James, who was a friend, and asked him if he could help me.

He told me he would come and get me the following morning, because he knew a woman that would allow me to bury Max on her land. That evening I went upstairs to take a shower with plans of spending the night outside with Max once I was done. Upon returning to the back yard, one of the Ms. G.'s, son's (the one who stole my car) and his friend's were all sat outside in a circle with bottles of Hennessey and Rum in their hands.

Apparently, they came to mourn with me because they all knew how important Max was to me. The only problem was, I wanted to be by myself, and so I told them that, but they would not leave. They all told stories of Max and I, some of which made me smile, but for

the most part, I sat there amongst them broken to pieces, lost in my own world. They kept pouring me drink after drink, all of which had no effect on me. They wanted the alcohol to knock me out, so I would go to sleep and leave Max's side, but that wasn't happening.

I must of finally went to bed about five o'clock that morning and was up again by seven o'clock. Once I was up, I ran to the window to look at Max, but he wasn't there. I ran downstairs and searched the back yard, but he was no place to be found. I questioned everyone in the house, including waking up Ms. G., to ask her where Max was, but everyone told me they had no idea. I was livid and demanded that someone tell me what they did with my baby, but no one answered.

In the end, one of Ms. G's, son's friend's told me what happened to Max. Ms. G., gave her truck to her son and told him to go and dump Max's body before I woke up. I was devastated, not only because I didn't get to bury Max, but because he was disposed of in a dumpster. I was already experiencing a severe heart ache, but after hearing what they did, left me feeling like a knife was pushed through my heart. Sometimes I wonder if her son conspired to kill Max when I was at the warehouse because he had access to my room that night, but I guess I will never know.

Max died just ten days before my birthday, which turned out to be the worst birthday I ever had. I spent my birthday alone in my room weeping all day. I was consumed with the heartbreak I endured from missing Max and Fluff. I was utterly devastated as I sat in my room feeling empty and alone without them. I ended up back in the state of mind where I lacked the ability to see any point or purpose for living. My mind was traveling through a very dark tunnel, unable to see any hope of sunshine at the end of it.

I saw absolutely nothing to look forward to in life, and found it impossible at the time to believe my life would change again for the better. All I could see were cloudy days ahead of me, with no hope

313

for a brighter future. For the rest of that year, I basically lived in depression, while mourning all my loved ones who had passed. Thank God, I had Bev to vent too during that year, which helped me keep it together. Six months flew by so quickly, because the next thing I knew, we were welcoming in 2013.

With Bev's help, I eventually found hope in believing the new year would bring fresh opportunities with it, leading to something good happening. I thought for sure things would turn around for me and maybe I would finally get my breakthrough. Before I knew it, summer was around the corner again, and I still was unable to find employment. I had not made any progress with my life, and I was still pinning for Max and Fluff, which left me feeling even more empty every time I thought about them.

Out of the blue, one afternoon in May, aunty called to let me know that my cousin Jenny had died. Jenny was one of my favorite cousins whom Bev and I used to go visit in London. Once aunty relayed the news, she asked why I had not called her since we last spoke. I reminded her of her insults and explained that was the reason. I wasn't expecting her to say that I shouldn't allow what she says to me, to stop me from calling. I was surprised she was even speaking to me, but then I realized Jenny's passing made her realize time is too short to hold onto family rifts.

At that time, it had been six years since I had last seen aunty, and although she rejected me so many times, I was concerned that she was not getting any younger. I carried an inner fear of her passing and not being able to see her or spend time with her again before that happened. Because I was so happy to hear from her, by faith, I told her I would come and visit her the following month. When I hung up the phone, it dawned on me that I didn't even have a dollar to my name, so it would take a miracle for me to be able to go to Jamaica the following month.

Bev happened to call me a few days later, while I was sitting in my room wondering how I was going to make that trip happen. Bev was calling as usual to see how I was doing, and to find out what was going on. When I told her my flat screen television was stolen, and that aunty was finally speaking to me, Bev then said something quite unexpected. "I'm going to pay your fare to Jamaica so you can spend time with aunty, and that will be your birthday present for the next ten years."

Those words instantaneously took me out of my great depression and sent me into extreme excitement in a matter of seconds. Bev suggested I stay in Jamaica for at least six months with aunty, but after we thought about it, we realized I couldn't stay that long if I wasn't a Jamaican citizen. At the end of our conversation, we decided she would book my stay for two months. We planned it that if things worked out between aunty and I, then I would figure out a way to stay longer.

My flight was booked the following week for me to leave six days after my birthday. I was beaming with excitement, especially after realizing I only had three weeks left before I would finally leave that God forsaken house. I was counting down the days, hours and the minutes, while making all the necessary arrangements. I even had my suitcases packed two weeks before my departure, due to my eagerness to leave. I needed to get away from it all so badly, and although I only had a few days left, it felt like an eternity.

When my day for departure finally arrived, I was eager to get to the airport. My luggage and I were at the front door bright and early that morning, waiting for the driver to arrive. Once I saw him pulling up to the front of the house, I rushed outside with my suitcases and bags. When my last piece of luggage was loaded into the car, I went back to close the front door, and never looked back. I made a vow that morning that whenever I returned, it would only be to retrieve

what was left, but I would never again spend another night in that house.

Chapter Twenty-Three:

Bittersweet

Sometimes we are deeply hurt by someone we love, but if our love for that person is unconditional, we won't deliberately hurt that person in return. Our loved ones do not always meet our expectations, but we love them anyway. When a parent figure rejects or abandon's a child, it can be quite devastating as it leaves traumatic effects. In the end, we have to either choose to hold on to the hurt and stay bitter, or forgive, which will in turn start the healing process of our broken hearts.

I only had one hundred and fifty dollars to travel with after I bought a couple outfits and a few things that I needed for my trip. I packed as much as I could fit into my extra-large suitcases which was filled with clothes, personal documents and sentimental items. I knew my room would be raided and items stolen before I got back, so I brought everything that was important with me. I had no idea though that I was going to have to pay one hundred dollars out of my one fifty for my overweight luggage.

When my luggage was weighed, the price for the overweight was actually one hundred and eighty-nine dollars, which was more than I even had on me. After nearly breaking down into tears, the lady at the ticket counter figured another way to price my luggage so she could reduce the price. It bothered me terribly to only have fifty dollars left to travel with, which caused me to panic during the entire flight.

When I landed at Montego Bay airport, I had to take a bus to Ocho Rios which ended up costing me an additional twenty-five dollars. After the other passengers were dropped off to their destinations, the Juta bus driver took it upon himself to take me sight-seeing. I would have felt bad not giving him a tip, so I ended up giving him five dollars. In the end, I was only left with twenty dollars to last me during my two months stay.

Collin was already waiting for me when the driver finally arrived in front of the Jamaica Grand hotel, which was the drop off point. That also happened to be the hotel whose parking lot I fell from. As soon as Collin put my luggage in the car and I sat down, he asked two questions. "Where is the bottle of Hennessy I asked you to bring, and how much money did you bring with you?" I avoided answering both questions, instead I cunningly redirected the conversation.

My heart skipped a beat when we arrived at the house about ten o'clock that night on June 26th 2013. I had waited a long time to get my heart's desire, that had finally come to pass. I dropped my luggage at the front door and ran up the stairs into aunty's bedroom, then suddenly stopped when I saw her. Tears of joy ran down my cheeks as I stood their looking at aunty sitting up on her bed, waiting for my arrival.

I no longer needed to fear her passing before I got the chance to see her again, because my wish came true, I was standing right in front of her. She was alive and well, so my heart leaped with joy as I hugged and kissed her. That changed instantly though, when the first thing aunty said was, "Look how you are suffering, it looks like you didn't even have food to eat". "Here we go," I said to myself, wondering how to respond to that statement without sounding rude.

With a soft response, I informed her my weight loss wasn't from suffering, but was in fact from working hard to lose the sixty-five pounds I had lost. In her eyes, I looked like I was suffering, but I

didn't care because I was happy with my weight loss and how I looked. After that conversation was over, the next thing she surprised me with was to let me know I had to sleep in her room. I wasn't going to get my own room, even though she had four other bedrooms that were not being used.

I thought, "You got to be kidding me, really! I have to share her bed for the next two months." My next thought was, "I guess I won't be staying in Jamaica for two months after all, and will have to cut this trip short." After taking my shower and sneaking a cigarette in one of the other bathrooms, I felt a bit better once I returned to her room. Aunty and I talked for about two hours, catching up on gossip and other stuff, until I finally fell asleep.

My sleep only lasted for two hours because the room was so hot, and the little fan she had on the side table next to her bed, served no purpose. I tossed and turned all night anxiously waiting for morning to arrive, so I could get out of bed. At six o'clock, Collin was up knocking on the bedroom door, telling me to come downstairs for breakfast. I usually never eat breakfast and if I did, it sure wasn't that early, but he insisted. He cooked a big breakfast fit for a queen which tasted really good. It turned out to be a pleasant surprise, since I was unaware he could even cook.

After we ate, aunty told me the cleaning lady was coming and that I should pack my things away and make sure my suitcases were closed before she arrived. I found it strange that she told me to put my stuff in the master bedroom, but I figured it would only be until the helper left, but it wasn't. She then told me I could actually sleep in the master bedroom for the rest of my stay. Wondering what caused her change of heart, I found out later in the day that it was due to Collin's influence.

He made sure to let me know that he was the one that told aunty I needed my privacy and that she couldn't expect me to sleep with her

for my entire two months stay. I was a little disappointed when he informed me that he was the reason aunty changed her mind. I was hoping she changed her mind on her own accord, not because Collin convinced her too. He had an ulterior motive to convincing aunty to letting me stay in the master bedroom, which I found out later on during my stay.

I knew Collin very well, so I knew he was up to no good. I was well aware he was nothing but a wolf in sheep's clothing. Collin was aunty Davis's eldest son, and although aunty knew how much I loved aunty Davis, she didn't even call to tell me when aunty Davis had passed away from cancer. When Collin went to Jamaica for his mother's funeral, he ended up returning a few months later to stay with aunty, after seeing how vulnerable she was.

Daddy wasn't there anymore, and although aunty had Aaron has a live-in helper at the time, Collin saw the situation as an opportunity for his gain. He told aunty that he gave up a sixty thousand dollar a year job in Ft. Lauderdale so he could stay with her, and she actually believed him. Numerous people including myself told aunty that Collin had been laid-off from his job, but she chose to believe him instead of everyone else. Aunty refused to believe Collin was trying to use her, so she gave him daddy's car to drive, while he lived there for free and collected rent from his mother house.

Anyway, right before the cleaning lady came, I went downstairs and saw a man whom I had not seen before, sitting in the living room watching television. When I asked Collin who he was, I was told that the stranger was my cousin Basil, but we were not introduced. I went and introduced myself, and found out he was the brother of my cousins in England. They were the ones aunty, daddy and myself would visit in Birmingham on a regular basis when I was younger.

I never met Basil because he was still living in Jamaica, but after speaking with him for just a few minutes, I knew I would have

an ally during my stay. Aunty asked if I met Basil and when I told her I did, she made sure to inform me that I should be careful what I said to him. Something was going on between them and I was determined to find out exactly what it was. I knew Collin and Basil didn't like each other, which was evident from their interaction with one another. I decided to wait until Collin wasn't around to find out from Basil what was really going on.

When the cleaning lady showed up, there was something about her that intrigued me. I couldn't quite put my finger on it, but there was something. Leoni was her name, and she was a couple years younger than me, with three sons whom she worked so hard to care for. I followed her around most of the day, talking about all sorts of things while I assisted her, without Collin or aunty knowing. When her working day started winding down, I sat with her on the veranda talking as she ironed the clothes.

I realized I had asked her so many questions, none of which was where she lived. When she told me she lived in Hamilton Mountain, I was taking back by surprise. I then asked her who she knew up there, to which she replied by asking me who I knew. I asked if she knew Michael, not expecting that she did, so I was surprised again when she told me he was her cousin. We both started laughing when I told her he was my ex-husband, and just when I was about to ask another question, we had to stop talking.

Collin walked in on us and asked what we were laughing about. I wanted to say none of your business, but neither of us answered him, instead we changed the subject and carried on talking. He didn't like the fact that Leoni and I were so friendly, so he told me I needed to leave her alone, so she could do her work. He was starting to show his true colors, which was when I realized he wasn't only a wolf in sheep's clothing, but he was also controlling too. Basil then called me downstairs, but Collin was against me talking to him, so he told me to go sit with aunty instead.

I wasn't going to let Collin dictate what I could or couldn't do, so I went to see what Basil wanted. Basil had a lot of anger built up inside, and was obviously grateful that he now had someone to vent too. He began by telling me all the deceitful things Collin had done, and how he was using aunty. The conversation with Basil and myself was very enlightening to say the least. What angered me the most was finding out that Collin was telling his friends and the neighbors that when aunty died, her house would belong to him.

I was told Collie went as far as to tell people that when aunty died, he was planning to turn the house into a bed and breakfast. I tried to keep my cool and not say a word - my plan was to just listen and observe, but that didn't last too long. After Collin started approaching me in ways I didn't like, especially when he was drinking, I ended up losing my cool. I didn't want to be rude to him the first time, but after his continued inappropriateness, I told him exactly what I thought of him.

Collin continued harassing me on a daily basis, until I finally went and complained to aunty about what he was doing. I asked her to speak to him about what he was doing, not knowing he was eavesdropping. He rushed into the room and told aunty I was telling lies on him, but what upset me more, was the fact that aunty believed him. While walking away in disgust, I heard him tell her that Basil and I were talking about him and had ganged up against him.

Collie then started telling lies on Basil and kept on telling aunty that she needed to put him out. Because aunty believed every lie that Collin told her, just three weeks after I arrived, aunty told Basil he had to leave. Aunty gave Basil no specific reason, when he went upstairs to pay for his room and board. She only told him she wasn't going to accept his money, and gave him two weeks to find somewhere else to live. I was shocked when Basil gave me the news, and also perplexed when he told me not to get to comfortable, because I would be next.

That weekend, the neighbor across the street planned a small gathering with a few friends and invited Basil and me. When Collin found out, I overheard him telling aunty that we had turned the neighbors against him too. While at the gathering, Collin became the subject of conversation. I found out the neighbor didn't want Collin back at his house, because every time he went over there, he drank off all the liquor and talked about all the plans he had for aunty's house after she passed.

Just about everything Basil had told me was confirmed that night. The following morning when I woke up and went to say good morning to aunty, she answered me by saying, "When are you leaving?" The first thought that entered my mind when she asked that question was, "Okay then, I guess Basil was right when he said I was going to be next. After informing her that I had another month left before my departure date, she told me I couldn't stay in the master bedroom any longer.

I inquired why I had to move out the room, so she lied and told me I had to move my things out, because she was going to use it. She then told me to find another room to stay in until I left. Saying I was hurt by what she said would be an understatement. I packed my things and moved into the room downstairs, that was used as the helper's quarters. I was crushed to say the least, and couldn't believe aunty was treating me that way because of Collin who wasn't even a family member.

Basil kept pressuring me to do something about Collin, and continuously asked if I was going to allow him to take my inheritance. It was frustrating trying to explain to him and others, that if aunty chose to give the possessions she and daddy worked so hard for to Collie, there was nothing I could do about it. The atmosphere in that house became cold, which caused me to somewhat regret going to visit aunty in the first place. At the same time, I knew that if I didn't see her again, I would never have forgiven myself.

Although aunty was rejecting me, I don't think it would have been possible for me to heal from the heart break, if aunty had passed and I wasn't able to see her one last time. Aunty wasn't the same woman who helped to raise me - she had now become cold, unforgiving and resentful. She wanted me gone before my time was up, but I had no intention of going back to Ms. G.'s house, so I started pondering on what to do. I finally made up my mind, after being greatly influenced by family and friends not to leave.

When my two months were up, I didn't say anything, instead I went about business as usual. Aunty was upset when she found out that the date of my return flight had passed, and in turn informed me I could no longer stay at her house. I was supposed to leave the first week of September, and because I didn't leave when I should have, she insulted me every time I went upstairs to ask her if she needed anything. Because of that, I stopped going upstairs to see her, and when I knew she was going somewhere, I hid until she left.

Two months had passed without our paths crossing, so when November came around and aunty saw I had no intention of leaving, she gave Collin a message to pass on to me. She told him to tell me that if I wasn't gone by the following Friday, she would put my suitcases out the front gate. When that Friday morning came around, aunty called me upstairs. She did not delay in asking what my plans were and when I was leaving. When I told her I was staying, she made it clear that she wanted me out of her house, and so she gave me three hundred and sixty dollars to book my flight.

I debated whether I should leave Jamaica or not, but I had no place to go if I stayed, and I didn't want to go back to Miami. I definitely didn't want to leave aunty until our relationship was repaired, so I was indecisive as to what I should do. Bev and other close family members ended up convincing me not to leave, but to stay and not allow Collin to win. They managed to influence me to stay and fight, but I had no clue how I was going to do that.

324

As luck would have it, I happened to bump into Aaron on the way to the store, after making up my mind to stay. Aaron was aunty's live-in helper for nearly ten years, until Collin moved in and convinced aunty to put him out. After Aaron filled me in on how Collin treated him and how aunty was being used, I made arrangements with Aaron to stay at his place. Ms. G., also called and told me I should stay in Jamaica, so staying with Aaron would give me more time to figure everything out.

Collin's plan was to divide and conquer, but aunty chose to close her eyes from the truth. I led aunty to believe that I had booked my flight and gave her a date I would be leaving. When the day came, my bags were packed, and I called Aaron's friend who was a taxi driver to pick me up. I went upstairs with a broken heart to tell aunty goodbye and thanked her for allowing me to stay at her house. She stopped knitting, looked at me and said, "Bye," then carried on with her knitting.

I felt resentment towards her while walking through her bedroom door and down the stairs. I knew Collin was only standing in drive way just so he could see who came to pick me up. He didn't look too happy when I walked past him and told him goodbye. I had planned to brush my feet off when I walked out the front yard as a sign that I would never return, but I was in such a rush to leave, that I forgot. It wasn't until the taxi pulled off, that it dawned on me how much aunty really hated me.

I kept thinking to myself that aunty could never have treated me that way if daddy was still alive, because he would never have allowed her to put me out. Not even in my wildest dreams would I ever have thought my visit to aunty would end with me having to find refuge with Aaron. I met Aaron back in 2000 when I first went to visit aunty and daddy after they had migrated back to Jamaica. Aaron lived with them and served basically as the handy man, although aunty treated him like a son.

He was infatuated with me since our first meeting and followed me around like a puppy. Aunty didn't allow me to go out anywhere unless Aaron was with me, so we got to know each other quite well. Aaron wanted to date me, but eventually he got the message I wasn't interested in him in a romantic way, so he finally backed off and left me in peace. I was quite anxious during the drive to his home, not knowing what the house was like or what to expect.

Once we turned off the main road and drove up a very steep hill, most of the houses which line both sides of the road were small and shabby with zinc roofs. I figured Aaron house would look the same as the rest, but surprisingly enough, although the house was situated in a very poor neighborhood, the house stood out among all the rest. Beautifully manicured lush gardens line the long winding driveway, which led to a modern and renovated structured three-bedroom two bath home. I was in love with the gardens which were filled with tall luscious trees, and numerous varieties of topical flowers and plants I had never seen before.

I knew Aaron didn't actually own the home, he was the caretaker and had been living there ever since aunty put him out. He was standing at the end of the driveway with a wide grin on his face when we pulled up. After he took my luggage to the room I would be staying in, he couldn't wait for me to get settled so he could vent. That evening, we sat on the veranda, had a few drinks and took a trip down memory lane, back to when daddy was still alive. We talked for hours that night, during which he revealed so much more that Collin had done, things I knew nothing about.

During our conversation, we were both upset with aunty and Collin, especially after realizing he told lies on everyone who stayed there, so he could get them out of the house. We talked until we were both tired and decided to go to bed. He's room was on one side of the house, and mine was on the other, so once the lights were turned off, I was spooked. Both the interior and exterior of the house was pitch

black, so dark that I could barely see my hand in front of me. There were no lights on the outside of the house, and what made it even worse, were the graves that were approximately 100 feet from my bedroom window.

The following day I called and told Collin that I missed my flight, because I had a strong feeling that they were going to find out I didn't leave. It so happened that when I called, he told me that he and aunty already knew I didn't leave. According to him, someone had already called and told them, but I don't know how true that was because no one else knew except for Aaron, and I know he didn't tell them. It was a relief knowing that aunty knew I was still in Jamaica, just in case I had to go back if things didn't work out at Aaron's.

Life was fun and relaxing on the hill for the first couple weeks anyway. The neighbors were very nosey, friendly and inviting, as well as the owners of the two shops that were located close to the house. After living there for a month, Aaron started making plans to move to another parish in Jamaica, and wanted me to move with him. It took some time getting through to him that I had no intention of staying in Jamaica, and that I had to go back home to America. The only problem was, I had no idea where in America my home was going to be.

Christmas came around so quickly, and it was definitely in the atmosphere. Bev sent me some money for christmas, so I took a taxi to the western union in Ocho Rios to pick it up. Christmas carols were being played in the crowded streets where people were merrily walking around doing their christmas shopping. Everyone seemed so happy during the christmas season, with smiles on their faces as they wished me merry christmas as I passed by.

People were dressed up more than usual, and with such a cheerful and whimsical atmosphere, I couldn't help but feel joyous along with everyone else, regardless of my circumstances. I realized christmas

was a very big deal throughout the island. Both the young and the old seemed to be excited about christmas, and eagerly looked forward to it. It reminded me of how christmas was growing up in England, and it brought back a lot of wonderful memories.

Early christmas morning around four o'clock, I woke up to christmas carols being played in the living room and found Aaron in the kitchen making preparations for christmas dinner. The jerk pork and baked chicken were nearly finished, and he had just put on a big pot of rice and peas when I walked in. I didn't plan on being up so early, but considering the merry atmosphere, I decided to go take my shower and join Aaron in the kitchen.

A cup of tea and breakfast had been prepared and were waiting for me on the kitchen table. The hospitality I experienced was incredible. I wasn't allowed to do anything in the kitchen but eat and enjoy myself. I was extremely relaxed and filled with the christmas spirit, which felt really good. By the time nine o'clock came around, visitors were coming and going, all of whom came by to wish us a merry christmas and hang out for a while.

I was contented and at peace, something I had not experienced for some time. After our very big dinner, we drank a few glasses of wine and I danced to the music playing in the background, enjoying every moment. In the evening, Aaron and I sat on the veranda, drank some more wine, talked all night and had some good laughs. It turned out to be one of the best christmas's I had in years. Aaron really put his all into making it a special day for me, and so before I went to bed, I thanked him for all the effort he put into making my day such an enjoyable and memorable one.

The following day was Boxing day, which happened to be aunty and daddy's wedding anniversary. It would have been their fifty ninth, so I knew she had to be heartbroken, and because of that, she weighed heavily in my thoughts. Collin happened to call me that

morning, requesting I come to the house because uncle Lloyd was there and wanted to see me. I told him I was not going back to that house, but that quickly changed when he put my uncle on the phone who insisted I come and visit him before he left.

My uncle managed to change my mind by telling me that aunty didn't have to know I was there, and insisted I hurry up because he was waiting on me. When I arrived, I felt so bad that I couldn't go upstairs to see aunty, especially on the day I knew her spirits were down. After all, it was the christmas season and everyone else was spending time with their family. Yet, I couldn't spend time with the one person who was the reason I was in Jamaica in the first place.

I stayed for a few hours without aunty knowing I was there, then took a taxi back to Aaron's. Aaron didn't even wait until I got into the house properly before he asked me if I was moving back in with aunty. When I asked him why he asked that question, he didn't answer, so it had me thinking. The following day, I saw him walking around the house mumbling to himself. I asked what was wrong, but I certainly wasn't expecting his response.

His explanation caused my jaw to drop when he said, "You mean to tell me that I have a woman in the house with me, and I can't get any sex." What an awkward moment that was! Once he spoke what was in his heart, I knew it was time for me to move on. I then realized that all along Aaron had thoughts of us being together in a sexual relationship. I had a few choice words for him, but for the sake of keeping the peace, I kept my mouth shut. I no longer felt comfortable being around him, therefore, I started thinking about what my next move would be.

The following day, Aaron told me he was going away for the weekend, and gave me his spare cell phone to use, along with the only set of keys to the house. I hung out with Kamal at the shop down the hill on the first day Aaron was gone, and he walked me back to the

house that night. The second night, at midnight the electricity in the entire neighborhood went out, which left me scared silly. I stayed up all night paranoid because of the noises I kept on hearing in the house. I laid in bed wishing that time would speed up, so morning could arrive, but it didn't come quick enough.

Finally, when morning came, I took my shower and left the house in a hurry after Collin called and told me I should come to the house, because he needed to have a talk with me. On the way there, I accidentally left the phone Aaron gave me in the taxi, so when Aaron tried calling me, he was unable to reach me. While I was at aunty's, Aaron returned to the house and was angry because he couldn't get in. He figured out I was at aunty's because he called her tenant and gave her a message to give me.

I left right away and arrived at Aaron's about thirty minutes later, but he wasn't there. When I tried to get in, I noticed there was an extra pad lock on the grill to which I had no key. I went to his closest neighbor to see if Aaron was there, but he told me Aaron came by complaining that he couldn't get in and then he left. I didn't want to stay by myself sitting outside in the dark until Aaron returned, so I went down the street to Kamal's store.

He also told me that Aaron had come by looking for me and left him with a message to give to me. When I asked what the message was, he didn't want to tell me at first. My persistence in asking caused him to eventually give in and relay the message. Not only was I astonished, I was also embarrassed when Kamal told me that Aaron said I needed to take my clothes and leave when he returned. The entire neighborhood it seemed was out at the shop that evening, and the news spread quickly that I was locked out of the house.

I tried to hide my emotions as I sat there in embarrassment not knowing what to do. I felt like a fish out of water, being locked out the house and unable to take a shower and change my clothes. On top

of that, I had no idea where I was going to spend the night. The people in the store tried to cheer me up, while I was busy wondering what to do next if Aaron didn't return. Everyone was upset with Aaron and vowed never to speak to him again. I found out Aaron wasn't much liked in the community when the people started voicing their thoughts of how rude, unfriendly, and selfish they thought he was.

When Kamal closed the shop, he walked with me up the hill to the house to see if Aaron had returned, but he had not. The yard was so dark which made it impossible to see anything without a flashlight. We walked around the back to see if Aaron had removed the extra pad lock, but it was still there. Kamal wanted me to come back to the shop with him, but at that point, I just wanted to be by myself. He insisted if Aaron did not return within the hour, I should come to his house, so I told him I would, just so he would go.

After Kamal left, in dismay, I sat on a wall at the entrance of the driveway just watching as people walked by. In the midst of my bewilderment, the goats brought a smile to my face as I observed them lined up behind one another walking home by themselves. I heard music coming from Troy's shop and the sound of the dominoes hitting the table, so I walked down the hill, hoping Aaron was there. He wasn't there either, but I was surprised when Troy told me he also heard what happened.

"So, I guess the entire neighborhood knows that Aaron locked me out," I asked. Troy responded with a smile and reminded me that it was a small community in which news spreads quickly. Troy was angry and had a few choice words to say about Aaron, as did everyone else. I had no idea what to do, but seeing how perplexed I was, Troy tried to come up with some solutions. He walked with me back to the house, because I realized I dropped the keys somewhere in the back yard when Kamal and I went to see if Aaron had returned.

Troy used his flashlight so we could search for the keys, but we couldn't find them. When Troy shinned the flashlight on the grill, we realized that Aaron had found the keys, because one of the padlocks that I had the keys for, was opened. One of the lights were also on in the house, so we knew Aaron was inside, but he refused to answer. Troy didn't want me to stay in the back yard by myself, so he decided he would find some where for me to stay that night.

I didn't want to go with him, but he wasn't taking no for an answer. His shop was still opened, so I stayed there with him until his customers left. Troy decided he was going to take me to a woman he knew that attended the church located next door to his shop. He wanted to make sure I had some place to lay my head that night, but I didn't want to go to a stranger's house. I guess my facial expression revealed my disapproval, because after we had already walked halfway to the woman's house, he stopped.

He turned to face me and asked if I would prefer to spend the night in his shop instead. Without hesitation I gladly took him up on his offer. We then turned around and walked approximately fifteen minutes back to his shop. I don't even know if it can be called a shop, because it was basically a little wooden shack, made of ply board with a zinc roof. The four-foot wooden bench built under the counter, ended up being my bed for the night. Before Troy locked the shop door behind him, he made sure to tell me not to open it for anyone unless it was him.

As I curled up on the bench unable to stretch my legs, I heard the footsteps of rats running around on the roof. Paranoia took over as I was convinced the rats were going to fall through the zinc roof. Not only was it extremely hot with no fan to cool me down, it was by far the most uncomfortable night I had ever spent in my life. I was still grateful though that Troy allowed me to stay there and trusted me with all his inventory.

Troy came back around eight thirty that morning, and I couldn't wait to go up to the house to see if Aaron was there. Aaron was outside sweeping the veranda when I arrived, but he never said a word when I told him what I thought of him. When I asked him to let me in so I could get my clothes, he never said a word, he just opened the grill and let me in. I wanted to take a shower so bad, but under the circumstances, I figured that would have to wait.

I quickly got my stuff together and thanked him for allowing me to stay there, when I walked past him struggling with my heavy luggage. I tried to contain my anger but was unable to keep the rest of my thoughts to myself. I told him I knew he locked me out because of jealousy, and because I had no interest in sleeping with him. In the heat of my anger, I told him he was beneath me and must have lost his mind to think someone like me would have even considered being with an ignorant, illiterate fool like him.

Nothing I said seemed to faze him, because he kept on sweeping without saying a word. I struggled with my luggage down the long driveway wondering where I was going next. I was so happy when I noticed Kamal's shop was actually opened, because he usually didn't open up until late. Most of the time, his customers had to go to his house next door to get him when they needed something. When I told him where I ended up sleeping, he was upset and offended that I didn't come and stay at his house, instead of sleeping in Troy's shop.

I had no idea how to answer when he asked where I was going to go. He knew about my situation with aunty, and suggested I had no other choice but to go back to her house. When I first arrived at Aaron's, I thought about having to go back to aunty if it didn't work out, but I planned on that being my last resort. I didn't want to go back there, but after Kamal asked if I had a better solution, I knew I had no other choice. After thinking long and hard about it, I built up the courage to call Collin and asked him to come and get me.

Collin didn't show up until two hours later, during which time I sat outside the shop with my luggage for all the passersby to see. I tried my best to avoid telling Collin what happened between Aaron and I, but I ended up telling him the truth. He then informed me aunty was unaware I was coming back to the house, so therefore I had to duck down in the car so aunty couldn't see me once we pulled up to the front gate. I was relieved she didn't know I was back, therefore I didn't have to deal with her insults right away.

I ended up hiding for nearly two weeks before Collin insisted it was time for aunty to know that I needed to come back. He pretended he left to go get me, when all along I was downstairs getting ready, so I would look as though I had just arrived. When I went upstairs to greet aunty, she didn't say much, but she wanted to see the rash on my arm that Collin told her I had. I left Aaron's with the rash which everyone thought was tin poisoning, but it turned out I had eczema again.

While at Aarons, a couple neighbors including Kamal gave me various remedies and ointments that didn't work. It itched so much and spread so fast, but it didn't dawn on me that it was eczema. It had been so many years since I last had eczema, so I had forgotten what it looked and felt like. When Aunty saw it, all she said was, "That is what you wanted," and then she asked how I missed my flight. After I told her we were stuck in traffic, she looked at me with a look of disbelieve, but she didn't say anything else about it.

It was a good thing I did come back, because a couple weeks later, aunty's blood sugar went sky high, to the point that it affected her memory and eyesight. She became confused and didn't know where anything was, so I spend most of that week taking care of her. It so happened to be the most enjoyable week I had with aunty during my stay. She didn't remember she was upset with me, so we had so many laughs together that week, took trips together back down memory lane and had a wonderful time doing it.

It didn't last long though, because once her blood sugar went back to normal, she was back to her normal self. When Collie told aunty that I was the one taking care of her, she became angry and asked him why he allowed other people to take care of her. I was livid at her remark, when I questioned if she was really calling me other people, but she didn't answer. I then asked her if she would have preferred to have Collin take care of her than her own niece, but rather than answering, she just gave me a dirty look.

I stopped speaking to her once again – her insults resumed and the way she treated me was too much for me to bear. I stopped going upstairs all together for a few weeks, and made sure to stay in my room when she came downstairs. Whenever aunty and Collin left the house, they locked the grill upstairs to the second floor. The fridge was upstairs, so if I wanted anything to eat, I had to wait, sometimes all day before they returned. I just couldn't believe aunty was really treating me that way, which left me totally heartbroken once again.

It was hard to accept that the way we once were, was no more. Regardless of the way she treated me, my primary goal was for us to reconcile before I left. I feared that if we didn't, the opportunity may never present itself again. Our cousin George and his wife Zena, came to visit one afternoon, so aunty came downstairs to entertain them in the living room. I was in the bathroom and happened to walk pass and overheard aunty talking badly about me. When I spoke up for myself, aunty asked why I was listening to her conversation.

Zena spoke up for me and told aunty I was not eavesdropping, but was only passing by and overheard the conversation. Aunty became irate and started disgracing me even more. My inability in controlling my emotions at the time, led me to tell Zena that aunty basically treats me like shit, to which aunty replied, "You are a piece of shit." Aunty had hurt me so much already, which led me to believe that nothing else she said or did could do more damage than they already had. But I was wrong, because what she said, cut like a knife through my heart.

I saw the tears and look of disgust in Zena's eyes when aunty said what she did. When George came into the living room, aunty told them she wanted me out of her house, but she couldn't get me to leave. I knew then that it was time to leave again, but permanently this time. I was ambivalent, wanting and not wanting to leave until aunty and I pacified our relationship. I had a deep inner feeling that once I left Jamaica this time, I wasn't going to ever see aunty again, so it was important to me not to leave without restoring our relationship.

Although it was evident aunty was reluctant to make peace, I continued to pray that God would intervene and touch her heart. I sat in the living room with George, Zena and aunty in awe of her unwillingness to forgive whatever it was that caused her to revile me. I was attentive when I heard George tell aunty that Collie was using her and that she should put him out, but once again, aunty didn't want to believe, so she just brushed it off. I couldn't take anymore and left them in the living room and went back to my room. Shortly after, Zena came to my room to tell me not to allow aunty or Collin to run me out of the house.

I avoided aunty and Collin as best I could, until the day I passed Collin on the stairs when I was headed to the fridge. I tried my best to contain myself when he asked where I was going. When I told him, he told me I needed to ask for permission to walk up his stairs. I felt as though all the blood in my body rushed to my head when he said his stairs. "Yours stairs? I replied, This is my daddy's stairs. Aunty and daddy worked many years to build this house, and they sure didn't build it for you. This house doesn't belong to you, so move out of my way, because you cannot stop me from walking up these stairs."

I boldly stepped past him as I continued up the stairs and walked to the fridge to get what I wanted out of it. While walking passed him headed back downstairs, he told me it was his fridge, and I was no longer allowed to get anything out of it as I pleased. Later that night while sitting out on the living room veranda, I heard him and aunty

on the veranda directly above, talking about me. I was dumbfounded when Collie told aunty she needed to inform me in the morning that she left the house for him in her will.

I was outraged when I heard aunty respond by telling him she wasn't going to say anything to me, because I would find out after she was dead. As soon as daybreak came, I was up and ready to confront aunty. I wanted her to tell me herself that she really gave the house and all her assets to Collin, instead of one of her own family members. When I approached her about it, she told me she had no one else to give it to, because I told her to take me of the will. When I asked what happened to all her other family members, she didn't answer.

I had to mention how daddy had to be turning in his grave, because he didn't work all those years in England, to leave everything to Collin of all people. When I said that to her, she responded by reminding me daddy was dead, so the house was hers to do with as she pleased. There was no getting through to her, which led me to begin agreeing with everyone else that were convinced Collin had brainwashed her.

I was so fed up with the whole situation, and had made up my mind to leave her and Collin alone. My entire family wanted Collin out the house and insisted I stay and fight, but I had nothing left within me to fight with. All I could do was pray that God would open her eyes, so she would be enlightened to the truth. Every chance she got, aunty would go out of her way to make me feel unwelcomed in her house. As time passed without hearing of my plans to leave, she once again told Collin to ask when I was leaving.

I was still waiting for God to open another door, so I had no idea what to tell them. Instead, I left the house every morning at sunrise and walked down to the beach, where I stayed all day just so I didn't have to be around either one of them. Most days on the beach, I would see the fisherman I met on previous trips to Jamaica whom I

befriended. On the days they noticed I was sitting on the beach by myself all day, they would offer me roast fish to eat from their morning catch. If it wasn't for them, I would have went hungry. Although they didn't have much, the little they did have, they shared with me.

I returned to the house every evening around six o'clock to always find the front gate locked, so I had to climb over the five-foot fence. I was disheartened of being in such a circumstance not knowing what to do. One morning Collin met me at the gate before I left for the beach, so he could relay a message from aunty. Aunty wanted me out of her house by the following Friday, and if I didn't leave willingly, she was going to put me and my luggage out herself.

The neighbor across the street was at her front gate and heard when Collin gave me aunty's message. She called me over when I greeted her to let me know that if aunty put me out, I could come and stay with her. She knew a lot about what was going on, because Basil had told her, plus she had her own run ins with Collin. Although I assured her I would if it came down to it, I really didn't want too. It wasn't a good idea anyway, so I had to figure another way out.

During this time, I was totally angry with God, blaming Him for everything that was happening to me. My faith and trust in Him were diminished and I was completely at a spiritual loss. Not only was I bewildered, mentally drained and frustrated, I was worried. I was panicking about how and when I was going to get back to America, as well as where I was going to live when I got there. It was all starting to take a toll on me, and I can't even explain how rejected, hurt, empty and low I felt.

Friday came and I still didn't know where I was going, but no one said anything to me, so I was under the impression that I was safe for the time being. Well, I thought wrong, because a few days later, while headed out the door to go to the beach, aunty was outside waiting for

me. She decided she was going to relay the message herself, and so she asked me why I had not left her house yet. Without thinking, I told her not to worry, because I would be gone by the end of the week, which was only four days away.

Aunty's rejection and hatred towards me affected my inner being, right down to my very soul. The woman I loved and cherished my whole life, was treating me like the enemy. A ton of emotions flooded my being, which left me stressed, heartbroken, and confused, not knowing what I was going to do. I went back to the beach where it was peaceful, and sat under a palm tree watching the waves all day, wondering how my life had got to that point.

The following morning, I went back to the beach again, gazing out at the sea, lost in my own world trying to figure out what my next move would be. I dreaded going back to the house only having two days left, with no idea where I was going to end up. On the way back to the house that evening, the idea to call aunty's half-brother entered my mind. I knew there was no room for me where he lived, otherwise I would have called him before, but I had a strong urge to call anyway.

His first response was to tell me there was no room where he lived, which I had already known. He then told me he would see what he could do and would call me back. I never heard back from him until the following night when I called him again. He tried to convince me to stay with aunty and ignore what she was saying, but that was impossible. He along with everyone else in the family, wanted me to stay and put Collin out.

They all failed to understand that wasn't possible when aunty gave him full authority of everything. I was no longer of any importance to aunty, but they refused to believe that. Collin was all that mattered to her and there was nothing I could do to change that. Disappointment took over me when he told me I had to stay because he couldn't find a suitable place for me to go. Upset and frustrated, I

told him I was leaving on Friday whether I had some where to go or not.

Once my uncle realized how determined I was, without hesitation, he told me I could come stay with him and I could have his room. One of aunty's tenant drove by my uncle's place every morning on his way to work, so I waited up for him to come home that night, in order to ask him for a ride the following morning. I knew he wouldn't say no, but I was worried because it would be just my luck that he wouldn't be going to work the next day. Thank God he was, so it worked out in my favor. He was shocked when I told him I was leaving, and he agreed not to say anything to either aunty or Collin about the plans we had made for me to meet him at his car the following morning at six o'clock.

Aunty and Collin thought I hadn't found any place to go, so I didn't say a word until I was ready to leave. Once I put my luggage out in the driveway, I went upstairs to break the news. Aunty was laying down when I went in her room to tell her I was leaving. She quickly sat up on the bed to inquire where I was going, but I refused to answer. She was furious when she asked again where I was going, because she believed I was going to stay with her neighbor across the street. Instead, I thanked her for allowing me to stay in her home and wished her all the best.

I will never forget the stunned look on her face as she continued to question me. I then asked why it was of any importance to her where I was going, when she told me to get out of her house. She jumped up off the bed and said, "I want to know where you're going," but I ignored her questioning because she had treated me with such contempt. As I walked towards her bedroom door, in anger she asked again, to which I responded, "It really doesn't matter where I'm going, I'm leaving as you wanted, and that's all that matters."

340

I turned and took one last glance at her as I walked through her bedroom door with a heavy and broken heart, knowing that I might never see her again. I had finally given up all hope of reconciliation because her heart seemed to have turned to stone. I had to come to terms with the fact that I tried my best and there was nothing else that I could do. Daddy's last words came back to my remembrance when he said, "I don't like it when you and Valda argue," and it brought tears to my eyes.

Collin was stooped outside the front gate again watching my every move, as I loaded the car with my luggage. He had a saddened look on his face, or maybe it was the look of shame. Which ever it was, I didn't care, because he was the reason behind aunty's behavior towards me. When I got in the car, I guess he was expecting me to say goodbye, but I didn't. Instead, I took one last look at the house, then looked at him with utter disgust as I closed the car door. I made up in my mind that once I left that morning, my feet would never enter her house again.

I fought back the tears, wanting to appear strong in front of the driver, but my heart was weeping. The tenant wanted to know why I left, but I was too broken to explain. All I could say was that aunty wanted me out of her house, but he too tried to tell me I should have stayed. He tried to keep the conversation going, but he quickly caught on that I wasn't in the mood to talk. All I could think about was how much aunty broke my heart, while also wondering what it would be like once I reached my next destination.

Chapter Twenty-Four:
For My Own Good

Some disappointments turn out to be for our own good. Off course we do not see it at first, because we are too busy drowning in our emotional woes, when something we were hoping for doesn't work out the way we wanted. It usually takes time to realize that it was for our own good, or that something better was in store. In my case, the disappoint of aunty telling me I had to leave, turned out to be for my own benefit.

It took us about an hour to reach to Brownstown, St Ann. My uncle timed our arrival perfectly because upon our arrival, he was standing outside the front gate waiting for me. Once he helped to unload my luggage from the car, he didn't tell me what was behind the gate. I was wondering why he opened the gate with such caution, not expecting to see five dogs eagerly awaiting to greet me. I was pleasantly surprised, but even more so when told there were seven more dogs, and ten pigs in the back yard. He quickly made sure to warn me not to go in the back yard because those dogs were vicious.

The house was homey and comfortable, although it wasn't like aunty's. It was a place to stay, so I was grateful nevertheless. Mom's eighty four-year old cousin named Elma, also lived there, but she didn't seem too pleasant when I first greeted her. I did find out afterwards why she was upset with me though, apparently it was because I had not visited her during the time I was with aunty. When she warmed up to me about two hours later, she started to express

everything that was on her heart regarding the situation between aunty and me.

When my uncle took me downstairs to see the room I would be staying in, it was then that I realized there were four other men living downstairs also. The owner of the house was one of my first cousins whom I had only met once before. He's the one who owned the funeral home where I viewed daddy's body. He allowed some of his employees to live at the house, so I realized I wasn't going to have much privacy. The room wasn't as clean as I wanted, so the first thing I did was to give it a deep cleaning.

After cleaning up the room I was going to stay in, I helped aunt Elma clean the house upstairs, even though she didn't want any help. Right after we finished, she wanted me to go to the market with her, so I could carry the bags. She put me to shame because I was out of breath while struggling to walk up the steep hill which led to the main road, whilst she walked up the hill with no problem. I thought my chest was going to explode, which caused me to realize how unfit I was.

Aunt Elma kept insisting that I pay attention and remember how we got to the stores and the market. I wondered why it was so important to her that I remember, before she explained I would be doing the grocery shopping by myself the next time around. I was exhausted by the time we finished shopping and got back to the house. I kept checking the time, as I couldn't wait for the day to end so I could go downstairs to the room and be by myself.

I needed time to take it all in. I was still experiencing severe heartbreak, and the sudden change of opposite environments was a major shock to my mentality. When evening came, I wanted to go downstairs so bad, but aunt Elma wanted me to stay upstairs with her and talk. No matter how many times I told her how tired I was, she refused to allow me to go to bed until after I watched the evening

343

news with her. Once I finally was able to go downstairs, I had to pass all my new roommates to get to the room.

They stopped me when I greeted them, and being inquisitive, they too wouldn't allow me to go to bed until all their questions about me were answered. It wasn't until around midnight that I was able to go in the room and be by myself, and when I did, everything hit me like a brick. As soon as I sat on the bed, I began to weep. I couldn't get over the way aunty treated me, but as broken as I was, I still didn't regret going to Jamaica. I decided it was better to have experienced the rejection, than to have not seen aunty at all.

My heart was severely damaged, but it was finally appeased after six years of longing and pinning to spend time with her. Even though I sat on the bed weeping, I was comforted knowing I at least had a place to stay. I was with family and that was a big relief, but I still had a major hurdle ahead of me. Right up into the wee hours of the morning, all I kept wondering was, when and how I was going to get back to America with no money. And when I did, where was I going to end up once I got there. Many thoughts ran through my mind as they usually did, but this time, it felt as though I was drowning in them.

Although I had people around me, I felt alone in a strange place, believing God had abandoned me. I felt hopeless moving from place to place, as well as feeling anxious not knowing what to expect during my stay in Brown's Town. I ended up finding some consolation once I remembered my prayer before I left for Jamaica. I told God I wanted to meet some of my other family members I had not met before, while I was in Jamaica, and asked Him to pave the way for that to happen.

Well, it happened, not the way I expected, but it happened all the same. I was now living in a cousin's home whom I had only met briefly at daddy's funeral. It was a home where many family members visited, ones whom I had never met before, so my prayer

was answered. Although I was apprehensive about staying there at first, it didn't turn out so bad after all. It wasn't long before I started enjoying myself, especially because there was never a dull moment in that house, plus I didn't have a curfew.

Much of my time was occupied with the dogs. I was either feeding them, playing with them, teaching them, and trying to tame the wild ones in the back yard. When I took a break from the dogs, I would help to feed the pigs or go on top of the roof to feed the fifteen birds my cousin kept in large cages. When I wasn't doing those chores, I was helping aunt Elma in the kitchen, or walking back and forth to the shops, because aunt Elma always forgot something she needed, after I already went and got back.

I met many people during my stay and became quite popular in the town. Saturday was the big shopping day. That was the day most of the groceries for the week were bought, and I had a driver to take me sometimes. On the days that I didn't want to go with the driver, I went by myself, that way I could hang out longer in the market and chill with my new-found friends. There was always some young man offering to help me carry the groceries back to the house, once I was seen struggling with all the bags. Therefore, I never had to worry how I was going to manage carrying all the bags on my own.

After I became fed up with hanging out at the same places on weekends, I asked one of the tenants who lived at the house, what she did for fun. She told me she went to singing, "Singing?" I responded, "What in the world is singing?" When she told me, it was the gathering of friends and family the night before someone's burial, I thought, "You have to be kidding." She went on to tell me that a band was usually there, and that it was a lot of fun.

"How in the world can that be fun, when it's a solemn occasion?" I asked, but she insisted I would enjoy it, if I went to one. One of my cousin's employees liked me and wanted to take me on a date. He

was too old for me, and I didn't like him in that way anyway, but he was a nice person, so I asked him where he wanted to take me. When he said to a singing, I burst out laughing and said, "You've got to be joking," but he wasn't finding it funny. He took it as an insult when I laughed and asked him, "Who in their right mind, takes a person on a date to a dead yard?"

Needless to say, I told him no thank you and tried to leave it at that, but instead, he offered to take me to the beach. I had no intention of going to any beach with him either, so I told him I would let him know because I was going to be very busy. It so happened that another one of my cousin's employees named Westford who made the coffins, and caskets found out he had cancer. He slept downstairs in the room next to mine, so we spent a lot of time talking and getting to know each other.

After his last visit to the doctor, he told me the cancer had spread. Although he was getting worse, no one could tell by just looking at him, because he looked fine. The day after his doctor's visit, my uncle and I were making plans to go out. When I went downstairs to get ready, Westford told me to wait for him because he was going to join us. The three of us walked through the town and up the hill to my uncle's favorite bar, which was across the street from my cousin's funeral home, located on Top Road.

Some of the employees were in front of the building talking, so Westford left us to go greet them. Top Road was quite lively both day and night because of the three funeral homes, bars and restaurants located there. I was busy enjoying the music and atmosphere, while observing the people walking back and forth, when Westford walked up to me and said, "Thank you." "Why are you telling me thanking me?" I asked. "I'm thanking you for listening and being a friend." I thought that very odd, especially when he gave me a fist bump, smiled and told me he was going further up the road.

346

A few hours later, I heard one of the employees telling my uncle that Westford was at another bar drinking rum, knowing he was not supposed to drink alcohol with his medication. Even though I heard the conversation, I still didn't think much about it until after we reached back to the house the following morning. When we arrived back to the house some time after five, I noticed Westford was already in bed sleeping, when I passed him to go into my room.

The moment my head hit the pillow, I was knocked out. I do remember hearing someone knocking on my door, saying something about Westford, but I was out of it and fell back into a deep sleep. I didn't get to sleep for very long though, because I was woken up by aunt Elma, who came downstairs to ask me if I heard what happened. When she told me the news, it took a while for it all to sink in. Westford had been taken to the emergency room, after one of the men came in and found him lying unconscious on the floor next to his bed.

The news spread like wildfire, because by the time I took my shower and sat on the front veranda drinking my morning tea, people were already coming to the house to find out what had happened. After everyone began discussing Westford's activities the night before, it all started to make sense. It was then that I understood why he came to thank me. He was saying his goodbyes. My uncle was at the hospital with him and call about ten o'clock to inform us that they had been there for nearly four hours and Westford still had not been seen by a doctor.

He told us that a nurse had put Westford in a wheelchair, but he kept falling out, and he didn't think Westford was going to make it. I was saddened after hearing the update, and aunt Elma started to cry. As the minutes passed, the house and front yard was quickly filling up with noisy neighbors, and friends who came to gossip and give their input as to what they thought happened. My uncle returned home at noon, and the moment he opened the front gate, everyone began questioning him.

He told us that at eleven o'clock the doctor finally took Westford in a room and hooked him up to the IV, and by eleven thirty, he had passed away. Aunt Elma fell back into the chair and started crying, and I was speechless as I sat in shock. I don't know how the news spread so quickly, but within the hour, the house was totally crowded, both inside and out, with people coming by to give their condolences. Everyone concluded that Westford basically committed suicide by drinking alcohol with his medication.

We were told he drank quite a few glasses of rum, even though he knew he should not have drunk alcohol with his medication. For this reason, everyone was convinced he drunk because he knew it would kill him, so that's why he did it. I knew he didn't have hope of recovery and didn't want to suffer, but I didn't think he would have decided to put an abrupt end to his life. Apparently, he told a few people goodbye that night, and when he was asked where he was going, he just laughed.

His brothers, sisters and his two sons drove down from Montego Bay the following day, to make the funeral arrangements. The funeral was planned and my uncle and some of Westford's friends decided they were going to plan a singing, which would be held on my cousin's property. I thought to myself, "So I am going to experience firsthand what this singing is all about after all." The house was crowded inside and out, with people coming and going the evening before the funeral.

About twelve members of Westford's family arrived that evening and were all planning to stay at the house. When I asked aunt Elma where they were all going to sleep, she informed me that no one would be sleeping that night. Some of our family came too. Some that I had not seen in years, and some I had never met before, so it was like a family reunion for me. I felt like I was in a sardine can because of how pack the house was with people. Aunt Elma told me to share my room with the woman in Westford's family, so they had

somewhere to put their bags. Reluctantly I did, and they ended up taking it over for themselves.

Soup was being cooked at the store/bar next door, cartons of beer were being brought in, along with bottles of white rum, and then I saw a van pull up and musical instruments being taken out. I was so busy running back and forth and didn't see when all the instruments were being set up, because I was the one the guests came too when they needed something. I was inside the house when I heard someone testing the microphone. When I heard the bass guitar and a keyboard, they sounded like the familiar sounds of a stage show.

I rushed outside to see but was stopped in my tracks when I saw what seemed like the entire neighborhood in front yard, and the street. I turned out to be the waitress, once I was seen with a glass in my hand. All the drinkers there knew it was alcohol in my glass and they wanted some too. I couldn't wait until the musicians started playing because I could tell from the vibes, it was going to be an enjoyable night.

I was enjoying the atmosphere which was not that of a solemn occasion at all, it felt more like a celebration. Once the music started playing, it was loud and the lead singer really knew how to entertain the crowd. I was in the front row with my drink in hand, dancing along with everyone else, feeling like I was at a concert. In the midst of my enjoyment, aunt Elma sent someone to get me, so I could help serve the soup. I was upset because I was enjoying myself too much to leave and serve people, but duty called.

I had never experienced anything like this in my life, because there was absolutely nothing solemn about that occasion. One minute it felt as though I was in a worship service with gospel music being sung, then within the next, it felt as though I was at a music festival. The singing went on until seven thirty the following morning, when the band stopped playing and started packing up the instruments. I

349

enjoyed the band so much, that I helped them pack up and stayed outside with them until they left.

Aunt Elma was preparing breakfast for everyone, and I once again became the server. With only one bathroom to use, it became chaotic after breakfast when everyone tried to get to it first, in order to take a shower. The funeral was planned to start at eleven o'clock, and by the time ten o'clock came around, most of the guests were ready. Aunt Elma and I were cleaning up after everyone, and hadn't even taken our showers yet when everyone else was preparing to leave. When the driver came for us, we were nowhere near ready, so he ended up leaving us behind.

Aunt Elma started to panic once she realized we were the only ones left in the house. She seemed as though she was going to have a breakdown because all the cars had left, but one of Westford's brothers came back for us. I never expected the church to be filled to its capacity when we arrived. I had no idea Westford was so loved and respected by so many, and it was such a shame that he chose not to hold on. It was a very nice service, as well as heart felt when Westford's co-workers who were all dressed in uniform, sang a song in his honor.

It wasn't until we arrived at the burial ground, and the coffin was being lowered, that it sunk in Westford was really gone. Out of nowhere, with no apparent sign of its coming, the rain started pouring down and the people began scattering. Most of them came back to the house, and some hung out at the bar next door, where the food was being cooked. The rain eased up a little for a while but started again, yet no one seemed to mind, because people were still standing out in the street talking.

Music was being played from the bar, which was loud enough for the entire neighborhood to hear. People were eating and drinking and enjoying themselves, as they did the night before, but I didn't join in.

For me, it was not such a joyous occasion anymore after accepting that fact that Westford was really dead, and now buried. The crowd didn't disperse until approximately two o'clock the following morning, and even then, some people lingered around. I, on the other hand was exhausted from all the activities of the prior day, with no sleep the night before, so I was ready to go to bed.

I went to many "singings" with my uncle after my first experience. I had to laugh to myself, when thinking how shocked I was at first, when told about "singings" being a form of entertainment. I never thought I would find myself looking forward to attending them. Life is funny I thought, sometimes we are quick to judge something, then end up doing it ourselves. I even snuck out a few times after aunt Elma went to bed and went out on the town, sometimes ending up at a "Singing."

Although I was having fun, I knew it couldn't last much longer, because I needed to get back to the states. I needed to get my life in order and get back on my feet. I had already overstayed my permitted time in the country of three months, by more than a year, and I wanted to go back home. Four months had passed since being in Brown's Town, doing the same routine day after day, and it was beginning to take a toll on me.

My life needed to make a drastic U turn, but I couldn't see a way out, and I definitely couldn't see a way out of the hole I felt I was in. That was until I got an unexpected call from Bev, telling me she had a big surprise for me. With great anticipation, I waited for her to tell me what it was. I needed to hear something that would pick my spirits up, and she most certainly did. When she told me she would be in Jamaica which at the time was two weeks away, I was unable to hold back my excitement.

She was coming to see me and her dad and wanted me to meet her in Clarendon where she was going to be staying. I had not seen Bev

in eleven years, I talked to her all the time, but it wasn't the same as spending quality time together, so I couldn't wait. Aunt Elma asked why I was so happy all of a sudden when I hung up the phone. "My best friend is coming to see me, and I can't wait." I replied. I was overwhelmed with joy until the following week when I woke up to find I had caught the Chikungunya virus.

Chikungunya was a virus spread by mosquitoes that was taking over Jamaica. It seemed to spread from parish to parish, and it had finally arrived in Brownstown, St. Ann. I couldn't move at first when I tried to get out of the bed, as my body felt like someone had beat me with a baseball bat. I tried to make it up the stairs and couldn't, which lead me to believe something was terribly wrong, when my legs wouldn't work. Jeff was a tenant who lived downstairs with the rest of us, but in his own private section. He happened to be leaving for work when he saw me struggling. He ended up having to pick me up and carried me upstairs to aunt Elma.

Aunt Elma helped me take a bath and then made me a cup of tea, but I was feeling so sick, I was unable to drink or eat anything. After aunt Elma felt my forehead, she told me I had a fever and escorted me back to bed, where I stayed all day. Once my fever broke, I found myself wanting to go to the bathroom to pee every fifteen minutes, but couldn't make it, even though the bathroom was right next to my room. Jeff did tell me that having a weak bladder was one of the symptoms, but I didn't believe it would happen to me.

For two days straight, I wet myself before I made it to the bathroom, which was literally only eights steps from my room. After that stopped happening, the symptoms which followed were aches and pain in my joints. The pain in my joints were so intense to the point that I could not lift up my arms, so taking a shower was quite difficult and painful. I was told this would last between six months to one year, which I didn't believe, but it did, it lasted six months. My only concern at the time was getting better before Bev arrived.

I was quite relieved the worst part of it had passed before she came. I counted down the days and hours until Bev's arrival, and was overwhelmed with excitement, the day she called and said she was in Jamaica. I was so happy that I didn't know what to do with myself. I felt like I did when I was a child waiting for Christmas, so I could open my presents. For me, seeing Bev was my present, and when the time came for me to go spend time with her, I was up bright and early getting ready to leave out at daybreak.

It was a three-hour journey, that seemed like forever, but I got to see parts of the island I had never seen before. When I finally reached my destination in Clarendon, it took me another hour to get a taxi. Every five minutes, I kept asking the taxi driver how much longer it was going to take to get to the address. I knew I had to be getting on his nerves, but I didn't care, I just wanted to get there. When he told me we were about to turn onto the street we were bound for, I quickly sat up straight.

I could see Bev standing in the front yard waiting for me from a distance and fought hard to hold back the tears of joy that were bubbling up inside. My broken spirit that had weighed me down for so long, had be lightened once we eagerly greeted each other with hugs and kisses. Bev represented home for me, it was as though I was instantaneously transported back to the good old days. The good days when life was wonderful, filled with joy, love and excitement.

It was a nice surprise to see that Cherelle, Bev's eldest daughter had accompanied her on her visit. Yet I was saddened to see how she had grown up into a lovely young lady, and I wasn't there to see that happen. Before I was able to settle in, Bev didn't hesitate to tell me I had lost too much weight and looked like someone suffering from malnutrition. Aunty had said the same thing, but since aunty's insulting remarks, I had lost an additional thirty-five pounds during the four months in Browns town.

Aunt Elma was the reason for the additional weight lost, because she had me walking back and forth up that steep hill to the shops and market, just about every day. We had a good laugh about it, but Bev was very concerned about my weight loss, and decided she was going to make sure I ate as much as possible while I was there. She brought with her all my favorite assortments of biscuits and Mr. Kipling's Cherry Bakewell pies that I loved as a child and still can't seem to grow out off.

I ripped the bags opened as though I had never seen food before, not knowing which one to start with first. I sat there stuffing my face to the point that Bev took them away from me, and asked, if I was planning to eat them all at once. The surprise wasn't finished there, because it was as though Christmas had come early, when she opened her suitcase, and took out the clothes she had brought for me.

Yet another surprise came, a sentimental one, when she started playing all the reggae lovers rock we loved as teenagers. The songs I went crazy over when we use to hear them at the club. She had downloaded them all for me before she left England, so we listened to them all night, and took a trip back down memory lane. I finally saw the sunshine in the midst of my cloudy days with Bev by my side. Re-living a fragment of my past, remembering what life used to be like, and could be again, gave me the hope that was temporary missing out of my life.

The week was flying by so quickly, but I did not want it to end. I couldn't shake the thought of my happiness coming to an abrupt end, once I left Bev. I started getting separation anxiety and found myself dreading the day we would have to go our separate ways. The reality of my situation came back to haunt me. Bev would be going back home to England, and I wanted to leave Jamaica and go back home too. My only problem was, I saw no way of how that was going to happen, and had no idea at the time where home was going to be.

We spent most of our last day together sitting on the veranda talking. With great confidence, Bev was convinced that my situation would work itself out. She was also convinced I would be back in America sooner than I thought, and when I least expected. "Yeah right, I have been telling myself that for quite some time, but instead, nothing as worked out for me," I told her. I certainly wasn't as confident as she was. In fact, I became more heartbroken when the sun went down, knowing it would be our last night together in Jamaica, with no idea when I would see her again.

Morning came, and I was taking my sweet time getting ready to leave, when I got a call from Brown's Town. It was my uncle calling to tell me that I needed to return as soon as possible, because aunt Elma had caught Chikungunya and wasn't doing well. When Bev's father came to pick us up to take me to the taxi stand for my long ride back, depression started to creep in. The sadness in my heart was written all over my face once we were ready to leave the house. Saddened, because I was about to say goodbye to one of the most important people in my life.

When I got out the car and kissed Bev's father and daughter goodbye, I tried not to cry when I left Bev until last. I looked at her and started thinking, "She's my best friend in the whole world, the one person I know I can count on for anything, the one person left from my childhood that I know loves me unconditionally, and now I have to part with her again." I tried to be strong when I held on to her, not wanting to let her go. But my tears came rushing down, as they always have every time we are together and have to say, "Goodbye."

The joy and happiness I had, instantly vanished when the taxi pulled out, knowing I was heading back to the unknown. I wondered what my future had in store for me, but I knew whatever it was, I had to face it all on my own. When I turned to wave goodbye one last time, that feeling of emptiness quickly returned. I was contented and

filled with joy with Bev around, but once we parted, I was back to feeling hopeless, depressed and lonely.

Aunt Elma was sick in bed when I got back to the house, insisting she was going to wait on my return before she would go see a doctor. Once I got her prescriptions filled, it was my job to nurse her back to health, which only took a couple of days. Considering her age, she was strong and revived much quicker than I did. During her time of bed rest, I took care of her and the household chores. I was back to my regular routine, taking care of the animals, doing the grocery shopping and even cooking for the workers who lived downstairs.

When I needed to get away from it all, I would go sit on top of the roof of the house. About two weeks after Bev had gone back home, I was sitting on the roof talking to God and asking when He would deliver me. I was on the roof weeping when my uncle climbed up to join me. Not wanting any company, I tried to get him to leave, but he came to ask me a question. "Are you ready to go back to America?" he asked. Stunned by his question, instead of answering, I inquired why he was asking.

My uncle informed me that my cousin who was living in Florida unbeknownst to me, had suffered a stroke and needed to be released from the hospital. "Yes, I heard someone talking about him," I replied, not having the slightest idea why he was telling me this. He then told me that the hospital wouldn't release him unless someone was going to be at home with him. There was no other family member that lived in Florida except for me, so therefore his brother whose house I was staying at, wanted me to go take care of him.

I was speechless and unable to give him an answer at first, because it took a minute to get over the shock. My deliverance had come; God had come through for me once again, and in such an unexpected way. Bev was right, something did work out for me, and it happened when I least expected, in a way I least expected, only two weeks after she

left. By the following day, my ticket was booked for the following week. I wanted to stay and leave after Christmas, but they told me I couldn't, because Trevor had already been in the hospital for nearly two months, and it was time for him to go home.

It was all so sudden, and aunt Elma didn't take the news very well. She broke down into tears when I told her I was leaving. It touched my heart when she told me how I had made such a difference in the home, and how I taught them to care for the dogs. "We watched you bathe them, love them and go out of your way to care for them. We never saw anyone love animals that way, and we see how much they love you for what you did for them, so now we know how to treat them."

She also told me that out of everyone that had ever come there to stay, I was the only one she didn't want to see leave. I was so happy to be finally leaving Jamaica after my year and a half stay, but at the same time I was going to miss it. I was going to miss everyone I met and became friends with during my stay in Brown's Town. Although I had no money most of the time, everyone looked out for me, and made me feel so welcomed.

December 4th 2014, had arrived and it was time for me to say my goodbyes. I had spent five months in Brown's Town, which was the best time I had during my entire stay. It seemed so unreal that I was finally leaving. I had gotten so accustomed to the way of life, and knew it was going to take some time to adjust when I arrived back to Florida. My cousin handed me an envelope before I left, which to my great surprise, was filled with hundred-dollar bills in American money. So, it turned out that I left Jamaica with way more money than I arrived with.

I kissed everyone goodbye, and when it was time to say goodbye to aunt Elma, she started to cry and so did I. Leaving was what I wanted all along, but when the time came for me to leave, I was

apprehensive about going back to the unknown. Overstaying for the length of time that I did, caused me to be concerned about what would happen once I arrived at the airport. It turned out I had nothing to worry about after all, because my late arrival caused the officer to quickly stamp my passport without checking my date of arrival into the country.

Chapter Twenty-Five:
Do Good to Others

Be very careful not to mistreat others, because you never know what the future holds. You may have to turn to that same person you once hurt or mistreated and ask them for help. Somewhere in the world, at this very moment, someone is probably asking for help from someone they once hurt. So, always treat others the same way you want to be treated.

I was picked up at Ft. Lauderdale International airport by one of my cousin's friend, but I had no idea we were going straight to the hospital. I wanted a day or two to myself first, so I could relax and mentally prepare myself for my new assignment. When we arrived at the hospital and my cousin saw that I was the one who had come so he could be released, his face revealed his emotions. Not only was it evident how startled he was, but he was also quite upset. I was the last person on earth he expected to see, especially after what happened when we saw each other last.

Luckily for me, the social worker had already left for the day, so the doctors were unable to discharge him, which was like music to my ears. I was going to get my heart's desire, at least for one day anyway, so I was happy when we left the hospital without him. I really needed quiet time to myself to allow everything to saturate in my brain. The friend drove me to my cousin's condo, which surprisingly was very much to my taste and liking. Clean, with a contemporary and chic design was far from what I expected his bachelor pad to be, but he obviously had good taste.

Before his friend left the condo, he wanted to know why my cousin had rolled his eyes at me, but I didn't go into details. I had only met my cousin twice before; one time when mom was still alive, and the other was at her funeral. The first time I met him was when he came to Boston to visit mom a couple days before his return to Jamaica. During our conversation I told him I was about to send Derrick's passport to the Jamaican Consulate to be renewed. My cousin insisted he was able to get the passport renewed in half the time it would take me, because he supposedly had contacts in the passport office.

I agreed and gave him the three hundred and fifty dollars he claimed it would cost, and he assured me that Derrick would receive his new passport within three weeks. I was hesitant at first, but then I figured he was one of my first cousin's after all. He wasn't wanting of anything because he was joint owner in a business, and wasn't in need of money, so he had no reason to deceive me. We exchanged phone numbers, and before he left, he made sure to reassure me that we would receive the passport no later than three weeks.

One month went by without hearing from him, and even though I called his home a few times, I was told the same story each time, he wasn't home. Two months went by, and it was the same answer I kept getting when I called, he wasn't home. After three months of waiting, I decided to call him from a different phone number, and surprisingly enough, he answered the phone. I was the last person he was expecting to be on the other end of the call, so he had no time to come up with a viable excuse.

After telling him what I thought of him, I told him to return the passport right away along with the money I gave him. Well, I did get a package from him the following week, but what I retrieved from the package was an unrenewed passport, minus the three hundred and fifty dollars. It would have been a waste of time to call him back and

ask him to return the money, so I didn't bother. Instead, I decided to leave it to fate, knowing I would see him again one day.

It so happened that I did see him again on the day of mom's funeral. I was already deranged from losing mom, so when I came out the house and saw him standing amongst some of our family members on the sidewalk, I let him have it when he greeted me. I can't even recall the words that came out of my mouth, but I do know I embarrassed him and he was speechless. He knew what he did was wrong, so there wasn't much he could have said, but he did make it a point to avoid me for the rest of that day.

Sixteen years had passed since I last saw him, and I couldn't help but wonder how he must have felt when he saw me show up at the hospital. Out of all the family members, it turned out I was the only one that was available to help him. I thought about it all night at his condo while sitting out on the patio, trying to get adjusted to my new environment. I thought about how true the idiom was that says, "Be careful not to burn your bridges, because you never know when you have to cross back over."

"Life is so unpredictable," I thought, you never know where circumstances can lead you. In my cousin's case, his circumstance led him down a path where he had to end up depending on someone he once wronged. I was now going to be living in his condo to take care of him, but I was very anxious that night, not knowing what to expect during my stay there. As usual, I sat and looked at the stars, and wondered when the change I wanted would come. Yet again, I was in another situation that I didn't want to be in, but I had no other alternative.

I had to accept my present state, and hoped that when my assignment was complete, opportunities would open up for me, so I could live the life I was once accustomed too. The following afternoon came sooner than I had hoped, but I was grateful when his

friend decided to go and get my cousin by himself, which gave me an extra hour of solitude. I was dreading my cousin's arrival - I figured it would be quite awkward to say the least, so I wasn't looking forward to it at all.

It wasn't until he arrived that I knew he was unable to help himself and needed assistance to bathe and walk. I knew he was unable to talk because the left side of his brain was damaged due to the stroke. I wasn't aware of the rest of his inabilities, so I knew then that I had my work cut out for me. When his friend left, I went into my cousin's bedroom to talk to him and found him to be quite pleasant. I guess he realized he had no choice but to be nice to me, because he needed my help.

The first thing he wanted to do was take a shower, but it took me a few minutes to figure out that was what he wanted. I was so uncomfortable with the thought of having to undress him. Because his right leg wouldn't move, it was very strenuous lifting him up off the bed and getting him to the bathroom. He wasn't embarrassed at all when I undressed him and struggled to get him to the bathtub. After bathing him, it took me about ten minutes to get him out the bath, which at first seemed like an impossible task, because I didn't have the strength to pick him up.

My back felt like it was broken and at the same time, I had to make sure not to allow him to fall. When I finally got him back to bed, I decided there was no way I would be able to bath, pick him up and dress him every day. I felt as though I wasn't strong enough to continue that task, especially with my back injuries from falling from the parking lot. I don't know how I ended up doing it, but I bathed him every day for one week, and by the end of the week, he was helping himself.

He saw the struggle I went through, so he decided to do his own physical therapy during the daytime. After the first week, he was

bathing himself and by the second week, he was practicing to walk. Although the right leg couldn't move, he was determined and started getting around by himself, which made my life much easier. As the weeks went by, I learned to figure out the meaning of the sign language and sounds that he made.

When visitors came, they were unable to understand what he was trying to say, so with frustration, he always turned to me so I could translate. My cousin was a very intelligent man who was educated in England and had everything going for him. He ran his own business, as well as taught fitness training and also coached a soccer team in Ft. Lauderdale. So, to end up in the predicament he was in, caused him great stress, and I could see that he was falling into depression.

He had everything going for him, he was healthy and free to do as he pleased, then in the twinkling of an eye, his whole world turned upside down. I found out what actually happened when I met Sam. Sam lived in the condo on the first floor directly beneath us. Sam introduced himself one morning when I was standing in front of the balcony outside the condo. When he asked how my cousin was doing, we got to talking and that's when I found out the details of what happened.

Sam explained that he was inside his condo trying to make a phone call but couldn't get good reception, so he stepped outside to use his phone instead. Once outside, he heard noises coming from the balcony above. When Sam looked up and saw my cousin, he asked if he was okay, but my cousin didn't answer, which was unlike him. Sam was about to go back into his apartment when he heard my cousin making louder sounds of distress. Sam knew something wasn't right at that point, so he ran up to the second floor balcony to find out what was wrong.

Upon arrival, Sam was startled to see my cousin sitting on the ground naked making sounds but unable to speak. After calling the

ambulance, Sam went into the condo hoping to find something so he could cover my cousin up with. That's when he noticed the shower was still running and a few items in the bathroom had been knocked over. His workout clothes were on the floor, so apparently, he had returned from the gym and was about to take his shower when he had the stroke.

Sam and I became friends after our first meeting - he was laid back and easy gooing, and we got along really well. When I needed a break, I went downstairs and hung out with him and his sister Gigi, and we always had some good laughs. I could always call on them when I needed help with my cousin, and they were always available and willing. One evening the three of us went for a walk by the canal behind the condo and when I returned, I found my cousin on the floor next to his bed with a busted lip.

As usual, he was trying to do something he shouldn't have been doing without me. I was in a panic at first because his mouth was bleeding, and he was disoriented for a few minutes. Unlike the other times that he had fallen, this time I was unable to pick him up and had to call Sam to assist me. I was afraid to leave my cousin and go anywhere after that incident because he was stubborn. He chose to do as he pleased and refused to accept the limitations he had.

His daughter came from Jamaica for his birthday, which was about a month after my arrival. By then, he was doing his own laundry and taking walks by himself. He was moving furniture around with his one good hand, and even cooked a few times for himself. I still wonder how he was able to chop an onion up in small square pieces with one hand, but I guess that will remain a mystery. He sure did do his own physical therapy and did such a good job of it as well.

Everyone was totally amazed how quick he showed improvement as well as his steady weight gain. He was certainly looking quite

healthy while gaining his strength back and even started walking up and down the stairs. The only problem I saw that prevented him from reverting to independent living, was his inability to speak. The family knew he wouldn't be able to live on his own without assistance if his speech didn't return. I couldn't stay there forever, so we had to start making decisions as to what we were going to do.

In the end, the only alternative was to send him back to Jamaica so his son and daughter could care for him. He didn't want to go and got very angry when anyone even suggested it to him, but he had no other choice. He tried to let me know he could take care of himself and refused to accept that he couldn't. While his daughter and I left for the supermarket one day, my cousin tried to prove to us he could take care of himself. It backfired though, because when we returned, we found him on the floor again, with not only a bloody lip, but forehead too.

I felt sorry for him, but there was no other choice but for him to go. He was furious and refused to hear the truth; the truth that he was unable to fend for himself. He could no longer operate his business and was unable to verbally communicate if he needed help. His son told me that he had once said, under no circumstances would he ever return to Jamaica, and if he died, he didn't want his body to go back there either. He was adamant about not returning, but after two months of persuasion, he reluctantly agreed.

After being in the country for seventeen years, I knew it was going to be hard for him to adjust to a new way of life. He was very sad the morning we took him to the airport, and I was worried because he was traveling by himself. I was worried that he wouldn't be able to communicate if he needed to go to the bathroom, but he managed just fine and made it to his destination without any difficulties. His daughter told me that friends and family were at the airport to meet him, and he seemed happy to see everyone.

After they left the airport, they stopped at a restaurant and ate, but he had a seizure on the way to the house. I knew the depression and shock of being back in a place he didn't want to be, took a toll on him and caused that seizure. That night as I sat in reflection, I thought how life can give some hard blows at times. My cousin was in his prime, having everything going for him, and then boom, when he least expected it, life as he knew it had ended abruptly.

Although I was missing his company, I did enjoy the fact that I was finally on my own again, after enduring four years of living with other people. I was so happy I didn't have to cook three meals a day anymore, and I could finally relax. I could walk around naked if I chose too, and I didn't have to do anything I wasn't in the mood to do. I enjoyed my quiet time for two weeks, gathering my thoughts and thinking about my next move which was to apply for a job.

After the first few weeks of job searching, I began getting frustrated that nothing had come through for me. five years had now passed since being the independent woman I was used to being, and it was taking a major toll on me. It was even more frustrating knowing I use to be the one people came to for help, but now it was the other way around. It was such a humbling experience, especially because I knew how liberating it was to be independent.

Being in that position made me wonder how so many people could be happy and contented living of the government or other people, not wanting work or to try achieving anything better for themselves. I was sick and tired of being sick and tired, and began questioning God as to why doors were not opening up for me. I knew God was a deliverer - I had proven that time and time again, but I couldn't understand why nothing was happening for me.

To add to my distress, out of the blue, I got a phone call from a friend in Miami, telling me that Ken's cancer had spread considerably since I was in Jamaica, and he wasn't doing well. In case you forgot

who Ken was, he was my friend that came to my assistance the day Fluff died. Anyway, both his lungs had collapsed, so I wanted to go see him. I got the number to his hospital room and called him, and although his voice was weak, I knew he was happy to hear from me.

I told him to stay strong and hold on because I was coming to see him, but he told me not to stress myself if I couldn't get a ride. I did stress because I wanted to go visit him so bad and couldn't get a ride. No one I knew with a car wanted to drive in Miami traffic, but that was until Millie came to my rescue. She was my cousin's neighbor whom I met when she came by to massage his feet every day. She had temporarily moved to Virginia, but had come back for a couple of days. It just so happened that she was going to Miami to spend the day with a friend, and asked if I wanted to go with her.

I thought for sure that was my opportunity to visit Ken in the hospital, but when we were on our way, I received a call to inform me that Ken had been moved to another hospital, but they weren't sure which one. I couldn't get a hold of Ms. G., so it turned out I didn't get to go and see him after all. Instead, I ended up spending the day with Rita, whom I hadn't seen since returning from Jamaica. I hadn't seen any of my friends for that matter, so although I was disappointed by not being able to visit Ken, I did look forward to spending time with Rita.

As usual we had a great time catching up and it was good for me to be with someone who was dear to me. My spirits were revived, my laughter was back, and I was happy, well for a short time anyway. But before I left, Rita insisted I find a way to visit Ken because she believed he had something he wanted to tell me. She wasn't as optimistic as I was, because she believed he didn't have much time left. I on the other hand, chose to believe he was going to pull through his illness.

The month of June was around the corner, and I was hoping for a change in my life before my birthday arrived. Instead, the month of June 2015 happened to be one of the worst months I have ever had. First, my phone was cut off for the entire month, leaving me with no way of communication with the outside world. I had no food, and was only able to drink tea and water, with the exception of two days. I wept every night before I went to bed with a hungry stomach, and dreamt about everything I was going to eat when I had money in my pocket again.

I learned a valuable lesson during that month, I learned first-hand what real hunger felt like. It led me to have even more compassion for people who had little to no food. People in countries like Africa, India and other parts of the world where people were starving and dying from their starvation. In the end, I decided to look on the brighter side, I was finally able to lose some of the weight I had regained after Bev insisted I needed to put some weight back on.

June 20th had arrived, and it was my birthday, but still no change. In fact, by that point, everything seemed to be getting worse. Early that morning I had a strange dream where I saw a row of old white houses and Ms. G's white SUV parked in the middle of the street. I pondered on the dream wondering what it meant but decided not to dwell on it. Although I still had no food, it was my birthday and I wanted to celebrate that I was still in the land of the living. I needed to entertain myself, so I got dressed up, played music, danced and celebrated. I actually had a great time by myself with only a cup of tea to drink.

I gave God thanks, because although I had nothing, I had my life. I knew many people hadn't lived to see their birthday that year, and thousands of people around the world, didn't wake up that morning, but I did. I woke up in my right mind, and I still had my health and strength. I used those facts to uplift my spirits on my birthday, not

knowing at the time, that my birthday was the last day someone I loved and cared about was going to spend in the land of the living.

On June 30th, my cousin Loris paid my phone bill and had it turned back on. Literally within three minutes of my service being reconnected, the phone rang, and it was Morrisa, asking if I heard. "Heard what?" I asked. She didn't want to tell me, instead she asked if I had spoken to Ms. G. When she told me to call Ms. G., I knew it was bad news, so I asked her what happened to Ken. I thought she was going to tell me he got worse, but I wasn't prepared for her to tell me that not only did he die, but that he died on my birthday.

I was speechless and needed time for it to sink in before I called anyone. Shortly after her call, everyone was calling or sending messages to inform me of his death. I called Ms. G., to get the details, and found out he died with the family surrounding his bedside. Ken was the first real friend I met after moving to Miami, and except for Rita, all the friends I had, came through him. Ms. G., called me back later that day to inform me she had made arrangements for me to come to Miami the following day.

When I told Ms. G., I was staying in Sunrise, she called her friend Roy who lived close by, and asked if he could pick me up the following day. She was having a celebration for Ken at her warehouse and wanted me to be there, plus it was an opportunity for me to retrieve the rest of my belongings that were left at her house. I was looking forward to retrieving everything I left at her house for approximately two years, but wasn't looking forward to returning to her home. I wanted to leave those bad memories behind me, but I needed my things, so I had no choice but to revisit the past.

Roy picked me up the following afternoon on time and took me to an all you can eat Chinese buffet that he was very fond off. After going through one month without food, I ate so much that I had to undo the button on my jeans when we were leaving. I was very

grateful for what Roy did, considering it was the first time we met. He was very talkative and pleasant, which made it an enjoyable drive to Miami.

When we arrived at Ms. G's house, the memories came rushing back, some were good, but the majority were very bad. Ms. G., was at the warehouse waiting for us to arrive, so I went upstairs to quickly grab what I could fit in the SUV. I expected to see that the room had been ravished and stuff stolen, but I sure didn't expect it to be as bad as it was. Most of my things were gone and what was left, were all over the floor. All the drawers were empty and none of my pot sets, plate sets and crystal glasses were any place to be found.

I was angry and disgusted while I stood in the middle of the room not knowing what to take. I didn't have time to sort through everything, because Roy was rushing me. I just grabbed what I could fit in the SUV, trying to fill it to its capacity. I knew I would have to return for the rest, so I took the most important things I could actually find. I couldn't believe the lack of concern Ms. G., had for the safety of my property, although, then again, I guess I could.

The celebration for Ken, was something similar to the singing in Jamaica, but not as extravagant and it was after the funeral, because he was already buried. Happy memories of Ken came rushing back the moment we pulled up in front of the warehouse. Ken's death didn't totally sink in, until I glanced over at the DJ booth and didn't see him standing there. I was so used to seeing him behind the DJ booth, or walking around with a smile on his face, pleasantly greeting his friends and customers. The warehouse wasn't the same without him there. Even though the vibes was the same, his missing presence left me in a gloomy and somber mood.

Roy and I left around three o'clock the following morning to begin our journey back to Ft. Lauderdale. On the way, Roy started complaining about having a sharp pain in his side and went on to say

he had been experiencing those pains for a few weeks. When I asked him if he had not seen a doctor, he told me he did, but the doctor only given him pain killers which were not working. The conversation changed to sharing funny experiences we both had, and before I knew it, we were pulling up in front of the condo.

Roy offered to help me with the boxes and the heavy stuff I had to bring to the second floor, but I didn't want him to help. I appreciated his offer, but under the circumstances, because of the pain he was experiencing, I told him I would take my time and take them up myself. I didn't want his pain to increase, but he insisted on helping anyway. Before Roy left, he told me he was going to get a couple hours rest before he left for work, and would call me later that day to check up on me.

After taking my shower, I sat out on the patio and drank the bottle of Heineken I brought with me from the warehouse. I thought about life, how fragile it is, and how sudden things can change. One minute a person is enjoying life, and within the next, they can be gone forever. I thought about how life is filled with so many surprises, so many ups and downs, so many storms, sadness, and heartbreak. I couldn't sleep, and so I sat there just thinking, thinking about Ken, and what he told me before I left for Jamaica.

Recalling how he said he thought he was going to die from cancer, and that's exactly what happened. I sat outside until nine o'clock that morning unable to sleep due to my sadness, of how Ken's life was cut short, right in his prime. Shortly after I finally went to bed, the phone rang. It was Roy calling to tell me he was in the hospital. "Uh! What are you doing in the hospital? I asked." He told me that when he got home and laid down, the pain in his side became so intense that no matter which side he turned on, the pain became increasingly unbearable.

He informed me that he would be in the hospital undergoing tests for a few days and would let me know the results when he got them. I called him every day to see how he was doing, and on the fourth day, I called to find out if he had received his test results from the doctor. At first, he told me there was a problem with his liver, but inquisitive me wanted more information than that. I wanted to know exactly what was wrong with his liver. He was hesitant to respond at first, so I knew it was something he didn't want to disclose, but I wanted to know.

The last thing I expected him to say was that he had cancer of the liver, which left me dumbfounded. I was lost for words at first, from the sheer surprise of his illness. I certainly didn't think the pain he was experiencing was caused from cancer, so I was speechless for a while. I was convinced the intense pain he felt after he left me, was triggered from him carrying my heavy boxes up to the condo. I had to comfort him somehow, so I told him to keep the faith and not to have negative thoughts.

When I hung up the phone I sat thinking, "life really knows how to throw some heavy punches." I couldn't move from the spot I was in for quite some time. I kept trying to imagine what he must have been going through, and the fear that must have overtaken his mind. I started blaming myself for allowing him to help me with the boxes, but then I realized how true the saying is that says, "Everything happens for a reason," and Every disappointment is for a good."

Had he not insisted on helping me, the pain he was already feeling would most likely have stayed the same. He would have continued to only take the pain killers his doctor had given him, which would have delayed the process of him finding out. I stopped blaming myself when I realized that because he helped me, it led to his emergency room visit where he was able to find out what was really going on inside his body. He called me later that day to ask how I

was doing, which under the circumstances, I was doing great compared to what he was going through.

Two days later, Roy told me he was going to be released from the hospital and requested my help. He was married but lived by himself because he was waiting on his wife and daughter's application for permanent residency to come through. He told me he was feeling weak and asked me if I could cook for him when he was released. I thought it was the least I could do after he had taken me to Miami to get my stuff, plus he had taken me out for dinner.

The following day Roy called to find out if I was still going to help him. Once I reassured him I would, he let me know that he and his friend would pick me up around noon. I wasn't paying attention to the time and got carried away on a phone call with my friend Rose, when Roy called to inform me that he would arrive in twenty minutes. It so happened that I was still on the phone talking to Rose when they pulled up outside blowing the car horn. When I grabbed my handbag and rushed outside to meet them, I was greeted with smiles, from both Roy and his friend Basil.

Once I was seated in the car, Roy then asked where my bags were. Not sure what bags he was talking about, I asked why he thought I needed to bring bags, if I was only going to cook. Roy then got upset and didn't answer me. Basil spoke up and told me Roy was under the impression that I was going to stay at his apartment and help him out for a couple of days until he returned to work. "That's news to me," I told Basil, as I continued to inform him that Roy and I never had that kind of an agreement.

Frustration was written all over Basil's face when he asked if I was available or not. I wanted to say, "Not," but instead I told him I could only help out for a couple of days. They were both rushing me to go and pack my bags, so I packed enough for three days, while still on the phone venting to Rose about Roy's attitude. They stopped at a

restaurant on the way to Roy's apartment and bought food, so I didn't end up cooking that day after all.

The following morning whilst preparing Roy's breakfast, I noticed the palms of his hands and his eyes were yellow. I didn't want to ask him about it, but I couldn't resist. My inquiry led me finding out he had jaundice. That was before he decided to inform me that his cancer was already at stage four. Once that information was revealed, I quickly spoke the next thought that entered my mind. "Hold up a minute, if you have stage four cancer you won't be going back to work in a couple of days."

He gave me an odd look before trying to convince me that he would be returning to work within a few weeks, once he started his chemo treatments. I most certainly had no intention on staying there for a few weeks, but he apparently did. When asked about his other relatives, he nonchalantly stated they were not close by and quickly changed the subject. I decided not to press the issue further, but had all intentions of revisiting it later on. Except for his yellow palms and eyes, he seemed quite strong and looked healthy, but I guess that is why they say, "Looks can be very deceiving."

My chores consisted of grocery shopping, cleaning, laundry and cooking food all day long. He asked for one thing, and then when I cooked it, he wanted something else, after which he complained that his appetite kept changing. This went on all day, nearly every day, and he was trying my last nerve. He wasted so much food and give stupid explanations, such as money and food were meant to be wasted, whenever I spoke about the amount of food that was going in the garbage.

He had money at the time, but his money quickly ran out because he had no income coming in, and the little savings he did have, went into the rent and utility bills. Basil came to give me a break now and again, and cooked for him, but Roy did the same thing to Basil. As

soon as Basil left, Roy complained about the food and so whatever Basil cooked went in the garbage also. Roy threw away the fruits his co-workers brought for him, and when his daughter finally came to visit and cooked for him, he complained it had no taste and threw that away too.

He was so unappreciative of the sacrifices people were making for him, and it was really beginning to take a toll on me. One afternoon while I was talking to Bev and had just made myself a cup of tea, he asked if I could make him one too. When I brewed the tea and gave it to him, he told me that wasn't the way he wanted his tea made. "Excuse me," I replied, "This is the way I make your tea every morning." He responded and said, "It's afternoon now, and tea is supposed to be made a different way, in the afternoon."

I whispered to Bev and said, "Okay, that's it, I have had enough of this man's crap. I can't take any more of his complaining and ungratefulness, and I'm not staying here any longer." After Bev managed to calm me down, she suggested I tell him how I felt, and so I did. I was frank with Roy, when I told him he knew I had only agreed to spend a couple days to help him out, but he deceived me because he knew he wasn't going back to work any time soon, and although he was unable to pay me, I still stayed.

I reminded him I was basically a stranger who was taking care of him, when his own family members including his children, were not lifting a finger to help. I also mentioned the fact that I didn't like the way he took his frustrations out on me, by talking down to me, which was unacceptable. I think he was astonished by what I said, although he had no reaction other than to tell me he did appreciate what I was doing for him.

The following day Roy started again, so I decided it was time to take a break and go back to the condo for a couple days. Six weeks had already quickly gone by since I started taking care of him, so I

told him I would have to leave for a couple of days to take care of some personal business. He was upset when I told him I was leaving for a few days, so he chose to ignore me. Basil took a couple days off from work so he could help Roy while I was gone, so I knew he would be okay.

Whilst driving me to the condo, Basil thanked me for the sacrifice I had made and explained how important it was that they had my help. He knew how frustrated I was because he was frustrated with Roy himself. I could tell Basil was afraid I wouldn't return, even after he explained Roy could not manage without me, although I was already quite aware of that. Basil then informed me that if I wasn't there to help, he would have to take time from work to help Roy, and he couldn't afford to do that.

It was during that conversation I was made aware Roy's money had run out, and Basil was the one helping to pay his rent. Although I did want to leave, my heart wouldn't allow it, so I had no choice but to be a team player and continue to help out. I knew Basil was under a lot of pressure working a fourteen hour a day, six days a week. After working those long shifts, he stopped by every morning after work to check up on me and Roy. He also took the time off to take Roy to all his doctors appointments, so I knew he was under a lot of pressure.

The cancer began to take its toll and so Roy began getting weaker. A couple days after I returned, I drove Roy to Publix one evening because he was too weak to drive. He walked around fine in the supermarket, but once we returned to the apartment and he began walking up the steps, I noticed he seemed a bit dizzy and discombobulated. Following my intuition, I rushed to open the front door in case he fell. Right when I pushed the door open, Roy started tilting over front ways. It happened so fast that I had no time to put the groceries down which were in my hands.

I grabbed the back of his shirt with my right hand, while still holding bags in my left. Only God could have given me the strength to hold a two-hundred and fifty pound man, with one hand in order to stop him from falling flat on his face. I made him sit down for a few minutes before he went to his room, but I had to make sure he was able to walk first. I managed to hold him up and take him to his room, but he couldn't wait for me to help him get on his bed. Instead, he practically dived on the bed as if he was diving into a swimming pool and slipped right off.

I used all the strength within me to get him on his bed probably, but I hurt my back in the process, and ended suffering all night from pain. He was knocked out the moment his head hit the pillow, but I stayed up throughout the night, so I could keep an eye on him. The following morning when he explained his symptoms from the evening before, I knew then that I would no longer be able to leave him by himself. I realized I was going to be in it for the long haul, and would have to stay there with him until his wife and daughter arrived.

Following that incident, I made sure he ate healthy regardless of his cravings. The doctors said the chemo was working, so the cancer began shrinking and his health was improving. I kept him on a diet of fruits, fish, soup and vegetables, but he had a sweet tooth. After explaining that sugar would cause the cancer to spread quicker, he compromised and settled for honey instead of sugar. He was looking much healthier - his eyes and hands were no longer yellow, so I was feeling quite good about his recovery and anticipated a happy ending.

I ended up staying with him for three months, until the beginning of October, when his wife and daughter finally got through to travel to America. I left a few hours before their arrival, but because I didn't stay until they actually walked through the door, Roy never even said thank you, for all I had done for him. I was hurt by it, but I ended up brushing it off as him just being ungrateful, but I would still get my blessing. It didn't take very long for him to start deteriorating after I

left, because by the following month, he was back in the hospital getting a blood transfusion.

Chapter Twenty-Six:
Approaching the End of the
Tunnel

When a breakthrough is about to happen, it seems as though the fire gets hotter right before the end. It can be compared to childbirth. When you first get pregnant you feel no pain, but right before the birth, the pain become intense, then its over and you don't remember the pain.

I was back at the condo packing boxes and arranging with the shipping company to have my cousin's furniture and other possessions shipped to him in Jamaica. I shipped everything including the bed, therefore I left myself with nothing to sleep on. The once filled condo was now empty, other than a quilt and blankets that I laid out on the bedroom floor to served as my bed. Life wasn't looking to bright, but I had hope. I was anticipating a miracle of some kind, because that was what it was going to take to turn my situation around.

Things did turn around when I received a letter from the condo association stating that everyone living in the condo had to be fifty-five years or older. The letter also stated that the only people allowed to live there, were people whose names were on the contract during the application process. I didn't meet either one of those requirements, so that was a sign I wouldn't be staying there much

longer. The plans I had of finding work and taking over the payments as planned, went right out the window.

When I informed my other cousin who actually owned the condo, he tried to convince me to stay, but I made it clear that wasn't possible, because the association wouldn't allow it. I suggested the only other alternative he had was to sell the condo, and so he asked me to find a buyer. It just so happened that the woman next door, left me a note asking if we wanted to sell the condo, because her aunt was hoping to buy one in the same building. The arrangements were made, but I was fearful not knowing what was going to happen to me.

The closing was set for December 4th, which was only a month away, and I still had no idea where I was going. My stepfather called out of the blue and asked me when I was going to make up my mind and move back to Boston. He offered to pay my plane fare as he had done in the past, this time though, he tried to convince me to start over again in Boston, and build myself back up. He ended that conversation by telling me to find out what the price would be for the plane ticket and let him know by the following week.

My spirit was broken at the thought of having to not only go back to Boston as a failure, but even more so, having to go back to that house knowing mom wasn't there. Mom filled that house with so much warmth, joy and happiness, so her not being there was a dreaded emotion I didn't want to deal with. The thought of having to go back to Boston and live with my stepfather after all these years, wasn't something I really wanted to do either.

A few days later, I got a call from one of my cousin's in New Jersey, telling me that aunty had a stroke. She wanted me to go and take care of aunty, but I knew aunty didn't want me there, and I didn't want to go somewhere I wasn't wanted. I tried to explain that to my cousin, but she wouldn't take no for an answer. She insisted I needed to go regardless of whether aunty wanted me there or not. None of

my cousin's knew aunty the way I did, she raised me, so I knew what she was capable of.

As much as I explained the situation between aunty and I, it still went in one ear and out the other. My cousin then recruited other family members to try and talk me into going, so in the end, they convinced me to go for at least two weeks. The plan was for me to go and help aunty with her recovery, because she needed a woman there to take care of her. As far as my family were concerned, I was the best person for the job.

The flight was booked, but I still had a bad feeling in my gut and didn't want to go. One family member who knew my personal situation, thought maybe that was the door the Lord was opening for me as a way out, but I didn't believe that it was. Although the plan was to stay for just two weeks, I still had to find somewhere to leave my belongings until I got back. I was having no luck at all in finding somewhere to leave my possessions, so as far as I was concerned, it was a big sign for me not to go.

I became confident everything was going to work itself out, when my neighbor told me I could use her storage. But that confidence quickly diminished when I saw the storage turned out to be the size of a large dog cage, which was not big enough. I then called Rita in Miami who said I could leave my things at her place, but I couldn't find anyone to take me. I only had three days left before the flight, and when I did find someone to take me, he didn't show up. In the end, we had to change the flight to the following week.

In the meantime, we heard aunty was out the hospital and doing better, but was unable to speak properly. I had a strong feeling aunty was going to get better, therefore I wouldn't have to put myself through the unnecessary trauma. The trauma of having to put up with aunty's insults, once I showed up at her house uninvited. My cousin and I had a good laugh, when I told her how aunty's speech would

probably instantly return the moment she saw me. Even though the flight was changed, I still didn't feel good about leaving, especially because I was already in a stressful situation.

I just couldn't shake the inner feeling I had, which told me not to go to Jamaica, especially because I had no idea where I would be living when I got back. I needed to sort myself out first before I went anywhere, and so I was very ambivalent about the whole situation. I had four days left before my new travel date, and I was still unable to get a ride to Miami. My cousin had paid for the flight and had to pay extra to change the date, so I really didn't want her money to go down the drain.

At the same time, I wasn't happy at all about going in the first place, but I didn't want to disappoint my cousin. To make matters worse, my stepfather was waiting for me to call him back, but I tried to avoid making that call. I was nervous about him calling when I still had not made up my mind about returning to Boston, so the pressure was turned up. I didn't want to go to Boston or Jamaica, I wanted to stay in Florida, although I had no idea how that was going to be possible.

I decided to do the only thing I knew to do in such a predicament, which was to pray. I prayed and asked God to make it plain which direction I should take. I wanted God to give me an answer that very same day, and let me know if He wanted me to go to Jamaica or Boston. I also asked God to give me a confirmation, so that I knew the answer came from Him. Within the hour of me saying that prayer, my stepfather called, and left a message telling me it was important that he speak with me right away.

It sounded to me like something serious had happened, so I returned his call as soon as I played his message. Well, talk about making the answer clearer than day! My stepfather answered the phone and said, "Pat, I've been thinking about you coming to Boston,

and I know I told you to come, but I've changed my mind. As I sat in reflection, I realized my prayer had been answered, even though it was answered in such an astonishing way.

I was somewhat relieved after, but was still worried as to what door the Lord was going to open up for me, because I didn't want to go to Jamaica either. The following day, I received a call to inform me that aunty was doing much better, and beginning to say a few words. Shortly after, I got another call from my uncle who wanted to inform me that I no longer needed to go to Jamaica. Another female family member who already lived in Jamaica was recruited to care for her.

There it was, I wasn't going to Jamaica or Boston after all, so where in the world would I be going, was the million-dollar question. I felt bad that the money for the plane ticket was wasted because it was non-refundable, but at the same time, I was relieved. I had more time to figure out where my destination would be, which eased some of the pressure I was feeling. I continued looking for work in the days and spent my evenings sitting on the patio trying to find a solution to my problem.

I felt like I was in the wilderness surrounded by nothing but darkness with no glimmer of light. My hope eventually diminished, even though I tried so hard not to lose it. History was repeating itself - nothing to look forward too and unable to see a purpose for my life. I was facing the storm alone, fearing the unknown, with no way of escape. The only good thing that happened was being told the closing date for the condo was going to be delayed, which gave me even more time. I didn't have enough money to move anywhere anyway, which was the main reason behind my depression and fear.

I didn't have much food, but I did have my tea bags which was somewhat of a comfort. One evening as I sat in my depression, I went to make myself a cup of tea, forgetting I had no carnation evaporated

milk. Feeling miserable and down, I really didn't want to walk all the way to the store at the gas station to buy the evaporated milk for my tea, but I pushed myself and went. Halfway there, the rain began pouring down and I had no umbrella. Because it rained so hard, I was soaked right through to my underwear.

I continued to the store anyway in the heavy rain, hoping it would ease up on my way back, but it didn't. On any other day it would have been fun, since I usually enjoyed walking in the rain, but not that day. I took my clothes off at the front door, and before I could dry myself off properly, Rose called to see what was going on. I told her what had just happened to me, and let her know I would call her back after I dried my hair, but she insisted I wash it first and then dry it. I wasn't in the mood to do all that, so I told her I would do it in the morning instead.

By the time we were about to finish our conversation, my hair was nearly dry, but Rose still insisted I wash my hair that night. It was as though she felt something was going to happen. The last thing she said to me before we hung up the phone, was that I should go and do what she told me to do. To my regret, I didn't listen to Rose when I should have. My hair was tangled when I woke up, so I decided that as soon as I finished drinking my morning tea, I would go wash and blow dry my hair.

I walked into the bathroom and wondered why the automatic light didn't come on, but thought nothing else of it. When I put the kettle on to make my tea, it took me a few moments to realize the light on the stove didn't come on either. It wasn't until I looked at the breaker and wondered if something was wrong before it finally hit me. "Oh no, don't tell me the electric has been turned off - I should have washed my hair last night when Rose kept telling me too," I said out loud.

"My life can't get much worse than this," I thought. It took me a couple days to get in touch with my cousin's daughter to find out why the electric was turned off. Her only response was she didn't realize I was still in the condo. What made it worse was when she told me the electric couldn't be reconnected once it was off. Her only suggestion was for me to hurry up and find somewhere else to live. Having one disappointment after the other got me to the point where I was ready to throw in the towel, as the saying goes.

I wanted to give up, but something deep down inside me, kept me going. I had persevered for so long, and was trying my best to hold on through the struggle of just wanting to give up. "How much longer Lord are you going to keep me in this pit? I feel like I am in the grave and cannot get out, and each time I try, it seems like I am sinking deeper. I can't take this anymore, You have closed every door I try to open. I don't see a way out, and I have no idea why you are torturing me like this."

I thought about the hope I had given to so many other people, but had lost it again myself. As usual, I called my cousin Urceline when I was void of hope. She began praying for me as she always did, but I was too broken to even care. Such deep despair caused an inability to foresee a way out, neither could I see the point in going on. I had no intention of ending my life, because my belief in the bible which reveals hell as a place of eternal fire and torment, prevented me from even considering it.

The hell I felt I was experiencing on this earth would be nothing compared to what the real hell would be, so I figured if God was the one that took me, that would be better. So long as I had repented of my sins, accepted Jesus Christ has my Lord and Savior and my name was written in the Lambs Book of Life, I knew I would spend eternity in Heaven. Because I knew I was living my life trying to be obedient to God's word, I wouldn't have to worry about where I was going to spend eternity, so in my mind, I was ready.

Apparently, that wasn't God's plan for me, He still had work for me to do, and after my cousin prayed for me, I felt so much better, and my spirit was revived. When the called ended, I sat in reflection thinking about all the other times I had reached that point of no return. I realized that just as He did in the past, God once again put someone in my path to pick me up and keep me going. I tried to revive my faith, hope and expectation, because I knew without them, life seemed impossible to bear. I had to keep going even though the trials I found myself in, seemed to be overbearing,

I thought about when I was leaving Boston and I heard the Lord say, "I will bring you to a place where you will have to totally trust Me." Through the years since then, I saw how God's words had manifested. The Lord was my source and my provider - He provided places to live, food to eat, and clothes to wear, although I had no income. He did what He said He was going to do, and although I so terribly missed the independent life I was used too, I was still living, and never had to beg for anything.

After remembering these things, instead of complaining, I gave praises to the Lord because He kept me through it all. The Lord promised to raise me up and give me more than my mind could comprehend or expect, and I had to remember that God was faithful, and never goes back on His word. I knew that my experiences were making me stronger and better - my tests would be my testimony and my mess would be my message. From what I knew, God usually did not use anyone in a great way, who hadn't been broken.

Therefore, I knew the trials and adversities that had broken me, would pave the road to the many blessing that were in store. Through it all, I tried to keep a smile on my face, even though my heart still felt broken and shattered. Most people thought everything was okay with me, not knowing I was fractured on the inside. I tried to keep my spirits up, knowing that even though I had gone through so much, it wasn't going to be in vain. Good things would come out of all the

bad, so I tried to keep the faith and told myself that things would change when I least expected it.

Two days after my cousin prayed with me, I was still in a positive frame of mind, even though I only had four dollars to my name. I was hungry and decided to walk to the store and buy some snacks, but I waited until evening to go on this particular day. I didn't care about my appearance, so I lightly ran the comb through my hair, and quickly put on the first thing I could find. I knew I looked like crap, but I didn't care how I looked, it wasn't like I was going to meet the man of my dreams. I strolled along the edge of the canal as always, enjoying my observation of all the fish and turtles that dwelled there.

As I was about to proceed onto the main road, I heard footsteps behind me in the grass. I turned around to see what it was, not expecting to see a tall handsome Hispanic man walking towards me. I smiled and held my head back down as I continued walking, lost in my thoughts. All of a sudden, I felt a presence in front of me and when I held my head up to see who it was, it was the same man now standing in front of me, greeting me with a smile.

He asked if I was walking to the gas station, and then asked if I had a man. Usually I would have said yes, but that day, I said, "No, and I'm not looking for one either." My response didn't deter him because he then asked if I minded his company. There was something about him that prevented me from hurting his feelings by telling him no, so instead, I allowed him to walk with me. When other men asked if they could walk with me, I immediately made it clear I wanted to be by myself, not caring what they thought, but with this guy, it was different.

By the time we arrived at the gas station, I felt as though I had known him for ages. It was a lovely evening stroll, and I was enjoying every moment. The more I spoke with him, the more my spirit took to him, then I remembered something. I wanted to kick myself when

I remembered I looked like crap and was so embarrassed that I went out looking the way I did. It was too late to do anything about it, so I just went with the flow. When we arrived back to the complex, Michael wasn't ready for us to part ways, and asked if I would hang out with him a while longer.

After much deliberation, I decided why not. Michael definitely made me feel special that evening, as I sat with him in awe, thinking how only two days prior, I wanted God to take me. Yet, in the blink of an eye, on the way to the gas station, when I least expected it, I met a handsome Cuban/American male, who instantly transformed my sadness to joy. I had such a wonderful time with Michael and his roommate that evening, and didn't head back to the condo until midnight.

Although I felt ugly and knew I looked like a hot mess, he made me feel so beautiful, and for the first time in years, I felt as though I was on top of the world. I compared my experience to being caught up in a whirlwind, and landed on cloud nine. I had totally forgotten what it was like to be mesmerized, which left me in dreamy state of mind. Reliving those six hours we spent together, took me to higher levels of euphoria. Well, it didn't last long though, because reality crept in.

I was in no position to be thinking about getting into a relationship with anyone. I had to focus on my circumstance which would have been impossible to do, if I let Michael distract me from my priorities. That's what I told myself anyway. It sounded good in my head, but it didn't help, because I could not stop thinking about him. He didn't see me as I saw myself. I saw me as a hot mess, and yet he saw me as beautiful.

Early the following morning, I received a text message from Michael which read, "Good morning beautiful," and a few minutes later he sent me a picture of his fine self. Once he started texting me

throughout his day at work, I knew it was going to be a difficult task to get him out my mind, but I had too. I decided the best way to do that, would obviously be to not spend any more time with him. With that plan in mind, when he asked if he could see me when he got home from work, I told him I had things I needed to get done.

Trying to take a stand against Michael's beguiles were useless, considering the effect he had on me. He was humble, gracious, considerate, passionate, tall, and handsome, with a great personality and I was lonely and in dire straits. It didn't take much persuasion the following evening, when he asked if we could spend some quality time together, once he was home from work. The more time I spent with him, the deeper I fell. He was gorgeous and a great reminder that life was worth living after all.

His compliments were a cut above the ones I received in the past. He made me feel as though I could do anything, accomplish anything, and that was the type of person I needed in my life. But I never in my wildest dreams expected him to ask me to move in with him. I knew I couldn't, but the thought of it was so tempting. I had no intention of living with a man again unless I was married to him, thanks to mom's training and my determination to live a life pleasing to God. Plus, marriage was the furthest thing from my mind during that season of my life.

I didn't want to lose him, but at the same time I wasn't sure if he was even the one God had in store for me. There was only one way to find out, pray and ask God to give me an answer. I then asked the Lord to make it clear if Michael was the man for me, and if not, to bring the relationship to an end. I had to ask God to end it if Michael wasn't for me, because he swept me off my feet, so I was incapable of ending the relationship myself. Well, I always hear people say, "Be careful what you ask for, because you just might get it," and I most certainly did.

To my dismay, our relationship ended abruptly, just two days after praying to the Lord about it. His roommate was the cause of the breakup, and although I did ask the Lord to end it if Michael wasn't the one, or if the time was not right, I wasn't expecting it to happen so quickly. Needless to say, I was devastated and utterly heartbroken, especially because it happened a week before Christmas. I eventually got over it, trusting that the Lord knew Michael's heart, and could see what I couldn't, or that maybe the time just wasn't right, which it wasn't.

I had taken a little break from my problems for the short time Michael was in my life, but I had to return to the dilemma I was trying to avoid. I continued applying for jobs and managed to get an interview on New Year's Eve. I saw that as a sign and envisioned the new year was going to arrive with a blessing. I went for the interview with excitement and the belief that my situation was about to finally turn around. Things quickly changed once I sat in the waiting room and observed that all the other interviewees were teenagers.

What made matters worse, was when I went into the so-called interview. I was told it was only a briefing and not the actual interview, which was opposite to what I was told over the phone. The interviewer whom I didn't like, then told me if I didn't hear back from them within two days, it meant I wasn't chosen. Well, that burst my bubble of hope and expectancy, and as I stood outside waiting for Steve who was a neighbor to pick me up, I felt my head spinning as though I had a hangover.

The disappointment affected me so much that it left me disoriented. I stood on the sidewalk feeling devastated. I thought for sure I was going to leave that interview with a smile on my face. I never even contemplated I would leave there disappointed, so at that point, my mind felt as though it was blown. It turned out to be the worst New Year's Eve I had ever had. That year ended with me going

back to the doom and gloom mindset, being unable to envision brighter days ahead.

When the clock struck Midnight and I entered into 2016, I got on my knees and wept before the Lord. I told him everything I was going through, as if He didn't already know. I had gone through disappointment after disappointment, and was mentally and physically weak when I laid everything out to the Lord. I cried most of the night until at some point I finally fell asleep. When I woke up on New Year's morning, I didn't answer my phone when it rang - I was emotional and didn't want to speak to anyone.

I was in a dark place in my mind. Nothing I planned worked out, and nothing was changing for me no matter how hard I tried. Life seemed so unbearable and the uncertainty of what was going to happen to me was crippling. My circumstances were very depressing, and once again, I could not see my way out of the dark tunnel I found myself in. I had lost my appetite and wasn't even interested in drinking my cups of British tea. I just wanted to give up on everything and didn't have the strength or motivation at the time to keep going.

I was in a mental prison and unable to find the keys to come out. In the midst of this, I found myself humming a song, but couldn't remember the name of it. The following morning, I woke up from my sleep humming the same song, and decided I wasn't going to stop until I figured out what song it was. In the past, whenever a song came into my spirit that way, I knew God was sending me a message, so I wanted to know what the message was. It was bothering me that I couldn't figure it out, so I hummed and hummed until the title of the song finally came to me.

It was, "He'll Do It Again" by Shirley Ceasar. I hadn't heard that song in a long time and couldn't remember the words, so I looked it up on YouTube and played it. When I listened to the words and realized they were exactly how I felt and what I was going through, I

began to weep. I knew then that the Lord was speaking to me through the lyrics of the song that follows. He was letting me know He was going to come through for me as He did in the past.

You may be down and feel like God

has somehow forgotten,

that you are faced with circumstances,

that you cannot get thru,

And right now, it seems like there's

no way out, and you're going under,

God's proven time and time again

that He'll fix it for you!

He'll do it again,

He'll do it again,

just take a look

at where you are now,

and where you've been.

Hasn't He always come through for you,

He's the same now as then,

you may not know how,

you may not know when,

but He'll do it again.

God knows the things

that you've been going through

and how you are hurting,

He understands just how your heart

has been broken in two,

He's the God of the sun, and

the stars and the seas,

He is our father,

He'll calm your storm

and He'll find a way

and He'll fix it for you …...

That was a message alright - the Lord wanted to remind me that He had come through for me in the past, and He was going to come through for me again. I meditated on that song all week, and every time fear tried to creep in, I played the song which strengthened my faith. I called my cousin in New York to find out if she had any news about the closing date for the condo, which was supposed to have happened on December 4th, but was pushed back. It was now January 9th, and everything was still up in the air, which left me in complete oblivion as to what was going on.

When she told me she had not heard anything from the lawyer, I felt a sigh of relieve. Knowing how she forgot to tell me things in the past, I was concerned that she would forget to tell me the new closing date when she found out. I decided to call the lady that was buying the condo instead, to find out if she had heard anything. When she

told me the association was delaying the process, I figured I would definitely have enough time to figure a way out.

I was trying not to panic as the days swiftly passed without foreseeing any form of a way out. I continued holding on to the words of that song, comforting myself by believing that God would not let me down, and everything would work out on time. I still had a gut feeling though, that the closing would happen sooner than I thought, and that time was of the essence. I knew in the past, God always waited until the last possible moment to show up to my rescue, but I didn't want that to happen this time around.

It was the morning of January 12th, when my cousin Stacey called and asked if I heard anything about the closing. She had never asked me that before, so my first thought was, "Oh no, I hope it's not today." I had a bad feeling when I hung up the phone with her, so I put the security lock on the front door. Not even an hour after our conversation ended, I heard someone at the front door trying to get in. I felt as though all the blood in my body had rushed to my head, as I slowly walked to the door, hoping it wasn't the new owners.

When I opened the front door, I saw an elderly gentleman and a young woman. "Sorry, this must be the wrong door," she said, and proceeded to make a call. I interrupted and asked if she was the new owner, but she looked confused when she confirmed that she was. "No one supposed to be living here, because we just closed on the condo this morning, and I was told the place was empty." She turned out to be the daughter of the woman who bought the condo, and I thought I was going to drop dead from embarrassment.

After explaining I was unaware the closing had gone through, she responded by telling me, I needed to be out by that evening. The man that was with her, told her to give me a couple more days, but she refused. She did however end up agreeing to let me stay until midday the following day, so I could make the necessary arrangements to

move out. Little did she know I had no arrangements, because I still had no idea where I was going. She called my cousin in New York and told her I was still there, to which my cousin responded that she told me the date of the closing.

So, my gut feeling was on point after all - I wasn't informed of the new closing date, after specifically telling my cousin to make sure she didn't forget to tell me when the new date was set. After the new owners left, I said, "Lord, its time now for you to do something, because as you can see, I have to be out by noon tomorrow." I kept remembering the message in the song and made up my mind to wait and see how my deliverance was coming this time around.

Shortly after the new owners left, Rose happened to call to find out what was going on with me. Once I filled her in on the new developments, without hesitation she offered to let me stay with her and her family. One thing I've always admired about Rose is she has never taken offense when I tell her exactly how I feel. When she first offered, I told her I wanted to be in a place where I would have peace and quiet, and that I had no intention of staying at her house with her and her noisy kids.

I was expecting the Lord to deliver me another way, but at that point I had no choice, and agreed to stay at her house until another opportunity came along. We arranged for her to come and get me the following morning, but when I hung up the phone, I was far from being happy. "This is how you delivered me Lord? by sending me to go live at someone else's house again, when I wanted to be on my own. The great God who is able to do anything, able to make a way out of no way, and this is the only thing you could come up with," I regrettably said in anger to the Lord.

I finally broke down and cried most of that evening, overcome by so many disappointments. Morrisa happened to call that evening in the midst of my breakdown, which was a surprise, because I hadn't

heard from her in a while. She too wanted to know what was happening with me, but as I filled her in on my drama, she found a way to make me laugh as usual. She was so happy that I was going to be living close to her, but I on the other hand was far from being happy to be headed back to South Miami.

Here I was having to move back to an area of Miami I did not want to be, and every time I thought about it, I burst into tears. Even though I had no electric at the condo in Sunrise, I was sure I would be happier where I was. I took my last cold shower, charged my phone in the laundry room, and sat in my chair on the patio gazing at the stars for the last time in that condo. I thought of the memories I accumulated during the year I had lived there, and wondered what the future had in store for me.

Chapter Twenty-Seven:

Open Doors

As the saying goes, "Don't judge the book by its cover." Sometimes you might be pleasantly surprised by whats inside. In my case, I was judging what my new living arrangements was going to be like, before I even got there. But I didn't know it was going to be a pathway to my deliverance.

Morning came and I only had a few hours left to enjoy my peaceful and quiet surroundings. I was making the most of the little time I had left, just taking it all in, when Rose called to let me know she was on her way. I never thought to inquire what her fiancée had to say when she told him I was coming to stay with them, so I call her back to find out. I couldn't believe she forgot to tell him something as important as that, so I became even more uncomfortable about the entire situation.

After asking if it occurred to her that he might not agree to me staying with them, especially because they didn't even have enough room for themselves, she nonchalantly told me she would tell him later when he finished work. "You mean later when he comes home from work and sees that I have already moved in," I questioned. I met her fiancée, Sean back in 2008 when Ken introduced us. We hit it off right away and a few weeks later he brought me home to meet Rose.

Rose and I took to each other the moment we meet, and our friendship grew stronger and closer over the years. Even though that

was the case, I knew they barely had enough room for themselves and the kids, never mind adding me to the equation. Rose told me not to worry about it, and that she would call Sean at work and let him know I was coming. I just felt so uneasy about the situation, but knowing it was the only door that had opened for me at the time, there was basically nothing else I could do about it, so I decided to go with the flow.

Rose arrived about eleven o'clock, and helped me pack everything into the car, except for one big box. We took it over to my neighbor Steve, so he could keep it for me, until I was able to return and get it. I walked around the grounds and to the canal one last time before I got into the car. It took everything out of me not to cry when we pulled out of the parking lot. I felt an overwhelming sadness, while Rose was rejoicing that I was finally moving back to her neck of the woods.

I was going to miss the neighborhood I was leaving - it was clean, very quiet and safe, and never once did I hear police sirens. It was safe enough that I could walk and sit by the canal any time of the night I wanted. I was going to miss all that, and although I had a smile on my face, I was totally broken on the inside. About ten minutes into our journey, Morrisa called to see if I had left out yet. When I told her Rose had not informed Sean that I was coming, she suggested I come stay with her instead.

I didn't even have to think about what my answer would be to her offer, when I quickly agreed. I told Rose about my change of plans, although she heard the conversation for herself. Rose was very cheerful as she turned the music up in the car and started singing along. I on the other hand tried my best not to dampen her joy by bursting into tears. Our journey that should have taken one hour, ended up taking us three, after stopping along to the way to buy food and coffee. For a while there, I actually forgot about the predicament I was in, and enjoyed myself.

Once we entered Miami, my only thoughts were, "life has I had known it, is about to drastically change." Rose decided to stop at her place first for a few minutes, which turned out to be a few hours. As we listened to music, and drank glasses of wine, my predicament hit me like a blow to the head, and that's when I finally broke down. Rose tried comforting me by telling me everything was going to work out fine, but she couldn't understand what I was feeling inside, so I didn't bother trying to explain.

With excitement in her voice, Morrisa kept calling to find out why it was taking so long for me to get to her home. When I told her that I was hanging out with Rose and would be there in a bit, she insisted I hurry up. Morrisa and her children had not seen me in two years, so they were anxiously awaiting my arrival, and complaining that I was taking too long. It was comforting to know I was loved, but it didn't change the fact that I still wanted to be by myself. Sean arrived home from work and was surprised to see me, not having the slightest idea that Rose had planned to move me in without his knowledge.

We were sitting on the patio in front of the house in deep conversation, discussing the trials of life, when Morrisa called again, telling me to hurry up. I sat there listening to Rose while observing the sunset, wishing I could delay the inevitable. Rose and I were enjoying the vibe, but it was time for me to leave. Rose wanted me to stay a little while longer, and so she suggested I have another drink with her before we left out. As I gathered my things and told Sean goodbye, I slowly walked to the car dreading the unknown which laid ahead.

Morrisa had waited five years to get the townhouse she had recently moved into. It just so happened that the town house was approved on the original date that was set for the closing of my cousin's condo. I had no idea what her neighborhood was like, as it slipped my mind to ask, so I was very anxious to find out. When Rose and I arrived close to the address Morrisa had given us, I saw that the

streets were quiet, clean and lined with newly built townhouses. From the aesthetic view of the neighborhood, I figured it wasn't going to be as bad as I thought.

Following the directions from her GPS, Rose then passed all the new townhouses and made a turn into a complex off the main road which looked like the ghetto. I told Rose she had made a wrong turn, but she insisted the GPS was right. I was convinced the GPS was malfunctioning, while insisting she had made a wrong turn. Rose was determined to keep going when I was telling her to turn around. I told her it couldn't possibly be the right turn, because we were in the ghetto, but she just laughed.

I refused to believe we were heading in the right direction, thinking at the time there was no way the Lord was sending me to the ghetto to live. Rose continued driving and told me to check for the house number. I decided to call Morrisa instead, so I could prove to Rose we were in the wrong neighborhood. The moment I started dialing her number, I happen to look up and saw Morrisa and the kids standing in front of their door with excitement written all over their faces, as they waited for me.

After I thought for sure I was going to have a heart attack, my second thought was, "I've died and gone to hell." I instantly went into the state of shock, and said to Rose, "There is no way I'm going to live here, no way in hell." Morrisa was standing there with a big smile on her face and couldn't wait for me to get out the car. I didn't want to get out the car, and at the same time, I didn't want Morrisa to see how disappointed I was. I was surprised though to see how much the kids had grown, when they ran up to the car to greet me.

I tried very hard to put a smile on my face and look as happy as they were, even though I was so upset. When I finally got out the car, Rose, Morrisa and the kids eagerly began unloading my luggage. They didn't waste any time taking all my stuff inside the house, and I

didn't have to end up doing anything. I was too stunned to move a muscle anyway, so it all work out for the best. Kendrick who was seven years old at the time, took my heavy suitcase inside by himself, and Sa'Naria, who was only five years old, took my other heavy bags with ease.

Sa'Naria was the five week old baby I was left to babysit on the second day after moving into Ms. G's house. She had been in my life ever since, but I hadn't seen her since I came back from Jamaica, so it was heartwarming to see how much she had grown. When all my things were in the house, Rose stayed for a few minutes before she decided it was time to head back home. When she hugged and kissed me goodbye, she whispered and told me not to worry, because everything would be all right.

After Rose left, Morrisa showed me around and took my things into the room I would be sharing with Sa'Naria. She and the kids were so excited as they were all trying to talk to me at the same time. I wanted to know if she had a back yard, so she opened the patio door to show me. We ended up staying out there for a while talking, when we were interrupted by the kids. Kendrick came and gave me a hug and said, "Thank you, Hilary." I asked what he was thanking me for, and when he said, "Thank you for coming," his words melted my heart.

After telling me he loved me, Sa'Naria came next and asked me how long I was staying. When I asked her why she wanted to know, she also melted my heart when she said, "Because I want you to stay for a long time." They both deeply touched my heart that night, which helped to ease my inner pain. That was until Morrisa told me there were two shootings on the street the night before, as well as informing me that the police had to circle the neighborhood on a regular basis because of the crime. I thought, "That's it, it's time for me to leave.

We sat outside talking for hours before everyone went to bed, except for me. I stayed outside in the back yard for a while, trying to accept my new predicament. I sat there saying to myself, "I'm in hell, and by the looks of things, I don't see how I will get out of here any time soon." I went on to question the Lord again and ask, "Is this Your great deliverance? And why are you torturing me like this?" I sat outside trying to figure a way out, because the only thought that circulated my mind, was that I needed to leave as soon as possible.

All sorts of negative thoughts ran through my mind that night. I tried my best to console myself but I was unsuccessful. Instead, all I could think was negative thoughts; "My life can't get much worse than this, because I'm living in hell. I'm in a neighborhood I never in my wildest dreams thought I could ever end up in. I'm not supposed to be in a place like this, I feel like I'm in a grave. I've reached the lowest of the lowest, and I'm at the point of no return. I'm in the middle of nowhere, so how is change going to come?"

Suddenly, I heard a voice in my head say, "When you write the book." Could this be the reason why nothing has come through for me? Is this the reason I am suffering, because I never wrote the book?" I questioned myself. I then remembered all the times in years past, when my friends told me I needed to write a book because my life was like a soap opera. I also remembered when I was still in Boston and seeking the Lord for direction, I heard that voice in my spirit telling me things would change when I wrote the book.

Although I had started it years ago, I put it down because at the time, I had no intention of sharing my personal business. I figured it wouldn't get published anyway, so what would be the point. After remembering the board member who asked why I was being obedient when God told me to write the book and yet I had not done it, it got me thinking. I was in deliberation for a while before I came to a conclusion. If writing the book was how my breakthrough would come, then I had no intention of putting it off any longer.

That night was the first time I took writing my book seriously. I then decided the quicker I got it done, the quicker my ultimate deliverance would come. Knowing that when God said something, it comes to pass and that His word never goes void, gave me the confidence I needed. I knew then that writing this book would not be a waste of time, because something great would come out of it. At that point, I no longer had any shame in my game. If I had to share my personal business with the world, then that's what I was going to do.

It was in that moment I realized it would have been impossible to give hope and bring healing to others, if I wasn't willing to air my dirty laundry and lay myself bare. I was no longer ashamed, and if writing the book was what I needed for my circumstances to finally change, then that was what I was going to do. I went to bed that night feeling very optimistic - instead of shedding tears, I was smiling, because I had something wonderful to look forward too. The dark clouds disappeared that night, allowing rays of sunlight to shine through.

Before Morrisa left for the store the following morning, I gave her twenty dollars to buy me a flash drive, so I could get started on my manuscript right away. The more I thought about what I was going to write, the more everything started to make sense. If I had not gone through all the trials, heartbreaks, disappointments, rejections, etc, I wouldn't have had any basis for giving hope to others. If the Lord had opened all the doors I wanted Him too, I wouldn't have ended up at Morrisa's which finally paved the way for my willingness to work on my book.

I was basically now in a place where I had no choice but to do what the Lord had told me to do years ago. I was finally at peace once I understood why I went through all I experienced. I was now able to focus on the task at hand, while foreseeing a brighter future ahead of me. I started to see things in a different light. Although I didn't like

the neighborhood, I decided to count my blessing and be happy because the house was clean, and I was comfortable.

God delivered me again, right in the nick of time, and instead of giving thanks, I complained, so I asked God to forgive me. I was busy complaining because my deliverance didn't come the way I wanted, but God knew best. God saw the bigger picture, even though I couldn't see anything at the time. God had to totally break me, so He could mold me like a potter molds his clay. This was where God wanted me to be, so I could continue to fulfill His purpose for my life.

Being the stubborn person that I am, it took all of what I went through, to get me to the mental state in which I finally arrived. Everything started to look brighter, and I could finally see blue skies and sunshine at the end of my dark tunnel. With excitement, I began typing and saw it has my day job. I got up early every morning and sat for hours each day in the back yard and worked on my project. The more I wrote, the more I believed that this book would help and touch the lives of people around world, which was my motivation to see it through.

After five months of living at Morrisa's, I got to know most of the people living on the street, all of whom were friendly, both the young and the old. At first when I would go for walks, passersby would stop and speak to me, asking where I was from. I was told many times, that I didn't look like I belonged in that neighborhood, so I would say I was just passing through. It turned out not to be so bad after all, and from the night I moved in, there were no more shootings.

Whenever I took a break and sat in the front of the house, people always came over to talk when they were passing by. Most of the time, they came to tell me about their problems, for which I usually gave a solution. Morrisa complained that my friendliness was attracting too many people to her front door, and so she tried to insist I ignore everyone that wanted to speak to me. She refused to

acknowledge anyone that greeted her at first. She ignored her neighbors, and it didn't faze her one bit when I told her how rude she was.

Eventually, Morrisa followed my example, and began talking to everyone. She even started doing the neighbors hair and allowed her children to play with other kids on the street. If I didn't see it for myself, I wouldn't have believed her change in attitude if someone else had told me. So many things changed in that household, and it wasn't until they did, that I realized I was there for a reason. I shared many life lessons and life skills with Morrisa and the kids, and they taught me a lot too.

We were a blessing to each other, although I was the bigger blessing, because Morrisa was free to leave when she wanted too, knowing she had a live-in babysitter. She sure took advantage of it too, because sometimes when she left, she didn't even tell me. I only found out when I was looking for her. We all had so many fun times together, so it turned out that life in the hood, well that one any way, wasn't that bad after all.

Although I finished the first draft of my manuscript the by the end of June, getting the editing done was next to impossible once the kids where home from school for the summer holidays. Instead of going to their mother when they wanted something, they always came to me, so with the continued distractions, I was unable to focus. Kendrick and Sa'Naria saw me as their second mother, their toy and their playmate. From the moment they woke up in the mornings until they went to bed at night, they bothered me none stop.

It became such an impossible task to do my editing with the kids around. I ended up telling the Lord that if He really wanted me to finish, He needed to provide some place else for me to go for at least six to eight weeks, where I would have peace and quiet. The summer flew by so quickly, and by the time October came around, I had a

strong feeling in my spirit. I couldn't shake the thought that the years of trials and tribulation I experienced, would come to an end, after October 31$^{st.}$ That date marked seven years since I had been going through what seemed like pure hell.

Because the number seven means completion, I was convinced that November 1st, would be the start of a new beginning for me. Well, it just so happened that Maria, whom I met on a prayer line a few months prior, was going on a six-week vacation to Italy with her parents. She called and asked me if I would house sit and take care of her dog Chevy while she was away. Not realizing she didn't have to convince me, she tried to entice me by telling me it would be a good opportunity to finish working on my manuscript.

I didn't hesitate when I agreed to house and dog sit for her, because I knew the Lord had answered my prayer. Maria informed me she was leaving on November 8th, but she didn't tell me what date she wanted me to come. I was then totally convinced my tribulation was coming to an end, when she said I should come any time after October 31st. I could finally see the light at the end of the tunnel, and in this case, the light was very bright.

I left for Cape Coral on November 7th, and met Maria for the first time when she picked me up at the station. We were strangers, but sisters in Christ, which was the only reason Maria was comfortable with leaving a total stranger in her home. I had no apprehension at all because I knew without a doubt it was the Lord's doing. Maria made me feel very welcomed, and even bought me a welcoming gift which was a very nice perfume bottle, that was gift wrapped.

I was given one of the guest bedrooms which was very cozy and inviting. I felt quite comfortable in her home, and looked forward to the time I would spend there. When I woke up the following morning, Maria had coffee brewing. After I got dressed, she made me a cup of coffee and put the television on, so I could watch the morning news

whilst she left to take her son to school. When she returned, she told me to put my leggings on because we were going to exercise.

I was not in the mood to exercise, but she insisted I come with her. She put the pink bike she bought for me to get around with in the back of her SUV, and told me we were going to the park. That was where she and her dog Chevy took their daily two-hour walks in the mornings. While they walked, I was having fun riding the bike, feeling like a kid again. On the way back from the park, she drove around to show me the neighborhood and where everything was.

Maria wanted to make sure I knew where to go when I needed something. I realized then that except for the Dollar General and the gas station, every place else was way too far to get to by riding the bike. Thank God Maria had told her neighbors across the street that I would be there, and had asked them to take me to the supermarket when I needed to go. If she hadn't done that, I guess I wouldn't have been able to go to the supermarket, because I had no intention of riding the bike that far.

Before I arrived, Maria had suggested I start looking for work in Cape Coral, so I could go on interviews while I was staying there. She had proposed that if I found a job, I could rent one of her rooms until I got my own place. But after seeing the place for myself, I realized traveling from one place to the next would be difficult without a car. Anyway, I decided that once I was finished with my manuscript, I would send my resumes out and see which door if any, the Lord would open.

That evening, while Maria went out to run errands, I stayed so I could relax. Upon taking another tour of the house, I noticed she had a very quiet parakeet. I asked Maria if the bird was always that quiet to which she replied that he did chirp sometimes but most of the time he was quiet. I then asked if she allowed the bird to fly around with Chevy in the house because I noticed the top of his cage was left open.

I found it odd, when she told me Chevy did try to catch the bird sometimes, but she didn't think he would actually hurt him.

Morning came around and Maria was ready to leave for her six-week vacation. Before she left, I observed as she went to bird cage to tell the bird named Blue, goodbye. After speaking to Blue, Maria turned around, looked at me and said, "Look how beautiful Blue is, I love him so much." She then gave me a number to call in case of an emergency, and then she left. I felt such a sigh of relief when Maria closed the front door behind her. After ten months of living with Morrisa and the kids, I was finally on my own again, in serenity.

That evening I took Chevy for a walk, after which I decided to relax on Maria's large patio enjoying the view around me. I was sitting there enjoying the quietness, and the warm evening breeze when suddenly, I heard the bird making noise. I thought to myself, "Wow, he's really loud," but thought nothing else of it. While the noises continued, I said to myself, "Maria said the bird is quiet, so I wonder why he's choosing to be so noisy when I'm here." The light bulb finally turned on in my brain when I realized those noises where actually sounds of distress.

I jumped up out the chair and ran to the area the bird cage was located, to see what was wrong. I then stopped in my tracks from astonishment at what I saw. Bird features were everywhere - it looked like a bird massacre. All I could see were feathers, but no bird. I thought for sure Chevy had eaten the Blue, which not only traumatized me, but left me in fear. How was I going to explain to Maria that Chevy ate her beautiful bird, just six hours after she left.

It wasn't until I went to grab Chevy and put him in is cage, that I realized he was standing over Blue. "Oh my gosh, you killed Blue," I shouted. Blue was lying on his back lifeless, and I felt as though my heart moved to my stomach when I saw him. I stood there wondering if it was the state of shock that I was in why Blue looked like an egg

to me. Something wasn't right with his appearance, but I couldn't figure out why.

I can't even explain the turmoil that was going on inside me. I was so afraid, as I stood there saying, "Lord, please don't let the bird be dead - Maria was just saying how beautiful her bird was this morning before she left, so Lord, I'm begging you please don't let the bird be dead." I put Chevy in his cage and went back to Blue, trying to build up the courage to pick him up. Other than Max and Fluff, I avoid having to pick up anything dead - so I was traumatized at the thought of not only having to pick him up, but having to bury him too.

As I stood over Blue looking at him in total despair, all of a sudden, he jumped up and started running. What a relief I felt, but I was still puzzled as to why he looked like an egg with legs. It wasn't until I finally caught Blue that I realized he looked like an egg because all his feathers, including his tail feathers where missing. So, it turned out that just six hours after Maria left, her beautiful Blue, looked like a miniature plucked chicken. "Oh my gosh," I said again, "Maria is going to have a fit when she gets back and sees her bird, and of course it had to happen on my watch."

My stomach felt as though I was on a roller coaster that night, because I was so afraid Blue was going to die. After praying for Blue every ten minutes, I kept going back to his cage to see if he was still alive. The continued fear of Blue dying even after I went to bed, prevented me from going to sleep. The fear was crippling me, and I needed it to stop. I knew if I was praying with real faith, I would be confident my prayer would be answered and I could be at peace, but I wasn't.

I knew I couldn't continue through the night with the feeling of dread that enveloped me, so I prayed again. This time with faith, believing that God would answer, and that Blue would recover from his traumatic experience just fine. I knew prayer changes things, but

it wasn't going to change anything if I didn't believe. I was at peace after my last prayer - my fear dissolved, and my stomach stopped turning. I decided to believe without a doubt, that Maria's beautiful bird, who had no feathers or tail, would recover from his attack and his feathers would grow back before she returned home.

I was able to go to sleep feeling a sense of peace, so when I woke up the following morning and remembered Blue, I jumped out the bed and ran to the cage. To my surprise, Blue was standing on his perch eating his food. During the days that followed, Blue seemed to be happy. He was probably a bit chilly when the air conditioning was on, but apart from that, all seemed to be well with Blue. Thank God nothing else dramatic happened, except for the day I took Chevy to the store with me, and unbeknownst to me, he chewed his leash off while we were walking.

When the leash snapped, he took off in the store parking lot headed for the busy main road. My heart skipped a beat a few times when I saw what was about to happen. Chevy was headed into a head on collision with one of the speeding cars. No matter how much I called out to Chevy to stop, he refused to listen. I didn't want to chase him because he would have just got hit sooner, so in the midst of my panic, I called out to God. I begged God to make Chevy stop, because only He could have stopped him at that point from getting killed.

There was no way I could let Maria come back to a featherless bird, plus tell her that her dog got hit by a car. Right when Chevy ran off the sidewalk into the traffic, I shouted out, "God, please do something." Within an instant, Chevy made the quickest U turn I ever did see. He ran so fast towards me, but then ran right pass me straight into a pole and hit his head. I couldn't stop laughing because it was such a funny sight to see. Chevy was disoriented for a moment as he stood in the same spot, shaking of the pain which gave me enough time to grab him.

After I took Chevy home that day, we went for walks around the neighborhood, but never back to the main road. Luckily for me, I had no other dilemma's during my stay, and was able to enjoy my tranquility. Blue's features grew back completely about one week before Maria returned, so that made me very happy. A few days before my six weeks came to an end, I finally finished the editing. When I was getting excited about being able to send the manuscript off to a publisher, I had a very strong feeling that I needed to read the entire thing all over again.

While proof reading, I was also searching for jobs, but nothing was available close to where Maria lived. I was disappointed because I didn't want to go back to Miami, since nothing was happening for me there. I was convinced though, that if God didn't open a door in Cape Coral, He would open it someplace else. I had strongly believed that something good was going to happen for New Year's 2017, even though I still couldn't see any open doors. I was trying keep my faith alive and continued to believe that my circumstance would start to change.

Well, when I least expected it, I got a call from Sylvia, a childhood friend from England. She lived in Nottingham where I was born, and I hadn't heard from her in years. Just three days before Maria returned, Sylvia called me through Facebook to tell me she was coming to America, and wanted us to spend some quality together. She was going to be in Ocala, Florida, which was somewhere I had never heard of before that day.

Sylvia was going to be staying with a friend of hers who she also knew from Nottingham. She was planning to stay for three months, and wanted me to join her when she arrived for New Years. I was hesitant at first, not wanting to go, but she insisted on us spending quality time together, so I agreed. She didn't waste any time making arrangements for me, because the following morning she called to confirm that she informed her friend I was coming.

The more I thought about it, the more I welcomed the opportunity of us spending time together like we did as kids. I hadn't physically seen her in nearly twenty years, so I looked forward to catching up. I needed her presence in my life, having someone from my childhood, would make a world of difference, I thought. All my special memories were coming back to the forefront, and I eagerly looked forward to her arrival. At that point I knew it wasn't God's plan for me to stay in Cape Coral, so I ended my job search there.

When Maria return, I told her what happened to Blue, but when she saw him, she didn't believe it was the same bird. She found it hard to believe that all his feathers were gone and had regrown within six weeks. She was convinced her bird died and that I bought a new one to replace him. It was a good thing I took weekly pictures showing Blue's progress, otherwise it would have been impossible to convince her it was the same bird.

I had planned to leave the day after Maria returned, but Maria insisted I stay a couple more days, so we could go out and spend some time together. Once I informed Morrisa I was going to Ocala after I left Maria's, she insisted I return for Christmas before I left to go anywhere. I could feel it in my spirit that things were about to change for the better, and I couldn't wait to see what the Lord had in store. Maria blessed me with so many gifts from Italy and new clothes she had bought, so much so, that I ended up leaving Maria's house with an additional suitcase.

I arrived back in Miami two days before Christmas and left for Ocala on December 29th. I didn't expect it to be so country, so I knew it was going to take a lot of getting use too. Sylvia came a few days later, and we had a lot of catching up to do. It was such a wonderful feeling spending quality time with a childhood friend, laughing and giggling as we did when we were kids. My plan was to spend a month with her, then go back to Miami, but God had another plan for me.

All I can say is, God truly did the unexpected, and works in mysterious ways, because on January 10th 2017, I was offered a position. The woman Sylvia was staying with got the application for me and told me to apply. It so happened that the position involved working with children and teenagers in a group home. Most of these children experienced some form of trauma through sexual abuse, neglect, loss, rejection etc., all of which had left them heartbroken, depressed and void of hope.

I began to see the manifestation of why people kept telling me that my experiences were going to be used for my ministry. I had to go through and experience certain things for myself, so I could be in a position to help, inspire and to give hope to others. My employment package included free living arrangements, so I didn't have to worry about where I was going to live. God had it all planned out ahead of time. He opened a door when I least expected, in a way I least expected, and through a person I definitely would never have expected.

He used Sylvia to come all the way from England to get me to the place He wanted me to be, so I could walk through the door he had opened for me. Although a new door was opened, it was a very humbling experience for me. This position was a definite down grade from the high caliber positions I became accustomed too, so I had a hard time adjusting at first. Once I bonded with the children and heard their heartbreaking stories, I realized I was placed with them for a purpose. Giving them hope for a brighter future was more important than my job title.

Chapter Twenty-Eight:
I Did My Best

We don't always get the desired outcome when it comes to reconciliation in relationships. So long as you have done everything you can to repair a broken relationship, just settle with the fact that you did your best.

Now, I have to tell you what else happened in the midst of the good things. I guess by now you have realized that once something good happens for me, there is always something that comes along to slap the joy right out of me - this time, it was aunty again. I got a call two months after starting my new job, to inform me that aunty had another stroke. Shaun happened to arrive on his vacation in Jamaica a few days after it happened, and called to tell me that I needed to come right away. He informed me that the verdict wasn't good and that no one there thought aunty would pull through this time around.

My passport needed to be renewed, which was something I kept putting off, but I made sure to take care of it after getting the news. I began looking for flights in the hopes my passport would be back in time, but for some reason, I held off with purchasing a ticket until I actually had the passport in my hand. That being said, I also wanted to make sure aunty would receive me with open arms, before I went through the hassle it would take to get there.

I called one of my cousin's and asked her to call aunty for me. I wanted her to test the waters, so to speak. Basically, her job was to find out if aunty would be willing to speak with me before I called.

When my cousin called aunty and told her I wanted to speak with her, I guess aunty thought I was on the line, because she hung up the phone. My cousin immediately called aunty back to reiterate that I wanted to talk to her, but aunty made it clear she did not want to speak with me.

Everyone who tried to persuade aunty to speak with me, were unsuccessful, as well as appalled at her unwillingness to make peace. I was heartbroken again to say the least, but this time it felt severe. It was heart wrenching enough to be losing the only parent figure I had left in this world, outside of my stepfather, but knowing she might die and still refuse to reconcile was devastating for me. I couldn't comprehend how someone who once told everyone I meant the world to her, could now be so unforgiving and bitter towards me.

I thought my world had fallen apart when mom died, but mom and I had a very loving relationship. I can always take a trip down memory lane and smile when I think of mom and the wonderful memories she left behind. Although I was in total despair after she passed, we were at peace, and I had no regrets. But that wouldn't be the case if aunty died without reconciling with me. I wanted to believe there was no way aunty could leave this world and not make up her mind to forgive me, for whatever it was she was upset about.

I was in torment over it, which in turn caused a loss of appetite and inability to sleep. I tossed and turned in bed every night in agony of the thought that aunty may die without us making peace. My heart wept, and left me feeling as though it would be impossible for me to get over the heart break, if she died and we didn't reconcile. To make it worse, Shaun sent me a video with him and aunty sitting outside in her front garden talking. Not only was I jealous, thinking that should have been me, but it left me with an unexplainable sadness.

My spirit was greatly disturbed knowing aunty was speaking with everyone else but me. I couldn't get over the fact that aunty and daddy

had been there for my birth, helped to take care of me, and treated me as their own, yet she turned on me the way she did. I wanted so badly to speak with her, even if it was to just hear her voice one last time. Shaun called again a couple days later, to tell me aunty wanted him to read some scriptures to her, but he didn't know what to read, so he asked for my suggestions.

I was given some solace at least, knowing I was able to pick the scriptures I wanted her to hear. One of which was about forgiveness, but apparently, she still chose to harden her heart. She still refused to forgive, and in fact verbally stated she would never forgive me. Even though she was told if she didn't forgive, God wouldn't forgive her, she still refused. The following day, I received another call from Shaun. This time it was to tell me aunty was not speaking, and so he insisted I come right away, even if aunty didn't want to see me.

The following week on April 9th 2017, a cousin called and gave me dreaded news. "Aunty died today at noon." I was unable to speak because the news hit me like a heart attack, instantly causing my entire body to feel numb. My mind couldn't accept that aunty had gone without us making up. After the first call, other calls seem to come in simultaneously, but I didn't want to speak with anyone other than Bev. She was the only person who thoroughly knew the relationship between aunty and I, and how much aunty meant to me. She alone understood the pain that penetrated my heart.

That night, I sat in tears as I thought about my life and the major role aunty and daddy played in it. I thought about all the happy memories I had with them as a child and teenager growing up in Nottingham. I thought about how much I loved them and how important they were to me. I thought about how much daddy loved me, how he never let me down, and how he cherished me right up until the end. I thought about how much aunty broke my heart, and how my hope for reconciliation was lost forever.

When I did start accepting calls, everyone wanted to know if I was going to the funeral. It was something I thought long and hard about. I kept thinking, "If she didn't want me there when she was alive, why should I go now she is dead." The passport came in enough time for me to book the flight, but after a long deliberation, I decided not to go. I wanted to see aunty when she was alive, and I knew that going to see her lifeless body in a coffin, and being placed in the grave, was something I would keep reliving every time I thought about her.

I choose to remember aunty the way she was on the day I last saw her - sitting on her bed asking me where I was going. Aunty was the only loved one I had, whose passing caused grief to my entire being. I still can't get over the fact that someone who was so important and dear to me, ended up treating me the way she did. What has made it even worse, is the fact that she still chose to be stubborn down to the very end, and left me without making peace.

I will forever be indebted to Bev. Had it not been for her, I wouldn't have gotten the chance to go to Jamaica when I did, so I could see aunty for the last time. Even though the trip didn't turn out as I had hoped, God through Bev, gave me the desire of my heart. The desire to spend quality time with aunty before she died. If aunty had died without me being able to spend the time with her that I did, although she treated me so unforgettably, I would be living my life with regret.

A few years have passed since aunty's death, and I am now somewhat at peace knowing I tried my best. I found out she did end up leaving me and my uncle something, but the house and everything else, was left to Collin. When I say everything, I mean everything. The house and all its contents, along with whatever was left in her bank accounts, minus what she left for me and my uncle. Up until this day, my uncle and I never did get what was left for us. All of the things that were sentimental to me which I owned since I was a child, Collin now has. That alone is heart breaking enough, but I have to

look at it as just material things, which none of us can take with us when we leave this earth anyway.

I'm still deeply saddened whenever I think about aunty, and how our relationship ended. I don't believe I have fully mourned her though. I think as a coping mechanism, I tend to block out the memories when they come to the surface, so I won't feel the pain. I don't know if I will ever be at peace with the outcome, but aunty will always hold a special space in my heart. Aunty and daddy provided some of the happiest times in my life, and for that, I will be forever grateful. I'm still hurting because of how aunty treated me towards the end, but as mom said before she passed, "Time heals all wounds."

Chapter Twenty-Nine:

Reflections

In school, you're taught a lesson and then you are given a test, but life will give you a test that will teach you a lesson.

Over the years, during my quiet times in reflections of life, I have reflected not only on my own, but also the lives of others, both near and far. In deep thought, I have reflected on some of my own traumatic experiences, or of people I knew, stories I was told, as well as what I have seen on the news media, or read in articles. In conclusion, I have discerned that every human being on this earth has at least one thing in common, we all experience some form of heartbreak or trial on our journey through life.

For some of us, the trials we experience sometimes feel like an uphill battle. When we climb up and think we are about to reach the top, there goes a stumbling block that causes us to fall right back down again. At times it gets so hard, so much so, that you feel like just giving up from the intensity of the situation. But what I have observed, is that no matter what age, ethnicity, class, or creed, we all experience some heartache, and no one is exempt.

Something else I have observed and learned during my journey, is that some of us tend to observe other people and think their life is so great. We think they have everything and are so happy, but are they? We see the outward man or woman, but we don't see what is going on in the inside. Take the rich and famous for instance, many people say they wish they had their favorite actor, actress or singer's

life, but they have no idea what that person is struggling with. They have no idea how unhappy that famous person might be, even though they have what seems to be everything.

Some of them have no peace, or real happiness, or are sick and no amount of money they have, can cure them. Many have been so broken that they have taken drugs to try and drown out their sorrows, and have overdosed and cut their life short before its time. It would be very foolish to think that there is any one on this earth, whether great or small, that leaves this earth without ever facing some form of adversity.

Some people do have it worse than others, because some people experience horrendous situations. So, having said that, we should never think anyone who walks this earth, has a life without some sort of distress. It could be something horrific, or something like rejection or a divorce. Some people have returned home to find their partners in bed with someone else, or a partner telling them they are no longer attractive, and no longer wanted.

It could be the loss of a house that a person has worked so hard to buy, and then some unforeseen circumstance, causes them to lose it. It could be that a loved one ends up in prison, or a child comes home and gives their parents distressing news. It could be that someone goes to the doctor for a regular check-up, and finds out they have cancer, or some form of incurable disease.

Whatever the circumstance, we all experience something that is very hard to deal with. At some point and time, we have or will experience some form of distress. Sometimes it's unforeseen, sometimes it's inevitable, and sometimes we cause it on ourselves, because of lack of wisdom. There are so many circumstances some of us could have prevented, but didn't, because we made a bad choice. If that be the case, we have to learn from our mistakes, and make better choices the next time around.

I asked a few of my friends and family a question, "What is the greatest lesson you have learned during your life's journey so far?" I received many interesting answers, but the answer I received from Rose, stood out above the rest. "We are all teachers and students at the same time - What are we learning and what are we teaching others?" Her response caused me to pause and think for a moment, because her answer was deep, and it was so true.

As I absorbed her statement, I realized it was basically what I was doing with this book. I have been taught so many lessons as a student on this road called life, and I have used other people's experiences to guide me from making the same mistakes in my own life. Now I am sharing some of my most valuable lessons learned, as well as observations, with the hopes that everyone who reads this book, can take some of these lessons and apply it to their own life.

We all have to walk this journey called life, even though we are headed in different directions. We have different experiences, but we all have learned and taught something to someone. It's like a circle, a continuum; we are forever learning and sharing our knowledge with others, whether it be good things or bad. This is why it is important to operate in wisdom, because without it, people suffer.

Having wisdom is a distinctive attribute to one's character, and one of the utmost importance. Wisdom or the lack thereof, can be the difference between life and death, success and failure, or victory and defeat. One who is wise is cautious and turns away from evil, but a fool is reckless and careless. (Proverbs 14:16 NKV) Those of us that have wisdom and use it, not only are usually successful in life, but live a long life.

Lack of wisdom has caused the death of many, both young and old. Fools despise wisdom and instruction, and all who have failed to follow instructions, such as that of a wise parent, but instead allow friends to entice them into wrongdoing, destroys their own lives.

Consider those that have decided to commit a crime such as a robbery for instance, who allowed themselves to be enticed by their peers to rob someone's house, not knowing that the owner was home.

Thinking they were going to get away with the crime, not knowing the owner was hiding with a gun, and that they were going to leave that house in a body bag or end up in prison. A wise person when tempted to do wrong, thinks about the consequences of their actions. They make the right decision, which is always to do what is morally right, because using wisdom and discernment can prolong a person's life.

A wise person doesn't drink, get drunk and drive. One who lacks wisdom, drinks, gets drunk and drives, and many times ends up either killing themselves and innocent people. A person using wisdom thinks before they act, and if they know they are too drunk to drive, they just don't, even if it means walking ten miles home. The sad thing is, drunk driving which ends in fatality, happens just about every day around the world, because so many people lack wisdom.

There are some proverbs which I try to live by. My favorites are: "Do unto others, has you would have them do unto you," because "What we sow, is what we reap." If you are kind to others, kindness will come back to you. The lesson to be learned here, is always do good to other people. Sometimes it will be total stranger, or someone you least expect, that does something good for you, when you least expect it, and need it. What you do for, or to others, is what others will do for or to you.

My other favorite is, "Action speaks louder than words." This is one saying that I make sure to remember on a daily basis. I'm pretty sure many of us have been disappointed because of taking someone at their word. Then we find out it was just that, only words, backed up with no action. If a person tells me they are going to do something for me and continues to tell me the same thing over and over, but

422

doesn't do what they say they are going to do, it would be foolish of me to keep believing them.

I have learned from experience to pay attention to what a person says, and watch to see if they are a person of their word. It also speaks volumes about their character - do they do what they actually say they are going to do, or are they just a talker? I find that when it comes to relationships, men and women tend to suffer heartbreak because of believing a partner's words, instead of observing their actions. In the past, I have listened keenly to male friends in conversation with one another, when they talked about women they had been with.

They would tell a woman everything she wanted to hear, yet they never returned her calls. Or they gave excuses as to why they never contacted the woman again once they got what they wanted. I've interrupted many conversations when listening to some of the comments my friends made, and asked why they deceived women that way. The response was always the same, "It was just so I could have sex with her."

A friend of mine called me crying because the father of her children had deceived her, by telling her she should save herself for him, because he was planning to settle down with her and get married. He never returned most of her calls, and when she did manage to get him on the phone, he always told her he was busy and would call her back, but never did. After many continued attepts to reach him, he finally answered and told her he was with his fiancée, which off course left her devastated.

The first words that came out my mouth was, "But you should have known he wasn't telling you the truth. He didn't show any interest, he never returned your calls, and you always asked me if I spoke to him, because he would never call you back." When I called him to find out why he did that, he told me it was pay back for the things she had done to him in the past. He also went on to say, "When

a man really wants a woman, he will always take her calls, even if he's tired, and he will always find time to spend with her, no matter how busy he is." I said, "Oh, Okay, I definitely won't forget that one." I knew that was something I needed to add to my lessons learned in life, so I would never fall into the illusion that someone wants me, when he really doesn't. So, once again, remember that actions speaks louder than words, and if you do, you will save yourself from unnecessary heartache.

Some of us tend to ignore the ones that adore us, adore the ones who ignore us, loves the ones who hurt us, and hurt the ones who love us. We must start making better choices in life, especially in relationships, because it consumes a great part of our lives. Life is just too short not to make the most of it. So, don't waste any more time settling for less than what you deserve. At the end of the day, and when you have come to the end of your journey, you will want to look back and say, "I have had a great life, a happy life, and spent it with the love of my life."

Procrastination is something else many people tend to do. Many times it causes missed opportunities, or a missed chance to prevent something bad from happening, which can also cause disappointments or heartbreak. When I asked my best friend, Beverly Jarrett, what important lesson she had learned in life, she said, "We tend to take time for granted, thinking we have enough time and continue to put things off, not knowing it could be our last chance. We tend to sometimes wait too long, then it's too late."

For instance, when my eight year old nephew, wanted to spend that weekend with me before he left - I put it off until the following weekend, because I was busy working on last minute details before my own move to Miami. At the time, I had no idea I would never get another chance to see him again. So, don't put off until tomorrow what you can do today, because tomorrow might never come.

I also asked my brother, Andrew Cornelius, what was his greatest lesson learned in life so far. I was surprised that his response was very similar to Bev's, when he said, "Don't waste time, because it passes by so fast. Accomplish as much as you can, when you can, because before you know it, the years have passed by, and you can't get them back." I used to hear this saying all the time when I was growing up, "Time waits for no man." I didn't understand what it meant then, but I sure do understand it now.

My cousin, Ann Fulton, said, "I have always been introspective, however, being ill as made me have a look at myself in a different light. I found out that the things I thought were important in life, really wasn't. Reconnecting with what I lost sight of was more important, which was my faith in God, my family, friends, laughter and being surrounded by my loved ones."

When I asked my cousin Leewan Phang, about her greatest lesson learned so far, her response was, "Take care of yourself first, before you take care of others. If you don't love yourself, its impossible to love someone else. Listen to your elders because they have a lot of wisdom and experience to impart. Live your life and enjoy it while you can - don't put off what you can do today, because tomorrow is not promised to anyone."

Here's something I have to share through this platform I have been given. There is only one race – the human race. All humans have the same basic physical traits, we all bleed red blood, and every person is made in the image and likeness of God Himself. Don't judge a book by its cover - judge each person individually, and you will see for yourself, that there are good and bad in all ethnicities, from all walks of life, both rich and poor, throughout the entire world.

In conclusion, through my experiences, I have learned that you have to ride above the storms in your lives and see it as an adventure. In order to overcome life's obstacles, we have to lend a helping hand

to one another, and help each other ride through their storms. I don't mean just help your own people, I mean help the people around you, the ones you see in need of help, no matter what color, or creed they may be.

Smile, and say hello to the person you pass on the street. You have no idea what that person is going through, and how just a small jester such as a smile and a greeting, can make their day and lift that person's spirits. No man is an island, and we all need someone to help us through the rough times, even if it's just someone to talk too. So, lend a listening ear, be considerate of other people, and let's help each other to overcome the adversities and trials we experience during our journey here on earth.

If you know someone who is experiencing hardships in their life, hardships which you have already experienced and made it through, help that person in your path to pull through. Chances are, you might be the only one in their surroundings that can uplift, encourage or strengthen that person. God's greatest commandment is that we love one another, so strive to love others, who ever they may be. Help up those who have fallen, wipe the tears of those who are weeping, and provide your shoulder for someone to lean on. Give hope to those who have lost it, and encourage those who need it.

Don't be envious of someone you know that is doing much better than you, because you have no idea what they went through to accomplish what they have. More times than none, you wouldn't be willing to endure the hardships they experienced, in order to achieve what they have. Share what you have with those less fortunate than yourself, because whatever we do in life, always comes back around to us.

I have helped many people from various ethnic backgrounds, from all walks of life, in some way or form. At the time, I had no idea that one day I would need help myself. I helped strangers, and

strangers helped me, I took people into my home, and people took me into theirs. Because of the help I gave to others, when I needed it, help was given to me. People were put in my path to help me through my hard times.

I don't know how I would have made it this far, without Bev, Rita Foy, Jill Kavanaugh-Green, Denzil Taylor, Loris Cummings, Urceline Forrester, Morrissa Baker and Rose Lewin. I thank them as well as the many other people God put in my life to help me and keep me going, when I wanted to give up. Some helped me financially, some gave me a place to stay, while others lent their shoulder for me to cry on. They picked me up when I had fallen, and encouraged me when I lost all hope.

Looking back on those days of despair and depression, I recollect that I chose to isolate myself. I withdrew into a dark place, and when I stayed there to long, it became like a grave. All my desires, and dreams were dead and buried, lost in an abyss. I began to doubt the beliefs I once had, that things would work out and life would get better. Once we water the seeds of doubt in our minds, it replaces our faith, and the things we once hoped for. This causes some people to totally give up and end their lives.

What they didn't realize, was change could have been on the way. Our breakthrough always seems to arrive when we least expect it, and sometimes through people we least expect. Some took their lives not knowing that if they had just held on one more day, week, or month, something good was going to happen. I allowed my mind to be poisoned with the belief that God wasn't with me and didn't care. All along, God was allowing me to go through the fire and undergo extreme pressure, but I didn't realize at the time, He was making me stronger.

I was being processed the way one processes fine gold. I was listening to Jack Graham, from PowerPoint Ministries one evening,

who said in not these exact words that, "When we go through trials, and our lives are broken and crushed, it brings us to our knees and on our faces before God. In that humbling moment, we receive in the trial the experience of knowing God as we have never known Him before, as He becomes Lord of our life."

Well, that is certainly what happened for me, I learned who God was on a deeper level than I had known Him before. I learned the character of God, that His love is never failing. I learned that He is a provider and a deliverer, He is faithful and never goes back on His word. If He says He is going to do it, then you can take it to the bank. Then again, He might not do it in our time, when we actually want Him too, but He will always come through right on time.

I hated going through my trials. But at the end of it all, I can now say it was well worth it, because I am now stronger and better because of it. When we are going through our adversities, we can only see the negative aspects of it at the time, but when it's over, we are able to see the full picture. My tests are now my testimony, and my mess, is now my message. God changes caterpillars into butterflies, sand into pearls, and carbon into diamonds, and these three things became beautiful through time, heat, and pressure.

So, I say to all who are feeling overwhelmingly pressured from the cares of this world - keep your hope alive because without it, it is impossible to hold on through the trials you will face during your journey. Don't give up, keep on pushing, keep on pressing. We all must go through something, but how we handle it, will either make us or break us. If you are reading this book, then you will know I made it, and my dreams are coming true.

When my life looked hopeless, I couldn't believe I would ever regain the things I lost. But that was a lie, because I have now been restored. I have been living here for five years and within that time, I bought another BMW, and a new construction home. If it can

happen for me, it can happen for you too. If I can make it, then so can you. It all starts in the mind – so you have to hold on to hope and keep your faith alive.

Faith is believing what isn't, as though it is - so, speak faith into your circumstance, and change your way of thinking. We can't keep doing things the same way, or having the same mentality, and expect things to be different. Try to think good things in the midst of your adversities - tell yourself you will get through it, and eventually you will. Although life can be so bitter at times, there are also times that it can be so sweet. Every day we wake up, God has given us new mercies. Many didn't wake up this morning, but you did. So, give thanks for each new day, which is a chance for a new beginning.

May you prosper greatly, may God bless, keep and protect you all, and may all your dreams come true!

I first would like to thank you for buying my book. I would also love to hear from you and get feed back regarding how my book as helped you. You can contact me at: **hilary.lifejourney@gmail.com**

I look forward to hearing from you.

Ingram Content Group UK Ltd.
Milton Keynes UK
UKHW050800070323
418120UK00001B/4